Cinema, Space, and Polylocality
in a Globalizing China

Critical Interventions
Sheldon H. Lu, general editor

Cinema, Space, and Polylocality in a Globalizing China
Yingjin Zhang

*Children of Marx and Coca-Cola: Chinese Avant-garde Art
and Independent Cinema*
Xiaoping Lin

CRITICAL INTERVENTIONS

Cinema, Space, and Polylocality in a Globalizing China

Yingjin Zhang

University of Hawai'i Press

Honolulu

15 14 13 12 11 10 6 5 4 3 2 1

Critical Interventions
Sheldon H. Lu, general editor

Critical Interventions consists of innovative, cutting-edge works with a focus on Asia or the presence of Asia in other continents and regions. Series titles explore a wide range of issues and topics in the modern and contemporary periods, especially those dealing with literature, cinema, art, theater, media, cultural theory, and intellectual history as well as subjects that cross disciplinary boundaries. The series encourages scholarship that combines solid research with an imaginative approach, theoretical sophistication, and stylistic lucidity.

Library of Congress Cataloging-in-Publication Data
Zhang, Yingjin.
 Cinema, space, and polylocality in a globalizing China / Yingjin Zhang.
 p. cm. — (Critical interventions)
 Includes bibliographical references and index.
 ISBN 978-0-8248-3337-4 (hardcover : alk. paper) — ISBN 978-0-8248-3408-1 (pbk. : alk. paper)
 1. Motion pictures and globalization—China—History. 2. Space and time in motion pictures. 3. Motion pictures—Production and direction—China. 4. Motion pictures—China—History—20th century. 5. Motion pictures—China—History—21st century. I. Title.
 PN1993.5.C4Z5 2010
 792.0951—dc22

 2009027714

University of Hawai'i Press books are printed on acid-free paper and meet the guidelines for permanence and durability of the Council on Library Resources.

Designed by University of Hawai'i Production Department
Printed by Edwards Brothers, Inc.

For Su, Mimi, and Alex

Contents

Illustrations

Acknowledgments

I began this project back in 2000, when the world was entering the new millennium with high expectations. As with my previous books, this project was supported by grants from various institutions. I wish to thank the Department of Literature at the University of California, San Diego (UCSD) for a course reduction when I joined the faculty in 2001–2002; the UCSD Center for the Humanities for a faculty fellowship in Fall 2002; the United States Fulbright Scholarship Board for a China research fellowship in 2003–2004; the David Lam Institute for East-West Studies at Hong Kong Baptist University for a visitorship in March 2004; the University of California Humanities Research Institute for a residential faculty fellowship at Irvine on law and information in the Winter Quarter of 2005; the University of California Pacific Rim Research Program for two mini grants in 2003 and 2005; and the UCSD Academic Senate for several research and travel grants between 2002 and 2008.

Earlier versions of parts of this book were presented at numerous colleges and universities in Australia, mainland China, Hong Kong, South Korea, and the United States between 2001 and 2008. For their warm hospitality and critical dialogue, I thank my hosts and audiences at these institutions. I also want to thank my colleagues at UCSD and elsewhere for productive academic exchanges, the anonymous readers of my manuscript for their insightful comments, and Patricia Crosby and the editorial staff at the University of Hawai'i Press for seeing this book through production. Finally, this book is dedicated to my loving family, Su, Mimi, and Alex: for our own experiences of space and polylocality across the Pacific and North America.

∽

I am grateful to editors, journals, and publishers for granting permission to incorporate revisions of my previous publications in this book.

An earlier version of the first part of Chapter 2 appeared as "Chinese Cinema and Transnational Film Studies," in *World Cinemas, Transnational Perspectives,* eds. Natasa Durovicova and Kathleen Newman. New York: Routledge, 2009.

An earlier version of the second part of Chapter 2 was published as "Comparative Film Studies, Transnational Film Studies: Interdisciplinarity, Crossmediality, and Transcultural Visuality in Chinese Cinema," *Journal of Chinese Cinemas* (United Kingdom) 1, no. 1 (2007): 27–40. © Intellect Ltd, The Mill, Parnall Road, Bristol BS16 3JG, United Kingdom.

An earlier version of sections of Chapter 3 appeared as "Cinema and Space: Critical Reflections on Postsocialist Chinese Cinema," in *China siglo XXI: Desafíos y dilemas de un nuevo cine independiente (1992–2007) / China 21ˢᵗ Century: Challenges and Dilemmas for a New Independent Cinema (1992–2007),* ed. Luis Miranda, pp. 353–371. Granada, Spain: Junta de Andalucía, 2007.

An earlier version of other sections of Chapter 3 appeared as "Rebel Without a Cause? China's New Urban Generation and Postsocialist Filmmaking," in *The Urban Generation: Chinese Cinema and Society at the Turn of the Twenty-first Century,* ed. Zhen Zhang, pp. 49–80. Copyright 2007, Duke University Press.

An earlier version of the first part of Chapter 4 appeared as "Remapping Beijing: Polylocality, Globalization, Cinema," in *Other Cities, Other World: Urban Imaginaries in a Globalizing Age,* ed. Andreas Huyssen, pp. 219–241. Copyright 2008, Duke University Press.

An earlier version of the first part of Chapter 5 appeared as "My Camera Doesn't Lie? Truth, Subjectivity, and Audience in Chinese Independent Film and Video," in *From Underground to Independent: Alternative Film Culture in Contemporary China,* eds. Paul G. Pickowicz and Yingjin Zhang, pp. 23–45. Lanham, MD: Rowman & Littlefield, 2006.

An earlier, shorter version of the second part of Chapter 5 was published as "Styles, Subjects, and Special Points of View: A Study of Contemporary Chinese Independent Documentary," *New Cinemas: Journal of Contemporary Film* (United Kingdom) 2, no. 2 (2004): 119–135. © Intellect Ltd, The Mill, Parnall Road, Bristol BS16 3JG, United Kingdom.

An earlier version of the first part of Chapter 6 was published as "Thinking Outside the Box: Mediation of Imaging and Information in Contemporary Chinese Independent Documentary," *Screen* (United Kingdom) 48, no. 2 (Summer 2007): 179–192.

An earlier version of the second part of Chapter 6 appeared as "Playing with Intertextuality and Contextuality: Film Piracy On and Off the Chinese Screen," in *Cinema, Law, and the State in Asia,* eds. Corey K. Creekmur and Mark Sidel, pp. 213–230. New York: Palgrave Macmillan, 2007.

A shorter version of Chapter 7 was published as "Chinese Cinema in the New Century: Prospects and Problems," *World Literature Today* 81, no.4 (July–Aug. 2007): 36–41.

Introduction

Cinema, Space, Polylocality

> Without space, no multiplicity; without multiplicity, no space.
> Precisely because space . . . is a product of relations-between . . . it
> is always in the process of being made. It is never finished; never
> closed. Perhaps we could imagine space as a simultaneity of
> stories-so-far.
> —Doreen Massey[1]

Three key concepts of space reflect a significant recent development in human geography and social theory. The first is the concept of *space as product,* according to which space is seen as produced by social, political, and economic forces rather than as a natural given; an analogous concept is Henri Lefebvre's "production of space," which occurs at different scales, from the globe to the body, from cosmos to hearth.[2] The second key concept is that of *space as process,* according to which space is conceived as multiple, coeval, and relational; as such, space inevitably engages other terms such as place and locality, and it calls attention to its multidirectional flows and its historical contingency. The third concept is that of *space as productive,* according to which space becomes a dynamic force that generates changes, shapes experiences, and demands narratives; as such, space constitutes what Massey calls "a simultaneity of stories-so-far," a discursive mechanism that at once foregrounds the multiplicity and heterogeneity of space and necessitates human intervention by way of narrativization and theoretization.

This book represents my efforts to trace distinctive threads in a multitude of "stories-so-far" concerning cinema, space, and polylocality in a globalizing China—stories seen through the abstraction of theoretical discourses, projected through imagination and technology on the screen, circulated through a myriad of spaces and places at different geographic scales, and received through negotiation in the experiential realm of everyday life. This book is not a theoretical treatise on cinema and space,[3] nor is it exclusively a study of representations of space in

Chinese cinema, although several chapters deal with this second area extensively. Rather, my initial interests are twofold: first, to explore what kind of new perspectives and insights we may gain from an investigation of contemporary Chinese cinema and culture in terms of space and polylocality; and second, to bring into dialogue various "stories-so-far" in contemporary Chinese cinema that articulate, explicitly or implicitly, ideas of space and polylocality. This introductory chapter, therefore, is devoted to a consideration of the theories of space, place, locality, and globalization that inform my discussion in the following chapters on trans/national cinema, the spaces of production and reception, the remapping of the city and polylocality, subjectivities and modes of independent filmmaking, performative documentaries, and piracy as intervention, as well as glocal, transnational market dynamics.

Cinema and Space

THEORIES OF SPACE AND CINEMA

Three major theoretical frameworks have inspired my investigation of cinema and space in contemporary China. First, as Lefebvre argues, if "space is a product," then the object of our interest must "shift from *things in space* to the actual *production of space*," that is, from space as a fixed entity to space as a "productive process" that induces change and is subject to revision.[4] Corresponding to what he describes as "three moments of social space" or a "triad of the perceived, the conceived, and the lived," Lefebvre differentiates three critical concepts: "spatial practice" (a physical space characterized by a certain cohesiveness without necessarily being coherent), "representations of space" (a space largely dominated by social engineers that tends toward a system of verbal signs), and "representational spaces" (a space dominated by artists and writers that tends toward a system of nonverbal symbols and signs, which David Harvey prefers to call "spaces of representation" linked to "imagination").[5] Cinema undoubtedly belongs to Lefebvre's representational space, because it "has an affective kernel," "embraces the loci of passion, of action and of lived situations," and "may be directional, situational or relational, because it is essentially qualitative, fluid and dynamic."[6] Lefebvre's dynamic model accounts for the coexistence of heterogeneous spaces in a salient representational space that is cinema: absolute space, abstract space, contradictory space, differentiated space, appropriated space, social space, natural space, leisure space, counterspace, and so forth.

Lefebvre's theory of space, which leaves an indelible mark on Massey's conceptualization of the relationality and open-endedness of space, emphasizes the *interplay* between the production of space and the space of production. Lefebvre has

convinced me to direct attention not just to the dominant or official space, but to an array of dominated yet alternative, interstitial, and contingent spaces that have been opened up or produced by the new spaces of Chinese film production since the early 1990s: underground *(dixia)*, independent *(duli)*, semi-independent, semiofficial, translocal, and transnational. As illustrated in Chapters 3 through 6, such new spaces of production have further assisted the production of alternative spaces of appropriation, contestation, and subversion in film representation and reception.

The second framework is Miriam Bratu Hansen's theory of early cinema and the public sphere, which shifts the emphasis from the space of film representation (which pertains to the symbols and signs in Lefebvre's analysis) to that of film exhibition and reception (which pertains to lived experiences). Drawing on the work of Oskar Negt and Alexander Kluge, Hansen explores the possibility of a "plebeian," "proletarian," or "oppositional" public sphere vis-à-vis the dominant industrial-commercial public sphere (marked by its Taylorist-Fordist technological operations) on the one hand and the idealized bourgeois public sphere (marked by its Habermasian democratic reasoning) on the other.[7] "The political issue," Hansen surmises, "is whether and to what extent a public sphere is organized from above—by the exclusive standards of high culture or the stereotypes of commodity culture—or by the experiencing subjects themselves, on the basis of their context of living *(Lebenszusammenbang)*."[8] By offering an attractive public space where moviegoers from different classes congregate in their leisure time, cinema may constitute a public sphere whose experiential function differs from rationalization in the bourgeois public sphere or commodification in the industrial-commercial public sphere.

The spatiality of Hansen's theorization is conspicuous—the abstract, dominant spaces of the industrial-commercial and bourgeois public spheres vis-à-vis the empirical, dominated space of *Lebenszusammenbang*—and her emphasis is unequivocally placed on the latter. Hansen's work dovetails with that of Lefebvre and Massey in that *Lebenszusammenbang* exists in certain sociospatial relations to the dominant public spheres, and such relations are not fixed but change over time due to different spatial configurations of power or what Massey calls "power-geometries," thereby producing the possibility of *opposition* within the same system.[9] While it is debatable whether the concept of a public sphere is applicable to modern China,[10] I contend that the possible existence of an oppositional public sphere in the space of film exhibition and reception is indispensable to the formation and maintenance of alternative film culture in contemporary China (see Chapters 3 and 6).[11]

The third framework is Michel de Certeau's theory of "spatial practices." It differs from Lefebvre's use of the same term in that it covers human activities more than physical space, and it also substantiates Hansen's conjecture concerning the

audience's sensorial, affective experience in an alternative, potentially oppositional, public sphere. Whereas Hansen speculates on the liberating effects derived from the female cult of Rudolf Valentino in the United States of the 1920s—"a kind of rebellion, a desperate protest against the passivity and one-sidedness with which patriarchal cinema supports the subordinate position of women in the gender hierarchy,"[12] de Certeau focuses on a more widespread, tangible everyday experience—"walking in the city"—and elevates this mundane act to a significant trope of spatial practices. Imagining a scenario of "pedestrian speech acts," he locates in this otherwise inconsequential practice of walking a triple enunciative function: "it is a process of *appropriation* of the topographical system . . . ; it is a spatial acting-out of the place . . . ; and it implies *relations* among differentiated positions, that is, among pragmatic 'contracts' in the form of movements."[13] Space, in de Certeau's theorization, is defined as much by preconceived borders as by improvised movements, as much by rigid institutional systems as by imaginative individual subjects, as much by strategies of the dominant power as by tactics of performative appropriation. De Certeau writes thus of the contrastive, contradictory functions of walking as a particular form of spatial practice: "Walking affirms, suspects, tries out, transgresses, respects, etc., the trajectories it 'speaks.'"[14]

De Certeau's concept of spatial practices acknowledges the power of "cognitive spacing," which, according to Zygmunt Bauman, "derives from modernity's desire to master space; to determine a place for everything and ensure that everything is in its place—so that surveillance might readily reveal what is 'out of place,'"[15] Although de Certeau's concept of power may be too monolithic and too binary in nature (domination versus resistance, surveillance versus transgression), the way he envisions walking as an act that "speaks" its own trajectories reaffirms Lefebvre's characterization of representational space—it "is alive: it speaks."[16] As a representational space itself, cinema likewise speaks to its audience—attracting them with many "stories-so-far"—and, as Hansen suggests, drawing on Kluge's work, "makes the viewing 'public' *(Publikum)* a public sphere *(Offentlichkeit)*" through a shared intersubjective horizon in collective reception.[17] Indeed, similar to de Certeau's scenario of an individual's appropriation or transgression under the dominant power's strategic surveillance, filmmakers and audiences may obtain new experiences and generate new meanings in excess of—if not in opposition to—those intended by the nation-state or the market, and they can choose to share these experiences and meanings in public, collectively. This is exactly what has happened in China as it globalizes, where a new set of power-geometries has produced new spaces of film production and reception, and these new spaces— however marginal, ephemeral, or liminal—have provided individuals with a potent means of experiencing, sharing, and enhancing the liberating potentials proffered by cinema.

GLOBALIZATION, SPACE, AND PLACE

Globalization is subject to spatial conceptualization in a number of ways. First, in terms of sociospatial restructuring, Manuel Castells points to the transformation of socially and spatially based relationships of production into flows of information and power that articulate the new flexible system of production and management. Central to a new sociospatial logic, the "space of flows" is considered global in its impact on the new "informational society" and functional at three prominent levels: the infrastructural (the "wired world"), the organizational (world cities), and the managerial (informational elites). Although paying more attention to structural than human factors, Castells nonetheless presents a convincing argument that globalization is "an era where *timeless time* exists in tension with chronological time" and "a space of flows exists in tension with a space of places."[18]

Second, in terms of the space-place configuration, place seems to be losing out to space in the era of globalization. As Castells asserts, "A place is a locale whose form, function and meaning are self-contained within the boundaries of physical contiguity."[19] Driven by the logic of flows, the world of places (for example, the home, the city) is increasingly superseded by spaces characterized by circulation, velocity, and flow, and this tendency is visually reflected, on the one hand, in the widespread demolition of old neighborhoods in developing cities like Beijing and Shanghai (see Chapter 4) and, on the other, in the proliferation of serialized, ahistorical, and acultural architectural projects like international hotels, airports, and supermarkets in world cities.[20] Interestingly, such architectural projects, along with the shopping mall, the highway, and the multiplex cinema, are classified by Marc Augé as "non-places," which serve as symptoms of supermodernity and "its essential quality: excess."[21]

Third, in terms of scale readjustment, globalization tends to favor the global at the expense of the local. Even the apparently balanced term of "glocalization"—a neologism derived from a 1980s Japanese marketing slogan, *dochakuka*—already implies unevenness in that it means globalization for some and localization for others.[22] Globalization thus works to polarize society in accordance with differentiated mobility: "Some inhabit the globe; others are chained to place."[23] The polarization of freedom of movement and its lack consequently adds a new dimension to deprivation: being merely local in a globalized (or glocalized) world is automatically rendered a secondary existence.[24] Globalization, in Bauman's judgment, "divides as much as it unites—the causes of the division being identical with those that promote the uniformity of the globe."[25]

Some scholars, however, have questioned the current trope that local places are victimized by the forces of globalization. Arturo Escobar, for one, is not persuaded by the structurally lopsided view in which "the global is associated with

space, capital, history and agency while the local, conversely, is linked to place, labor, and tradition—as well as with women, minorities, the poor and . . . local cultures."[26] The problem is that the victimization view identifies with a "development discourse" that champions the space of capital and power and gives the impression that place is left behind due to its grounded locality and backward tradition, both of which have rendered it less competitive in globalization and more susceptible to stagnation and poverty.[27] Worse still, Massey observes, "So long as inequality is read in terms of stages of advance and backwardness not only are alternative stories disallowed but also the fact of the production of poverty and polarization within and through 'globalization' itself can be erased from view."[28] To restore a balanced view of place and locality in the geography of globalization, Massey calls for "a global sense of the local, a global sense of place."[29]

In a more radical fashion than Massey, Arif Dirlik draws on Bruno Latour and poses a challenging question: "What if the global were local, or placed-based, just as the local or placed-based were global?"[30] One objective of Dirlik's challenge is to disrupt the deceptive symmetry in recent discussions of the global and the local: "The global is localized, and the local is globalized. That is the symmetry. But the globalization of the local does not compensate in terms of politics, economy, and culture for the localization of the global. That is the asymmetry."[31] Dirlik's challenge also seeks to move beyond the hybridity of the global-local or the glocal toward "a recognition of the primacy of place, and of its autonomy, and, *on that irreducible basis,* to produce translocal or, better still, transplace alliances and cooperative formations."[32] Herein lies the core of Dirlik's project of "placed-based imagination," which Dirlik himself admits is open to the charge of "utopian dreaming" but which urges academics to prioritize "the voices of the weak who are straining to be heard" over "the voices of globalism that erase both people and places."[33] As demonstrated throughout this book, many Chinese independent directors make it their mission to articulate the voices of the weak (Chapter 4), and translocal alliances have emerged to launch place-based projects of independent production and exhibition (Chapter 5). These new translocal formations thus require us to reflect further on issues of cinema and polylocality.

Cinema and Polylocality

THE PRODUCTION OF SCALE AND TRANSLOCALITY

In reasserting the primacy of place, Dirlik has, in effect, attempted to rebalance the scales in relation to place, tipping them toward the local: "Place as metaphor suggests groundedness from below, and a flexible and porous boundary around it, without closing out the extralocal, all the way to the global."[34] Two ideas are behind

this attempt: the multiplicity of places along the continuum of scale, and the production of scale itself. First, as Yi-Fu Tuan remarked decades ago, "Place exists at different scales," which stretch from the cherished hearth (home) to the boundless cosmos (nature).[35] Notwithstanding Dirlik's emphasis on the political advantage of staying place-based, the sheer possibility of the coexistence of place at different scales implies the necessity to consider the relationality and multiplicity of place and locality; this is what Massey has pursued in her work. Second, as Neil Smith theorizes, geographical scales such as local, regional, national, and global are not given in nature but are historically contingent outcomes of diverse social processes.[36] As with space, scale is socially produced. Understood as "a process that is always deeply heterogeneous, conflictual, and contested,"[37] the production of scale thus permits the possibility of jumping scale, both jumping up vertically along a hierarchy (as in a corporation bypassing the state and reaching the European Union directly) and jumping across horizontally (as in an NGO [non-government organization] forming an alliance through a multilocal network).

Jing Wang's study of the changing cultural policy in a globalizing China reveals that the production of scale can be done in an authoritarian (that is, state-mandated) manner or in a contested (that is, extrastate or even counterstate) manner. The overhaul of the state-owned media industries reflects authoritarian, yet market-driven, efforts in the production of scale.[38] To furnish an example from China's film industry: several previously state-owned but city-based film studios were merged around 2001 to form new, formidable-sounding "film groups" *(dianying jituan)*, such as the North China Film Group, based in Changchun; the Northwest Film Group, in Xi'an; the Southwest Film Group, in Chengdu; and the South China Film Group in Guangzhou. Strategically positioned as *regional* players, these new film groups have shed their former *municipal* affiliations (such as Changchun and Xi'an) or geographic associations (for example, Emei, a mountain near Chengdu, and Zhujiang or the Pearl River, which runs through Guangzhou), have jumped beyond the *provincial* scale of certain smaller provincial studios (such as Fujian and Zhejiang), and are competing for investment *nationally* and *internationally* with the two most prominent film production conglomerates, China Film Group, based in Beijing, and Shanghai Film Group, in Shanghai. By producing a new regional scale—capable of encompassing both intranational regions (as in new film groups) and extranational regions (as in coproductions with Japan and South Korea), Chinese state policy-makers appear to believe that size and scale matter in China's confrontation with Hollywood, especially after its entrance into the World Trade Organization (WTO) in December 2001.[39]

The production of scale engenders new scale relations, which are complicated by the increasing flows of capital, information, goods, and people in a globalizing China. Moreover, such flows across scale create new linkages among previously

unconnected or loosely connected locales, thereby generating a new sense of trans-locality. According to Carolyn Cartier, "Dialectical scale relations may be thought of as a set of 'translocal' processes for the ways in which the translocal are those multiple places of attachment experienced by highly mobile people."[40] In China today, highly mobile people include not only the transnational business elites who trot the globe with ease but also—and far more important for anthropologists and sociologists—hundreds of millions of "migrant workers" (*mingong;* also known as the floating population) who leave their rural villages and move about in big cities in search of better opportunities.[41]

Proceeding with David Goodman's working definition of translocality as *"being identified with more than one location,"* Tim Oakes and Louisa Schein elaborate the concept in order "to highlight a simultaneous analytic focus on mobilities *and* localities," as well as identities and subjectivities.[42] For them, translocality designates not just the mobility of people but also the circulation of capital, ideas and images, goods and styles, services, diseases, technologies, and modes of communication. "The flow of media messages represents a chief form of translocality that does not entail human movement," they remind us; so even when people stay put in a local place, their subjectivities may be transformed by translocal processes.[43] In Oakes' study, ethnic tourism in southwest China is one such translocal process, in which a local village theme park is linked to the national agenda of modernity, while in Schein's study, migrant Miao minority women's hair dye, ethnic costume, and chili spices become their embodied means of translocal identification.[44]

Thus elaborated, translocality implies multiple sites of identification (no longer a unique "native place" or *guxiang*) and suggests that "home itself becomes complicated, its roots to a single locality multiplied to a network of localities."[45] Not surprisingly, such a home-related network of localities can be multiplied across scale, as is confirmed by Yunxiang Yan's fieldwork on managed globalization in China. In 1998 Yan met a successful Chinese businesswoman in her late thirties, a self-styled "world citizen." She was a U.S. permanent resident who owned two real estate companies in two mainland Chinese cities, an export-import firm in Hong Kong, and a family house in Connecticut, and she claimed that she only experienced "the feeling of being at home" in her American residence.[46]

Yan's example demonstrates that the production of translocality in the age of globalization involves both displacement (migration) and emplacement (resettlement) and that people on the move may have access to *agency* and assert identity in a place where it is least expected. Stuart Hall's insight is illuminating: "From the diaspora perspective, identity has many imagined 'homes' (and therefore no one single homeland); it has many different ways of 'being at home'—since it conceives of individuals as capable of drawing in different maps of meaning and locating them in different geographies at one and the same time—but it is not tied to one,

particular place."[47] Not only does such identification with multiple places of "being at home" establish the persistence of translocality across scale, but it also keeps agency alive, no matter how intermittently or interstitially, in a world dominated by capital and its attendant development discourse.

The question of agency surfaces when migrant Miao workers, in Schein's study, renegotiate the ranking of scales between urban and rural and remake them so they are less hierarchical and more horizontal. "Horizontality, then, becomes another way of expressing an unbounded local scale," Oakes and Schein contend, and they encourage us to "read these instances as struggles that seek to 'equalize' social relations across scale, to replace the ladder with more traversable concentric circles."[48] Admittedly, in a fundamentally authoritarian society like China, the projection of agency in such a bottom-up attempt at scale adjustment seems to verge on utopian dreaming, as Dirlik acknowledges for his place-based projects. Nonetheless, a reexamination of scale relations highlights the still-evolving and unprecedented phenomenon of migration and mobility in today's China.

In the framework of cinema and polylocality, my discussion of the production of scale and translocality serves to foreground an unswerving concern with the *experiential* realm of everyday life or the quotidian, a concern China anthropologists and geographers—more than China economists and sociologists—share with the majority of Chinese filmmakers. Everyday spatial practices in specific locales are what attract scholars and filmmakers alike. In Jing Wang's opinion, "This emphasis on practice and locale immediacy inevitably turns the quotidian into the most important scale for the Chinese. . . . It is in the quotidian where their struggle over space is improvised, where the inevitable embeddedness of a place is lived and the production of differences taken for granted."[49]

POLYLOCALITY, TRANS-SPATIALITY, CINEMA

Trans-spatiality enables cinema to play with all kinds of space, and such play contributes substantially to the production of space at different scales. As summarized above, translocality simultaneously designates three areas: places of attachment or identification, people whose physical or imaginary movements across scale connect disparate spaces and places, and technologies and modes of communication that facilitate such attachment, identification, movement, and connection. Although I use both translocality and polylocality in this book to denote the multiplicity of space and locality in contemporary Chinese cinema, I maintain a crucial difference between the two terms. Whereas *polylocality* recognizes the existence of multiple, diverse localities and therefore contains the possibility of a *trans*locality that could connect these localities, it differs from translocality in that it does not guarantee the realization of this translocal potential. In other words, polylocality acknowledges that identification and connection between localities can be denied

or prohibited; that not all polylocality is brought into translocality in the same way; and that inequality or unevenness exists in polylocality because of different access to translocality.

As a spectacularly successful product of and vehicle for modern technology and culture, cinema is polylocal and translocal at different scales. Insofar as production is concerned, the polylocality of cinema is built into its division of labor; the individual responsibilities of the producer, the director, the screenwriter, the cinematographer, the cast, the crew, and so forth are rarely accomplished in one locality alone, and the practice of shooting on location requires travel to different places beyond the studio. Cinema's capital-intensive processes are complicated by equally intensive, and often highly precarious processes of distribution, exhibition, and reception—processes that by necessity extend from the local through the provincial to the national (for a domestic box-office success) and, in the case of transnational blockbusters *(dapian)*, to the regional, the continental (Asia, Europe, North America), and even the global (in the case of simultaneous premieres). Such is the translocality of cinema that all localities across scale must be coordinated in an efficient way, and all disparate elements must weave together into a seamless screen product. It is a truism to declare that "no film is an island."[50]

In the era of globalization, the polylocality of cinema can be stretched in an extraordinary fashion in order to minimize production costs, maximize market profits, and intensify visual and other pleasures. *Crouching Tiger, Hidden Dragon* (Ang Lee, 1999) is one such celebrated success. The principal personnel of this transnational coproduction consisted of director Ang Lee (Taiwan-born, U.S.-educated); screenwriters James Schamus (Lee's longtime New York-based collaborator), Wang Hui Ling (Taiwan), and Tsai Kuo Jung (Taiwan); cinematographer Peter Pau (Hong Kong); action choreographer Yuen Wo Ping (Hong Kong); production and costume designer Tim Yip (Hong Kong); music composer Tan Dun (mainland China-born, U.S.-educated); as well as major stars Chow Yun-Fat (Hong Kong), Michelle Yeoh (Hong Kong), Chen Chang (Taiwan), and Zhang Ziyi (mainland China).[51] Originally marketed as a martial arts picture for the art-house circuit in the West (including Australia, Europe, and North America), *Crouching Tiger* garnered high praise at European film festivals and went on to rake in US$128 million in the United States alone, making it the highest-grossing Chinese-language film to date.[52] The film was nominated for Best Picture and Best Director at the Academy Awards and won Oscars for Best Foreign Film, Best Art Direction, Best Cinematographer, and Best Music-Original Score.

Schamus touches on the film's polylocality in his reminiscence:

> This film was shot in almost every corner of China, including the Gobi Desert and the Taklamakan Plateau, north of Tibet, near the Kyrgyzstan border. We

were based for a time in Urumchi, where all the street signs are in Chinese and Arabic, then all the way down south to the Bamboo Forest in Anji and north to Cheng De, where the famous summer palace is. The studio work was done in Beijing; we recorded the music in Shanghai. The background vocals for the end credit song were recorded in Los Angeles and we did post-production looping in Hong Kong.[53]

Apart from such polylocality on and off screen, many other aspects of the film also underscore translocality at work. The screenplay and subtitles, for instance, undertook several translocal—or trans-Pacific in this case—shuffles. As Schamus recalls, "I write in English, it's rewritten into Mandarin, then I have it translated back into English"; after adapting what he calls the "international subtitle" style for the screenplay, he compares his translocal, translingual experience to "going

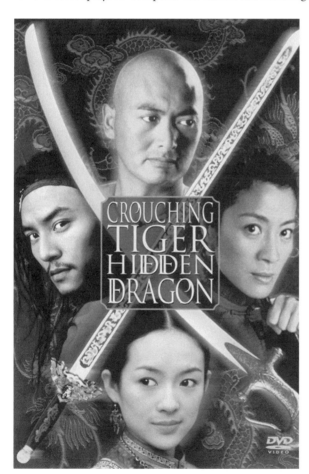

Figure 1.1. DVD cover of *Crouching Tiger, Hidden Dragon* (1999): a worldwide martial arts sensation

to another mental space."[54] The music in the film likewise reveals its polylocal sources (from traditional, ethnic, and pop music in China to Western orchestral music), and Yo-Yo Ma plays the cello solos.

While recent global successes such as *Crouching Tiger* have compelled scholars to reexamine the paradigm of national cinema and explore transnational cinema (see Chapter 2), Schamus' experience of "going to another mental space" redirects our attention to cinema and space. In addition to being polylocal, cinema is *trans-spatial*. Its trans-spatiality is embodied first and foremost in the multi-dimensioned space created by the screen projection, so the viewer's attention can easily travel from one space to another, from the image-track (for example, the sets, the costumes, the mise-en-scène) to the sound track (both diegetic and non-diegetic sound), from the space of narrative to that of performance, from physical to symbolic and imaginary spaces on and off screen—in short, from the material to the dream world.[55] After all, Ang Lee confesses, "My desire to direct a martial arts film comes from nostalgia for classical China . . . a conceptual world based on 'imaginary China' . . . that does not exist in reality"; precisely because it no longer exists, Lee feels "free and unrestrained" in his recreation of that dream world on screen: "I can express sentimentality. . . . I can design music and sound effects. There are no limitations."[56] Indeed, cinematic space is virtually boundless.

Cinema's trans-spatial practice returns us to Massey's concept of space as multiple and relational, and this conceptualization makes "trans-spatiality" a superfluous term because space itself now contains such trans-spatiality or multiple spatialities. I will therefore drop "trans-spatiality" in the following chapters, but I want to emphasize that cinema's capacity to play with all kinds of space contributes directly to the production of space at different scales. Polylocality, which pertains more to the space of production than to the production of space, further enriches the enormous sociospatial potentiality of cinema. Together, space and polylocality have engendered countless stories-so-far in film studies, film production, and film reception, some of which I will now investigate in the context of a globalizing China.

SUMMARY OF CHAPTERS 2 THROUGH 7

Chapters 2 through 7 are also each divided into two interrelated parts, and the term "space" is used more thematically than conceptually in chapter titles to pinpoint topics under double scrutiny. Chapter 2, "Space of Scholarship: Trans/National and Comparative Studies," urges scholars to move beyond the national cinema paradigm and to explore the transnational and comparative frameworks of film studies. The first part of the chapter revisits the concept of national cinema and investigates what the old paradigm has marginalized or obscured. I argue that the movement and auteur approches typical of national cinema scholarship tend

to emphasize national cultures and political exigencies at the expense of transnational and cross-regional practices. If examined from the perspective of translocal or transnational flows, certain "ruptures" dismissed by official film historiography may be reconfigured as polylocal dynamics that have tapped into vast resources from disparate geopolitical localities.

The second part of Chapter 2 pursues a different kind of translocality by proposing comparative film studies as a subfield larger than transnational film studies. I recommend that, apart from rethinking issues of Eurocentrism, film studies go beyond the imperative of following money and simultaneously address contextual as well as textual, intertextual, and subtextual aspects of film production, distribution, exhibition, and reception. Within a general comparative framework, this part identifies certain neglected and underdeveloped areas in Chinese film studies, such as audience research, piracy, literary adaptation, and cross-mediality between film and arts such as theater, photography, and video. An emphasis on interdisciplinarity only enriches our understanding of the transcultural visuality embodied by film language and technology.

Chapter 3, "Space of Production: Postsocialist Filmmaking," considers both the space of production and the production of space in postsocialist Chinese cinema. Dai Jinhua's *guangchang* (square) complex provides a sharp lens on the changing power-geometries in 1990s China, while Lefebvre's differentiation of isotopias, utopias, and heterotopias and Foucault's meditation on other spaces help illustrate the coexistence and interpenetration of underground, independent, semi-independent, and official modes of filmmaking. After presenting a diagram on modes of interactions among contending players of politics, capital, art, and marginality, the first part of the chapter traces the early trajectories of Wang Xiaoshuai and Zhang Yuan and emphasizes the importance of marginality in cultivating an alternative public sphere.

The second part of Chapter 3 examines the emergence of the sixth generation by focusing on a symptomatic film, *Dirt* (Guan Hu, 1994), which, by mixing outcry with nostalgia and implosion, represents a rebellious spirit and intentionally depicts socialist history and memory in ruins. A detour through the subcultural margins of rock music in the early 1990s further clarifies the situation in which a new urban generation struggled to position themselves in a changing landscape of postsocialist China. From the late 1990s to the early 2000s, Chinese urban cinema went through substantial transformation as a newer group of young filmmakers joined the earlier generation and explored feelings of deprivation, disillusion, despair, disdain, and indignation.

Chapter 4, "Space of Polylocality: Remapping the City," examines the cinematic representations of Beijing and a persistent engagement with polylocality in hinterland China. In this era of globalization, Chinese filmmakers' remapping of

Beijing favors street-level views over cartographic surveys, contingent experience over systematic knowledge, and bittersweet local *histoires* over grand-scale global history. The first part of the chapter delineates the local/global dynamic of Beijing in two ways: it surveys the imaginaries of Beijing in Hollywood history and then analyzes four Chinese films set in Beijing and released in the new millennium. Significantly, Beijing has emerged from this new round of cinematic remapping as a city of polylocality, and the transnational production of all four films reveals another kind of polylocality at work in postsocialist China.

The second part of Chapter 4 analyzes Jia Zhangke's most recent works as place-based projects grounded in polylocality and critical of the trappings of modernity and globalization. While his documentaries *In Public* (2001) and *Dong* (2006) record the ambivalences of public space, expose the journey as a recurring trope in contemporary life, and heighten the vitality and dignity of human bodies, his feature *Still Life* (2006) foregrounds the disappearance of the local at the same time that it captures translocal connections ranging from landscapes on RMB banknotes to migrant workers displaced to faraway provinces like Guangdong and Shanxi. The motif of currencies—Euros, U.S. dollars, and RMB—further intensifies translocality at different scales, as underprivileged people struggle to cope with the enormous consequences of the Three Gorges Dam, a place of history superimposed on the space of nature.

Chapter 5, "Space of Subjectivity: Independent Documentary," contextualizes the claims of independent Chinese directors to truth and reality and their experiments with various documentary modes and styles. The first part of the chapter exposes the subjectivity hidden behind the Chinese independents' insistence on the truthfulness of their perception of realities. The question of the audience complicates the unusual methods of underground film production and their limited exhibition in unofficial venues in Chinese cities. A study of the drastically different reception of *Xiao Wu* at home and abroad further underscores the dilemma facing Chinese independents, who seek to redefine their positions as unofficial, underground, independent, personal, and/or amateur filmmakers.

The second part of Chapter 5 explores the origins, styles, problems, solutions, and directions of the Chinese independent documentary. I argue that the Chinese preference for the cinéma vérité and interview styles represents an attempt to resist the propagandist, voice-of-God approach in official news and documentary programming. However, self-erasure and misconceived objectivity typical of earlier independent works engendered problems in documentary filmmaking, and a self-repositioning from the late 1990s onward has reclaimed the subjective voice and readjusted the artists' attitude toward their subjects. The call for returning to the personal is further exemplified in the current euphoria for DV (digital video) works, and amateur and activist filmmaking once again highlights the translocal

connections between independent documentary and ordinary people's lives in a changing society.

Chapter 6, "Space of Performance: Media and Mediation," examines Chinese independent works in a reception context of polylocality where domestic neglect contrasts with overseas celebration. The first part of the chapter proposes that we approach the contemporary Chinese independent documentary as a troubling case of information. The case is troubling not only because certain types of intended information may trouble age-old normative concepts in Chinese culture and society, but also because the status of images and information in Chinese independent documentaries raises critical questions regarding interpretation, access, mediation, ethics, affect, and agency. An analysis of *The Box* (Ying Weiwei, 2001), a documentary about a lesbian couple, brings the performative into critical scrutiny and challenges the conventional framework of truth and reality.

The second part of Chapter 6 examines piracy as a thorny issue that cuts across the interconnected domains of film, law, market, morality, creativity, and democracy. Rather than endorsing the media industry's outright condemnation of film piracy as an illegal practice in need of control and eradication, I am interested in both the intertextuality and the contextuality of film piracy in China. The intertextuality in question derives from the multifarious uses of piracy on and off the Chinese screen, and I focus particularly on the production of alternative meanings through the "pirated" intertextuality in recent Chinese independent filmmaking.

Finally, Chapter 7, "Conclusion: Progress, Problems, Prospects," offers an overview of Chinese cinema in the twenty-first century and traces representative directors and important works in a lopsided industry dominated by transnational coproductions of blockbuster films. I offer two tables of the latest market statistics, which I hope will stimulate further research into the interplay between production and exhibition, between underground and aboveground, between domestic and overseas agencies, and between capital and culture.

Overall, this book seeks to rethink the local/global dynamics in contemporary Chinese cinema and to prioritize space and polylocality in our consideration of the power-geometries in a rapidly changing society. If I devote most of my attention to the space of marginality and alternative film culture, it is because this newly opened space represents some of the most interesting works, ones that broaden the scope of social concerns and artistic expressions at the local and global scales. My emphasis on either end of the scale, however, does not in any way render the national insignificant or ineffective. On the contrary, the national remains a haunting presence, which is why I have chosen to confront it first, in Chapter 2.

Space of Scholarship

Trans/National and Comparative Studies

> It is now space more than time that hides things from us. . . . [T]he
> demystification of spatiality and its veiled instrumentality of power
> is the key to making practical, political, and theoretical sense of
> the contemporary era.
> —Henri Lefebvre[1]

More than any other scale discussed in Chapter 1, the scale of
the national used to occupy the central attention in film studies, and the result-
ing myth of a unified national cinema in a given nation-state had tended to hide
things from us and is therefore in need of demystification. Since the late 1980s
scholars have become more aware that the national-cinema paradigm does not
adequately respond to contemporary issues in film studies and film practices.
Even the concept of "national cinema" itself has proven to be far from unprob-
lematic, and critics have advocated a shift from national cinema to "the national"
of a cinema—a shift that allows for diversity and flexibility rather than unity and
fixity as previously conceived. Nonetheless, even as the forces of transnationalism
assume increasing power in this era of globalization, the national as a new criti-
cal concept continues to be unstable, and its conceptual space is constantly criss-
crossed by other discourses and practices.

This chapter investigates what is at stake in a paradigm shift from the scale of
the national to that of the transnational or global. The first part attempts to recon-
ceptualize Chinese cinema in relation to the shifting problematics of national cin-
ema and transnational film studies in both the theoretical and historical contexts.
In terms of theory, we can no longer ignore the glaring gaps and blind spots in
film history that were previously covered or glossed over by the national cinema
paradigm. In terms of history, we must revisit the existing framework of film his-
toriography and reevaluate certain disjunctures or ruptures in a century of Chi-
nese film production, distribution, exhibition, and consumption. This combined

theoretical-historical perspective seeks a better understanding of Chinese cinema at a historical juncture when it has evidently outgrown the parameters of national cinema and has emerged as a significant force in world cinema. The second part of the chapter examines film studies from a different perspective than transnationalism and speculates on what we might gain from comparative film studies, which would offer a larger framework that would permit us to more adequately address issues of interdisciplinarity and cross-mediality and examine underdeveloped areas in Chinese film studies.

Space of Trans/National Cinema

REPROBLEMATIZING NATIONAL CINEMA

Over the past two decades, critics of national cinema in the West have identified a number of problems in film scholarship and have worked to shift the paradigm from unity (an assertion of national consensus) to diversity (several cinemas within a nation-state), from self-identity (a cinema defined against Hollywood) to self-othering (a cinema acknowledging a nation's internal heterogeneity), from text (auteurist studies) to context (cultural history, political economy), from elitist (great intellectual minds) to popular (mass audience), from production (studio-centered) to financing, distribution, and exhibition (process-oriented). In a seminal book on French cinema that subsequently launched an influential national-cinemas series from Routledge in the mid-1990s, Susan Hayward questions two standard film historiographical approaches, those of the "great" auteurs and movements. For her, both approaches pay narrow attention to "moments of exception and not the 'global' picture," and both place a national cinema in "the province of high art" rather than popular culture; these approaches thus require a synchronic and diachronic filling of the gaps between auteurs and movements.[2]

Indeed, Gerald Mast, one of the early proponents of the auteurist approach, had this comparison to offer in the mid-1970s: "Just as the history of the novel is, to some extent, a catalogue of important novels and the history of drama a catalogue of important plays, the history of film as an art revolves around important films."[3] For Mast, film art is undoubtedly the most reliable textual source, based on which a scholar is entitled to study what he calls "the great film minds" in the history of cinema. Not surprisingly, at a time when auteurism prevailed in film studies, the emphasis on "great" auteurs came hand in hand with an emphasis on "pivotal" film movements, these movements seeking to identify like-minded auteurs in groups, generations, and nations. As Andrew Higson observes of British film history, a select group of relatively self-contained quality film movements have been recognized and assigned the responsibility for "carrying forward the

banner of national cinema."[4] On a larger scale, writes Stephen Crofts, "such cinema 'movements' occupy a key position in conventional histories of world cinema, whose historiography is not only nationalist but also elitist in its search for the 'best' films."[5]

Both the auteur and movement approaches prevalent in national cinema studies involve a selective appropriation of history and tradition—what Higson calls "the myth of consensus"—as well as a significant degree of amnesia or pretended ignorance about other contemporaneous types of identity and belonging, "which have always criss-crossed the body of the nation, and which often cross national boundaries too."[6] To supplement the typical strategy of a self-identity defined against Hollywood or another national cinema, Higson recommends an inward-looking process, in which a national cinema is conceptualized in relation to the existing national, political, economic, and cultural identities and traditions.[7] Writing on Australian cinema, Tom O'Regan urges national cinema scholars to take on "multiple and diverse points of view" because, for him, "National writing is that critical practice which thoroughly establishes and routinely works through the heteroclite nature of cinema."[8]

Higson's and O'Regan's attempts at internally "othering" national cinemas bear the imprints of the multiculturalism debate in the West during the 1990s, but an outstanding result of the shift from unity to diversity is the critical realization that, even within a nation-state, "there is no single cinema that is *the* national cinema, but several [national cinemas]."[9] This paradigm shift is reflected in Crofts' taxonomy, which evolved from seven categories of national cinema in 1993 to eight varieties of nation-state cinema production in 1997.[10] Albeit still in need of further elaboration, Crofts' new proposal "to write of states and nation-state cinemas rather than nations and national cinemas" foregrounds a recent consensus regarding the sheer heterogeneity and incommensurability among nations, states, and national cinemas.[11] To quote O'Regan: "At some time or other most national cinemas are not coterminous with their nation states."[12]

The recent shift to diversity and heterogeneity has benefited directly from a gradual expansion of critical investigation beyond textual exegesis. As early as 1985, Steve McIntyre called for redirecting "attention away from concern for exact theoretical explication of progressiveness (or whatever) supposedly immanent in texts, towards a historically and culturally specific analysis . . . of production and consumption, audience composition, problems of reference, and so forth."[13] Higson followed in 1989 with "an argument that the parameters of a national cinema should be drawn at the site of consumption as much as at the site of production of films; an argument, in other words, that focuses on the activity of national audiences and the conditions under which they make sense of and use the films they watch."[14] Crofts concurred in 1993 with a recommendation that "study of any

national cinema should include distribution and exhibition as well as production within the nation-state."[15]

The new emphasis on exhibition and consumption has generated new visions as well as new problematics. Pierre Sorlin, for instance, rewrites the history of Italian national cinema in terms of generations of filmgoers, but the undeniable fact that, historically, a national audience watches domestic *and* foreign films has provoked a debate on what exactly counts as "national" in film consumption.[16] John Hill thus warns against Higson's argument: "The problem . . . is that it appears to lead to the conclusion that Hollywood films are in fact a part of the British national cinema because these are the films which are primarily used and consumed by British national audiences."[17] What Hill wants to preserve in the exhibition sector of a national cinema, then, is a clear-cut distinction between national (or domestic) productions and those from Hollywood or other national cinemas.[18]

Obviously, recent attempts at problematizing national cinema have fundamentally destabilized—if not yet collapsed—this bounded, highly territorialized concept, making it impossible to function as an essentialist, unitary, all-encompassing category of analysis. "National cinemas," O'Regan suggests, "are identified as a relational term—a set of processes rather than an essence,"[19] and this shift of emphasis from essence to process—reminiscent of the new conceptualization of space, place, and scale discussed in Chapter 1—explains the increasing frequency in the use of "the national" in national cinema studies. Hayward, for one, draws attention to a mutually enforcing process: "Cinema speaks the national and the national speaks of the cinema."[20] Being "relational" on a continuum stretching across scale from the local to the regional and the global, the national has found in cinema a powerful means of enunciation, but inevitably such enunciations change in response to evolving sociopolitical and cultural processes. Two key words have surfaced to describe the ongoing process, "fluctuating" and "unfinished": a national cinema cannot help but be "historically fluctuating" for the simple reason that "the underlying process is *dynamic* and perpetually *unfinished*."[21]

RECONCEPTUALIZING CHINESE CINEMA

As a national cinema, Chinese cinema is both fluctuating and unfinished: it is fluctuating due to its unstable geopolitical and geocultural constitution in China's fractured space of nationhood, and it is unfinished due to the historical ruptures caused by regime changes and China's intermittent mass movements of border crossing and self-fashioning. As is well known by now, "Chinese cinema" has unstable borders; it may simultaneously refer to pre-1949 cinema based in Shanghai, mainland cinema of the People's Republic (1949 to present), Taiwan cinema, Hong Kong cinema, and even Chinese diasporic cinema (for example, works by directors like Ang Lee). With its structural multiplicity and instability,

Chinese cinema is "a messy affair . . . [and] is fundamentally dispersed," to borrow O'Regan's characterization of Australian cinema. I want to further emphasize that Chinese cinema is dispersed "historically, politically, territorially, culturally, ethnically and linguisticially."[22]

Given this dispersed nature, it is debatable whether "Chinese cinema" can be adequately replaced by "Chinese-language cinema" *(huayu dianying),* as Sheldon Lu and Emilie Yeh have recently proposed. This new term first surfaced in the early 1990s when scholars in Taiwan and Hong Kong—for instance Lee Tain-dow (Li Tianduo) and William Tay (Zheng Shusen)—attempted to bypass the limiting territorial imagination of "Chinese [nation-state] cinema" *(Zhongguo dianying)* and looked for an alternative, flexible conceptualization similar to that of "Cultural China" or "Greater China."[23] While "Chinese-language cinema" has the advantage of foregrounding differences of regional dialect as well as challenging—if not transcending—the singular nation-state model, its narrow linguistic emphasis may not be sufficient to capture the rich variety of geopolitics, regionalism, ethnicity, and polylocality in Chinese cinema. Moreover, "Chinese-language cinema" is wholly inadequate for referencing commercially successful films from mainland China, Taiwan, and Hong Kong, because films like *Big Shot's Funeral* (Feng Xiaogang, 2001), *Double Vision* (Chen Kuo-fu, 2002), and *Silver Hawk* (Ma Chucheng, 2004) intentionally deploy extensive English dialogue in a mixture of "global mélange" and employ a multinational cast in order to expand international viewership beyond an established base of Chinese-language audiences.[24]

Sheldon Lu's recent work on dialect and modernity in twenty-first-century "Sinophone cinema" reveals the polylocality of Chineseness as it is embedded in regional dialects and the "official languages" of different Chinese-speaking territories, yet his term "Sinophone cinema" raises further questions. For Lu, "'Huayu dianying,' 'Chinese-language cinema,' and 'Sinophone cinema' seem to be equivalent terms denoting the same field of cultural production and the same analytic framework," but he is aware that "the connotations of these terms may diverge as well as overlap": "Chinese-language films address audiences beyond the Chinese nation-state; engage citizens of Taiwan, Hong Kong, and Macau; spread to the Chinese diaspora; and reach interested spectators anywhere in the world. Sinophone cinema thus assumes a more flexible position in regard to national identity and cultural affiliation."[25] While locating ideological differences between these two linguistically based terms, Lu intends "Sinophone" to be *inclusive* of mainland China and thus differs substantially from Shu-mei Shih's *exclusive* use of the term. For Shih, the Sinophone refers to "a network of places of cultural production outside China and on the margins of China and Chineseness where a historical process of heterogenizing and localizing of continental Chinese culture has been taking place for several centuries."[26] In Shih's conceptualization, "Sinophone" is

counterhegemonic, but its territorial exclusion of mainland China fails to recognize an even longer historical process of heterogenizing and localizing of continental Chinese culture within mainland China that has lasted a few millennia.

Rather than privileging language, a reconceptualization of the national in Chinese cinema as multiple *discursive projects* is more productive. Inspired by the recent problematization of national cinema and by Judith Butler's theory of enunciation, Chris Berry advances an argument in favor of "recasting national cinema as a multiplicity of projects, authored by different individuals, groups, and institutions with various purposes."[27] Apart from having multiplicity as an obvious strength, this recast model of national cinema has the major attraction of its flexibility, both in project articulation and participatory alliance. The national—which is fluctuating and unfinished—is articulated historically by different projects and different participants in different localities, and the makeup of such participation changes over time as different individuals, groups, and institutions negotiate their positions and form or dissolve their translocal alliances. As Berry suggests, sometimes the modern, unified nation-state model may not accommodate the nation as it is articulated in a cinematic project, and sometimes it may exceed it.[28] In other words, the boundaries of a cinema and a nation or state may not—and do not have to—fit perfectly, and the long history of such imperfect fits (especially in Hong Kong and Taiwan) has resulted in the current "messy" and "dispersed" nature of Chinese cinema(s), with or without a plural designation.[29]

Thinking in terms of a multiplicity of projects in polylocality, we can delineate at least three significant shifts in Chinese cinema that may parallel what has happened in other national cinema studies. The first is the shift from conventional scholarship involving great auteurs and movements to an exploration of alternative practices previously downgraded or excluded from Chinese film history. The second is a shift from a thematic, ideological analysis of individual films to what may be broadly termed "industry research," which includes various aspects of film production, distribution, exhibition, and consumption.[30] The third is a shift from a narrow concern with national cinema per se to a transnational reconceptualization of cinematic projects on a continuum that stretches across scale from the local and the national to the regional and the global.

Like its European counterparts, Chinese cinema has been studied extensively in terms of auteurs and film movements. Among the favorite subjects are three "avant-garde" movements of the 1980s—the Fifth Generation in mainland China (including Chen Kaige, Tian Zhuangzhuang, and Zhang Yimou), the Hong Kong New Wave (including Tsui Hark, Stanley Kwan, Wong Kar-wai), and the Taiwan New Cinema (including Hou Hsiao-hsien, Edward Yang, Tsai Ming-liang)—and all three of them have received close textual scrutiny.[31] The Left-wing (or Leftist) Film Movement, which dominates scholarship in Chinese, has likewise received

two recent book-length treatments in English, while a subtle differentiation of cinematic nationalisms (for example, industrial nationalism, class nationalism, traditionalist nationalism, colonial and anticolonial nationalism) has been used to structure an evenhanded survey of pre-1949 mainland Chinese cinema.[32]

Needless to say, Leftist films of the 1930s and the new waves of the 1980s represent but two high points (or "golden ages" as some have preferred) in Chinese film history. It is crucial to keep in mind, however, that they were neither the only cinematic projects of the national during their time, and nor were they instantly absorbable into the dominant ideological and commercial realms. More often than not, these retrospectively glorified movements appeared first as alternative practices that constituted disjunctures or ruptures in Chinese film history. For instance, ideologically, the Taiwan New Cinema questioned state-building under the KMT (Kuomingtang or Nationalist) regime and released the repressed memories of Japanese colonialization (reinterpreted, rather nostalgically, as more benevolent than KMT). The "island nation" imagined in the Taiwan New Cinema was thus placed squarely at odds with state policies, in particular the language policy that prior to the mid-1980s excluded or discouraged the use of Taiwanese dialect, but later found congenial the new political project of the national (for example, de-Sinicization) that was implemented by the pro-independence Democratic Progressive Party after it gained power in the 1990s.[33] Its ideological trajectory from

Figure 2.1. Zhang Yimou: a maverick of art and blockbuster films (courtesy of China Film Archive)

alternative to mainstream notwithstanding, the Taiwan New Cinema was accused (mostly by old-fashioned film critics) of being responsible for the deterioration and eventual bankrupcy of the Taiwan film industry after the late 1980s.[34]

A similar trajectory from periphery to center can be observed in the career of the Fifth Generation directors, whose emergence in the mid-1980s signified first and foremost a rupture from the dominant sytem of socialist filmmaking. Yet ironically, in economic terms, this rupture was made possible by the socialist state apparatuses, without whose financial support the Fifth Generation's early dissenting films, such as *Yellow Earth* (Chen Kaige, 1984) and *Red Sorghum* (Zhang Yimou, 1987), would not have been produced in the first place. In a further ironic twist, the decline of state funding in the early 1990s engendered yet another rupture, in postsocialist filmmaking, which forced the Sixth Generation directors (for example, Wang Xiaoshuai, Zhang Yuan) into independent or underground production outside the purview of the state ideological apparatuses, which in turn resulted in routine official bans at home but high-profile international awards overseas (see Chapter 3).

Going farther back in history, the Leftist Film Movement had itself emerged as a rupture—between two major waves of commercial filmmaking in the 1920s and 1940s—and it would not have gained such momentum without several distinct transnational factors. Behind a characteristically nationalist, patriotic posture, young Leftisit filmmakers borrowed ideologically from Marxist vocabulary ("imperialism," "capitalism," "class," and so forth), aspired aesthetically to international modernism (Art Deco design, German impressionism, Hollywood genres, and Soviet montage), and depended financially on a translocal, intranational integration of resources from Beijing, Shanghai, and Hong Kong. Luo Mingyou's Lianhua Company was instrumental in the rise of Leftist cinema, but his transnational connection to Hollywood via his distribution and exhibition network in Beijing and northeast China, his transregional codependence on Hong Kong financing, and his initiatives to establish overseas Lianhua branches in Singapore and the United States have typically been ignored in official film historiography in favor of Luo's expedient slogan of "reviving domestic cinema" *(fuxing guopian)* issued in 1930. A careful look into Luo's industry practices may reveal other dimensions of his translocal, transnational practices as well as the complex reasons behind his failure to sustain a national cinema movement.

To reexamine Chinese film history from the perspective of industry research, we have to realize that several previously canonized auteurs and movements may have appeared originally as disjunctures or ruptures, but that they were subsequently rewritten as representative of national cinema at the expense of popular (and therefore mainstream) film practices, most of them commercial in nature. If Chinese cinema is measured in terms of what audiences actually watch, many

Leftist films and new waves become exceptions rather than norms, and what pre-
vious historiography brushes aside as "frivolous" commercial fare (martial-arts
films, costume dramas) were in reality part of the economic force that drove the
development of Chinese cinema across national borders. What is significant for
industry research is that waves of commercial filmmaking (such as in Shanghai
in the mid- to late 1920s, in Hong Kong in the 1950s–1960s, and in Taiwan in
the 1960s–1970s) occurred precisely during times when polylocal, cross-regional,
and transnational resources were mobilized from disparate geopolitical territories,
which extended from mainland China, Hong Kong, and Taiwan to Southeast Asia
(in such largely Mandarin companies as Cathay and Shaw Brothers) and even to
the United States (the Cantonese company Grandview).[35]

One pressing problem with using industry research as a heuristic tool is that
the field is insufficiently prepared in theory and methodology to cope with issues
of production, distribution, exhibition, and reception. As elaborated in the second
part of this chapter, audience study is perhaps the least-developed branch of Chi-
nese film studies, and market analysis is only starting to attract serious attention.[36]
In spite of a growing number of Chinese publications on the rapidly changing film
market in the age of globalization and the WTO, scholars have yet to learn how
to interpret changes in a way that is more meaningful than merely stating box
office and market statistics.[37] To chase the pendulum swing from the extreme of
aesthetic criticism (dominant in China during the 1980s) to the other, of market
euphoria (increasingly fashionable in the new millennium) may introduce more
problems than solutions, for it may reduce scholars to mere trend-followers (or
worse, subservient government and industry consultants) rather than indepen-
dent thinkers. An enthusiastic celebration of transnational market successes, most
of them coproductions with multinational corporations based in Hong Kong and
the United States, may hide a motivation that is fundamentally national or even
nationalist in nature, such as a view that China has finally shed its "third world"
image and has joined the ranks of developed countries.

REFASHIONING TRANSNATIONAL STUDIES

To avoid being carried away by the all-powerful forces of global capitalism and
its complicit local, regional, national institutions, we must keep transnationalism
in a proper historical perspective. It is true, as Alan Williams asserts, that "in the
beginning, the cinema appeared to be the first truly global, transnational medium,
for this simple reason: it had no, or very little, language."[38] The absence of spo-
ken language seems to foreground what Martine Danan calls a "prenational" stage
of development when the cinema attracted audiences with its astonishing visual
images and corporeal sensations.[39] This prenational stage, for which the term "Chi-
nese-language film" would make little sense except for half of the intertitles, also

proved to be transnational at the levels of image-making and industry operation.[40] Charlie Chaplin's typical acts and mannerisms, for instance, were duly incorporated into Chinese film comedy, a genre traditionally thought to be indigenous in its audience appeal, and early Chinese producers relied heavily on American and Japanese technicians, especially during the transition to sound in the early 1930s.[41] The pioneering work of foreign technical crews in early Chinese cinema (a subject so far largely ignored) illustrates Higson's observation: "Cinema was from the outset a matter of transnational cooperation, and filmmakers have been itinerant."[42] Indeed, the fact that since the mid-1980s, Chinese filmmakers and actors (Ang Lee, John Woo, Jackie Chan, Jet Li) have been particularly itinerant (or translocal) and have frequently traveled between Asia and North America makes it tempting to entertain a vision of "postnational cinema," as Danan does for French cinema. Nonetheless, the linear—if not teleological—logic embedded in Danan's model does little justice to the immense complexity of Chinese film history.

Instead of following a neatly charted temporal progression from prenational through national to postnational, I find it more illuminating to conceive of the national as a *spatial continuum* stretching across scale from the local to the global. Alan Williams distinguishes three types of contemporary commercial narrative cinema. The first type is the capital-intensive, increasingly faceless "global cinema" of the interrelated action-film genres; the second type is the medium-budget "national" production designed for a home audience; and the third type is "the low-budget, film-festival-oriented 'art,' 'independent,' or 'auteur' cinema . . . [which] may properly be termed 'international' . . . [in that] these films function, in part, as armchair travel experiences for the global couch-potato class."[43]

In transnational Chinese filmmaking, Jackie Chan and John Woo indisputably belong to the action-filled "global cinema" category, and Zhang Yimou is seeking to join their ranks by launching such high-budget films as *Hero* (2002), *House of Flying Daggers* (2004), and *The Curse of the Golden Flower* (2006), all released commercially in the United States (see Chapter 7). In the middle spectrum of "national" productions are Feng Xiaogang's New Year's pictures *(hesui pian),* such as *Be There or Be Square* (1999) and *A Sigh* (2000).[44] These function very much like what Eric Rentschler describes as "the post-wall cinema of consensus" in Germany, which has lost the critical edge of New German Cinema and seeks, instead, "to entertain, rather than instruct, and explore trivial rather than deep conflicts, typically by means of conventions associated with popular generes and tastes" like comedies.[45] Feng Xiaogang may be criticized for catering to popular tastes and peddling fantasies of wish-fulfillment, but he prides himself on commanding a loyal domestic following.[46] In comparison with high-budget and medium-budget productions, low-budget independent or underground filmmaking constitutes the most exciting area in contemporary Chinese cinema. As is evident in Jia Zhangke's

Xiao Wu (1997) and *The World* (2004), the national is deliberately marginalized or bypassed in this third type of filmmaking, and this tactic of scale jumping (see Chapter 4) foregrounds new tensions of the local (small towns in the hinterland, migrant communities in globalized cities) and the global (Western commodities, global tourist landmarks).

Upon closer scrutiny, the messy state of contemporary Chinese cinema does not fit Alan Williams' general typology that well. While Feng Xiaogang's popular national productions have gone global in that they have been transformed into relatively big-budget transnational coproductions with Hollywood and Hong Kong,[47] the majority of medium-budget national productions are no longer profitable in the domestic market and have increasingly been forced into the low-budget category. In a worse position than low-budget independent films, the mid-level national productions have little hope of acquirinig international recognition, although a few of them still count on winning domestic prizes handed out by the state-sponsored groups. Worst of all, most Chinese productions are now deprived of commercial release, and without theater screening they are almost invisible in the national cinematic landscape (see Chapter 7).

Both big-budget Chinese coproductions and low-budget independent films may confirm Higson's scale-related argument that "the contingent communities that cinema imagines are much more likely to be either local or transnational than national,"[48] but it is too early—and irresponsible—to dismiss the national altogether in Chinese film studies. While it is true that, as cinematic projects, the national may have conceded much ground to the local and the global in the current phase of transnational Chinese cinema, the very fact that independent or underground Chinese auteurs like Jia Zhangke are "discovered" and honored at international film festivals as the representatives or spokespersons for China and Chinese culture suffices to indicate the persistence of the national on a global scale. Indeed, the very term "transnationalism" betrays such inevitable grounding in the national, while the plethora of prefixes—"trans," "inter," "intra," "extra," "multi," "pre," "post," and "para"—only testifies to the conceptual centrality of the national in refashioning film studies.[49]

In response to Sheldon Lu's 1997 statement that "the study of *national* cinemas must then transform into *translational* film studies,"[50] Chris Berry and Mary Farquhar pose three questions that deserve further elaboration:

- What does "transnational" mean and what is at stake in placing the study of Chinese cinema and the national within a transnational framework?
- What happens to "national cinema" in this new conceptual environment?
- What does it mean to think about "transnational film studies" as an academic field?[51]

First, in addition to conceptualizing the transnational in the Chinese case as a higher, potentially homogenizing, symbolically centripedal order, as in Greater China or Cultural China, Berry and Farquhar recommend approaching it as "a larger arena connecting differences, so that a variety of regional, national, and local specificities impact upon each other in various types of relations ranging from synergy to contest."[52] The transnational, in this conceptualization, is simultaneously translocal at several scales. Historically, Chinese cinema has always engaged specificities at different scales, and the new transnational framework must not seek out only cases of homogeneity and consensus while neglecting those of heterogeneity and contestation. A new analogy may well take shape if heterogeneities are examined in a transnational framework, and this exactly parallels the ideological and industrial practices adopted by the contending state cinemas during the 1950s and 1960s—socialist cinema on the mainland and policy film in Taiwan's Mandarin cinema.

Second, conceived of as a multiplicity of cinematic projects, Chinese cinema provides rich resources for studying recurring patterns and modes of articulation—patterns that emerge more noticeably from a transnational perspective than from a narrow focus on national identity and auteurist style. In a fashion similar to what I advocate as a site-oriented approach to transnationalism,[53] Berry and Farquhar concentrate on film genres as sites of intersection where patterns of cinematic articulation are formed and transformed across a wide spectrum of temporalities, spacialities, thematics, and ideologies in China and Chinese diasporas. As distinctive Chinese genres, opera *(xiqu)* and martial arts *(wuxia)* receive close scrutiny, and contesting examples of the respectively "national" are gathered, translocally, from Shanghai *yingxi* (shadowplays of the 1920s), Taiwanese *gezaixi* (regional operatic plays, the mainstay of Taiwanese dialect filmmaking of the 1950s–1960s), Hong Kong *huangmeixi* ("yellow plum," from a regional folk theater, popular in the territory and Southeast Asia during the 1950s–1960s), revolutionary *yangbanxi* (model plays of Peking opera and ballet during the 1960s–1970s), as well as from iconic figures such as Bruce Lee, Jackie Chan, and Jet Li.[54] In the rubric of "vernacular modernism" theorized by Miriam Hansen, a different type of transnational investigation of martial arts films has yielded insights into an intriguing polylocal network of cross-media, transnational discourses and practices, from the late Qing Chinese fascination with the magic science of flying to the anarchic energy of "bodies in the air" on screen, from the 1920s debate on nativist historicism to the transfiguration "from Pearl White to White Rose Woo" in the image of the Chinese *nüxia* (female knight-errant).[55]

Third, given the historicial and geopolitical complexity of Chinese cinemas, Berry and Farquhar believe that they "can stand as key sites in the intellectual shift to cinema and the national, and also be part of the urgently needed attack

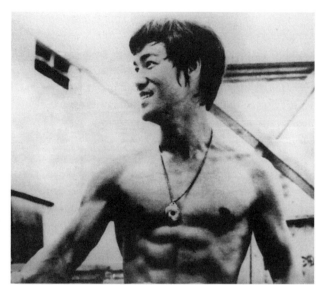

Figure 2.2. Bruce Lee in *Fist of Fury* (1972): kung fu craze and Chinese nationalism (courtesy of China Film Archive)

Figure 2.3. Jackie Chan in *Rumble in the Bronx* (1994): testing Hollywood waters (courtesy of China Film Archive)

on Eurocentrism in English-language film studies as that field also becomes transnational."[56] The logic of site-oriented investigation requires that film studies must be refashioned as transnational studies not just by linking polylocal sites of production, distribution, exhibition, and consumption across scale (for such projects have been pursued previously, especially in terms of international relations and the division of labor), but also by interrogating its own locality and positionality in the production and dissemination of knowledge in film history and film theory. As cinema continues to provide a powerful means of articulating the inequality of power-geometries and the increasing unevenness of human experiences across the world, film studies cannot help but become transnational studies.

Space of Comparative Studies

TWO VISIONS OF FILM STUDIES: COMPARATIVE AND TRANSNATIONAL

Berry and Farquhar's characterization of the dominant Eurocentrism in film stud-
ies recalls an interesting observation Paul Willemen made a decade ago:

> As for comparative literature, regardless of its many historical deficiencies, it
> must be acknowledged that comparative studies in cinema do not as yet exist.
> What is worse, given the current insufferably ethnocentric bias of film theory,
> it may well be a while before this urgently needed discipline of comparative
> cinema studies will displace the kind of film studies currently being inflicted
> on university and college students.[57]

Willemen's mention of comparative literature intrigues me because I have, since the
early 1990s, noticed a bifurcation in the development of comparative literature and
film studies in North America: while comparative literature has largely conceded
its previous dominance in literary theory and been struggling to survive academic
downsizing in the humanities, film studies has become a thriving interdisciplin-
ary field.[58] It is ironic that comparative literature, which is equally "ethnocentric"
in its grounding in European theory, tends to be folded back institutionally into
the reconfigured discipline of English, which now claims to be transnational or
at least postcolonial (as in Anglophone literature). The irony comes from the fact
that comparative literature used to claim such a transnational position, although
its foundation was from the start distinctly national. A discipline whose origins
are traceable to the ideology of the modern nation-state, comparative literature
was developed to account for the "unique" contributions that various national lit-
eratures make to "general literature"—a mission that requires transnational opera-
tions and multilingual faculty. This hidden transnationalism is evident in the
discipline's capacity of uncovering what brings national literatures together: uni-
versality embodied in humanist values and aesthetic aspirations, commonality in
identifiable—if not identical—themes, motifs, genres, modes, patterns, and move-
ments, and comparability, which is sustained by methods of tracking influences
and establishing parallels among national literatures. In hindsight, the decline
of comparative literature in the age of multiculturalism and globalization seems
inevitable because, as with national cinemas, homogeneous national literatures are
nothing but a myth, and literary theory that justifies comparative, transnational
procedures is no longer the unique territory of comparative literature.[59]

Despite its recent flowering, film studies still encounters difficulties in securing
an independent institutional base. Its perceived interdisciplinary nature resulted in

contradictory decisions by university administrations in the late 1990s: film studies was removed from communication studies and merged with comparative literature at the University of Iowa, but at the same time it was detached from comparative literature and merged into communication at Indiana University, Bloomington. The logic of such decisions may escape common sense, but the fact is that film studies has long been regarded as congenial with comparative literature.

The question remains as to why the "urgently needed discipline of comparative cinema studies" has not materialized. Yes, the entrenched habit of Eurocentrism is a major cause, and Willeman's criticism is still relevant:

> This expansion in academia's disciplinary field creates job and departmental expansion opportunities. The result is that scholars formed within the paradigm of Euro-American film theory are rushing to plant their flags on the terrain of, for instance, Chinese, Japanese, or Indian film studies. In that respect, those scholars and departments are actively delaying the advent of genuine comparative film studies by trying to impose the paradigms of Euro-American film and aesthetic theories upon non-European cultural practices.[60]

To contest Eurocentrism in film studies, Willemen exposes two problematic modes of scholarship: the first, "projective appropriation," is concerned with "conquering markets, eliminating competition, and securing monopolies"; the second, "ventriloquism," functions as "the monopolist-imperialist's guilty conscience," but "allows him to remain an authoritarian monopolist while masquerading in the clothes of 'the oppressed.'"[61] To achieve a genuine comparative vision, Willemen draws on Bakhtin's concept of alterity and advocates "creative understanding" as a process of double engagement: "It is not simply a matter of engaging a 'dialogue' with some other culture's products but of using one's understanding of another cultural practice to reperceive and rethink one's own cultural constellation at the same time."[62] Comparative film studies, therefore, aims not just to project or export one's theoretical paradigm but also to revisit and rethink the foundation of one's theory.

I have similarly drawn on Bakhtin's dialogism as well as Shohat and Stam's work in my critique of Eurocentrism in an earlier phase of Chinese film studies.[63] However, I would suggest that Chinese film studies came into being in the West precisely through its tactful negotiation with the dominant Euro-American paradigms in film theory and criticism. Chinese film studies, therefore, is by its nature comparative. It stands to benefit from comparative scholarship with regard to Hollywood and other national cinemas. Indeed, one reason why comparative film studies does not exist as a separate discipline is the widely held assumption that the study of any national cinema is by necessity comparative.

Since both Willemen's vision of comparative film studies and Berry and Far-quhar's model of transnational film studies share an agenda of contesting the Eurocentric tradition in film studies and of pursuing comparative work, we face a task of assessing their potential for advancing film studies. For me, transnationalism is likely to be one large aspect of the comparative apparatus of film studies. In most cases, transnationalism involves looking outward, in that it follows the traffic of financial, technological, and human resources across nations, regions, and continents. This kind of traffic was deemed of little value by such previously dominant film theories as semiotics and psychoanalysis, but emerging industry research and media studies have contributed substantially to comparative film studies. Still, an overriding concern with looking outward does not suffice to account for the multifaceted systems that create and are created by film production, circulation, and reception.

As a general framework, I prefer comparative film studies to transnational film studies because comparative studies is more likely to capture the multidirectionality with which film studies simultaneously looks outwards (transnationalism, globalization), inwards (cultural traditions, aesthetic conventions), backwards (history, memory), and sideways (cross-media practices, interdisciplinary research). Conceived this way, comparative film studies demands investigations into diverse areas. In the area of political economy, for example, it examines the flows of translocal and transnational capital and the strategies of resistance or complicity a nation-state or locality may adopt or abandon at a given time. In the area of communication and articulation, it analyses the specificity and interconnectivity of media and technologies. In the areas of distribution, exhibition, and reception, it explores the ways people market and consume films. In the area of aesthetics, it exposes the structures and functions of narrativity and audiovisuality. For me, comparative film studies is better situated than transnationalism to benefit from theories and methods that have been developed in other disciplines, such as industry research, media studies, cultural studies, visual anthropology, urban sociology, human geography, and comparative poetics.

The framework of comparative film studies differs from comparative literature in at least three ways. First, it moves beyond the nation-state model, especially its implicit hierarchy of ethnonational cultures (the West versus the rest), which sustained both comparative literature and film studies in the past. Second, it disavows the elitism in comparative literature that has driven that discipline into an obsession with great thinkers and high concepts and ignores popular culture and everyday practices. Third, it loosens the term "comparative" to include not only influences and parallels but also interrelations and cross-fertilization between disciplines, media, and technologies. It is not my intention to survey the entire terrain of comparative film studies; instead, I will focus on interdisciplinarity and cross-mediality

in order to draw attention to areas that are underdeveloped in Chinese film studies and hence would stand to gain from a broader comparative perspective.[64]

INTERDISCIPLINARITY AND ITS IMPLICATIONS: AUDIENCE AND PIRACY

When Chinese film studies first entered academia in North America, Chris Berry rightly emphasized the urgent need for "a multidisciplinary approach" and anticipated that "Chinese cinema can be productively studied from a number of angles."[65] My overview of Chinese film studies in the West demonstrates that interdisciplinarity has given this new field much strength and prosperity, for it has expanded successfully into the areas of historical research, industry research, genre studies, aesthetic criticism, psychoanalytic criticism, feminist criticism, gender studies, and cultural studies.[66] Understandably, not all areas are equally developed, and audience study is one area that unfortunately is neglected and sometimes irresponsibly dismissed.

A significant case of dismissal occurred when E. Ann Kaplan, based on her "informal discussion" with Chris Berry, declared that "relying on audience interviews would not lead anywhere" and that Chinese film reviews were seldom reliable because of their customary lip service to "the establishment party line."[67] Compared with Kaplan's outright dismissal of two sources of audience study, Berry's early neglect of Chinese audiences may have been unintended. He interprets *Big Road* (Sun Yu, 1934) as a sublimative text that "attempts to arouse revolutionary ardor in its audience by the arousal of libidinal drives and their redirection towards the object of revolution."[68] What is missing in Berry's psychoanalytic reading is an interrogation of the audience—whether the historical audience of the 1930s, the individual spectator as constructed in film theory, or a present-day film critic informed by a theoretical paradigm.

Berry's failure to address the complexity of issues related to the audience can be understood in terms of what Michael Ryan diagnoses as a major problem in psychoanalysis:

> Audiences are not univocally "positioned" by films; rather, they either accept or reject cinematic representations of the world, but they do so in accordance with the social codes they inhabit. The specifically cinematic discourse, whereby a film addresses an audience, is determined by broader social discourses, the systems of significance and valorization that determine social subjects as male or female, working class or ruling class, and so on.[69]

Ryan's intervention reminds us that audience questions in film studies require an interdisciplinary approach, one that simultaneously draws from literary analysis

and social formation and takes into consideration textual, subtextual, and contextual factors.

Even at the textual level, audience interviews and film reviews are no longer as "unreliable" as they were judged to be in the 1980s—a fact evident in Berry's recent work with precisely these two sources in his study of Chinese independent documentary—and film statistics (e.g., annual productions, box-office rankings, audience preferences) are increasingly available in Chinese.[70] Yet with a few exceptions scholars still seem reluctant to embark on audience research.[71] I would venture some speculations as to why this reluctance persists. First, in terms of academic disciplines, audience study does not fit the respected forms of text-based research in film, history, and literature (three principal disciplinary bases for the majority of Chinese film scholars), while on the other hand communication scholars skilled in statistical analysis and industry research may not be familiar with the language and culture involved and thus do not want to risk making embarrassing mistakes. Second, in terms of methodology, most scholars are trained to conduct close readings in which they confidently bring preferred theoretical insights to bear on selected film texts; in comparison, audience study seems messy and often requires extensive fieldwork and archival research, the outcome of which appears difficult to predict in the planning stage. Third, in terms of ideology, audience study seems to work in favor of the industry, because it interprets numbers and presents diagnoses, or in favor of the state, because it measures the effectiveness of its propaganda machinery; perceived either way, audience study may risk compromising a scholar's critical integrity and ideological commitment.

Nonetheless, the perceived risks of venturing into audience study can certainly be managed. One method of risk management is to turn the marginality of audience study into its strength: thanks to its marginalization inside academia, audience study can thrive on interdisciplinarity, drawing upon a variety of disciplinary methodologies from the quantitative and empirical to the historical and even to the speculative. Another way to tackle academic marginality is to ensure that audience study be historically informed, ideologically sensitive, and theoretically sophisticated.

As early as 1992, Mayfair Yang conducted anthropological fieldwork and closely followed film discussion groups (mostly consisting of factory workers) in Xi'an and Shanghai. Her analysis of various discourses at work in film reception reveals the translocal dynamics of how audiences interpret and appropriate film texts and their complex relationships to the hegemonic party-state and the potentially emergent public sphere.[72] Yang's ethnography dovetails with what Higson advocates as a consumption-based approach to film studies:

[This approach] means laying much greater stress on the point of consumption, and on the *use* of film (sounds, images, narratives, fantasies), than on the point of production. It involves a shift in emphasis away from the analysis of film texts as vehicles for the articulation of national sentiment and the interpellation of the implied national spectator, to an analysis of how actual audiences construct their identity in relation to the various products of the national and international film and television industries, and the condition under which this is achieved.[73]

Both Higson's emphasis on consumption and the participation-observation method adopted in Yang's ethnography of Shanghai audiences are equally important to Seio Nakajima's sociological study of Beijing film clubs. Based on his multiyear fieldwork in Beijing, Nakajima expands Bourdieu's model of "cultural production" to that of "cultural consumption," which informs his mapping of the geography of cultural consumption and the dynamics among cultural institutions (film clubs, censorship), cultural players (club owners, audiences), and cultural products (independent films). Not only does Nakajima identify which films were shown in unofficial venues in Beijing and how they were selected and distributed, but his sociology of film consumption also brings up questions such as self-censorship, geocultural locality, and patterns of conversion among political capital, cultural capital, and economic capital.[74]

Yang's and Nakajima's cases prove that audience study benefits from interdisciplinarity and demands comparative work. The apparatus of interdisciplinary comparison therefore anticipates other types of audience study. For instance, historically, both the Nationalist and the Communist regimes invested heavily in the mobile film-projection team, the Nationalists during the wartime period and the Communists continuing the practice into the socialist period. What kind of cultural policy was served in such operations? What kinds of audience were projected and recruited? As for socialist cinema, was the audience ever a significant factor in film production, distribution, and exhibition? Or was it merely a phantom presence that both the Party and artists sought to evoke in order to justify their activities as service for the nation? In the case of Taiwan cinema, how did linguistic factors complicate film consumption? What was the audience's reception of Japanese films—whether exhibited legally or illegally—during the 1950s and 1960s? How did Taiwanese-dialect films serve their audiences in comparison with state-sponsored Mandarin cinema? Moreover, how did the Taiwan New Cinema so quickly lose its audience base after its initial success?

To move into the contemporary era, what can audience study offer to the thorny issue of piracy? Jia Zhangke, a spokesperson for independent filmmaking in China since the late 1990s, conjures up a utopian progression "from piracy to

democracy," in which "ordinary people" like him resort to piracy to reclaim their right to watch international film classics and to utilize DV technology for documentary and experimental filmmaking. For Jia as a consumer-turned-producer, piracy has a liberating function that strips away the exclusive privilege of film administrators and film experts and hands it over to consumers at large.[75] On the other hand, the vision of "democracy" made possible by piracy is categorically denied in Laikwan Pang's critique of piracy as an outrageous operation that deprives global capitalism of its intellectual property rights but that nonetheless benefits an underground, illegal form of transnational capitalism based in Asia. In contrast to Jia's enthusiastic celebration of the potential effect on its audience of pirated material, Pang paints a pessimistic picture of "pleasure-seeking" consumers engrossed in pirated images of sex, violence, and the like:

> Obviously, it is naïve to assume that piracy is an egalitarian effort of the people to oppose some authoritative policy, because what the people desire is entertainment in the form of commercial Hong Kong and Hollywood films, which are hegemonic in their own discursive structures. The popular commercial films being pirated are often invested with various forms of prejudices, ranging from racism, chauvinism, and homophobia, to capitalist greed. The so-called tactics involved in piracy are neither humanistic nor democratic in nature but are carried out in their own system of exploitation, through which some gangster tycoons earn astronomical profits.[76]

The elitism implicit in Pang's criticism of the Chinese audience's unsavory taste in pirated products comes to the fore when her critique is compared with Shujen Wang's investigation of piracy in Chinese-language markets. Like Pang, Wang is attentive to the political and economic aspects of piracy (power relations, financial decisions), but contrary to Pang, Wang refuses to pass simplistic judgments and is willing to hear what consumers say about their perceptions and uses of piracy. Wang's profiles of consumers indicate that most purchase pirated products for economic reasons, but personal choice is also important. A sojourner Taiwanese businessman in Shanghai turns out in Wang's study to have "an impressive collection of American and European art films" at home: "To him, the price difference between pirated VCDs (video compact disks) and the cinema tickets is not an issue. It is rather a matter of choice and the availability of nonmainstream films."[77] Clearly, this Taiwanese businessman belongs to a huge group of educated consumers on the basis of whose appropriation of piracy Jia Zhangke has projected his hope for a democratized playing field in Chinese film culture. The consumer's *agency,* in other words, constitutes a key component in audience study.

The sheer contrast between Jia's and Wang's confidence in film audience and Pang's distrust of consumers' taste brings us back to the question of interdisciplinarity in comparative film studies. A self-reflexive cultural critic should be aware of his or her own disciplinary blind spots and be open to findings from related disciplines. Even at the grassroots level of everyday consumption, an audience is never a homogeneous entity. The comparative apparatus of film studies alerts a scholar to the necessity of differentiating objects of study. Such comparative differentiation may take place at the level of local consumers in Beijing and Shanghai, or at the level of comparative analysis of consumption habits in various cities as a whole, and it can illuminate a higher level of analysis, as in transnational studies. Wang's investigation of piracy takes us to transregional markets in mainland China, Hong Kong, and Taiwan; similarly, Nakajima's mapping of Beijing clubs reveals that the local club owners and audiences are familiar with the transnational operations of major international film festivals in Europe.

CROSS-MEDIALITY AND ITS POTENTIAL: ADAPTATION AND AESTHETICS

The imperative of interdisciplinarity leads us to another crucial issue, namely, cross-mediality. This also stands to gain from a comparative film studies informed by various disciplinary models. As a composite art, cinema plays with multiple spatialities (see Chapter 1) and cuts across boundaries between several media, such as literary, graphic, photographic, musical, and performative. An emphasis on cross-mediality from the comparative perspective encourages research into underdeveloped areas in film studies, such as adaptation, acting, music, and visual aesthetics.

Historically, film adaptation has been a central element of Chinese film production. Among the earliest examples of features from China and Hong Kong are films of traditional operas, such as *Conquering Jun Mountain* (1905) and *Zhuang Zi Tests His Wife* (Li Beihai, 1913). Just as adaptations of literary works—many of them translated or rewritten from foreign sources—helped elevate the quality of Chinese feature productions, adaptations of legends and myths propelled the first commercial wave of filmmaking in Shanghai in the mid- to late 1920s and the second commercial wave in wartime Shanghai. Adaptations of literature and operas continued to be major genres in the 1950s and 1960s, in both China and Hong Kong. As recently as the 1990s, the success of so-called "ethnographic films" by Zhang Yimou and others in the overseas market derived in part from their sophisticated literary sources.[78]

The study of film adaptations of literature and drama in Chinese cinema, however, remains underdeveloped. Individual case studies appear from time to time, such as those on early adaptations of traditional drama and foreign literature, the film adaptations of Ba Jin's novel *Family* (Jia, 1931) and literary adaptations

Figure 2.4. *Zhuang Zi Tests His Wife* (1913): Li Minwei cross-dressed in a Hong Kong opera movie short (courtesy of China Film Archive)

Figure 2.5. *Hero* (2002): a sumptuous treat of swirling colors

in Taiwan, but a more systematic articulation of problems—theoretical as well as practical—in film adaptation is yet to come.[79] Simply put, this area is wide open. Things we may consider include how concepts of fidelity and expressivity operate in Chinese film adaptation (per Xia Yan) and literary translation (per Yan Fu); how appropriation, distortion, and reinvention work to advance certain ideological, cultural, or aesthetic visions; and how critics respond to a wide range of adaption strategies taken up by different generations.[80] We may also explore the complex reasons behind the decline of the screenwriter's function and prestige in the contemporary production of blockbuster films like *Hero* and *The Promise* (Chen Kaige, 2005). Although subtitling may not belong to the subject of film adaptation proper, we may test how Chinese audiences receive American and European films by scrutinizing obvious mistakes—ranging from the excusable to the humorous

to the outrageous—in Chinese subtitles from pirated DVDs circulated in mass quantity in China.

If film adaptation of literature is confined to a comparative procedure centered on written words, film adaptation of drama compels us to pursue comparisons across different media. In the 1980s, when Chinese film studies tried to redefine itself as a self-sufficient discipline, some scholars advocated breaking film's reliance on the "clutches" of literature and theater and, instead, embracing the ontology of film (that is, visuality).[81] However, historically, the dramatic is structurally built into Chinese cinema, and a comparative study of the dramatic, the literary, and the visual should yield new insights into changing cinematic practices in China. What, for instance, accounts for the establishment of opera film as a legitimate genre in socialist filmmaking? How does socialist tradition relate to the so-called "shadow-play theory" of Chinese film studies and complicate the artistic models of revolutionary realism and romanticism developed during the 1950s and 1960s? On what basis did ultra-leftist leaders like Jiang Qing judge the acceptability of a film version of a revolutionary model play in accordance with her vision of "three prominences" *(san tuchu)*? Conversely, how did filmmakers in the early 1970s negotiate political, cinematic, theatrical, musical, and performative issues in order to deliver a truly "revolutionary" product by technical means (camera angles, close-ups, mise-en-scène, and color schemes)?[82]

The technical aspects of cinematography and the ideological connotations of certain filmic styles bring us to another unexplored cross-medial connection between Chinese cinema on the one hand and experimental photography and video arts on the other. For instance, contemporary Chinese experimental photography cultivates an unofficial stance that has developed through "a documentary turn" since the late 1980s and has explored new visions of history, memory, and locality as well as the performativity of the self and the body.[83] Similarly, independent or underground Chinese filmmaking since the early 1990s has emphasized its claims to truth and objectivity and its "documentary style" and experimental quality. The issues of recording reality, preserving memory, and performing new subjectivities have occupied a new generation of Chinese directors for years (see Chapters 3 and 5). Another overlap between Chinese experimental photography and cinematography is taking place in the video arts; examples such as *San Yuan Li* (Ou Ning, Cao Fei, 2004) and Yang Fudong's works may be fruitfully examined by comparative film studies in terms of the cross-fertilization of artistic media. Indeed, experimental video arts have been so attractive that Wu Wenguang, a pioneering new documentary filmmaker, ventured into a new subfield by shooting *Diary: Snow, Nov. 21, 1998* (1999), a short video that both records the official shutdown of an art show in Beijing and elaborates on the liberating effects of the experimental documentary as a performative act in itself.

From the perspective of performance, film acting certainly demands compari-
son across media, just as a study of stardom requires attention to the discursive
and the performative space on and off screen.[84] On a broader scale, filmic images
of the new woman drew upon and in turn shaped the mass-mediated formation
of a new subjectivity and a new archetype of urban modernity during the Repub-
lican era, while such formation was similarly mediated in literary (fiction, poetry),
graphic (cartoons, illustrations), and photographic (calendars, pictorials) forms.[85]
We may assert that, working as vernacular modernism, "cinema created new voca-
tions for women as well as significant social positions and public images."[86] On
a smaller scale, makeup and costume add to the fashioning of a particular star
text, and what emerged from early Chinese cinema is not so much the authenticity
of Chineseness as hybridity through *bricolage.* Thus, in *The Female Knight-Errant
White Rose* (Zhang Huimin, 1929), the star appeal of the martial arts heroine Wu
Suxin derives from a complex of cross-cultural, transgender references: a Douglas
Fairbanks-type moustache, a headscarf, a cowboy hat, a large bow hung across her
right shoulder, and a sword she poses in front of her in a macho male gesture.[87] Such
an exercise in comparative film studies reveals the ingenuity of early Chinese film-
makers in securing gender-bending (transvestism), genre-mixing (Chinese operas
and marital arts films, American serial queen adventures), and media cross-fertil-
ization (film, drama, literature).

Like film acting, film music is another underdeveloped area in Chinese film
studies that stands to benefit from research in cross-mediality. A few case studies
suffice to demonstrate the potential contributions that film music and film songs
can make to comparative film studies.[88] At the very least, the predominant influ-
ence of Western orchestral music on Leftist films of the 1930s, which frequently
creates an ironic contrast between the image track and the sound track, invites an
explanation in terms of the perceived status of Western music as an icon of cosmo-
politanism and the experience of Chinese composers in transnational trafficking
(China, Japan, and Euro-America). Understandably, more research is needed to
construct a genuinely comparative model of the visual and musical discourses in
Chinese cinema.

Finally, even within the visual realm, comparative film studies may learn
from comparative poetics as developed in comparative literature. The conscien-
tious attempt to connect Chinese cinema to traditional Chinese aesthetics in a
group of essays by Hao Dazheng, Ni Zhen, and Douglas Wilkerson in the volume
Cinematic Landscapes aims to rearticulate aesthetic categories such as multi-
focal perspective, blank space, and "roaming imagination" *(you)* in a compara-
tive approach to artistic cross-mediality (painting, poetry, film).[89] Coming from
a neoformalist tradition, David Bordwell's meticulous shot-by-shot analysis of
"the pause–burst–pause pattern" in Hong Kong action cinema reveals, without

his prior knowledge, a structuring principle embedded in a traditional Chinese dialectic of *dong* (swift action) and *jing* (poised stiffness), the latter further linked to the "transitionless acting" Eisenstein found in kabuki.[90] Bordwell's evocation of Eisenstein and kabuki reminds us, once again, of the vast potential—largely uncharted and underestimated—of comparative film studies for advancing visual and performance aesthetics.

BEYOND TRANSNATIONALISM: TRANSCULTURAL VISUALITY IN COMPARATIVE FILM STUDIES

To return to the two visions of film studies sketched earlier, I want to reiterate my belief that comparative film studies covers a larger field than transnational film studies. The term "comparative" denotes flexibility in mapping an evolving field of interdisciplinarity and cross-mediality, while the term "transnational" remains unsettled primarily because there are multiple interpretations of the national in transnationalism. What is emphasized in the term "transnational"? If it is the national, then what does this "national" encompass—national culture, language, economy, politics, ethnicity, religion, and/or regionalism? If the emphasis falls on the prefix "trans" (on cinema's ability to cross and bring together, if not transcend, different localities, cultures, and languages), then this aspect of transnational film studies is already subsumed by comparative film studies.

Actually, "translingual practice" has been identified as an important aspect of comparative literature,[91] and many film scholars now prefer "Chinese-language film" as an umbrella term to emphasize the transnational capacity of Chinese cinema in crossing boundaries between the officially designated "national language" (*guoyu*, peculiarly designated as "Mandarin" in English) and China's numerous regional dialects. However, "transcultural" seems to be a more favored term than "translingual" in film studies. For instance, Rey Chow highlights the phantasmagorical effects of cinema as a form of technologized visuality: "Film has always been, since its inception, a *transcultural* phenomenon, having as it does the capacity to transcend 'culture'—to create modes of fascination which are readily accessible and which engage audiences in ways independent of their linguistic and cultural specificities."[92] Similarly, in his formulation of a "poetics of Chinese film," Bordwell foregrounds a series of "transcultural spaces" in international cinema, linked together not so much by differences as by affinities.

Two points deserve further elaboration. First, Bordwell's model of poetics approximates that of comparative poetics in comparative literature, as he is convinced that "poetics is inherently a comparative undertaking."[93] Second, comparative film studies aims to move beyond transnationalism by foregrounding filmic visuality as always already technologized. Bordwell, for instance, proceeds with "comparative Chinese film stylistics" by identifying, in a bottom-up empirical

fashion, influences and affinities between Chinese and Western films. On the one hand, Hong Kong cinema has transformed Hollywood's classical continuity system that serves as "a transcultural bridgehead," and it does so by intensifying Hollywood's already "intensified continuity" and thus has appeared "more Hollywood than Hollywood"; on the other hand, Taiwan cinema has taken up a long-lost convention in European cinema by experimenting with depth staging.[94] Bordwell's work shows why transcultural visuality demands that critical attention be paid to both technical and conceptual aspects of comparative film studies and that cross-mediality involves comparison between different artistic media as well as between artistic and technologized media.

The areas in comparative film studies that I have selected are not meant to be comprehensive; rather, they are meant to help map the underdeveloped areas in Chinese films studies. In relation to issues discussed in Chapter 1, these areas of comparative film studies may be understood as interconnected, sometimes overlapping spaces produced and structured by cinema, and, as a consequence, the relationship between cinema and space requires comparative film studies. In its conceptual horizontality, comparative film studies promises to cover more of cinema's polylocality and reveals certain things hidden from view by transnational film studies. Transnational film studies is preoccupied with the demystification of the national—a particular, albeit crucial point that buttresses the verticality of the scale as power-geometry. Comparative film studies enables us to move beyond the imperatives of simply following the money (transnational capital flows) or analyzing cultural politics on the national (for example, censorship) and international (for example, film festivals) scales, and it broadens our vision to include relevant aesthetic, cultural, sociospatial, political, economic, and technological aspects of cinema.

Space of Production

Postsocialist Filmmaking

It thus becomes more urgent than ever to keep our contemporary consciousness of spatiality—our critical geographical imagination —creatively open to redefinition and expansion in new directions; and to resist any attempt to narrow or confine its scope.
—Edward Soja[1]

This chapter moves our attention from the space of scholarship (Chapter 2) to the space of postsocialist filmmaking in China, which has produced an amazing array of what Lefebvre posits as "representational spaces," defined as instances of "that concrete (practical and social) space-time wherein symbolisms hold sway, where works of art are created, and where buildings, palaces and temples are built."[2] An outstanding recent symbol of concrete space-time is *guangchang* (square, plaza), which Dai Jinhua evokes through a catchy phrase, "from square to market," so as to visualize a kind of "invisible writing" that has fundamentally transformed mass culture in China during the 1990s.[3] Within a relatively short period, the meaning of *guangchang* changed from a political space (a public square imprinted with memories of revolutionary and democratic events, from May Fourth of 1919 to June Fourth of 1989) to a consumption site (a shopping mall or plaza crowded with commodities and consumers). With "invisible" Dai conjures up the "invisible hand" of the capitalist economy that has engineered a decisive displacement of the political by the commercial and has produced a disquieting silence in the Chinese public with regard to the widening gaps between the classes. Here is Dai's pessimistic assessment: "Behind the glamorous commercial prosperity of the new *guangchang* displays lie the far more profound, disturbing, and yet invisible issues of division between the classes. . . . The socialist legacy has either been abandoned or subverted. . . . [A] public, critical social conscience is absent in our time."[4]

I quote Dai's observation not so much to extend her alarmist warning as to locate an entry point through the social fissures and cracks that have opened since

the early 1990s due to China's rapid transformation from a socialist police state to a postsocialist consumer society. For one thing, Dai's spatial metaphor "from square to market" foregrounds the importance of transnational capitalism in contemporary Chinese cinema, which has thrived because of its strategic moves across national boundaries in both directions: simultaneously "marching toward the world" *(zouxiang shijie)* by winning top prizes at prestigious international film festivals (as evident in a series of spectacular successes that started in the mid-1980s) and "bringing the world home" by importing Hollywood blockbusters on a revenue-sharing basis (which began as a state-sponsored project in the mid-1990s).[5] For another, Dai's evocation of *guangchang* as an intriguing public icon in Chinese culture calls attention to a wide range of cinematic images of space whose production, circulation, and reception may generate new meanings and experiences peripheral, supplemental, contestatory, or even oppositional to those produced by the mainstream media.

I contend that the sociospatial logic of displacement in what Dai describes as "the *guangchang* complex" is not exactly binary in nature: neither does the logic of displacement imply one unilinear destination in the abandonment or subversion of the socialist legacy, the way Dai sees it, for the recent public interest in the resurgence of "Red classics" or *hongse jingdian* indicates otherwise;[6] nor does the logic prevent a public, critical social conscience from recollecting its thought and reasserting its voice in alternative spaces outside and even within the state-sanctioned space of film production and exhibition. Displacement works at different scales and in multiple directions, as I demonstrate by sampling cinematic representations from a new urban generation in the second part of this chapter. First, however, I offer a topographic view of the production and reception of contemporary Chinese cinema.

Topography of Production and Reception

MODES OF INTERACTION: POLITICS, CAPITAL, ART, MARGINALITY

At the beginning of the 1990s, Chinese film productions fell into three large categories. First, state-subsidized and propagandist leitmotif films *(zhuxuanlü dianying)* were becoming an increasingly visible presence. Second, less avant-garde than a few years before, art films *(yishu dianying)* were shrinking to a minority in quantity. Third, entertainment *(yulepian)* or commercial films *(shangye dianying)* of various genres and production value were coming to constitute a dominant majority. By the end of the decade, as exemplified by the 1999 season celebrating the fiftieth anniversary of the People's Republic of China, both art films and entertainment films were moving closer to official ideology, while leitmotif films were

gradually acquiring commercial polish and successfully recruiting some of the leading art film directors. The result has been a new alliance of art, politics, and capital—a powerful synergy that has redirected many of the resources and much of the creativity toward the market and has tempted or compelled some underground directors to try filmmaking inside the state system.[7] Nonetheless, independent films *(duli dianying)* have survived at home and received international recognition abroad, making independent filmmaking a significant contender because it flaunts its marginality and its repeated claims to truth and reality.

In a schematic way, we can now position art, politics, capital, and marginality as four competing players and identify their modes of interaction in the force field of contemporary Chinese cinema (see Figure 3.1).

Figure 3.1 requires some clarification. Art, characterized by imagination and generated by creativity, pursues aesthetics and prestige and draws decent funding from private and overseas sources to produce art films targeted at relatively small, educated audiences *(xiaozhong)* at home and abroad. Politics, characterized by power and sustained by censorship, pursues propaganda and domination and draws on state subsidies to produce leitmotif films at huge financial losses and impose these films on the masses *(qunzhong)* nationwide. Capital, characterized by money and motivated by the market, pursues profits and domination and draws

Figure 3.1. Four contenders in Chinese cinema

considerable funding from private sources and sometimes from state sources to produce entertainment films targeted at popular audiences *(dazhong)*.[8] Marginality, characterized by truth and inspired by dissent, pursues reality and prestige and draws low-budget funding from private and overseas sources to produce underground films targeted at a specialized audience *(fenzhong)*, a niche market, abroad and, occasionally, circulated at home through irregular channels.

Since the mid-1990s all four categories now revolve around the market—domestic as well as overseas—as their center stage, and, except for the nexus of politics and marginality, there have been increasing accommodation and compromise among them. While politics has readjusted its strategic relations with art from all-out domination to sugarcoated co-optation, art appears to have willingly accommodated politics to such an extent that at times it is entirely complicit with official ideology, as in *My 1919* (Huang Jianzhong, 1999) and *The National Anthem* (Wu Ziniu, 1999).[9] Similarly, capital has also changed its strategic position on art from domination to co-optation, and in some cases the lure of prestige and profit-sharing has compelled art to accommodate capital, as in *Beijing Bicycle* (Wang Xiaoshuai, 2001), or become complicit with—if not dependent on—capital, as in *Hero* (2002).[10] The nexus of art and marginality is the least stable of all. From the establishment's standpoint, art tends to disregard marginality's claim to truth, and marginality pretends to revolt against art by exposing offensive pictures

Figure 3.2. *Beijing Bicycle* (2001): love is in the air (courtesy of Wang Xiaoshuai)

Figure 3.3. *Lunar Eclipse* (1999): new urban fashions on display (courtesy of Wang Quan'an)

of postsocialist reality.[11] Sometimes a combination of or compromise between art and marginality may surface, as in *Lunar Eclipse* (Wang Quan'an, 1999) and *Suzhou River* (Lou Ye, 2000), both of which verge on underground filmmaking but were acclaimed as artistic successes. Indeed, although by definition marginality must show contempt for capital, in actual operations marginality can accommodate capital when capital cooperates with it by investing in production of a special type of Chinese reality deemed more truthful than that represented by art and politics, such as *Postman* (He Yi, aka He Jianjun, 1995) and *Platform* (Jia Zhangke, 2000), a situation we will investigate in more detail in Chapter 5.[12]

The most striking change since the mid-1990s has occurred at the nexus of politics and capital. Under the pretext of sharing profits and resources, politics and capital have entered a complicit partnership, as with the "private" *(minying)* company Forbidden City (Zijincheng), which seeks simultaneously to achieve political correctness and maximize market effects.[13] Two early commercial pictures from Forbidden City, *A Time to Remember* (Ye Daying, 1998) and *Be There or Be Square* (Feng Xiaogang, 1999), are two examples of such politics-capital partnership. The nexus of politics and marginality is the only site where dissent and resistance remain possible.[14] However, because of prohibition by politics and dismissal by art, the impact of marginality and its pictures of disputed "truths" have been largely felt overseas at international film festivals, with films such as *Devils on the Doorstep* (Jiang Wen, 2000) and *The Orphan of Anyang* (Wang Chao, 2001).

The apparent lack of regular engagement with domestic audiences has rendered marginality a seemingly ineffective force in the political economy of postsocialist Chinese filmmaking, where co-optation, complicity, and accommodation have prevailed since the late 1990s.

Nonetheless, as a space of radical openness, marginality continues to attract new talents and remain one of the most intriguing spaces of cultural production in postsocialist China.[15] Irregular production and exhibition patterns have not prevented underground and independent filmmaking from reaching its curious audience at home, however small they are in numbers. Precisely due to its "illegal" or "banned" status, marginality in production is redoubled by marginality in circulation, exhibition, and reception. In addition to overseas film festivals, alternative spaces for the exhibition of underground Chinese films have quietly spread from privately operated bars and cafés to art galleries and film clubs in major cities across China, and unauthorized or pirated copies of independent works are circulated on the college Internet and in unofficially duplicated video format. Indeed, as Seio Nakajima's investigation of four Beijing film clubs in the early 2000s demonstrates, the interested Chinese audience follows independent Chinese films closely, and the selections of these clubs are quite comprehensive, in some cases more inclusive than the international film festivals.[16]

Theoretically, marginal underground venues like the Beijing film clubs might function as an alternative or even oppositional public sphere (see Chapter 1), where the audience's discussion would easily shift from art to politics, and where subversion could take place at least on a symbolical level. And in fact, such symbolic subversion of state power was staged at the closing ceremony of the first independent film exhibition in Beijing on September 27, 2001. When the authorities banned this unofficial event after seven days of screenings, the organizer moved the location of the closing feature, *Platform,* from the campus of Beijing Film Academy to a suburban open-air site, where the audience watched Jia Zhangke's film in the chilly wind, applauded the awards ceremony, and felt a sense of solidarity achieved through marginality.[17]

"A public sphere can be produced professionally," writes Alexander Kluge, "only when you accept the degree of abstraction which is involved in carrying one piece of information to another place in society, when you establish lines of communication. That's the only way we can create an oppositional public sphere and thus expand the existing public sphere."[18] Kluge's emphasis on keeping the lines of communication open underscores the crucial importance of distribution, exhibition, and reception in our exploration of cinema and space in postsocialist China. Independent directors' tactics of appropriation or transgression would not amount to anything substantial if lines of communication between them and an interested domestic audience were severed, and without the benefits of watching

independent works, domestic audiences could not participate in resistance or sub-
version in any collective sense.

SPACES OF PRODUCTION AND RECEPTION: NATIONAL, INTERNATIONAL, TRANSNATIONAL

Kluge's remark on the oppositional public sphere reminds us of Hansen's specula-
tion on the liberating effect generated by the audience's reception of films in an
alternative public sphere (see Chapter 1). The emergence of the Sixth Generation in
the early 1990s is one example of liberation delivered by the cinema, although such
liberation would not have been possible without two unprecedented reconfigura-
tions of the national and international spaces of film production and reception.

The first occurred on the national scale: the far-reaching economic reform
the Communist party had implemented beginning in the late 1980s forced state-
owned film studios to seek financial solvency aggressively and to deny the Sixth
Generation any chance of subsidized avant-garde filmmaking within the national
film industry in the early 1990s, which their immediate predecessors—the Fifth
Generation—had been able to obtain in the mid- to late 1980s.[19] It is significant to
note that two early Sixth Generation directors resolutely severed ties with the state
system: Zhang Yuan declined his assignment to the August First Film Studio upon
graduation from Beijing Film Academy in 1989, and his classmate Wang Xiao-
shuai left the Fujian Film Studio after two years of not making films there. Ironi-
cally, it was precisely the economic reform that opened up new cracks and fissures
in the state system for appropriation by aspiring young filmmakers. Relaxed regu-
lations made it possible for independent directors to borrow film equipment and
procure low-quality film stock from state enterprises, and sometimes they literally
"poached" in the state territory by gaining through personal connections "ille-
gal" access to state facilities in film processing and editing. Their "underground"
activities thus exemplify tactics of appropriation and transgression: "The space of
a tactic is the space of the other."[20] Self-positioned as the other, young directors
affirmed their emergent identity and subjectivity, carved out a new space for inde-
pendent filmmaking, and challenged official ideology on and off screen.

The second change, in the early 1990s, was reflected on the international
scale, with the growing international attention paid to Chinese cinema and, in
consequence, the increasing availability of exhibition and distribution space for
underground Chinese filmmakers at international film festivals in Asia-Pacific
(Hong Kong, Pusan, Tokyo) and Europe (Berlin, Cannes, Venice). It is not an
exaggeration to state that there would not have been an uninterrupted, sizable
output of Sixth Generation films in the 1990s without the moral and financial
support of international film festivals and arts foundations overseas. In this sense,
international film festivals overseas functioned not just as a much-needed space of

reception for aspiring Chinese independent directors but also, and more significantly, as a much-coveted space of production (that is, it produced financing and sometimes postproduction). One peculiarity of Chinese independent filmmaking is that very often distribution and exhibition rights for Chinese works are owned or co-owned by overseas, mostly European, institutions.

Wang Xiaoshuai's career is a case in point. In an interview, he vividly describes his experience of working on *The Days* (1993) as a first-time independent director. He borrowed about US$10,000 from friends who worked in advertising (for example, Zhang Hongtao, Xiong Qiang, and Wu Di). To complete a black-and-white feature film on a shoestring budget, Wang had to reduce his expenditures to a bare minimum. He and a friend managed to take a train from Beijing to Baoding without purchasing passenger tickets, and they obtained film stock from a state-owned factory in Baoding without paying anything, not even for a lunch to entertain their hosts. Wang relied on other friends for crew and cast and only paid nominal fees to get his film processed, although he admits to learning an unforgettable lesson because the processing plant went through two electricity blackouts while processing his film, which destroyed much of his early work. Disasters like this aside, Wang's debut work attracted the attention of Shu Kei (Shu Qi), a Hong Kong-based writer-director, who helped introduce the Sixth Generation to the international film festival circuit in the 1990s.[21] A docudrama of an artist couple's prosaic daily life of ennui and frustration in post-Mao China, *The Days* proved to be a huge critical success. It was accepted by the Young Filmmakers' Forum at the Berlin International Film Festival in 1994, collected by the Museum of Modern Art in New York, awarded the best director's prize at an Italian film festival in 1995, and selected as one of 100 film classics in the world by the BBC in 1999. For Wang, the Alexander Gold Prize he received at the Greek Film Festival in 1994 was particularly reassuring because the prize money of US$50,000 made his otherwise "miserable experience" of shooting *The Days* somewhat tolerable in retrospect.[22]

Wang's subsequent three films shift between the categories of underground, semi-independent, and official. Funded initially by Shu Kei (production) and subsequently by the Rotterdam International Film Festival (postproduction), Wang worked on and off for three years in polylocality—China, Hong Kong, and the Netherlands—on the underground project, *Frozen* (1997), a docudrama based on the 1994 suicide of the performance artist Qi Lei and expressive of the rebellious spirit in a time of political suppression and commercial marginalization. In the meantime, his semi-official project, *So Close to Paradise* (1998), went through stages of delays (scriptwriting, postproduction) caused by state censors: it took three years after its production before the film was cleared for release, but even so, no one cared to work on its distribution and exhibition. *A Dream House* (1999) was an official production funded by Beijing Film Studio as part of a young filmmakers'

multi-title project. It easily cleared censorship and was even nominated for the best actor and the best supporting actor at the government-run Golden Rooster awards. Nonetheless, no effort was made to promote the film, and *A Dream House* remains mostly unnoticed. It was not until *Beijing Bicycle* (2001) that Wang finally experienced a "normal" condition of filmmaking. A transnational coproduction from Arc Light Films (Taiwan), Flach Pyramide International (France), and Beijing Film Studio, *Beijing Bicycle* received the Jury Grand Prix (Silver Bear) and the New Talent Award (for two actors) at Berlin Film Festival in 2001, and this critical recognition soon translated into a commercial success when the film entered a broad art-theater distribution in Europe and North America (see Chapter 4).[23]

Wang Xiaoshuai's career illustrates that the topography of Chinese cinema since the early 1990s does not favor fixed boundaries between the national and the international, nor does it consist of merely binary tensions between the underground and the official. Rather, the boundaries of the national, the international, and the transnational are more porous than ever before and widely open for traffic. Spaces of production, distribution, exhibition, reception, and regulation are mutable and susceptible to new modes of interaction. Not surprisingly, Wang's trajectory connects disparate spaces of production and intersects various sites of identity: he is an underground, independent, semi-official, and transnational filmmaker all at the same time. Significantly, his trajectory is not a linear progression from point A to B (from underground to aboveground, for example) but one of crisscrossing lines and intersecting points. After the success of his transnational coproduction of *Beijing Bicycle,* Wang proceeded with a little-known independent project, *Drifters* (2003), which dramatizes the pressure of illegal immigration to the United States in a coastal town in Fujian province. He returned to the space of official filmmaking with *Shanghai Dreams* (2005), which revives memories of his childhood years in a remote industrial city in Guizhou province, and which enjoyed nationwide exhibition in China.

SPACE-TIME IN ZHANG YUAN'S FILMS: ISOTOPIAS, UTOPIAS, HETEROTOPIAS

As Massey argues in her investigation of politics and space, "space must be conceptualized integrally with time; indeed the aim should be to think always in terms of space-time."[24] As "a configuration of social relations" or "an ever-shifting geometry of power and signification," the concept of space-time highlights "the existence in the lived world of a simultaneous multiplicity of spaces: cross-cutting, intersecting, aligning with one another, or existing in relations of paradox or antagonism."[25] Figure 3.1 displays this simultaneous multiplicity of spaces in postsocialist Chinese cinema, in which "the social relations of space are experienced differently, and variously interpreted, by those holding different positions as part of it."[26] Just as individual players can switch positions and thus acquire

different sociospatial relations to power, so modes of interaction between any pair of the four major players can change over time, from resistance to complicity, for instance, or vice versa.

The radical transformation of Zhang Yuan's position from resistance to complicity within a relatively short period from 1993 to 2003 foregrounds the simultaneous multiplicity of spaces in postsocialist China. I propose to adopt "isotopia," "utopia," and "heterotopia"—three spatial terms conceived separately by Lefebvre and Foucault—to structure my discussion of instances of space-time constructed in and around Zhang's works from *Beijing Bastards* (1993) to *Green Tea* (2003).

In Lefebvre's conceptual grids, "isotopias" refer to analogous spaces, "utopias" to spaces occupied by the symbolic and the imaginary, and "heterotopias" to mutually repellent spaces.[27] In Zhang Yuan's case, the concept of isotopia operates at three levels. First, as Zhang sees it, the emergent Sixth Generation prefer to imagine themselves entering into an isotopic relation with the Fifth Generation in terms of life experience and aesthetic values:

> Our thinking is completely different.... They are intellectual youths who've spent time in the country, while we're urbanites.... They all went through the Cultural Revolution and they remained kind of romantic.... I make films because I am concerned about social issues and social realities.... I don't like being subjective, and I want my films to be objective. It's objectivity that'll empower me.[28]

In statements like this, the Sixth Generation directors tend to evoke perceived binary oppositions between rural and urban, romantic and realistic, subjective and objective, allegorical and existential, mainstream and marginal as features that clearly set them apart from the Fifth Generation.

Second, tension develops because this perceived isotopic relation may change at a higher level of configuration because the emergent Sixth Generation sometimes finds certain Fifth Generation directors in their category of "banned in China"— a category that routinely pits the space of the underground against the official in Western media reports. In March 1994, for example, Zhang Yuan and Wang Xiaoshuai joined Tian Zhuangzhuang, a renowned Fifth Generation director, on a list of seven directors prohibited from filmmaking due to their violation of official rules.[29] Like *Beijing Bastards* and *The Days, The Blue Kite* (Tian Zhuangzhuang, 1993), which configures private space and marginal space in diametric opposition against official space and public space,[30] was screened at international film festivals overseas without prior official approval. Unlike Zhang's and Wang's defiance, however, Tian acquiesced to the official ban and stayed within the state studio system to promote other independent Sixth Generation directors, such as Lu Xuechang.[31]

Figure 3.4. *The Blue Kite* (1993): a film about the socialist revolution, banned in China

Third, another isotopic relation takes shape in dissimilar public spheres operating at home and abroad. The frequent banning and censorship on many early Sixth Generation films point to the potentially subversive function these films might perform if they were allowed to enter the public sphere. Indeed, "deeply subversive" is the phrase Linda Jaivin uses to describe the impact of one independent documentary, *The Square* (Zhang Yuan, Duan Jinchuan, 1994). Without doubt, when films like *The Blue Kite, Beijing Bastards,* and *The Square* were exhibited overseas, they contributed to the maintenance of an alternative, if not oppositional, public sphere. Significantly, this oppositional public sphere is more often found overseas than in China. Just as Tian was praised for his political courage in directing *The Blue Kite,* the Western media gave Zhang Yuan a heroic profile as an "outlaw" director for *Beijing Bastards.*[32] In the case of *Beijing Bastards,* a further imbrication of space-time occurred when it was broadcast on UK Channel Four in 1995. The fact that the British television audience would stay up until midnight to watch an underground production—announced as "China's first rock and roll movie . . . banned by the Chinese Authorities"—not only testifies to the attraction of the "banned in China" label but also suggests the British audience was experiencing a comforting cultural memory associated with their pride in having launched rock and roll as a viable alternative cultural form decades before.[33]

In China in the early 1990s, the establishment of an oppositional public sphere by way of underground filmmaking was still largely a utopian act. It is true that filmmaking tends to construct utopian spaces that are occupied by the symbolic and the imaginary, as Lefebvre sees it, but by definition "underground" filmmaking can only target "sites with no real place," which belong to Foucault's definition

of utopias as "fundamentally unreal spaces."[34] The idea of the underground as utopia, as an inverted analogy with the real space of society, is obviously embodied in *Beijing Bastards*. Indeed, Zhang's docudrama is structurally built on the lack of utopian space—"utopian" in the sense of "lacking a place"—and this lack motivates the recurring motif of "seeking" in the film. The rock band's frustration as they seek a stable rehearsal space and concert venue thus acquires an allegorical meaning for the Sixth Generation, because the emergent rock *(yaogun)* culture, like emergent independent filmmaking, were seeking an alternative public sphere in China precisely at that historical moment.[35] Moreover, as Dai Jinhua writes of Zhang Yuan, "the director is also seeking in life—seeking for his own style of life"—or seeking a most effective way to live a life of protest.[36] Given the repressive post-1989 political environment, the space of protest and rebellion constructed in *Beijing Bastards*—as well as a few other Sixth Generation films centering on the alternative rock culture (see the second part of this chapter for more elaboration)—can only be contingent: it exists in an imaginary space—literally a utopia—produced by the rock band's performance and by the audience's identification with this emergent subculture. This contingent space of search and performance belongs to the margin, where utopian visions are nurtured, creative energy finds expression, and a crisis of male subjectivity demands immediate attention.[37]

Exactly five years after his filmmaking was banned, Zhang Yuan obtained official approval to shoot *Seventeen Years* (1999) in the otherwise off-limits territory of a state prison. In Foucault's conception of space, prisons belong to "heterotopias of deviation, those in which individuals whose behavior is deviant in relation to the required mean or norm are placed."[38] Attentive as it is to an inherent power imbalance, Foucault's definition is more useful than Lefebvre's notion of heterotopias as mutually repellent spaces. What makes *Seventeen Years* particularly fascinating—or even subversive—is not its juxtaposition of the deviant and the normal as two mutually repellent spaces; rather, these two spaces are constructed as so mutually implicated and interpenetrating that the deviant can be judged as the normal (a model prisoner permitted to visit her parents for the Chinese New Year) while the normal is found pathetically deviant (that is, home is where the heart is missing). When the female prison guard accompanies the convict daughter home, she is shocked to see no sign of normal affection, not even a courteous greeting, from the convict's aging stepfather.

Reminiscent of *Beijing Bastards*, *Seventeen Years* is a tale of searching, but this time the objective is the heterotopia of a devastated home, which finds a perfect manifestation in the film's elaborate footage of urban ruins in Beijing. Clearly urban ruins may function as heterotopias in Foucault's sense, as "counter-sites . . . in which the real sites . . . are simultaneously represented, contested, and inverted."[39] Because of the widespread, large-scale demolition in Beijing, the convict daughter

cannot locate her parents' home, and it takes the prison guard's persistent effort to bring the convict to her parents' new apartment.[40] As a specific type of heterotopia in contemporary China, urban ruins constitute a space of disappearance as well as a space of what Wu Hung terms "critical gaze"—a gaze that implements an "emphasis on the present" and sees through a "fascination with violence and destruction."[41] Characteristic of the logic of contestation and inversion in heterotopias, ruins provide evidence of the authenticity of the past precisely at the same moment that their fragmentary embodiment bears witness to the disappearance of the past and thereby "invites viewers to imagine or reconstruct a lost whole from the enduring fragment."[42] In *Seventeen Years,* this "lost whole" is home, a place that normally promises a plenitude of love, but here a place that was devastated seventeen years earlier when the convict daughter accidentally killed her stepsister.

Nonetheless, because cinema is a contradictory space, one detects in *Seventeen Years* both a contestatory trope of disappearance, via the symbol of urban ruins, and a more subtle, ideologically conciliatory trope of disappearance—of the rebellious spirit so distinctive in Zhang Yuan's previous films. In an emotional scene, the convict daughter kneels down in front of her stepfather and pleads for forgiveness for the crime she committed as a juvenile. We cannot help but read the space-time of this scene allegorically: after years of exile in heterotopia, the rebel generation is now seeking forgiveness on screen and desperately searching for a way to return to the real space of the mainstream. This conciliatory gesture to the authorities at home immediately compelled *The New York Times* to question Zhang Yuan's decision to move aboveground: "Will he always be able to find topics that excite him and are acceptable to the censors?"[43]

With the benefit of hindsight, we know that Zhang has continued to find topics that excite him and are acceptable to the censors, and he has done so not just in fiction films but in documentaries as well. In *Crazy English* (1999), a feature-length documentary approved for public release in China, Zhang presents an enterprising, charismatic English teacher named Li Yang, whose peculiar pedagogy has garnered him a national reputation. In scene after scene, Li Yang speaks loudly and confidently—in the manner of an inspired priest spreading a new gospel—to mass gatherings, where hundreds of listeners, many of them students, eagerly follow his instructions on how best to pronounce English words, to master English as a tool indispensable to commercial success, and eventually to make the entire Chinese nation rich and strong. The typical public setting of Li's mass gatherings is reminiscent of Dai Jinhua's description of the *guangchang* complex, in which elements with political connotations have been displaced by new commercial interests. Indeed, *Crazy English* vividly demonstrates a new mass movement in contemporary China, a movement toward complete commercialization that the masses participate in with nationalist pride and self-acknowledged craziness.

Of course, being an experienced filmmaker, Zhang Yuan has distanced him-self from such a nationwide craze for wealth. He can even be critical of the snob-bishness of the Chinese nouveaux riches, as *Green Tea* demonstrates. However, I contend that by 2003 the *guangchang* complex was firmly entrenched in Zhang's own filmmaking. As head of a private film company, he is now responsible for generating financial returns to his investors, so he has repositioned himself deci-sively into the space of commercial-art film. He casts top Chinese stars like Jiang Wen and Zhao Wei and recruits transnational talents like Christopher Doyle.[44] Appropriate to an underlying theme of the displacement of the political by the commercial, *Green Tea* displays glamorous spaces of urban consumption, from the chic teahouse to the brash nightclub. Gone is the existential angst from the space-time of *Beijing Bastards;* in *Green Tea,* male and female consumers seem to find themselves comfortably at home in an apparently affluent, carefree new era.

BACK TO TIANANMEN SQUARE: SYMBOLISM, EVERYDAY LIFE, UTOPIA

The spatial logic of displacement allows for the possibility of multiple configura-tions: the displacement of the commercial by the political and vice versa, or the displacement of one kind of politics by another. *The Square,* a 100-minute docu-mentary Zhang Yuan directed with Duan Jinchuan, illustrates precisely this pos-sibility.[45] Its timing announces its subversive intent: the project was started during May 1994, a month after Zhang had learned of his banned status and right before the fifth anniversary of the internationally publicized June 1989 democratic move-ment and the Chinese government's brutal crackdown on it. Zhang defied the ban. Through Duan's connection to a CCTV (China Central Television) crew, Zhang took his camera to the heart of Chinese political power, Tiananmen Square.[46] In this most politically sensitive space-time, however, Zhang decided to forgo his *Bei-jing Bastards*-style loud protest; instead, the documentary "records the rhythms of life on Tiananmen Square, from the crowds that gather for the flag-raising cer-emony at dawn to the shifts of strolling lovers, kite fliers and Frisbee players who populate the square in the evenings."[47] In a path-breaking cinéma vérité presenta-tion (see Chapter 5), the film rejects an authorial voiceover commentary so that the images of space-time in *The Square* are open to different uses, appropriations, and interpretations.[48]

As Lefebvre asserts, "The most effectively appropriated spaces are those occu-pied by symbols."[49] To contest—if not subvert—the absolute power symbolized by Tiananmen Square, where imperial glory is signified by the awe-inspiring palaces of the Forbidden City and where Communist leaders used to preside over mass parades in national celebrations, Zhang Yuan highlights the dimension of every-day life, very much the way de Certeau conceives of walking as spatial practice: "Although I set out to examine historical issues," Zhang admits in an interview,

"I found myself fascinated by scenes of everyday life."[50] It is true that the daily ceremony of raising the national flag is now appreciated perhaps more as a tourist attraction than a reminder of socialist legacy, thereby lending support to Dai Jin-hua's argument for the displacement of the political by the commercial, but documenting spatial practices of ordinary people on the square without superimposing any ideological reading suggests a different kind of politics at work. Significantly, Zhang's intention is never purely observational or objective: "I think every shot in the film attests to 1989 and is full of 1989."[51] With this statement he projects his own interpretation of the square as a space-time in the public sphere demanding continual observation and appropriation.

It is an intriguing coincidence that *One Day in Beijing* (1994), a much-less-known, shorter documentary (fifteen minutes) was also shot in May 1994, and this Betacam video came from a group of Beijing Film Academy students called the Youth Experimental Film Group and headed by Jia Zhangke. Like Zhang Yuan and Duan Jinchuan, Jia and his fellow students decided to record passing crowds in Tiananmen Square, and their images of ordinary people's "quotidian activities" are meant to subtly challenge the "layers of symbolism accumulated by the official representations of Tiananmen."[52]

In short, Tiananmen Square, as the quintessential symbol of *guangchang* in contemporary China, remains at once an absolute space, an abstract space, a contradictory space, a differentiated space, a social space, a leisure space, potentially a counterspace, and therefore a utopian space. As a space of utopia occupied by the symbolic and the imaginary, it constitutes a central focus in our critical reflections on cinema and space in postsocialist China as well as a significant site of archaeological work for future historians. "For this reason," to quote Kluge, "the history of film contains a utopian strain—which is what accounts for the attraction of the cinema—but it is a utopia which, contrary to the Greek meaning of *ou-topos* = no place, is in existence *everywhere*."[53] Cinema provides precisely such a sociospatial linkage between nowhere and everywhere, which is illustrated in the emergence of a new urban generation of Chinese filmmakers.

Toward a New Urban Generation

DIFFERENCE: THE EMERGENCE OF THE SIXTH GENERATION

As indicated in Figure 3.1, postsocialist China constitutes a varied landscape of culture against which filmmakers of different generations, aesthetic aspirations, and ideological persuasions struggle to readjust and redefine their different strategic positions in different social, political, and economic situations. My emphasis on difference derives from my conviction that the period in which the Sixth

Generation emerged marks a new regime of political economy and therefore constitutes a new chapter in the cultural history of contemporary China. Sometimes labeled as "post-New Era" *(hou xinshiqi),* this post-Tiananmen period—namely, the period following the government's crackdown on the pro-democratic student demonstration on June Fourth of 1989—differs significantly from the New Era of the 1980s.[54] Consequently, filmmaking in the post-Tiananmen period demands that we pay attention to different configurations of cultural production, artistic pursuit, political control, ideological positioning, and institutional restructuring.

Difference has been frequently used as a marker to distinguish the Sixth Generation as a unique group in postsocialist China.[55] Critics have established a list of binary oppositions to highlight the differences between the Fifth and the Sixth Generations. Where the former is associated with the rural landscape, traditional culture, ethnic spectacles, grand epics, historical reflections, allegorical frameworks, communal focus, and depth of emotion, the latter is aligned with the urban milieu, modern sensitivity, narcissistic tendencies, initiation tales, documentary effects, contingent situations, individualistic perceptions, and precarious moods.[56] On the surface, such markers of difference, together with their unofficial or semiofficial production, do not favor the Sixth Generation as standard-bearers of postsocialism in terms of aesthetic practices. Nonetheless, critics characterize these young directors as being among the most experimental in the 1990s, when the Fifth Generation, many of them avant-garde auteurs in the mid- and late1980s, had reverted to more traditional genres and styles, such as tear-jerking melodrama and spectacular historical epic.

What makes the works of the Sixth Generation more symptomatic of postsocialism than their predecessors is their institutionally imposed but self-glorified marginal status at a crucial turning point in postsocialism as a regime of political economy.[57] After the government had launched the program of a wholesale market economy and had instituted a series of reforms in the post-Tiananmen era, the Sixth Generation entered the film market in confrontation—initially not quite yet competition—with several major forces in film production. The mainstream or leitmotif film was given substantial state subsidies following Tiananmen; the art film as practiced by leading figures of the earlier generations continued to attract transnational capital; and cheap commercial films (especially comedies and martial arts flicks) flooded the market. By the mid-1990s, some state studios had teamed with private investors to coproduce films of relatively high artistic values and strong box-office appeal, such as *Red Cherry* (Ye Daying, 1995).

It is worth remembering that underground operations are not the only tactic deployed by the young directors. What is less known—or intentionally ignored—in the Western media is that many new graduates from Beijing Film Academy and other institutions retained nominal affiliation with their assigned units in the early

Figure 3.5. *Red Cherry* (1995): a commercial art film set in the Soviet Union during World War II (courtesy of China Film Archive)

1990s. In addition to Guan Hu, Beijing Film Studio listed on its staff other active young directors such as Lu Xuechang and Zhang Yang. During the mid-1990s, several of their films were approved for public release in China. *Dirt* was joined by *Weekend Lovers* (Lou Ye, 1994), *The Making of Steel* (Lu Xuechang, 1997; completed in 1995), *No Visit after the Divorce* (Wang Rui, 1997), *Yellow Goldfish* (Wu Di, 1995), and *Rainclouds over Wushan* (Zhang Ming, 1995).

Situated in this brand-new political-economic regime, the Sixth Generation is itself a cultural phenomenon made possible by the postsocialist market economy, which developed rapidly in the 1990s in full complicity with transnational capitalism and which values the "ideology of entrepreneurship."[58] Somewhat ironically, underground filmmaking may be treated as a by-product—even if unintentional—of postsocialism in the 1990s because, as entrepreneurs themselves, "independent" filmmakers turned their financial disadvantages into ideological advantages and negotiated their way through the changing market economy. Relaxed state regulations enabled them to go independent in the first place, renting film equipment and facilities and dealing directly—albeit unofficially—with overseas distribution agents. But because of their initial dependence on state equipment for production and their reliance on international film festival circles for exhibition their very status as "independent" filmmakers is rather dubious.[59]

The qualified existence of the Sixth Generation as "independent" filmmakers reminds us that postsocialist China is a reality evolving along an unexplored path and toward an uncertain future. As such, postsocialism has remained an anxiety-causing force that continues to generate feelings of deprivation, disillusion, despair, disdain, and sometimes even indignation and outrage. To explore the cinematic

Figure 3.6. Poster for *Weekend Lovers* (1994): young rebels from the Shanghai streets

articulation of feelings like these, we now turn to *Dirt* as symptomatic of the Sixth Generation in its formative years.

DIRT: HISTORY AND MEMORY IN RUINS

Guan Hu started his career making films within the state system. In 1991 he managed to obtain an investment of RMB 800,000 (roughly US$100,000) from the Golden Bridge International Trading Company, a subsidiary of Sino-Chemicals (Zhonghua), through connections of Kong Lin. With her prominent roles in *Bloody Morning* (Li Shaohong, 1990) and *Raise the Red Lantern* (Zhang Yimou, 1991), both internationally released and acclaimed, Kong had acquired enough star power for fund-raising purposes. After paying Inner Mongolian Studio RMB 150,000 for the studio-label fee (18.75 percent of their budget, but cheaper than other big-name studios), Guan Hu assembled a crew and a cast, whose average age was twenty-four, and in May 1992 began work on what he envisioned as the first Chinese MTV-style rock feature.[60]

The film opens with the whole screen filled with the words of Mao Zedong's celebrated proclamation during the Cultural Revolution: "The world belongs to you as well as to us; but it is eventually yours. You youngsters . . . are like the morning sun. Hope rests on your shoulders." A group of schoolchildren gather at the Zhengs' house and play a record of the Beatles song "Hey Jude" (coauthored by John Lennon and Paul McCartney).

Against the sound track of the song, the scene shifts to Ye Tong (Kong Lin), who is walking along railroad tracks, carrying a guitar on her back.[61] She has just arrived from Guangzhou to visit childhood friends and to pursue medical training in Beijing. In MTV fashion, fragments of her childhood memories crosscut with glimpses of the modern cityscape, and the Beatles sound track intensifies her melancholy.

As Ye meets her friends one by one in a *hutong* (narrow back alley), the viewer gradually realizes the social values attached to each of them. On the positive side, Zheng Weidong, whose given name means "defending the east," is a policeman in charge of the neighborhood. In the middle, Chi Xuan, a former weakling, is now making a small fortune as a private entrepreneur, and Peng Wei, a longhaired rock musician, appears to defy all social norms. On the negative side, Big Head (Lei Bing's nickname) is an escaped prisoner who is hiding in a deserted house that used to belong to Ye's family before their relocation to Guangzhou at the beginning of the Cultural Revolution. "We were five kids living in the same *hutong*," Ye reminisces, "and we never imagined we would grow up like this."

With Ye's voiceover commenting throughout the film, *Dirt* foregrounds the female consciousness and thus distances itself from the type of male

narcissism—sometimes even misogyny—typical of the early all-male Sixth Generation.[62] Nevertheless, like his classmates, Guan Hu cannot help but depict his female lead as the other against whom male characters negotiate their social, sexual, and "aesthetic" identities. Even Big Head is attracted to Ye, and this eventually leads to an incident in which he stabs Weidong and, running from the police, dies when he accidentally falls from a bridge.

One of the central tensions in the film is the romantic rivalry between Weidong and Peng Wei, whose physical appearances codify them as the opposing forces of law and rebellion.[63] A childhood musical talent, Ye is attracted to Peng and his rock group—played by Beijing's heavy-metal band Pressure Points (Chaozai), which helped compose the film's score. She experiences in their rehearsals a kind of newfound freedom, or at least much-needed release from her tedious medical training. Donning a Bulls cap, she sings of revisiting her childhood dreams. In spite of her romantic involvement, however, Ye soon realizes the futility of Peng's rebellion and is repelled by his irresponsible sexual life.

If Ye's involvement with Peng has much to do with the desperation of two alienated souls, her relationship with Weidong seems to originate from a collective childhood dream of home and community. The Zheng house used to be the favorite hangout for the five when they were kids. Now, the same *hutong* still exists, but each of the young people has drifted in a different direction. All of them except Big Head briefly reunite at Ye's birthday party at the Zheng house, but Weidong's father, an aging music teacher long paralyzed by a stroke, soon dies, signifying the end of the socialist era. After Weidong is stabbed, Ye visits him in the hospital, and Weidong runs away from the hospital and roams the streets hand in hand with Ye. "I often dreamed of us five playing in this house," says Ye, when they have reached her deserted house, and the following sequences are coded with ambivalent images.

In one sequence, Chi Xuan sets up a film projector in the Zheng house to entertain Weiping, Weidong's sister who works for a foreign business venture and is just about to give birth to her former husband's baby. A fast tracking shot reveals people wearing white mourning flowers lining up along the streets. A medium shot of a funeral car passing the mourners in front of Tiananmen is followed by an extreme long shot of a sea of people in Tiananmen Square. A woman in tears appears in a close-up, holding a child who wears a black armband. Then the camera pans to other weeping mourners.

Another close-up presents Weidong and Ye Tong embracing in the deserted house. As the camera tracks behind the film projector and pans past Chi's indifferent face to Weiping's puzzled look, a group of cheerful men and women are seen on screen dancing *yangge* style in front of Tiananmen, while others parade with a

billboard-size sign reading "Smashing the Gang of Four/Celebrating the Victory."
A frontal shot of Peng Wei looking defiant in the Zheng house is followed by a
close-up of the back of Ye's lovely hair and Weidong gazing at her. An old portrait
of Mao Zedong is barely visible on the wall behind Weidong's naked shoulders.
As Ye lies down on the bed, her head over the edge and her long hair streaming
down, the sex scene cuts to a tracking shot of mourners lining a street, then to a
panoramic shot of tens of thousands of people in Tiananmen Square.

Suddenly, we see Weidong emerge from a *hutong* in a long shot; he is about
to vomit. We are not sure exactly what is disturbing him—his stab wound? His
intimacy with Ye? Or the fragmented memory from the documentary footage?
What is more disturbing is that Weidong immediately runs into a group of violent
youths, who provoke a fight and beat him into unconsciousness. In a symbolic
fashion, the film projects in these parallel sequences a mixture of unsettling feel-
ings of contradiction, bewilderment, and irony.

For Guan Hu, *Dirt* is intended as a "rebellious film" *(fanpan de dianying)* that
articulates a kind of "nostalgia for the past and indulgence in the future"—"a lin-
gering sense of idealism and sentimentality" unique to his generation of filmmak-
ers, who experienced "moments of crisis" in postsocialist China.[64] Indeed, back in
the early 1990s, the images of public mourning in Tiananmen Square could not
help evoking the publicly unspeakable moments of idealism and crisis of Tianan-
men in 1989.[65] Just as the juxtaposition of the private (a sex scene) with the pub-
lic (the documentary footage of Mao Zedong's 1976 funeral) in the film raises
questions of history and memory, the crosscutting simultaneously suggests the
fragmentation of private memory and the seeming irrelevance of public history in
postsocialist China.

Fragments of private memory are found everywhere in *Dirt:* the film con-
tains many MTV-style collages of images superimposed on a sound track of rock
music. The kind of sentimentality and nostalgia Guan Hu had in mind finds the
best expression in the song "A Night without Dreams" that Ye Tong sings at school.
In a rapid succession of fragments of private and collective memories, the song
sequence alternatively features Ye and Peng (identical in both their body move-
ments and their long hair) and the events that may or may not have taken place in
the film. These events include marching Red Guards and the reading of *Cankao
xiaoxi* (a newspaper that circulated internally) in the era of the Cultural Revolu-
tion, as well as bulldozers and *hutong* in ruins as a result of the contemporary
demolition of old Beijing.

The end of the film resembles its beginning, with a sentimental scene of Ye's
departure in a Beijing street. It is extremely ironic, however, for the screen shows
Chi Xuan pushing the convalescent Weidong in a wheelchair, with Weidong unable

to speak—an exact replica of his father earlier in the film. This is a decidedly symbolic gesture through which *Dirt* pays lip service to the sanctity of the law while exposing its fundamental vulnerability and its utter inability to justify itself fully in human terms (hence, another implicit criticism of Tiananmen in 1989). The traffic lights turn red, and a team of elementary school students singing the "Song of the Young Pioneers" passes in front of Ye and separates her from her childhood friends. Suppressing tears, Ye waves to Chi and Weidong, bidding farewell to a city where her childhood dreams are twice lost.

Ye's experience revisiting Beijing thus confirms Massey's remark: "For the truth is that you can never simply 'go back,' to home or to anywhere else. When you get 'there' the place will have moved on just as you yourself will have changed. . . . You can't go back in space-time."[66] This sense of loss in space-time is amplified by the Beatles song "Hey Jude," which plays again as the ending credits roll, but this time some of the lyrics appear in Chinese subtitles:

Hey Jude, don't be afraid.
.
And any time you feel the pain, hey Jude, refrain,
Don't carry the world upon your shoulders.[67]

The rebellious film thus ends with a vision of history and memory in ruins, leaving only fragments of images and songs to evoke a lingering sense of nostalgia, emptiness, and irony.

In spite of its heightened nostalgia, we should not forget that *Dirt* was a product of collective work. The film's original Chinese title was *Zang ren* (Dirty people), an unmistakable reference to the defiant longhaired artist that the Sixth Generation fashioned as a self-image or ego ideal in their formative years. Even though the Chinese title of the released version was changed to *Toufa luanle* (Disheveled hair) due to censorship pressure, a small seal with the number 87 on it (the year the class of 1991 entered Beijing Film Academy) significantly accompanies the title in the initial credit sequence. From the outset, therefore, Guan Hu had intended *Dirt* to be a collective expression of the group's rebellious spirit and their particular aesthetic aspirations—both embodied in the rock music popular among young Chinese urban audiences since the late 1980s.

ROCK: REBELLION FROM THE SUBCULTURAL MARGIN

Rock music appeared in China around the mid-1980s from "subcultural margins" where its participants—musicians, college students, and private entrepreneurs—"share a coherent ideology of cultural opposition."[68] Almost synonymous with

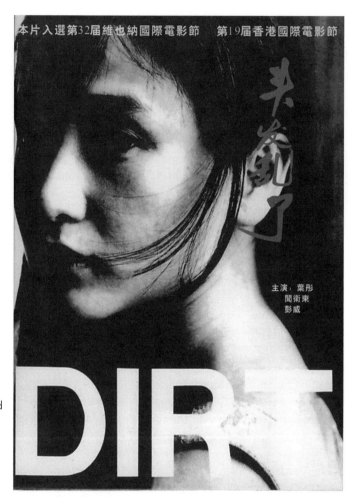

Figure 3.7. DVD cover of *Dirt* (1994): disheveled hair and rock as protest

Chinese rock, Cui Jian is typecast internationally as a "rebel rocker" and has been variously hailed as "China's Bob Dylan" or "China's John Lennon."[69] The rebellious nature of his work is captured in his metaphoric use of rock music. "Like a Knife," the title of one of his famous songs, was meant to "cut away at social and political problems."[70] The common perception of rock music as an effective means for the articulation of dissent and resistance thus brought the rock musicians together with the emergent Sixth Generation directors in the early 1990s. Their united stance vis-à-vis the mainstream political and commercial cultures engendered further significant parallels between these two groups of rebel artists.

First, in terms of its ideological function, rock musicians' pursuit of "authentic self-expression [*ziwo biaoxian*] and emotional release [*xuanxie*] in the face of oppression [*yayi*]" is not only shared by but is also physically embodied in many Sixth Generation works.[71] By featuring Cui Jian as a star in and a producer of *Beijing Bastards,* Zhang Yuan was quick to forge an alliance between rock music and cinematic rebellion in China. Other young directors immediately followed with their own explorations of this thematic link to rock music as an expression of alienation from and opposition to the mainstream. Lu Xuechang, for instance, admits that he added the rock scenes in *The Making of Steel* precisely because certain previous films made by his classmates, including *Dirt* and *Weekend Lovers,* had done so.[72]

Second, in terms of aesthetic practice, both early rock musicians and Sixth Generation directors emphasize collective performance not simply as a common ritual of release and resistance, but even more as a process of "self-discovery and moral self-redefinition."[73] In *Beijing Bastards* and *Weekend Lovers,* the process of looking for one rehearsal site after another functions as an allegory of the musicians looking for their rebellious identity and their marginal place in a hostile, or at least unsympathetic, society. In *Dirt,* the recurring images of uncomprehending neighbors crowded outside their rehearsal site (an abandoned warehouse) constantly remind the rock band of their alienation and isolation because of public disapproval.

Third, in terms of its institutional operation, rock musicians' lack of state support and their subsequent reliance on private and foreign venues for performance are mirrored in the early practice of the Sixth Generation. Just as rock musicians depended almost exclusively on the patronage of friends and foreign venues, so the young filmmakers sought private money to finance—and sometimes to distribute overseas—their early features. The unofficial or semiofficial channels of such operations thus heightened the public perception of their avowed resistance to the establishment. Ironically, for these rebel artists, cultural marginalization and political censorship at home could quickly translate into financial support from abroad in the 1990s. A rock singer like Cui Jian could expect the financial support of multinational recording companies (often via Hong Kong and Taiwan) and then proceed to convey his "authentic feelings" through rebellious rock to a huge audience.[74] Similarly, as an indispensable component of his "formulas for success," a young director like Zhang Yuan could use the government's latest ban on his film to generate more overseas investment and international reputation.[75] Since the late 1990s, this kind of transnational investment in "authentic" Chinese voices and images has constituted a notable trend of cultural production in postsocialist China (see Chapter 6).

Given the tightened censorship in the post-Tiananmen period, Andrew Jones reasons, "the Chinese rock subculture has not reached the level of articulated *political* opposition, [but] the rock sensibility does hinge upon a clearly articulated, self-consciously held ideology of *cultural* opposition."[76] As we have seen, many early Sixth Generation films share just such an ideology of cultural opposition. Although the nature of film production and distribution in China prohibited any direct treatment of the 1989 pro-democratic movement, which their rock counterparts were able to allude to from time to time, the young filmmakers turned to the Cultural Revolution via allegorical references. In one of its MTV images, *Dirt* shows the young Ye Tong being paraded as a spy by her close friends. Similarly, in *Urban Love* (1997), Ah Nian includes dream-like sequences of the Cultural Revolution in which the male lead remembers his parents' humiliation at the hands of the Red Guards. In another little-known film, *Yellow Goldfish* (1995), the male lead is infatuated with the revolutionary ballet "The Red Detachment of Women" restaged for nostalgic public consumption in the 1990s.

The Sixth Generation's revisiting of that chaotic decade in cryptic, fragmented, and surreal images forms a sharp contrast to the Fifth Generation's lavish, full-scale dramatization of the Cultural Revolution. *Farewell My Concubine* (Chen Kaige, 1993), *The Blue Kite,* and *To Live* (Zhang Yimou, 1994) were released when many early Sixth Generation directors were struggling with their debut features. What is interesting is how the younger generation explains their perceived differences. Just as their rock counterparts claim for their music a kind of truthfulness missing in other forms of popular music,[77] the young directors tend to insist on the "authenticity" of their cinematic vision as a distinctive marker.

However, it is possible that the Sixth Generation's rebellious attitude was more a symbolic posturing than an ideological opposition,[78] so the extensive use of rock as a subversive form of resistance must not blind us to other dimensions of the artistic pursuit of the Sixth Generation. The framing sound track of the Beatles song in *Dirt,* for instance, functions as much as an intensification of nostalgia for lost youth as an evocation of a rebellious spirit. In this context, it is worth remembering that even Cui Jian's songs like "A Piece of Red Cloth" contain a large measure of nostalgia and self-confession.[79]

In addition to rebellion (an explosive outcry) and nostalgia (a sentimental retrospection), monologue (an implosive introspection) appears to be a third form of aesthetic expression preferred by several Sixth Generation directors. After losing his wife and his own creative energy, the male artist in *The Days* (1993) confines himself in his studio and acts like a lunatic, repeating and imitating his own gestures in a mechanical manner. *Postman* (1995) continues this representation of monologue and solitude, this time featuring a taciturn postman who takes

pleasure—which borders on autoeroticism—in opening letters and prying into the secrets of others. In *Rainclouds over Wushan* (1995), another reticent character, a socially and professionally secluded signalman, acts out the meaninglessness of life in a mountain town. As these films elaborate the theme of oppression—a target of rock musicians' outcry—in its various social, political, and psychological manifestations, the atmosphere of silence and suffocation can sometimes reach the point of implosion—an emotional discharge that aims to expose the truth behind disguise, hypocrisy, and pretension.

In comparing Chinese rock music with Euro-American subcultures, Jones observes, "This rebellion is invariably met with outrage, stiff resistance, and eventually, co-optation from the dominant culture."[80] Because they chose to work within the state system, many young directors were even more restricted than their rock counterparts were. They were under pressure not only to tone down their antisocial sentiments but also to disguise their oppositional stance by inserting a token "repentance" of their rebellious adolescent years. To clear censorship, *Weekend Lovers* adds a final disclaimer announcing that all transgressive acts in the film took place years before and that the characters have changed since then. A different kind of disclaimer is conveyed by the female voiceover in *Dirt,* when Ye passes judgment on the "childish" behavior of herself and her childhood friends and pays lip service to law and order: "Weidong was correct, . . . all of us acted just like kids back then." On the one hand, we may consider disclaimers like these to be a sure sign of co-optation, a clue as to what went on behind the scenes that may have helped such films pass strict censorship, but even so, it did not happen without years of waiting and numerous cuts and revisions.[81] On the other hand, as material witness to the historical existence of a rebellious spirit that the Sixth Generation held in high regard, disclaimers like these symbolically serve as a tactical indictment of political oppression.

We are now in a better position to reassess Mao's quotation at the beginning of *Dirt.* By emphasizing the eventual triumph of time—"Hope rests on your shoulders"—the film has in effect revoked the tacked-on disclaimer that the young people have outgrown their adolescent rebellion. Their disclaimer works as a tactic of survival in the repressive sociopolitical environment, for they anticipate that their youth will guarantee their future success in accordance with the temporal logic of Mao's quotation—that is, in a final analysis, the world belongs to the young.

TRANSFORMATION: THE QUEST OF THE NEW URBAN GENERATION

Unlike Jones' choice of the word "subculture," Geremie Barmé prefers to use the term "nonofficial culture" to cover a wide range of urban youth culture,

counterculture, and dissident culture, to which rock music and some early Sixth Generation films certainly belong. Since "nonofficial culture can also be spoken of as a parallel or even *parasite* culture . . . it is neither nonofficial nor necessarily antiofficial," and for China's cultural scene of the 1990s "the term *nonmainstream* or *underculture* was more appropriate."[82] As Barmé contends, an "underculture" in postsocialist China cannot be simply oppositional to the "overculture" sponsored by the state, because this is a state "whose gravitational pull is often all too irresistible and that has itself undergone an extraordinary transformation."[83] The result of the combined efforts of censorship and co-optation is the interdependence of the mainstream and the marginal in a distinctively new phase of postsocialism in China: "Both have matured together and used each other, feeding each other's needs and developing ever new coalitions, understandings, and compromises."[84]

By 1999 the government was ready to co-opt the newly "reformed" Sixth Generation. In November 1999 the *Film Art* (Dianying yishu) editorial office organized a critical forum on "young directors," a term judiciously chosen to distance if not dissolve the rebellious connotation of "Sixth Generation." Among the official sponsors were the China Film Association (Zhongguo dianyingjia xiehui), the Beijing-based China Film Group, and Beijing Film Studio. Several directors mentioned earlier and a few first-timers were invited to submit films to the forum. Ah Nian came with *Call Me* (1999), Huo Jianqi with *Postmen in the Mountains* (1998), Li Hong with *Tutor* (1998), Lu Xuechang with *A Lingering Face* (1999), Wang Quan'an with *Lunar Eclipse,* Wang Rui with *Sky Leopards* (1999), Wang Xiaoshuai with *A Dream House,* and Zhang Yang with *Shower* (2000).[85] Zhang Yuan's *Seventeen Years* was originally included on the invitation list, but entering the film at an international film festival without following required procedure probably cost him a last-minute cancellation. Nevertheless, *Seventeen Years* opened in Beijing in January 2000 as scheduled, and the public showing of his films for the first time in China created some anxiety in the Western press.[86]

Technically, several films invited to the Beijing forum belong to a group that was emerging in the late 1990s, and some of them—Zhang Yang, Jin Chen, and Shi Runjiu—graduated from Central Drama Academy.[87] These newcomers do not have the Fifth Generation's burden of historical consciousness, nor do they share the Sixth Generation's indulgence in alienation and narcissism. Ni Zhen sums up the distinctive features of new films as represented by *Spicy Love Soup* (Zhang Yang, 1998) and *A Beautiful New World* (Shi Runjiu, 1999) this way: first, they discard tragic sentiments and embrace an optimistic outlook; second, they emphasize narrative and plot and provide a visual therapy for the troubled life; and third, they prefer conventional camera work, bright colors, and the smooth

flow of images typical of television commercials.[88] Produced by Imar Films, a joint venture managed by American producer Peter Lohre (or Luo Yi in Chinese) and funded in part by Taiwan's Tower Records, Zhang's and Shi's films adopt new strategies in film production, distribution, and exhibition. Their market success is due as much to their creativity as to the new producer-centered model of management.

Lacking a better designation, some young directors favor "city" or "urban" *(chengshi)* as a general term to apply to themselves. In a 2000 interview, Lu Xuechang made it clear that the so-called "Sixth Generation" directors did not have a coherent program, but the commonality among them resides in the city: these directors were born in the city, and they grew up there, so they naturally tell urban stories.[89] Similarly, Guan Hu believes that their generation has an advantage over the Fifth Generation because their urban sensibilities are more "authentic," and their films are more "urbanized."[90] While their repeated claims to authenticity, truthfulness, and objectivity must be subject to further scrutiny (see Chapter 5), the urban focus surely stands out as an initial rallying point for most Sixth Generation directors.

Differences, however, persist between the earlier directors and the newcomers. On the one hand, the newcomers, as represented by Zhang Yang, seem to prefer bright colors, glossy images, famous stars, bittersweet sentiments, and mostly happy endings in the increasingly affluent city. On the other hand, as *So Close to Paradise* suggests, the old-timers still retain individual styles and seek to expose the sinister sides of urban life (kidnapping, rape, murder, prostitution, illegal blood market). In their confrontation of social problems, films like *So Close to Paradise* subtly convey a lingering sense of pessimism reminiscent of the directors' earlier, more rebellious works.

As we have noted, the Sixth Generation has no uniform program so far as their strategies are concerned. In their early phase, the rebellious spirit—embodied in rock music—seemed to rule the scene. Alternatively, they sometimes chose a more subdued version of protest—as exemplified in *The Days* and *Postman*—to express their alienation and disillusionment with the new political-economic regime and their adolescent male subjectivity in crisis. In *Shower,* nostalgia is used as an engaging method to communicate a vision to a larger audience. By the late 1990s, the development of the new market economy had compelled almost all of these marginal or self-marginalized directors to reenter or at least to reconnect with the mainstream. Like Wang Xiaoshuai and Zhang Yuan, He Yi was willing to make *Butterfly Smile* (2001) within the system.

Yet again we see noticeable differences among the group. Where the younger filmmakers like Zhang Yang and Shi Runjiu embrace commercial filmmaking by

producing new social fantasies, directors associated with Beijing Film Studio have sought a compromise route that allows their artistic vision and box-office concerns to coexist. However, nothing is fixed at a time of rapid transformation, and the auteur status is so attractive that Zhang Yang changed his style in *Quitting* (2001), which explores a drug addict's rehabilitation and harks back to the underground-marginal tradition in the first half of the 1990s. Nor is the experimental art film passé yet, as many leading critics in China were convinced by the release of *Lunar Eclipse*, a surprise debut feature that challenges our ability to decode cinematic doublings in a postsocialist urban milieu.[91] The doubling as an effective means of exploring the ever-changing urban milieus is also successfully implemented in *Suzhou River*, an internationally acclaimed film that focuses its attention on Shanghai.[92] It is encouraging that the directors of the New Urban Generation have taken their cameras far beyond Beijing and Shanghai as two dominant spaces of urban imagination.

We need to note two matters here. The first is that the New Urban Generation's search for changing urban images in postsocialist China is not exclusive to this generation. Directors of other groups and generations have projected their own urban visions since the early 1990s. Ning Ying's first two Beijing tales, *For Fun* (1992) and *On the Beat* (1995), for example, exhibit an entirely different aesthetic dimension of urban cinema in China, one that is at once upbeat, humorous, and humane.[93] A latecomer in the Fifth Generation, Xia Gang directed melodramatic tales set in the city, such as *Yesterday's Wine* (1995) and *Life on a Tune* (1997).[94] Even Zhang Yimou directed spirited urban tales like *Keep Cool* (1997), in which he cameos as a migrant junk collector whose labor is for hire in the city. Huang Jianxin, another veteran urban director, released the much-acclaimed *Tell Your Secret* (2000) and *Marriage Certificate* (2001), two dramas of contemporary middle-class life marked by sentimentality. Indeed, the era of postsocialism—especially in the decade after Tiananmen—provided enormous possibilities for both the New Urban Generation and the older directors, and their visions of new cityscapes and new urban desires call for our continued investigation.

We should also note the emergence of an even newer group of talents in the new millennium. Just as the 1999 *Film Art* forum announced the official acceptance of the New Urban Generation, so in 2002 *Contemporary Cinema* (Dangdai dianying), another Beijing-based academic journal, extended the parameters of the new directors to include twenty-one debut features released in 2001 and the first half of 2002. Supported by articles from these new (but not necessarily all young) directors,[95] as well as from leading critics and industry leaders, the *Contemporary Cinema* editorial office declares that the new millennium has witnessed a phenomenon seen only once before in Chinese film history in 1979 when three

generations of directors embarked on filmmaking after a decade of delay during the Cultural Revolution. Like previous works from the New Urban Generation, the new films are mostly low-budget productions averaging RMB 2 million a title. But unlike their predecessors, private companies now produce the majority of the new films (in part because the Film Bureau now permits private companies to finance production without necessarily using studio labels), and many new directors themselves are involved in screenwriting, financing, production, promotion, and distribution.[96]

The willingness to participate in mainstream filmmaking is similarly reflected in the new directors' preference for contemporary urban life as their subject matter. Unlike the early Sixth Generation tales of personal frustration and symbolic rebellion, the new directors address social issues without always compromising their artistic vision, and in some cases they demonstrate a high level of sophistication in making genre films as well. *Roots and Branches* (Yu Zhong, 2001), a tear-jerking melodrama similar to the Xie Jin model, featuring the Hong Kong star Gigi Leung (Liang Yongqi) and the erstwhile rock star Cui Jian as the father figure, ranked number three in the 2001 domestic top ten.[97] *The Missing Gun* (Lu Chuan, 2002), a detective film mixing humor and suspense with Sichuan dialect, won the best debut film at the 2002 Beijing College Students Film Festival. At the same venue, *Spring Subway* (Zhang Yibai, 2002), a relationship film set against rapidly changing urban configurations dominated by subway trains, was voted the audience's favorite.

What happened in the early 2000s is that the New Urban Generation, including those "young" and "new" directors promoted by *Film Art* and *Contemporary Cinema,* has chosen to focus their camera without condescension on everyday life as the primary experiential or emotional realm of ordinary people. Following the success of *A Love of Blueness* (2000), a romantic story mixing suspense with avant-garde elements, Huo Jianqi directed *Life Show* (2002), a sympathetic portrayal of a divorced restaurant owner in a city night market caught between the ruins of her traditional family and the uncertainty of her emotional and financial future. Likewise concentrating on ordinary urbanites, *Cala, My Dog* (Lu Xuechang, 2002) cast Ge You as a worthless factory worker in Beijing who acts as an anti-hero in a pathetic effort to save his pet dog. Consistent with a recent trend toward sentimentality, as illustrated by Huang Jianxin's new urban films and *Together with You* (Chen Kaige, 2002), the New Urban Generation seeks truths or the real in the fast-changing life under postsocialism.

Despite his experimental visual images, Zhang Yibai claims that his *Spring Subway* aims to capture truths in life as well as in emotions: "To be trendy [*shishang*] is not to worship the city or to fetishize skyscrapers, neon lights, pretty

dresses, and luxury cars. . . . Rather, to be trendy is to proceed on the basis of truth."[98] Nonetheless, as Chapter 4 illustrates, truth is increasingly blurred by shifting urban images, and many directors have discovered that they must redouble their efforts at remapping the city in a globalizing China in order to keep their "contemporary consciousness of spatiality . . . creatively open to redefinition and expansion in new directions," as Edward Soja suggests in this chapter's epigraph.

Space of Polylocality

Remapping the City

> The present epoch will perhaps be above all the epoch of space.
> We are in the epoch of simultaneity: we are in the epoch of jux-
> taposition, the epoch of the near and the far, of the side-by-side,
> of the dispersed. We are at a moment . . . when our experience of
> the world is less that of a long life developing through time than
> that of a network that connects points and intersects with its own
> skein.
> —Michel Foucault[1]

To understand what Foucault envisions as the "network that con-
nects points and intersects with its own skein" or the simultaneity of multiple spa-
tialities (see Chapter 1) that structures our experience of the world in the present
epoch—requires an ongoing effort of cognitive mapping or remapping of spaces,
places, and localities around us. This chapter begins with an argument that remap-
ping has become a sheer necessity nowadays in any metropolitan Chinese city, not
the least because hasty, large-scale urban development since the early 1990s has
demolished much of the old cityscape and replaced it with nondescript high-rise
buildings and commercial blocks, rendering printed maps inadequate or irrele-
vant in a matter of months. In this frenzied age of "globalization" (quanqiuhua)—a
magic word sanctioned by China's bureaucracy and mass media—Chinese cin-
ema has participated in various projects of remapping the city, of producing urban
imaginaries that articulate new urban visions, negotiate changing urban values,
and critique problematic urban transformation.

This chapter investigates "cinematic remapping" as a particular mode of urban
imaginary, a mode that combines motion, emotion, and commotion in an inten-
sified, often visceral representation of temporality, spatiality, locality, inequality,
identity, and subjectivity.[2] With an emphasis on moving images—images set in
motion, marked by mobility, and charged with affect—of a local/global dynamic,

my investigation in this chapter differs from Fredric Jameson's remapping of Tai-
pei in terms of postmodernity, Ackbar Abbas' remapping of pre-1997 Hong Kong
in terms of a projected postculture of disappearance, and Dai Jinhua's remapping
of Chinese cinema of the 1990s in terms of postcolonialism.[3] Rather than cogni-
tive mapping conceived at a high level of abstraction, I am interested primarily in
instances of cinematic remapping that favor street-level views over cartographic
surveys, contingent experience over systematic knowledge, and bittersweet local
histoires over a grand-scale global history.

Three theoretical issues related to the global, the national, and the local have
informed my investigation of cinematic remapping in the twenty-first century.
First, we should bear in mind questions Anthony King raised in 1989: "Does [glo-
balization] imply cultural homogenization, cultural synchronization or cultural
proliferation? What does it say about the *direction of cultural flows?* Is it the inter-
action of the local and the global, with the emphasis on the former, or vice versa?"[4]
Even if we grant globalization the status of the dominant in contemporary China
(as the Chinese state is now deeply complicit with transnational capitalism cen-
tered in the West), its homogenizing tendency does not always work wonders at
the level of local culture. Indeed, as Stuart Hall writes of a global mass culture, "the
homogenization is never absolutely complete, and it does not work for complete-
ness."[5] Not surprisingly, urban imaginaries produced in contemporary Chinese
cinema tend to emphasize the local in its interaction with the global, and they
prefer cultural hybridization and "global mélange" to cultural synchronization or
homogenization.[6]

Second, as the foremost Chinese metropolises like Beijing and Shanghai
aspire to the coveted status of *global city,* the national continues to play a vital role
in China's integration into a globalizing world. In response to Saskia Sassen's ques-
tion, "What happens to the relationship between state and city under conditions
of a strong articulation between city and the world economy?"[7] we know with cer-
tainty that the Chinese state has so far maintained its power over the city, and the
national is structured into China's program of globalization as Beijing celebrates
its spectacular success with the 2008 Olympic Games and Shanghai prepares itself
strategically for the 2010 World Exposition, both enterprises blessed with the
influx of global capital. True, in the realms of economy, finance, technology, and
the like, Beijing and Shanghai are increasingly connected with global and global-
izing networks; however, instead of eclipsing the national, the city has remained
an indispensable site where the local enlists the national in negotiating with glo-
balization, while at the same time the national still counts on the local to exploit
cultural symbolism and popular memory.

Third, we must not forget that the local, despite its frequent idealization as the
space of authenticity, appropriation, and resistance, is itself in many ways translocal

(see Chapter 1). The notion of the translocal acknowledges the coexistence of different locals in the same urban area, albeit in different spaces and places; it also means that not all locals are equally indigenous to a locality, thereby leaving room for questions of migration and diaspora. In fact, a recurring motif in Chinese cinema of the new century is precisely the tension of the many forms of translocal or polylocality in the city, a tension drastically complicated by the steady nationwide rural-to-urban migration and by the stringent demands of globalization on a transnational scale.[8] Given such tension-filled circumstances, urban imaginaries in Chinese cinema often foreground the splendid façade of globalization as a mere pretext to show a rapidly shifting urban landscape in which alien economic power reigns supreme—alien, that is, to China's socialist memory—and in which the experiences of local individuals are repeatedly frustrating, fragmented, and fractured as they carry out the seemingly insignificant details of everyday life. What is more, even the "everyday" can no longer function as a fixed local; rather, it constitutes what David Campbell calls "a transversal site of contestations," which occur at various scales, from the local (or translocal) to the national and the global.[9]

Remapping Beijing

IMAGINARIES OF BEIJING IN FILM HISTORY

The first part of this chapter focuses on Beijing as a salient polylocality in contestation. My bracketing of Shanghai in this chapter in part follows Joseph Esherick's call to redirect academic attention beyond Shanghai because Shanghai has dominated research since the early 1990s, especially in modern Chinese history, but likewise in Chinese cinema and urban culture.[10] My concentration on Beijing is also motivated by my interest in the extent to which previously prevailing imaginaries of Beijing as a traditional walled city and a sacrosanct site of China's imperial power and its later socialist enterprises have been transmuted by the forces of globalization and transfigured into new imaginaries of Beijing as a global city wrought with ambivalences and contradictions. Before examining the contemporary attempts at cinematic remapping, however, we should first look back at representative imaginaries of Beijing in film history.

When it comes to China, Western films typically project Orientalist and salvationist fantasies filtered through the imagination of bygone imperialist conquistadors and the vestiges of Cold War ideology. From *Broken Blossoms* (D. W. Griffith, 1919), *The Bitter Tea of General Yen* (Frank Capra, 1933), *The Inn of the Sixth Happiness* (Mark Robson, 1958), and *The Sand Pebbles* (Robert Wise, 1966), to *M. Butterfly* (David Cronenberg, 1993) and *Red Corner* (Jon Avnet, 1997), a tradition of cinematic Orientalism and salvationism is easily traced through American film

history.[11] So first I will briefly discuss three examples from this long history to probe the deep recesses of the widespread Western imaginaries of Beijing.

The first example comes from *Shanghai Express* (Joseph von Sternberg, 1932), a film deliberately contrasting Western "civility" (honesty, etiquette, and romance embodied by a British officer, Doctor Harvey) and Chinese "barbarism" (betrayal, torture, and murder embodied by a Chinese warlord, Chang). In spite of its titular reference, this star vehicle for Marlene Dietrich (as Shanghai Lily, self-acknowledged as the notorious "white flower of China") shows no images of Shanghai's cityscape. Instead, it starts with the railroad journey from Beijing, a city projected as primitive, backward, and vulnerably locked inside its formidable ancient city walls. As the screenplay describes it:

> The Shanghai Express has drawn out of the station and is slowly puffing down the middle of a Chinese street decorated with banners and dragons. We have left modern China behind at the railroad station and are entering a China that is age-old. The street is teeming with ancient traffic. . . . Hucksters cry their wares.[12]

In this chaotic sequence, the express train—the marvel of Western technology— crawls through an overcrowded neighborhood, incredulously led by fleeting pedestrians and a flock of chickens, and then temporarily blocked by a cow calmly nursing a calf right on the tracks. The train's whistles and bells have no impact on the stubborn animals, and it takes the brakeman a long time to clear the tracks. "You're in China now, sir," Chang tells Carmichael, a fellow traveler, "where time and life have no value." Among other things, *Shanghai Express* configures Beijing as a city paralyzed by an agrarian lifestyle, abandoned by historical progress, and utterly indifferent to Western modernity.

The second example comes from the end of *55 Days at Peking* (Nicholas Ray, 1963), in a scene where Empress Dowager Tzu-Hsi concedes that the dynasty is over after the foreign troops have stormed into Beijing and ended the fifty-five-day siege of the international legation during the 1900 Boxer Rebellion. As the eight powers gather their troops outside a Beijing gate tower in preparation for a victory parade, American officer Major Matt Lewis (Charlton Heston) tells his British friend, Sir Arthur Robertson (David Niven) that he has yet to "make a home" for himself. He mounts on horseback and looks at a silently admiring Chinese teenage girl, who beams into a radiant smile when she catches his attention. "Here, take my hand," Major Lewis reaches down to her, and cheerful nondiegetic music starts as the ecstatic girl climbs up and rides behind him. To the upbeat tune of "Yankee Doodle," the American troops march triumphantly through a decorative street arch *(pailou)*. What is noteworthy here is not only the image of military

conquest but also the sense of moral justification: the violence of a foreign invasion in an ancient empire is justified insofar as a token innocent Chinese girl is "rescued" from misery and "adopted" into the American way of life. Ultimately, *55 Days at Peking* imagines Beijing—a synecdoche of China—as an empire in ruins, a collapsed civilization desperately awaiting rescue or salvation from the West.

The extent to which Western filmmakers insisted on reliving the past glory of imperialist conquest at the heights of the Cold War is demonstrated in the production of *55 Days at Peking* in the early 1960s, which ran into financial difficulties from the start. In the name of cinematic realism, a full-scale sixty-acre replication of Beijing of 1900 was built outside Madrid, and thousands of Chinese extras were hired from all over Spain and even from other parts of Western Europe. A number of costumes for the imperial Chinese court were believed to be authentic because they reportedly "were loaned by an illustrious Florentine family which wished to stay anonymous but was able to rescue them from the collapse of the dynasty right after the Boxer rebellion."[13] The use of the word "rescue" in this bit of trivia is particularly revealing, if not shocking, because what in the eyes of the Chinese was the Western conquistadors' barbaric looting of cultural treasures from Chinese imperial palaces in 1900 is unproblematically valorized as "rescue" or salvation in the Western imagination.

The third example comes from *The Last Emperor* (Bernardo Bertolucci, 1987), an epic film shot on location in Beijing's Forbidden City. It centers on the life of Pu Yi, China's last emperor, through a tumultuous century in modern Chinese history. In a scene echoing Major Lewis' offer of his hand to a nameless Chinese girl, Reginald Johnston (Peter O'Toole) comes to the rescue when Pu Yi (John Lone), distressed by his mother's death, climbs up to the top of the palace wall and shouts, "I want to go out!" He slips and falls to the edge of the wall, whereupon Mr. Johnston, aided by several eunuchs who hold each other's hands to form a human chain on top of the wall, reaches out to Pu Yi, "Give me your hand, sir." The following scene shows Pu Yi having an eye examination by a Western optometrist, and his blurred vision is corrected by superior Western technology. These two scenes complicate Bertolucci's professed intention of "seeing things through Chinese eyes" due to his conviction that "every time we [Westerners] try to read a Chinese event with our mental structure, we are wrong."[14] Abundant Orientalist displays notwithstanding, *The Last Emperor* features Johnston as a private English tutor who enlightens Pu Yi with Western knowledge and physically rescues him because he understands the double signification of the gigantic walled city: protection, safety, and security on the one hand, but restriction, imprisonment, and suffocation on the other.

It is true that in the Chinese cultural imagination of the early twentieth century, an ambivalent attitude toward the walled city of Beijing was widely recognized, and the "ancient capital" (*gudu*) loomed largely as a traditional city teeming

with rustic values, personal relationships, leisure, and an articulate disdain for Western values. In contrast, Shanghai was imagined as a metropolis dominated by money and exchange values, frantic activity, and the pursuit of pleasure, diversity, and a Western lifestyle.[15] Because the Chinese film industry was concentrated in Shanghai before 1949, Chinese films of the time tended to privilege Shanghai over Beijing, and Beijing thus functioned as the other to cosmopolitan Shanghai. Instead of rapid-fire montages of the cityscape in films about Shanghai,[16] Chinese filmmakers would entertain a rather nostalgic vision of Beijing as a safeguarded hometown relatively intact from the onslaught of modernity. Rather than a car or tram that zigzags through Shanghai streets, Beijing's preferred images included the teahouse, where the locals are seen indulging in leisurely conversation, and the rickshaw, which brings residents through a maze of *hutong*. As late as the 1980s, and despite decades of socialist propaganda, Chinese filmmakers were still delighted at the sight of the teahouse, the rickshaw, the *hutong*, and the *siheyuan* (a traditional one-storey residential compound typically shared by several families), all of which tend to evoke nostalgia for the lost or disappearing hometown in the popular imagination.

In the era of globalization, the *hutong* and the teahouse decorate an urban landscape of cultural disappearance in Beijing,[17] and the new generation of Chinese filmmakers must negotiate between local, national, and global discourses and practices. Understandably, not all imaginaries of old Beijing are obsolete, for new configurations are frequently developed in counterposition to the old. Cinematic remapping of Beijing thus acknowledges the older imaginaries of Beijing and at the same time endeavors to invent new ones. More than "mapping"—an attempt to formulate a rigidly coordinated mental map of the cityscape, Chinese cinema of the new century seems to have discovered in *drifting* an aesthetically gratifying, cognitively challenging, and psychologically complicating mode of urban imagination. Drifting captures a raw documentary effect, projects fantastic kaleidoscopic images, and enables perpetually changing psychological and emotional flows. In its conceptual indeterminacy and sensory immediacy, drifting facilitates boundary-crossing (local/global), class-commingling (rich/poor), and cultural-mixing (Chinese/foreign), although it may also imply a disturbing deprivation of agency that engenders a crisis of subjectivity. Drifting thus carries with its images unresolved (or perhaps irresolvable) ambivalences and contradictions. As such, it has become a preferred mode of cinematic remapping—remapping both in the sense of rewriting on previous maps and anticipating that it will itself be rewritten shortly—a self-reflexive mode of capturing the fast-changing cityscape in a globalizing world.[18]

I substantiate this conceptualization of drifting as a new mode of cinematic remapping by elaborating on the cultural significance of four means of

transportation in four Chinese films released in the new century: the bicycle in *Beijing Bicycle* (2001), the motorcycle in *Big Shot's Funeral* (2001), the taxi in *I Love Beijing* (Ning Ying, 2001), and the airplane in *The World* (2004). With recourse to drifting through these four means of transportation, Chinese filmmakers reconnect the increasingly divided social realities and interweave a variety of intriguing urban imaginaries in their continuous remapping of Beijing as a city locked in a tension-filled local/global dynamic.[19]

THE BICYCLE: FRUSTRATED DESIRES IN *BEIJING BICYCLE*

An interesting attempt at remapping Beijing takes place at the beginning of *Beijing Bicycle.* Against a giant Beijing map that covers an entire office wall, a group of freshly recruited migrant workers (*mingong,* that is, people who have migrated from rural areas to work in the construction, manufacture, and service sectors in the city) line up and listen to their manager, who orders them to memorize the location of every residential *hutong* and every commercial street in Beijing. Equipped with new haircuts, new uniforms, and new mountain bikes, they are transformed from ragged outsiders (*waidiren*) to acceptable representatives of an express delivery company. After reminding them to maintain the company's good image, the manager announces, "Starting today, you're the modern Rickshaw Boys."

The manager acts as if he were a commander dispatching his troops (migrant workers) to secure a territory (the market) so impeccably delineated on the Beijing map, but significantly, his remapping takes a verbal detour through a reference to "Rickshaw Boy" (Xiangzi), a quintessential Beijing figure made memorable by Lao She's novel *Camel Xiangzi* (Luotuo Xiangzi, 1936).[20] Like Xiangzi, an example of "homo economicus" who works industriously pulling a rented rickshaw along Beijing *hutong* in the early decades of the twentieth century and who calculates his savings obsessively in the hope of buying a rickshaw of his own,[21] Guei (Cui Lin), a migrant worker in *Beijing Bicycle,* keeps a record of his deliveries and anticipates the day when he will have earned enough money to own his mountain bike. As Guei pedals through Beijing's infrastructure, monstrous high-rise buildings and highway bridges tower behind or above him, visually rendering him a human relay in a series of drifting images of the alienating cityscape. Yet the bicycle proves to be an efficient means of transportation for cutting through the notoriously congested traffic in Beijing and delivering business documents to office buildings and hotels furbished to the latest global standards of extravagance (revolving doors, marble floors, and a shiny ceiling that reflects Guei's dumbfounded image upside down).

In addition to featuring the bicycle as a daily necessity in Beijing (or in China in general, for it used to be called "a kingdom of bicycles") and conceptualizing the global business world as site of alienation (where a woman who receives Guei's

delivery symbolically remains faceless), *Beijing Bicycle* introduces a more subtle level of remapping by juxtaposing the local and the translocal in Beijing and by differentiating the bicycle's bifurcated associations with work and leisure.[22] On the day Guei expects to own his mountain bike, it is stolen from outside a public bathhouse, and Guei is fired for his failure to complete his delivery. By sheer persistence, Guei discovers that the stolen bike has been purchased by Jian (Li Bin), a teenage vocational school student who lives in an old neighborhood. After much violence and negotiation on an empty floor of a high-rise building under construction, Guei and Jian agree to settle the disputed ownership by sharing the bicycle on alternate days. Through this shared ownership, the bicycle functions as an intimate connection between two overlapping "ethnoscapes"—migrant workers from the countryside and local residents, both living in an old Beijing neighborhood threatened with imminent demolition.[23]

The juxtaposition of Guei and Jian also foregrounds different associations that the bicycle has in Beijing. For Guei, the bicycle is work-related, and the fact that it is a mountain bike is crucial because it can hold up under its conditions of use (the lack of this is exemplified when Guei uses his friend's old bike and has to abandon it after it falls apart in a busy street). For Jian, the bicycle is associated with leisure, and the mountain bike is an expensive device (for which he paid a hefty price of RMB 500 or around US$60) that is an indispensable attraction when he dates his schoolmate Xiao (Gao Yuanyuan). Parallel to Guei riding in hectic streets en route to delivery, Jian cycles cheerfully with Xiao along a lakeside covered with willow branches. After Xiao's compliment, "It's a nice bike," their romance is about to bloom when Guei recognizes his secret mark on the bike and claims it as his. The bicycle's intimate tie to eroticism works itself out as Xiao leaves the infuriated Jian for Da Huan (Li Shuang), a cool local youngster who handles his bike with acrobatic dexterity, treating it obviously as a phallic symbol.[24] Given this symbolism, the bicycle may also function as what Slavoj Žižek elsewhere conceptualizes as "the link between the capitalist dynamics of surplus-value and the libidinal dynamics of surplus-enjoyment."[25]

Deprived of his surplus enjoyment, Jian seeks revenge at the end of *Beijing Bicycle* by hitting Da Huan on the head with a brick while Da Huan is riding with Jian's ex-girlfriend Xiao, whereupon Da Huan's friends chase Jian and Guei through the labyrinthine *hutong* system, beat them up, and wreck the bike. The film ends with the battered Guei carrying the ruined bike on his shoulder and walking (in slow motion) across a street intersection, where stopped cars and bicyclists witness his unfulfilled dream of earning a decent living in the ruthless urban jungle, just like millions of contemporary migrant workers and like Rickshaw Boy decades before.[26] Regardless of the bicycle's associations with work or leisure, the local or the translocal, Guei's and Jian's desires are frustrated, and their

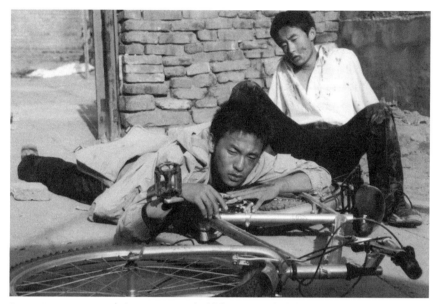

Figure 4.1. *Beijing Bicycle* (2001): one wrecked bike, two crushed dreams (courtesy of Wang Xiaoshuai)

dreams crushed. In remapping Beijing through two parallel stories of drifting, *Beijing Bicycle* paints an alarmingly dystopian cityscape, where the splendid façade of globalization appears alien to the underprivileged local, the familiar *hutong* neighborhoods are threatened with demolition, and teenage romance is evoked with nostalgia as a lingering reminder of a past that is forever gone and a present bound to disappear soon.

THE TAXI: COMPROMISED AGENCY IN *I LOVE BEIJING*

I Love Beijing seems to start where *Beijing Bicycle* ends. A high-angle, extreme long shot presents a panoramic view of a Beijing intersection congested with multidirectional flows of pedestrians, bicycles, cars, and buses. As a few jump cuts get the viewer closer and closer to the congested intersection, the patterns of traffic change and slow, and at times even appear to stop completely. Car radios announcing traffic and other news become audible intermittently. After two minutes, the camera pulls back slightly to emphasize the grand scale and duration of Beijing's traffic nightmare. The feeling of stagnation is intensified by the divorce proceedings of Feng De (Lei Yu)—or Dezi for short—and his wife, which take place right after the credit sequence that occurs during the traffic scene. After Dezi's ex moves out, he is free to hit the streets in his taxi, and his adventures take the viewer in an aimless exploration of a changing Beijing.

Drifting characterizes Dezi's existence: as a taxi driver, he goes around town, drifts in and out of strangers' lives, and connects public and private spaces. His own private affair of divorce is made a public spectacle when his mother slaps his ex as she is leaving with her lover, one of Dezi's fellow taxi drivers. Otherwise considered a public space, his taxi is sometimes used to satisfy his customers' private sexual desires, as when he follows their instructions to circle around the Third Ring Road and ignores the shrill giggles from the unfolding backseat romance. Like Rickshaw Boy from old Beijing, Dezi is for hire from dawn to midnight: his service takes him anywhere his customers dictate, and his life therefore promises no preset direction and little individual agency.

In many of his nocturnal adventures, drifting images of Beijing's cityscape and ethnoscape add to the feelings of alienation, frustration, and restlessness that permeate the film. Dimly lit Tiananmen is stripped of its daytime grandeur; eerie blue lights shine above dozens of high-rise buildings under construction; seemingly nonstop, poorly marked road construction poses danger to both drivers and pedestrians. One rainy night, Dezi brakes abruptly to a shrieking stop as a horde of exhausted migrant workers carrying their baggage walk across a dark street, then disappear out of view like ghosts. The next morning, when Dezi wakes up in his taxi, he is greeted with strange sounds, which he traces to a public park where older people are engaged in various kinds of exercises in a pine grove—one of few rare peaceful scenes in this film—which seems to catch Dezi utterly unprepared.

Such is the transformative power of globalization that traditional leisure life appears out of place to a local taxi driver. Constantly drifting into view are spectacles of high-rise buildings (which recede fast behind the taxi and look distorted from the car windows) and nightclubs (which gather businesspersons, gangsters, party girls, and foreign expatriates). The taxi as a drifting vehicle that connects contrasting ethnoscapes in Beijing is best exemplified in three scenes. In the first, Dezi drives a group of gangsters, weapons in hands, to a suburban residential community to carry out their plan of extortion or revenge; instead of being paid for a day of hard work, Dezi is beaten up outside a nightclub, where the gangsters celebrate their victory. In the second, Dezi picks up two rural passengers as he listens to the radio announcement of the richest men in the world (John Rockefeller and Bill Gates); when he learns that his fare, a father and his toddler son, cannot pay, Dezi kicks them out and orders them to strip off their clothing and stand naked by the roadside. In the third, Dezi drives the host of a popular radio program on dating to an upscale Western-style nightclub, where he is completely lost in a multinational crowd speaking English, French, Italian, and Chinese all at the same time. A former bartender, who was forced to drink bottle after bottle of beer until she threw up, tells Dezi that she is very happy now because she is married

to an Italian. A half-drunk white woman pops her face in front of the camera and asks in accented Mandarin, "Do you like me?" By now this predominantly Euro-American crowd has started to dance, but Dezi is already intoxicated and is thrown out of the nightclub by its uniformed Chinese staff.

These three scenes indicate that, just as the global is by no means homogeneous—for the expatriates at the nightclub come from various nations (many of them probably descendents of bygone conquistadors)—so the local consists of people of different social, educational, and geographic backgrounds. Xiaoxue, Dezi's former girlfriend, has come from the now-bankrupt industrial area in northeast China with the hope of securing a better future in Beijing (as symbolized by a decorated kite she and Dezi once flew in Tiananmen Square), but this transient local who has worked as a waitress is raped and eventually murdered, her dream devastated like that of Guei in *Beijing Bicycle*. Zhao Yun (Tao Hong), on the other hand, is an educated local whose parents teach at a university and who seeks a one-night affair with Dezi, but she volunteers to introduce Guo Shun, a female migrant worker from Hunan province, to Dezi as a serious love interest: in spite of his decent income, a taxi driver is still not eligible for admission to the educated circles by marriage.[27]

What gradually emerges from the cinematic mapping in *I Love Beijing* is a cityscape plagued by class and gender tensions and besieged by disaffection, dislocation, and displacement.[28] Almost all characters are out of place, including those expatriates who feel at home in an alien and alienating capital. The director's docudrama style heightens an acute sense of drifting, contingency, and irrationality in the globalizing city—a sense further substantiated in two cases of "hysteria" near the end of the film. In the first, an unknown party girl wearing a light blue skirt, leather boots, and dark sunglasses hops into Dezi's taxi after exiting the nightclub and starts dancing alone ecstatically when Dezi stops by the roadside, gets out, and falls to the ground in a drunken stupor. In the second, an unknown female passenger in the taxi sings a melancholy song about lost love and asks Dezi candidly, "Did you ever break up before?"

As the film ends with Dezi's silent refusal to answer the question, its English title—"I Love Beijing"—becomes profoundly ironic: at the very least, it is out of place, its enunciator unspecified, and its agency unrecognizable. By comparison, "Summer Heat"—the alternative English title that appears in the Chinese DVD version—better captures the feelings of frustration and restlessness that saturate the film. The Chinese title, *Xiari nuan yangyang,* is largely nondescript, referring to "warm summer days" when people feel comfortable, drowsy, and even apathetic. At least this Chinese title invites the viewer to hop into a hired taxi, disarm him or herself temporarily, and let life drift along in a globalizing city.

THE MOTORCYCLE: PHANTASMAGORIC COMMERCIALISM IN *BIG SHOT'S FUNERAL*

The underlying pessimistic view of globalization in *Beijing Bicycle* and *I Love Beijing* is given a hilarious twist in *Big Shot's Funeral,* where the local not only proves equal to the global but also outsmarts the global on numerous occasions. Yoyo (Ge You), a freelance Beijing cinematographer recently laid off by a state-owned film studio, wears a black-leather jacket and rides his motorcycle to work for Don Tyler (Donald Sutherland), a world-famous Hollywood director who is shooting a remake of *The Last Emperor* in Beijing but who has lost his interest in recycling hackneyed Orientalist motifs, such as gorgeous costumes, obedient servants, and spectacular palaces inside the Forbidden City. A street-smart local, Yoyo receives instructions at the job interview from Lucy (Rosamund Kwan), Tyler's Chinese-American personal assistant: "You are just a pair of eyeballs . . . and the last thing we need is your creativity." The local, according to this division of labor, is restricted to a mechanical, documentary account of what global capital (in this case, Hollywood and its Japanese partners) plans to achieve in China. However, the ingenuity of the local is so vibrant and uncontainable that Tyler entrusts Yoyo to conduct a "comedy funeral" for him, for Tyler is on the verge of lapsing into a coma. The remarkable way Yoyo raises advertising money to fund the funeral preparations prompts the recuperating Tyler to admire Yoyo's "boundless" imagination even more and to consider him a genius, an angel, a messenger from heaven who had brought a perfect movie for him to make.

The motorcycle provides Yoyo with a much more reliable means of transportation than the bicycle: it is motorized, which translates into greater freedom and efficiency; its small size helps Yoyo navigate through Beijing's infamous traffic, taking him wherever he wants to go. He turns this tri-wheel motorcycle around easily to park outside his *hutong* apartment near the Wangfujing Catholic Church (a landmark in Beijing's upscale shopping area); he murmurs the phrase "comedy funeral" while riding his motorcycle in a moment of enlightenment after accompanying Tyler and Lucy on a tour through a Buddhist temple; he even gives Lucy a ride through narrow access lanes inside the Forbidden City, where he later parks his motorcycle next to a BMW X5 and other crew vehicles. Situated at a midpoint between the bicycle and the car, the motorcycle grants Yoyo upward mobility in a globalizing world. Indeed, this upward mobility proves so spectacular that Yoyo is almost beside himself at a high-profile, press-covered auction he has organized where billboard advertisements are going for as high as RMB 1 million apiece. With this newly acquired money and publicity, a motorcycle-riding local gleefully lets himself be swept into the vortex of globalization.

Drifting implies a sense of abandonment, indulgence, and excess. Thanks to Yoyo's ingenuity, the comedy funeral triggers a fierce bidding war for product placement where companies fight over every inch of visible space at the funeral

grounds in front of the most sacred site of the Forbidden City, the Hall of Ancestry. In a tour to inspect the work in progress, Lucy is bombarded with black-and-white balloons promoting a Korean cosmetic product, two billboards for Outback Steakhouse and Cozy Cola (in mimicry of Coca-Cola), and a giant plastic column for Bad News Beer. On the funeral platform, a mannequin of Tyler is covered by disparate products such as contact lenses, a pair of sunglasses, a gold necklace, a tea bag, a shampoo bottle, a gold watch, a sports jacket, and a leather shoe and a sport shoe, one for each foot. The logic of global capitalism is stretched to the extreme in this carnivalesque celebration of all-penetrating advertisements, which saturates the field of vision with drifting images of product logos and replicas.[29]

Through the tropes of indulgence and excess, *Big Shot's Funeral* maps Beijing as an ancient capital transmuted by phantasmagoric commercialism, an emergent cosmopolitan city marked by global mélange (Chinese, English, Japanese), and a frantic business world populated by foreign expatriates and local entrepreneurs (some of whom have gone crazy as is shown in a psychiatric hospital scene) dealing in profitable sectors like finance, real estate, and Internet technology. The film thus maps a local species different from those in *Beijing Bicycle* and *I Love Beijing*: as if pulling himself up by his own bootstraps, Yoyo has ascended into an elite club of Chinese transnational brokers, who work with their foreign partners in securing economic and cultural transactions that typically cross national and regional borders, and for whom the definition of "success" is proudly enunciated in the film by an insane real estate mogul—"Buy the most expensive things, not the highest quality."

A parody of rampant commercialization not just in Beijing but also across China, *Big Shot's Funeral* ultimately exposes its own metacinematic structure.[30] At the end of the psychiatric hospital scene, which seems to be just another scene from Yoyo's real life, Tyler suddenly shouts "cut." The scene is thus revealed to be, in fact, a filmed episode within a film—Tyler's latest project—which is about a Beijing drastically changed since Bertolucci's time there. The metacinema problematizes the agency of the Chinese local engaged in transnational cultural brokerage. After all, Tyler is reinstated as the authoritative behind-the-scene director of this hilarious comedy funeral, and Yoyo is nothing but a puppet-like actor helping to broker lucrative transnational deals to secure funding for the extravagant comedy funeral show. Just as Tyler's producer wants him to make a "happy ending" for the film within the film—so two lovers end up in bed—Yoyo volunteers to conclude his ingenious performance in an intimate scene with Lucy, in which Yoyo clumsily moves around Lucy to find the best position, and the two eventually kiss off screen. This is a romantic union between the local (Yoyo/Beijing) and the transnational (Lucy/Hong Kong), fantasized in a hopelessly clichéd way to better serve the interest of the global (Tyler/Hollywood).[31]

THE AIRPLANE: IMAGINED FREEDOM IN *THE WORLD*

In stark contrast, the motorcycle appears in *Unknown Pleasures* (Jia Zhangke, 2002) as a vehicle that gets unemployed youngsters in China's hinterland practically nowhere. A sense of "trapped freedom" is metaphorically represented by a highway under construction, which ends abruptly, leaving no access to the promised freedom of globalization outside the small town in mountainous Shanxi province.[32] The bicycle also appears in *Unknown Pleasures* as a vehicle for articulating frustrated desires, as in the scene at the deserted bus station where Bin Bin refuses to kiss his college-bound girlfriend because he has been recently diagnosed hepatitis-A positive and is afraid of transmitting the disease to her. This secret illness has disqualified him from enlisting in the military and has thus trapped him in a bankrupt industrial town with no prospects at all. His girlfriend rides the bicycle alone, circles around in the empty waiting hall, and eventually disappears from his vision.

Trapped freedom and frustrated desires are visualized with more existential angst in Jia's next feature, *The World*, his first officially approved aboveground project. This film depicts migrant workers from Shanxi province, who are employed by a Beijing theme park, as helplessly incarcerated prisoners behind the phantasmagoric façade of globalization. The sprawling theme park boasts of over a hundred acres of land and 110 scaled-down replicas of world tourist attractions, such as the Tower Bridge in London, the Leaning Tower of Pisa in Italy, and the Taj Mahal in India. After an extended tracking shot of Tao (Zhao Tao) walking through the backstage rooms in search of a Band-Aid, we get a glimpse of the park's daily evening gala show, and Tao's ride in a slick tour train over the park's greenery and a simulacrum of the Great Pyramid in Egypt. The Chinese characters for the park's slogan show up, "Tour the entire world without ever leaving Beijing," and the slogan is validated by the park's website address <www.worldpark.com>.[33] An extreme long shot presents a panoramic view of the park from a distance, with the Eiffel Tower at the center and a few high-rise buildings on the right. All of a sudden, a garbage picker with a large hat and a heavy bag intrudes into the frame on the middle ground, pauses near the center to face the viewer. After the credit "A film by Jia Zhangke," the garbage picker continues toward the right and walks outside the frame, and then the film's title appears, "The World."

With this title sequence, Jia Zhangke remaps Beijing and globalization with intended irony and contradiction. While some critics may suspect his complicity in promoting the theme park (one of the film's sponsors), Jia nonetheless insists on introducing a disruptive moment into this apparently serene view of suburban Beijing. The garbage picker represents the unspeakable poverty and misery glossed over by the sheer spectacle of globalization: he appears as a nameless eyesore defacing the fabulous image of a globalizing city, but both the actual world

Figure 4.2. *Unknown Pleasures* (2002): motorcycle ride to the middle of nowhere

Figure 4.3. *The World* (2004): an eye sore in the panoramic view of a theme park

and its selective simulacra are simply too far away and utterly irrelevant to his concerns of daily subsistence.

Jia's remapping of Beijing in relation to the unevenly developed world continues with the unexpected visit of Tao's friend from Shanxi, who has obtained a passport and is going to work in Ulan Bator, the capital of Mongolia. The era of globalization has seen massive migrations in multiple directions, both transnational and intranational. Anna, a Russian performer, joins the gala show in the theme park, but after her sponsor takes away her passport, she is forced into prostitution in a modish karaoke parlor. More and more young people migrate from Shanxi to Beijing in search of a better life, and an unsophisticated young migrant worker dies in a construction accident, leaving behind a list of meager amounts of money he owes to his equally low-income friends (presumably due to the company's delayed wage payments). To most of the migrant workers, the ersatz world of the theme park embodies a space of leisure and wealth beyond their imagination. "This is the United States, Manhattan," Tao's boyfriend, Taisheng, who works as a security guard, proudly shows the attractions to his native Shanxi folks—proud because

the replicas include miniatures of the twin towers that no longer exist in New York City. But the newly arrived Shanxi folks are more interested in the salaries of their friends (as low as RMB 210 or US$26 per month) than they are in the symbols of global capitalism.

As a recurring motif in *The World,* the airplane articulates the migrant workers' frustrated desires and imagined freedom. Dressed in a blue uniform, Tao acts as a flight attendant in a grounded passenger airplane, one of the theme park's exhibits. The camera pans through the empty plane and zooms in on Tao and Taisheng embracing each other in the pilot's seat. Not much passion is demonstrated, however, for Tao is worried about tourists coming in. Neither has ever traveled on an airplane, and a text message to Taisheng's cell phone triggers Tao's imagination. "I am bored to death here," says Tao, pleading with Taisheng to take her out of the park. In one of several animated sequences that follow cell phone calls or text messaging, Taisheng is seen in the cockpit as the airplane flies away, passing Tao as she drifts in the air all by herself, still in her flight attendant's uniform, gliding over a bird's-eye view of the cityscape of Beijing. Her imagined flight in the sky serves as a chilling metaphor for the freedom denied to low-income migrant workers in Beijing.

The airplane appears in another scene, when Tao visits her Shanxi folks on the top floor of a high-rise building under construction. Above a concrete jungle of unfinished pillars, a distant airplane quietly flies in the sunset. A shot of two workers admiring this beautiful scene becomes an emphatic comment on the gap between the rich and the poor in a globalizing world. Migrant construction workers risk their lives to build luxury apartments and offices to which they remain strangers (as in *Beijing Bicycle*), just as the theme park workers put on smiling faces and extravagant shows for tourists whom they never know. A group of female flight attendants actually visits the park, and their giggling heightens

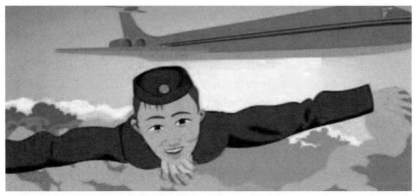

Figure 4.4. *The World* (2004): imagined freedom in an animated sequence of flying

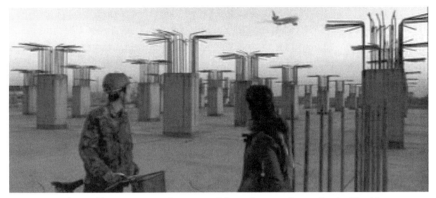

Figure 4.5. *The World* (2004): an airplane viewed from the top of an unfinished building

the difference between the park as a leisure place for them and the park as a work place for underprivileged Shanxi migrants.

In a subtle, yet revealing way, *The World* remaps Beijing as a city of polylocality, a city marked by translocal residents and their differentiated mobilities, a city where the global (represented by miniature replicas) claims the attention of the local, while the local dreams of traveling beyond the national borders. Such imagined freedom is typically set in motion by animated sequences, where a sense of drifting is magically conveyed through images of Tao flying over Beijing's sky, Taisheng riding a horse through a flurry of red rose pedals, a train speeding over the theme park, or a fish swimming freely in the water. The drifting metaphor returns in a pathetic fashion to conclude the film. The two lovers have lost consciousness in a friend's apartment in suburban Beijing due to a gas leak. As they drift out of their coma after they have been carried to the open air, Taisheng asks in a pitch-black frame, "Are we dead?" "No," Tao answers, "this is only the beginning."

POLYLOCALITY IN A GLOBALIZING CITY

Although Jia Zhangke chooses not to identify what kind of beginning is in store for his beloved Shanxi characters helplessly trapped in a simulated global world inside Beijing, it is evident that he intends *The World* to be a critique of globalization's negative impact on the local and the translocal. As he claims, "Most individuals in China are living in an illusory world. . . . Reality is a mess in China. It's total chaos."[34] From its colorful, energetic beginning to its bleak, apocalyptic conclusion, *The World* shows globalization as an alluring façade, an illusory Las Vegas-style gala show, a series of physical and emotional dislocations that altogether promise no bright future to the underprivileged. More than in *Beijing Bicycle* and *I Love Beijing*, *The World*'s map of Beijing, composed out of a drifting mode of

experience, appears not just fragmented; it is virtually destroyed. To a great extent, the characters in all four films analyzed above seem to roam about a Beijing made up out of the physical and emotional detritus left behind by the forces of globalization. This map of ruins forces the characters to make repeated efforts to remap the "ever-changing world"—"*yitian yige shijie,*" as one section title in *The World* announces—with whatever means of transportation is available at a given time (a bicycle, a motorcycle, a taxi, and an animated airplane). In addition, this map of ruins serves as a painful, but timely reminder that such remapping efforts can be only provisional, fragmentary, and perhaps even irrelevant when perceived on a grand scale of the globalizing city.

The recurring pessimistic view of globalization in these four films brings us to questions that Michael Peter Smith asks: "Who has the power to make places of spaces?" Who has the power of place-making? Who produces or changes images of the place? Who consumes particular images and to what effects?[35] In most cases, the power of the local to claim urban spaces as their own places has been radically eroded, and they rarely care to consume the latest images of globalization that keep popping up on the new map of Beijing. What is worse, they either gradually become or remain out of place in the grandiose façade of globalization, as we see projected in *Beijing Bicycle* and *The World.*

The lingering pessimism in these films derives from a sense of powerlessness shared by the local vis-à-vis the national and the global, and this power imbalance motivates many Chinese filmmakers to insist on experiencing the changing world from the perspective of the underprivileged local, which means that they persistently construct a mode of drifting in their cinematic remapping of the city. Instead of offering up an intellectual who investigates the city and enlightens the viewer with a cartographic survey or a panoramic view of Beijing, Chinese filmmakers at present prefer ordinary locals and translocals, who are always left behind by economic development and who must resort to the makeshift tactics of drifting to survive in the changing city. The filmmakers' insistence on the trope of drifting, therefore, can be regarded as a new kind of cinematic remapping that questions the validity of the dominant systems and institutions on the one hand and privileges ambivalence, contradiction, contingence, and improvisation on the other.

What emerges from the drifting cityscapes in Chinese urban cinema is a heightened sense of polylocality (see Chapter 1). Beijing no longer provides a set of fixed imaginaries of imperial or socialist grandeur, peaceful leisure life, and self-content residents; rather, it has become a city caught in the whirlpool of globalization, a city crisscrossed by various spaces, temporalities, emotions, and ideologies, a city of ever-shifting landscapes, ethnoscapes, and mindscapes. This polylocality of Beijing is best exemplified by the virtual world tourist landmarks in *The World,*

but it is more dramatically represented by the mobile localities embodied by millions of migrant workers and more subtly indicated, simultaneously, by the fast-disappearing local landscapes and the increasing visibility of global symbols and transnational agents.

In addition, we must cast our attention to another space of polylocality—that of film production, distribution, and exhibition. Significantly, all four films analyzed in this chapter involved transnational coproductions, and all were distributed abroad by overseas agencies, two of them by the heavyweight Sony Pictures.[36] The consideration of polylocality, therefore, should take into account the local/global dynamics of China, Taiwan, Hong Kong, Japan, France, the United States, and elsewhere. With the steady influx of global capital into Beijing and other places in China, the field of Chinese cinema has been reorganized, revamped, and strategically remapped in the twenty-first century (see Chapter 3). Ultimately, the project of remapping Beijing or any Chinese city should move beyond the textual space of urban imaginaries and extend critical attention to the space of production, circulation, and reception of these imaginaries.

Visualizing Polylocality

DOCUMENTS IN PUBLIC: STRANGERS, JOURNEY, OTHERING

Before investigating the contrast between the domestic and the overseas reception of *Xiao Wu* (1997) in Chapter 5 and the unofficial production and exhibition of independent films and videos in Chapter 6, we will here consider a different type of urban imaginary in Jia Zhangke's place-based project of visualizing polylocality, which is dedicated to economically distressed cities and towns in the hinterland of China, such as Datong (a coal-mining city), Fenyang (Jia's hometown) in Shanxi province, or Fengjie in Chongqing municipality (formerly part of Sichuan province). Like Zhang Yuan before him, Jia occasionally engages in documentary work, and *In Public* (2001) reveals his vision of translocality as typically one of scale-jumping, which connects the local directly to the transnational (see Chapter 1). Produced by a South Korean company, this thirty-one-minute documentary was coordinated by Tsai Ming-liang of Taiwan and John Akomfah of England to form a three-part omnibus DV project, "Three Colors," slated for the Chonju International Film Festival in South Korea. Jia rode the tide of his previous success in feature films, for *In Public* won a top prize at the Marseille International Documentary Film Festival in 2002.[37]

Jia designed this documentary as a study of space, place, and movement, a dispassionate observation of the all-too-familiar "strangers" *(moshengren)* in "public places" *(gonggong changsuo,* the term used as the Chinese title) and their

"indifferent looks" *(wuke naihe de muguang)* captured by a prolonged gaze from an "objective" distance. Intentionally deprived of the specificities of characters, motivations, and words, *In Public* documents random actions and sounds and conveys "ennui and desperation floating in the dirt-filled air."[38] Datong, the documentary's location, is incidentally identified when the camera slowly pans, in a medium shot, over a wall-mounted map in a bus station of the city's public transportation system. Jia's observational style of documenting an apparently generic inland city thus contrasts with his initial excitement in choosing Datong. What attracted him to this "legendary city" plagued by chaos and terror, he admits, were the rumors that people in Datong would soon be forced to relocate, since nonstop mining had exhausted its underground coal, and that residents were indulging in pleasure as if doomsday had arrived. For Jia, Datong was an "especially sexy" city "overflowing with desires," "a sealed-off space full of vivacity."[39]

The contradiction between isolation and vivacity is captured in the bus station, where the public space of the waiting hall outside the ticket booths is divided by two door curtains and transformed into two separate commercial places, the front for playing billiards and the rear for ballroom dancing. Another example of a public space converted to a new function is a small eatery located inside a run-down bus parked on a street side. In Jia's vision, the multiple spatialities and functionalities of such converted public places work like abstract modern art, in which any "spatial supplement" *(kongjian diejia)* points to a deeper layer of meaning.[40]

After watching similar images of public spaces like a railroad station and a roadside bus stop in this documentary, film critic Zhang Yaxuan locates a deeper layer of meaning in Jia's motif of journey, which not only structures *In Public* but also carries intertextual references to Jia's other films.[41] For instance, *Xiao Wu* begins with the titular character's free bus ride, and *Unknown Pleasures* is punctuated with recurring scenes of the waiting room at a station. Indeed, as Jia remarks about *Platform:* "A platform is the place where you start a journey. It's also the place where you finish a journey. That is the fate of characters in this film—they end up where they started."[42] A sense of abortive journey and fated entrapment thus runs through all of Jia's films to date, starting with his debut experimental short feature, *Xiao Shan Going Home* (1995), where the titular character, a migrant worker from Henan province, is trapped in Beijing after failing to secure a train ticket to go home for the Chinese New Year.[43]

If *Xiao Shan Going Home* still specifies a destination (his hometown) for its protagonist's journey, *In Public* presents so many strangers on the move that the viewer is deprived of any chance of following or knowing any particular one. All four principal sites of the documentary—a railroad station, a roadside bus stop, a bus eatery, and a bus station—are public spaces of mobility where strangers come and go on their own respective journeys. Nonetheless, even without knowing them

personally, one can tell these are journeys without destinations, and as such, are no longer meaningful "journeys" but mysterious movements across spaces and places or pure embodiments of self-perpetuated mobility.

"Mobility is a constant in Jia's universe."[44] In its seeming aimlessness, the mobility captured in Jia's documentary approximates the metaphor of drifting discussed above, but here we have a special kind of drifting, one spiced with rhythms, and this rhythmic spatial movement is best embodied in the scene of ballroom dancing. Customers pay to enter the makeshift dance hall in the bus station and practice fashionable Western dances. In tune with popular songs, their rhythmic body movements transform the public space of transit and mobility into an intimate place of private desire and pleasure, and in so doing their bodies become emplaced in translocal linkages to multiple sites associated with musical scores and dance forms originating elsewhere. Mobility here produces a space of "othering," where the encounter with others is made enjoyable through embodied movements, and where individual identities are suspended to ensure anonymity in an urban crowd of others.

Jia and his cinematographer Yu Likwai are praised for their capacity "to encompass, mediate, map, and make expressive any physical space they choose to observe."[45] The bus station-cum-dance hall is one such physical space made expressive of two contradictory spatial strategies in times of modernity, for which concept Bauman draws on Claude Lévis-Strauss. First, motivated by "proteophobia" (fear of strangers), "cognitive spacing" adopts a repressive, "anthropoemic" strategy "aimed at the exile or annihilation of *the others*" and works for spatial separation; second, "aesthetic spacing" employs a seductive, "anthropophagic" strategy "aimed at the suspension or annihilation of *their otherness*."[46] Citing the *flâneur* as a classic example of "proteophilia" (love of strangers) in an earlier phase of modernity, Bauman holds that nowadays consumerism has created a public space where strangers shed their threatening otherness with the assistance of aesthetic distance and where, ethically, being *with* others does not equate being *for* others.[47] *In Public* captures the sense of proteophobia in the enigmatic figure of a gangster-like bald old man, who wears dark sunglasses and sits on a wheelchair decorated with two Mao Zedong amulets. Amidst the off-screen sounds of billiard balls and ballroom music, he remains watchful of strangers going into the dance hall. At times, however, he grins, apparently at the prospect of his brisk business, and a sense of proteophilia is revealed as the camera assumes his point of view and records the facial expressions of the dance-hall customers exiting the curtain-covered doors one by one to resume their interrupted journeys.

Bauman's terms "proteophilia" and "proteophobia" are reminiscent of Yi-Fu Tuan's concept of "topophilia" as "a neologism, useful in that it can be defined broadly to include all of the human being's affective ties with the material

environment."[48] With its emphasis on the journey motif, which by necessity contains mobility and movement and further implies polylocality and multiple spatialities, *In Public* does not develop any strong sense of attachment or invoke any love-fear emotions vis-à-vis public spaces like the bus and railroad stations. Instead, it dwells on enigmas of strangers, journeys, and forms of othering in public spaces. If we accept Setha Low and Neil Smith's definition of public space as "the range of social locations offered by the street, the park, the media, the Internet, the shopping mall, . . . and local neighborhood,"[49] then it becomes clear that while proteophilia and proteophobia may coexist in spaces of transit like the street and the park, topophilia requires certain commitment to a local neighborhood or community, even when it is threatened with imminent ruin, as depicted in Jia's award-winning film *Still Life*.[50]

STILL LIFE OF RUINS: CAPITAL, LABOR, NATURE

Set in the ancient town of Fengjie, *Still Life* is a painterly—and increasingly painful—study of ruins and survival, of the translocal flows of capital and labor, and of immeasurable costs of a mass migration and the irreversible disappearance of nature and a culture specific to a locality. Fengjie can be traced back in history two millennia to the origins of Chinese civilization, and the breathtaking scenery where it was sited along the Yangtze River inspired famous verses from great ancient poets like Li Bai and Du Fu of the Tang dynasty.[51] Yet the fate of Fengjie was sealed forever with a state megaproject, the Three Gorges Dam, which began in 1993 and is scheduled for completion by 2009. It has submerged much of the historic town, displaced 1.4 million people from the flooded area, and dispersed a total of US$25.5 billion on one of the largest industrial projects in human history.[52]

Still Life steers clear of the heated debate about this controversial project and forgoes a melodramatic treatment of the human and natural destruction visible everywhere in the Three Gorges area.[53] Instead, the film calmly unfolds the interplay of capital, labor, and nature in its initial credits sequence, a three-minute-long take of rural passengers on a ferry boat moving against the backdrop of the picturesque Yangtze River. The apt metaphor of the ferry thus begins the tale of two unrelated journeys to Fengjie: while Han Sanming, Jia's cousin and a real-life Shanxi coal miner playing his namesake character, comes to seek his ex-wife and daughter after sixteen years of separation, Shen Hong (Zhao Tao, Jia's muse since *Platform*), is a nurse arriving from Shanxi to find her husband, who has not contacted her for two years. Although sharing the same origin and destination, their journeys end in completely opposite directions: Shen secures her irresponsible husband's agreement for divorce, whereas Han decides to remarry his ex-wife, who was illegally sold to him in Shanxi for RMB 3,000 seventeen years earlier, but who had left him with their daughter for Fengjie after the police set them free.

Monetary values are frequent talking points in *Still Life* as people bargain and compare prices. Before disembarking, Han is dragged to a "magic show" on the ferry, where the trickster boasts of his incredible skills of turning U.S. dollars to Euros and then to RMB banknotes. Contrary to the trickster's flaunting of wealth, Han is too poor to afford even RMB 1 to watch the show. The disparity between poverty as a translocal condition (Shanxi, Fengjie) and prosperity as symbolized by global currencies is further suggested in a dilapidated boarding house, where Han stays for RMB 1.2 per night and where he sees, on a television screen, a Hong Kong gangster (Chow Yun-Fat) burn a counterfeit U.S. dollar bill to light his cigarette in *A Better Tomorrow* (John Woo, 1986).

Not surprisingly, currency, a vehicle of monetary exchange indispensable to mobility and translocality, turns out to be a recurring motif in Jia's films. Either as a symbol of wealth or its lack, currency is structured into Jia's Shanxi trilogy— *Xiao Wu* (an outcast pickpocket), *Platform* (a cash-strapped theater troupe), and *Unknown Pleasures* (a failed bank robbery). But in *Still Life* currency takes on more significance because here, more than elsewhere in his oeuvre to date, Jia pays as much attention to the national scale as to the local or translocal scale of power-geometries.

Two scenes best capture the power and irony embedded in the national currency. First, Han holds up a RMB 10 banknote and compares its printed icon of Kuimen against the actual landscape: the scenery looks alike, except that the water has risen higher against the mountain cliffs. An irony occurs in this scene when Han displays the wrong side of the banknote and sees the benevolent face of Mao Zedong, and this seemingly unintended act unequivocally pits political power against pristine nature. A further irony emerges as Han, deprived of economic power, is placed in the unlikely position of being able to appreciate the beauty of the Three Gorges made memorable by ancient poetry and contemporary tourism. But he does not recognize the national symbol of such natural beauty either in actuality or on the banknote until he is informed by the local demolition workers. In return, Han shows them a RMB 50 banknote, which depicts Shanxi's Hukou Falls, another national symbol of beautiful nature, but the irony remains that, despite the appreciation from others—"It looks very beautiful"—Han is not physically in Hukou to enjoy what his home province has to offer.

The second scene takes place one evening at a rooftop dance venue in the new town overlooking the mountain scenery. Shen is disappointed that her husband, a seedy demolition company boss, is not there as she expected. While she waits with her friend and drinks a glass of red wine, a local tycoon shows up and, to impress his VIP guests, uses a cell phone to order his staff to turn on the garish colored lights that cover a new red arch-shaped bridge over the gorge in a distance. The project has cost him RMB 240 million, the tycoon brags, and the splendid view of

prosperity has realized Chairman Mao's poetic vision of "transforming a natural abyss to a thoroughfare" *(tianqian bian tongtu)*. As hinted by the RMB 10 banknote and a present-day legend, Mao has now been emplaced in the Three Gorges area.[54] To quote Stephanie Donald's argument, "Mao Zedong is a continuing immanence in the mountains, a presence behind the appropriation of rural hinterlands for infrastructure projects to support the urban drift, whilst also central to the dictum of maintaining certain iconic spots of 'national landscape' in the visual lexicon of Chinese society and politics."[55]

The dominance over nature by the combined forces of capital and politics brings us to Lefebvre's sharp observation: "But today nature is drawing away from us. . . . It is becoming impossible to escape the notion that nature is being murdered by 'anti-nature'—by abstraction, by signs and images, by discourse, as also by labor and its products."[56] The Three Gorges Dam is precisely such an example of anti-nature. Nonetheless, I would suggest that labor is only a middle term between capital and nature. In order to conquer or "murder" nature, capital counts on labor to carry out its "modern developmental brutalism."[57] The destructive power of capital materializes in *Still Life* through the physical labor of migrant workers like Han, who risk life and limb to demolish buildings and factories, salvaging bricks, concrete blocks, scrap metals, and wooden doors and windows for resale. The eerie sights of anti-nature haunt what is left of the ancient town of Fengjie, as debris is piled along roadsides and riverbanks, and half-demolished buildings stand precariously, ready to fall down any moment. Time after time, *Still Life* directs the viewer's attention to these sites of ruin, including one out-of-business state-owned factory that visually suggests the ruins of the socialist legacy.[58]

Figure 4.6. *Still Life* (2006): ruins of nature, ruins of emotions

The logic of development makes no distinction between migrant rural workers and former state-employed industrial workers, for both are abandoned by the state and capital to survive on their own in the era of globalization. Just as the sense of futility is intensified every time we hear workers hammering away at the heavy metal structures in the abandoned state factory, so does the sense of irrationality disturb us as workers use axes and hammers to knock down walls and level buildings. Why do they toil in this most primitive way? Where are bulldozers? Where is the heavy machinery we expect to find in the vicinity of the largest engineering project in the world? Typical of Jia's observational style, questions like these are not answered directly in *Still Life*, although the widespread poverty and dirt-cheap labor in the hinterland is too obvious to miss.

Donald is right to assert that *Still Life* is "a critique of the loss of [natural] beauty through the loss of place (through the double destruction of both natural environments and human habitations and communities)."[59] In addition, the film criticizes the loss of local culture as a consequence of development, which we see in the scene where Shen's friend tries to salvage items from an archaeological site, one among countless others that will be lost forever to the rising water. The loss of Fengjie as a community is further demonstrated in the fate of Han's ex-wife, whose house has already been submerged and who has been forced to work as a bonded slave on a boat to pay the RMB 20,000 her brother owes to the senile boat owner. In response to her statement that her life is not as good as it was sixteen years ago when she was married in Shanxi, Han offers to settle the debt with the boat owner in a year when he has earned enough money so that he can remarry his ex-wife.

Still Life ends with a rare sight of translocal solidarity, as Han and a group of migrant workers leave the town in ruins. Demolition jobs in Fengjie are paid around RMB 40–50 a day, whereas a coal miner in Shanxi can earn RMB 200 a day. The sheer difference in polylocal labor values is enough to convince some of Han's fellow workers to journey with him back to Shanxi, even though he warns them of the severe dangers involved in coal mining, as one may not come out alive after one goes down the mine shaft.[60] Nonetheless, eight migrant workers depart with determination. As Han turns around to take another look at the ancient town in ruins, he is dumbfounded to see a tiny human figure walking on a tight rope between two buildings under demolition. Is this a high-wire artist practicing awe-inspiring yet dangerous skills? Is this another magic show (which would harken back to the scene of transforming currencies from Euros to RMB)? Or is this merely a hallucination of Han, or Jia, or indeed viewers like us?

Characteristic of Jia, *Still Life* provides no clue to the meaning of this surreal ending vision, nor does it explain similar surreal moments: when a boy sings a love song out of tune amidst urban ruins and then on a ferry boat; when Shen and

her estranged husband, before agreeing to divorce, dance alone on the riverbank against the backdrop of the newly completed dam, to the tune of a film theme song popular in the 1980s; when, to the bewilderment of both Han and Shen, a UFO flies across the Kuimen scenery, as if surprised by the enormous change taking place in nature; and when, with no one even looking around, an oddly shaped concrete monument suddenly takes off like a rocket.[61] For Jia, these surreal moments function to intensify a haunting sense of mystery in the area, for they prove that after gigantic changes in reality, many surreal elements become part of the real.[62]

As with these surreal moments, the film's title, in both Chinese and English, appears equally enigmatic. "Still Life" sounds like an oxymoron when set against the constant mobility of people and capital in the film, and even nature—the imagined space of eternal stability—cannot hold its ground under the premeditated assault of capital and labor. In comparison, the Chinese title "Sanxia haoren," which literally means "good people in The Three Gorges," seems nostalgic for the good old days forever gone. Indeed, Han's cell phone ring tone is taken from an old song "Bless This Good Person for Life" (Haoren yisheng ping'an), but Han is forced to toil in hazardous conditions, showing his concern not so much with safety (ping'an) as with earning enough money to regain his ex-wife. Jia admits that the Chinese title is inspired by Bertolt Brecht's play, *The Good Person of Sichuan* (*Der Gute Mensch von Sezuan,* 1943; Chinese title *Sichuan haoren*), but Jia's intention is not to dramatize the dilemma of being a good person but to represent the reality of the Three Gorge area—a reality fraught with the ironic, even absurd coexistence of "rationality and irrationality, progressiveness and backwardness, misery and optimism, vitality and repression."[63] Thus intended, the film becomes a cinematic study in "still life" of the unfolding, unsettling interplay of capital, labor, and nature.

A COMPASS OF POLYLOCALITY: BODY, VITALITY, DIGNITY

Still Life demonstrates what Harvey calls "geographical imagination"—the awareness of how lives in one place are affected by the unseen actions of distant strangers elsewhere.[64] As discussed in Chapter 1, this geographical imagination is central to the concept of translocality in a globalizing China. In *Still Life,* Fengjie is linked translocally not only to Shanxi and Guangdong provinces in terms of cheap migrant labor, but also to Shanghai in terms of newfound prosperity and to Beijing in terms of national development. A compass of polylocality thus gradually takes shape. To the east is Shanghai, the emblem of China as a rising economic power and a dreamland for the emerging middle classes; as such, Shanghai becomes the logical destination of Shen, who embarks on a cruise trip down the Yangtze with her new lover and who becomes one of the millions of tourists (including Westerners) arriving each year to consume the beauty of The Three Gorges. To the west

are places like Fengjie, where deficiency, displacement, and decline are epidemic and where able-bodied laborers have migrated or are migrating elsewhere. To the north is Shanxi, evoked as a place of danger and presented in Jia's first trilogy as being equally stagnant and distressed as Fengjie. To the south is Dongguan, a fast-growing area close to Hong Kong where farmland is quickly being turned into industrial complexes and where Han's sixteen-year-old daughter is employed either as a factory worker or a housemaid.[65]

An acute sense of polylocality is likewise present in *Dong* (2006), Jia's feature-length documentary that brings the viewer farther south, transnationally, to Bangkok, Thailand. According to Jia, *Dong,* which documents two related painting projects by Beijing artist Liu Xiaodong, is actually the film that inspired *Still Life*.[66] Apparently taken from the artist's given name, "Dong" means "east," this title is associated less with Shanghai than with the Yangtze itself, which flows east and poetically evokes "sorrow," a dominant structure of feeling in the documentary. Attentive to the microscale of the body on the move and in place, *Dong* succeeds in foregrounding an embodied sense of polylocality.

In accordance with the yin-yang principle, *Dong* explores gender differences in association with directions and localities: the male body, located in the north (Shanxi) and the west (Fengjie), is assigned meanings of strength, sorrow, and death, whereas the female body, relocated to the south (Bangkok), is associated with charm, exoticism, and enigma. The first part is set in Fengjie, where Liu contemplates the same Kuimen scenery on the Yangtze as Han does in *Still Life,* and where similar scenes of riverbank debris, a rundown factory, and building demolition are repeated. Not surprisingly, Han reappears as a migrant worker, and he serves as a model for Liu, together with ten other workers. They pose naked from the waist up amidst the ruins, while Liu directs them to assume certain postures and takes photographs. For Liu, the workers' bodies are expressive and exude raw human vitality. Indeed, Jia's camera captures the beauty of male torsos against the Yangtze landscape rendered vividly in Liu's colorful oil painting.

Nevertheless, the workers' facial expressions and body positions also convey a heightened sense of sorrow behind their apparent blankness. After a shot of a tall building wall being pulled down, some workers emerge from the dust carrying a victim who has been killed in the process, his body covered with a red quilt, a scene similar to one in *Still Life*. Liu looks extremely sad, for the vital male body is susceptible to destruction just the same. Scenes of rainy mountains are followed by Liu's visit to the victim's family. He shows them the pictures he took and offers them gifts, including a backpack with Snow White on the front. While the victim's wife and school-age daughter look on without much emotion, Liu loses his composure and wipes tears from his face. The victim's father comes in, as emotionless as his daughter-in-law and grandchild, and a close-up of his face resembles a

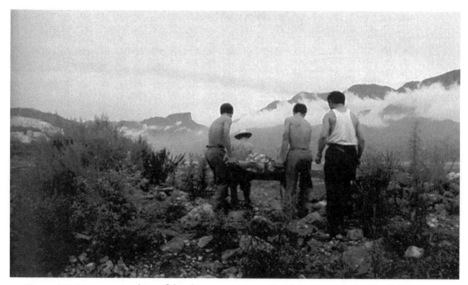

Figure 4.7. Human casualties of development: repeated in *Dong* (2006) and *Still Life* (2006)

famous painting by Luo Zhongli, "Father" (Fuqin, 1980), which is believed to have influenced *Yellow Earth* (1984), an avant-garde film about the resilience of life in a poverty-stricken China. As will be elaborated in Chapter 5, Jia's interest resides in capturing the condition of life in hinterland China. Like Liu, Jia is an intruder in Fengjie, and both men feel helpless to bring any fundamental change to those around them in need. What they can do best, therefore, is to project ideas through painting and filming their bodies.

The second part of *Dong* is set in Bangkok, where Liu works on a painting of eleven young Thai women. Admittedly without much knowledge of Thai custom and culture, Liu relies on close observation of their lovely faces and thinly clad bodies. Contrary to the male bodies set against the natural scenery in Fengjie, the female bodies are positioned inside a large studio, where artificial lighting projects their silhouettes against a white wall. As the camera lingers on the models' faces and bodies, sometimes when they are taking a nap, a sense of voyeurism inevitably creeps in, and it reaches a climax when a pretty model, who has just risen from an attractive reclining posture, is seen in the intimate act of stripping off the costume and putting on her daily dress. Liu's remark on the model's "tropical mannerism" only adds to such voyeurism. When the camera reveals the finished painting, the charm and vitality of the Thai women are unmistakable, as colorful strokes accent the curves of their youthful bodies and their suggestive postures.

Jia attempts to reduce the voyeuristic gaze on the female body by following the models into Bangkok's congested traffic and crowded markets and showing their

impenetrable mystery in public, but such attempts at the same time intensify the documentary's resemblance to exotic ethnotourism. A redeeming moment arrives near the end when Liu is caught on camera in a confessional mood. Art is an unrestricted form of work, enjoyable most of the time, he says, but when moments of anxiety, pain, and sorrow approach, they are invisible, boundless, and overwhelming. Art is not subject to any set criteria, and any work of art is thus incomplete. As for the male and female bodies he paints, Liu admits that he adopts them as means to express his own ideas and to offer some dignity to humankind. Cinematically, this sense of dignity is projected through a couple of blind musicians who are singing in a night market in Bangkok, but ignored by most of the people around, including a family of Western tourists.

Liu's translocal linkage of Fengjie and Bangkok via yin-yang complementality and his projection of differentiated ideas on male and female bodies suggest the intricate imbrication of body and place, gender and space, mobility and unknowability, vitality and vulnerability. To some extent *Dong* dovetails this chapter's epigraph from Foucault: "our experience of the world is less that of a long life developing through time than that of a network that connects points and intersects with its own skein."[67] A pervasive mood of dislocation and disorientation is palpable in all three of Jia's films analyzed above, as if people's ties to places have been irreparably loosened, and their rootlessness has sentenced them to a neverending life of mobility.[68] On a positive note, however, Gilles Deleuze and Félix Guattari celebrate precisely this rootlessness: "We should stop believing in trees, roots, and radicals. They've made us suffer too much"; in lieu of roots, their alternative metaphor of the rhizome stresses movement, variation, and unpredictability.[69] Arguably, the metaphor of rhizome may undermine that of network that Castells constructed (see Chapter 1), because linkages formed by rhizomatous movements may not always develop into a new system of rationality.

As with *Still Life, Dong* is rich in rhizomatous connections that highlight polylocality and intertextuality. Liu's visit to the Chinese diaspora in Bangkok's Chinatown, for example, is meant to convey Jia's impression that Bangkok looks like Hong Kong, a city of overcharged mobility and energy, yet continuously and helplessly weighed down by fatigue.[70] A random television news report about a raging flood in Thailand, furthermore, is evocative of the rising water that has consumed most of Fengjie. In a wild rhizomatous move, Liu reflects on how the aesthetics of fragmentation or "broken pieces" *(canpian)* from the North Qi and North Wei dynasties may have influenced his painting: this aesthetic runs in the Chinese blood and carries strong visual impact, he claims. In both *Dong* and *Still Life,* the aesthetics of fragmentation is best embodied in the half-demolished buildings, which announce the end of traditional rooted lives and the arrival of a precarious new era of mobility and translocality.

Dong provides a compass of polylocality by documenting two complementary projects in otherwise unrelated urban locales, Fengjie and Bangkok, and the projects are further unified by the artist's meditation on male and female bodies. The artist's ideas of vitality and dignity are expressed through layers of embodiment: from the models' bodies to Liu's painting to Jia's documentary. An unsettling note is evident near the end of *Dong;* in sharp contrast to the eloquent painter who projects vitality and dignity onto the human body, the models/workers remain largely nameless and voiceless in the film. A structure of asymmetrical power in representation is thus exposed, and it constitutes a serious challenge to Chinese independent filmmakers, as we shall see in Chapter 5.

Space of Subjectivity

Independent Documentary

A space . . . is neither a container for always-already constituted
identities nor a completed closure of holism. This is a space of
loose ends and missing links. For the future to be open, space must
be open too.
—Doreen Massey[1]

Marginality constitutes a set of new tactics that permit inde-
pendent Chinese filmmakers to open up new spaces for tackling social issues,
exploring individual subjectivities, and envisioning different futures. Since the
early 1990s, independent film- and videomaking has quickly developed as a new
player in Chinese cultural production—a player who is enthusiastically welcomed
at international film festivals overseas but who has been systematically ignored
and occasionally banned by Chinese state censorship.[2] In contrast to the regular
Western press coverage over the past decade, relatively little English scholarship
focused on Chinese independent filmmakers before 2006, and much less on their
insistent claims to truth.[3] Two points deserve our attention right away. First, we
should not blindly follow Western media reports, which tend to emphasize politics
and ideology and to accept the truth claims of independent directors at face value.
Second, we must distinguish our position as media critics, whose mission is to
scrutinize the objects of our investigation, from that of promoters of alternative
media practices, whose moral responsibility might make us reluctant to criticize
even obvious weaknesses in independent productions. It is in the spirit of con-
structive criticism that I offer the following thoughts on subjectivity and truth in
Chinese independent film and video.

In May 2002, *My Camera Doesn't Lie* (Wode sheyingji bu sahuang), a book
bearing a manifesto-like title, appeared in China. Designed to be the "document of
the avant-garde filmmakers born in 1961–1970" (the book's subtitle), this volume

offers biographic information on, interviews with, and directorial notes from
eight male representatives—Zhang Ming, Jiang Wen, Zhang Yuan, Wang Chao,
Lu Xuechang, Lou Ye, Wang Xiaoshuai, and Jia Zhangke.[4] Around the same time,
Solveig Klassen and Katharina Schneidere-Roos, two female European scholars
based in Beijing, were busy completing their independent documentary video,
also entitled *My Camera Doesn't Lie* (2002), which includes discussions of and
film clips from the above-mentioned representatives as well as numerous other
Chinese independents, such as women directors Li Yu (*Fish and Elephant,* 2001)
and Emmy Tang (Tang Xiaobai, *Conjugation,* 2001).[5] During 2003, the documen-
tary toured international film festivals in Berlin, Hong Kong, Singapore, and Los
Angeles.

The shared title of the book and the documentary provides an ideal entry
point for our investigation. By critically analyzing the statement "my camera
doesn't lie," I want to explore not merely truth claims but also the dilemma of
self-positioning and audience interaction in Chinese independent film- and vid-
eomaking. If "my camera" (that is, that of the avant-garde generation) does not
lie, are there cameras that do? Is there any basis on which one can claim that the
camera never lies? Is there validity in the persistent truth claims from this genera-
tion for almost twenty years now? For whom (auteur, audience, authority) does a
film appear true or real? What modalities of truth are documented or developed?
How does the director's subjectivity infiltrate, negotiate, or enhance the perception
and representation of the real? And where do we situate the audience (domestic
as well as international) in such a reproduction of truth or reality? To what extent
do independent production and overseas investment and distribution affect the
reception of these independent films and videos as documents of truth? What are
the channels and platforms of their receptions? Finally, how do we reconcile the
politics of such unusual circulation of the truths and poetics of independent film-
and videomaking in contemporary China? These are among the pressing ques-
tions I plan to investigate. I concentrate on three key issues—truth, subjectivity,
and audience—by attending not so much to the visual images (for that purpose,
see Chapter 6) as to the discursive materials, in particular the ambivalences and
contradictions in recent directorial pronouncements.

Subjectivity, Truth, Audience

THE POLITICS OF DIFFERENTIATION: WHOSE CAMERAS LIE?

After the appearance of the book and the documentary bearing the same title,
"My Camera Doesn't Lie" may be taken as a statement of truth behind which the

avant-garde or Sixth Generation would like to rally. Independent directors were already making similar claims to truth, reality, and objectivity in the early 1990s. For instance, Zhang Yuan stated, "I make films because I am concerned about social issues and social realities. . . . I don't like being subjective, and I want my films to be objective. It's objectivity that'll empower me."[6]

Like Zhang Yuan, many independent directors perceived the Fifth Generation and its imitators, who had been busy reinventing national myths and legends since the late 1980s, as their first target: these were the artists whose cameras presumably lie.[7] Before shooting his debut feature *Rainclouds over Wushan,* which is set in a Yangtze River town, Zhang Ming was fed up with the yellow earth, sorghum fields, waist drums, red cloth, bandits, landlords, and the like on the Chinese screen; he lamented the lack of a "sense of reality" *(xianshi gan)* in Chinese film-making.[8] Jia Zhangke, who had quickly replaced Zhang Yuan as the public icon of defiant independents after Zhang emerged aboveground in the late 1990s, was similarly indignant at all those "lies" *(huanghua)* he found on screen that obscured the contemporary condition of a great many people. Jia's indignation points to the second—and more politically sensitive—target for independent directors: "Remembering history is no longer the exclusive right *(tequan)* of the government. As an ordinary intellectual, I firmly believe that our culture should be teeming with unofficial memories *(minjian de jiyi)*."[9]

Jia's notion of *minjian,* which means "unofficial," "popular," and "folk" (as in "folk art," or *minjian yishu*), reveals inherent differences among the avant-garde generation. Apart from their reputation as "unofficial" (working outside the state system) and "subversive" (challenging conventional wisdom), independent directors themselves differ considerably in artistic vision and social orientation. On the one hand, Jia's implicit argument is that, as "ordinary intellectuals" (as differentiated from their official and semiofficial counterparts), independent directors must accept the social obligation of representing unofficial memories in addition to, if not in lieu of, projecting their own artistic vision; consequently, he was intending his second feature, *Platform* as such a cinematic rendition of unofficial history, to be accomplished through "personal memories" *(geren de jiyi).*[10] On the other hand, when the term "Sixth Generation" was first coined in the early 1990s to designate the "underground" or "outlawed" feature productions from Zhang Yuan, Wang Xiaoshuai, and He Yi,[11] the emphasis was placed on their rebellious, almost antisocial spirit and their decisive break—in terms of style and subject matter—from the much-celebrated tradition of the Fifth Generation. By renouncing cultural myths and national identity, these young directors announced the arrival of "personal filmmaking" *(geren dianying),* and as a consequence they were sometimes designated as the "newborn generation" *(xinsheng dai).*[12]

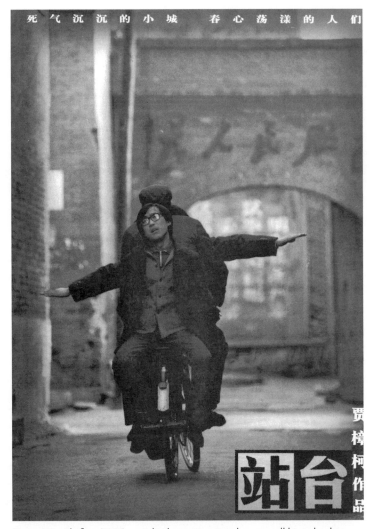

Figure 5.1. *Platform* (2000): socialist legacy imprinted on a small hinterland town

It appears that the naming of this new generation has been problematic both in China and overseas.[13] "Newborn generation" and "Sixth Generation" refer to the directors' ages and the period of their emergence in Chinese film history, but "avant-garde" and "personal" stress their artistic or stylistic character. For political reasons, most young directors refuse the term "underground" and prefer "independent." In my view, "independent" best describes the alternative modes of production and circulation of their works: if they are not entirely independent of state

institutions (for nominal affiliation is required in some cases), they are at least independent of official ideology. Their independent status, accordingly, is defined not in relation to the private sources of their funding (increasingly from overseas, which means they are financially dependent to varying degrees) but with reference to their lack or disregard of approval by the government.[14]

As a result of their preferred "personal" standing, critics have discerned a kind of "zero degree writing" *(lingdu xiezuo)* or a "nonpolitical" type of "automatic writing" *(zidong shuxie)* by means of which independent directors resolutely refuse to be messengers of the dominant ideology.[15] Nonetheless, since their apparently nonpolitical stance was initially defined in counterpoint to the official ideology and mainstream discourses of nationalism and heroism, Chinese independent film and video cannot help but become political once they enter the realms of production and circulation, as is illustrated by Zhang Yuan's films from the early to mid-1990s (see Chapter 3). Furthermore, the technology of the camera itself does not permit "zero degree writing" because, once produced, all moving images are loaded with textual, intertextual, subtextual, and contextual meanings that may or may not match the producer's original intentions.

THE PERCEPTION OF TRUTH: CAMERA, REALITY, SUBJECTIVITY

We should take a moment to consider whether the camera can lie, and, if it does, what motivates Chinese independent directors to hold on to an apparently unsustainable (or even self-defeating) claim to truth. Theoretically speaking, the sheer possibility—indeed, an impassioned accusation—that official and Fifth Generation filmmaking has produced "lies" on screen already proves that the camera, as a technological device, can and does lie. What invites further scrutiny, then, is not whether the ontological nature of the camera precludes it from being used as an instrument to produce lies, but the claim of independent directors that they have directed their cameras at what they perceive—subjectively, I must add—as truth or reality.

Contrary to Zhang Yuan's claim, I contend that "objectivity" is rarely the overriding concern for most independent directors; rather, their desire to reclaim the space of subjectivity is that which has motivated their disassociation from or competition with official and commercial filmmakers in the representation of the real. This is why Jiang Wen, the director of the acclaimed feature *In the Heat of the Sun* (1994), declares that the more subjective a director is, the better the film becomes, because "everything is subjective, and *objectivity resides in subjectivity.*"[16] Zhang Ming's preference for subjectivity is equally strong when he asserts that, although "truth" *(zhenshi)* is the weapon that each new generation of directors uses to blaze a new path for themselves, he does not want the kind of truth that is as authentic

as life itself. "Who," he asserts, "has ever obtained the truth? Truth itself never exists in a work of art. What we have are the author's vivid imagination, his attitude, taste, sensibility, and personality, as well as the extent to which you as audience identify with all these items."[17] Zhang Ming's perception of truth is significant because he acknowledges not only the importance of the artist's subjectivity but also the necessity of the audience's identification with—or at least appreciation of—the author's perception. As recently as 2007, Jia Zhangke reiterates that it is very difficult to distinguish or evaluate "truth" itself, and what is important to a film is its "rendition of the perception of truth" (chenxian zhenshi gan): "The perception of truth may not always come from direct capturing, for it may possibly come from the subjective imagination [zhuguan xiangxiang]."[18]

It is worth observing that independent directors, for all their claims to truth and reality, tend to avoid the term "realism" (either xianshi zhuyi or xieshi zhuyi), although "documentary" (jishi) is used from time to time, especially in connection with the much-acclaimed "documentary style" (jishi fengge). The absence of references to realism is understandable in postsocialist China because in its variant forms (such as "socialist realism" and "revolutionary realism"), realism has been endorsed officially for decades as the primary, politically correct method of producing literature and art in China. An overloaded concept, realism has become formulaic, prescriptive, and representative of an authoritarian tradition that has alienated and infuriated independent directors.[19]

Although the majority of independent directors rarely show serious interest in theoretical issues, we can still draw parallels between their productions and cinematic realism in film history. André Bazin's discussion of Italian neorealism, for instance, is quite illuminating. According to Bazin, neorealism calls upon actors "to be" rather than "to act" (hence, neorealistic films seek nonprofessional or at least nontheatrical acting); it prefers an open, natural setting (hence, nonspectacular images) and respects the actual qualities and duration of the event (hence, fixed-frame long takes); and it leaves fragments and gaps in the narrative (hence, not plot-driven) in the conviction that "the film must never add anything to the existing reality . . . [and] we do not know everything that happens to others."[20]

What Jia Zhangke seeks to achieve in Xiao Wu corresponds to much of what Bazin theorizes about neorealism. In Jia's case, an objective rendition of external reality is merely a part of the picture; what really counts is his subjective perception of the real "condition of life" (shenghuo zhuangkuang) in his hometown, Fenyang.[21] Subjective perceptions such as Jia's have produced what Zhang Ming calls a special "point of view" (shidian), something that distinguishes the "new films" of his generation from the "old films" of the previous generations:

We no longer value Balzac's type of omniscient point of view. We cannot see nor can we know everything. We are not the spokespersons of the nation. The age of the grand panoramic film is over. As ordinary people, we see from the inside of human hearts, adopt a concrete human point of view, and accept individual personality (good or bad) and all its limitations—this kind of truthfulness [*zhenshixing*] is hard to conceal.[22]

This personal—which is necessarily subjective—point of view has empowered Zhang Ming to capture, in *Rainclouds over Wushan* at least, the "mode of life" *(shengming zhuangtai)* characteristic of Wushan, his riverside hometown in Sichuan province, perceived as "a kind of truthful existence *(zhenshi cunzai)* that escapes the naked eye but can be sensed spiritually."[23] Not surprisingly, a sympathetic critic maintains that a similar point of view has enabled "truth" to appear in a new light in He Yi's feature *Postman* (1995), reputedly a "genuine, excellent 'personal film' [*geren dianying*]" that offers us "a naked soul" through the inquisitive camera's slow movements.[24]

I repeatedly refer to the emphasis independent directors place on their points of view regarding certain conditions or modes of life because, deep in their minds, truth pertains not so much to external reality (such as the physical landscape) as it does to their subjective perceptions of some transcendent entity (such as the soul or the spirit, as hinted above) beyond or behind the visual or visible realm. The question that obsesses them most, therefore, is not "Does my camera lie?" but "How can my camera capture what I perceive as truthful?" In this sense, styles, subjects, and subject matter become instrumental in their works as modalities of truth, as vehicles that facilitate a two-way communication between their subjective perception and external reality.

MODALITIES OF TRUTH: ALTERNATIVE STYLES AND SENSITIVE SUBJECTS

In a preface to the book *My Camera Doesn't Lie,* Tony Rayns enumerates the stylistic innovations of the independent directors in an exaggerated manner. First, he claims that China did not have the genre "documentary" in a strict sense until people like Wu Wenguang and Duan Jinchuan took up documentary methods and that Zhang Yuan and Wang Xiaoshuai "might be the first" Chinese filmmakers to interweave fictional and documentary episodes together.[25] Second, in pursuit of "street realism," independent directors are said to have succeeded in producing a straightforward presentation of reality without dramatic, stylistic, or manipulative filtering, and Jia Zhangke is credited for his "groundbreaking" use of the fixed-frame long take that minimizes the director's influence on the cast and the surroundings. Third, thanks to improvisation, Rayns believes that Chinese film has

finally broken away from the category of "literary art" because a film like *Mr. Zhao* (1998) may proceed without a written screenplay,[26] and the structure of a feature film like *Beijing Bastards* did not come into place until postproduction. Fourth, formal fractures have become integral to the works of Wang Xiaoshuai, Lou Ye, and He Yi, all of whom have resorted to fragmented narrative, disproportional composition, and interrupted sound effects to subvert conventional film forms. Finally, an ontology of the image has been established on the Chinese screen because independent directors prefer their images to be signifiers (that is, pure visual images) rather than signs for the signified (that is, coded with meanings deduced from a given framework).[27]

Regrettably, Rayns' enumeration does little to confirm the validity of independent directors' truth claims because many of the "innovations" he lists were implemented long before the 1990s. For instance, documentary footage was integrated into leftist films in the early 1930s—an era Zhang Yuan appreciates for its dynamic energy, innovative styles, and emotional impact.[28] The so-called "long-take aesthetics" existed in Fei Mu's work of the late 1940s and has been the trademark of Hou Hsiao-hsien, a leading contemporary auteur from Taiwan admired by Jia Zhangke and other independent directors.[29]

If we disregard Rayns' exaggerated "firsts" and "breakthroughs," we can see that improvisation, nondramatic plot, and fragmented narrative and images do indeed offer alternative stylistic choices for independent directors in their rendition of truthfulness. Other options, such as a natural setting and nonprofessional acting, have also been fruitfully explored. For Zhang Yuan, the first step toward truthfulness is to draw inspiration directly from "real people and real events" *(zhenren zhenshi),* as he did with his debut feature, *Mama,* which cast a real-life autistic boy and his agonized mother; the second step was to let real people (nonprofessionals) play themselves, which he did when he asked an alcoholic family to participate in his docudrama *Sons.* A fellow student who had started working on *Mama* before Zhang Yuan took over the project, Wang Xiaoshuai cast a real-life artist couple (Liu Xiaodong and Yu Hong) in *The Days* and shot *Frozen,* a fictional recreation of the shocking suicide of Qi Lei, a Beijing performance artist, as if it were a documentary.[30]

The international success of Zhang's and Wang's early films soon inspired imitations. Just as Wang Guangli went further by adding Shanghainese dialect to the formula of real people playing themselves in his feature *Go for Broke* (2000), Zhang Yang asked Jia Hongsheng to play himself as a drug addict struggling to rehabilitate himself with his parents' help in a feature film, *Quitting* (2001). Significantly, such a pursuit of "documentary styles" *(jilu de fengge)* did not prevent Zhang Yuan from experimenting with "theatricalization" *(xijuhua)* in his feature, *East Palace,*

West Palace (1996).[31] This case reveals that what sustains the truth claims of independent directors may have as much to do with alternative film styles, marginal subjects, and sensitive subject matter as with their subjective perceptions.

A common characteristic of independent directors in the 1990s is their dedication to exploring the marginal—marginal people and their marginalized life. Just as Zhang Yuan focuses his camera on the handicapped, rock musicians, alcoholics, gays, and prisoners in his features, Wu Wenguang recorded the despondent life of a group of provincial artists who pursue their elusive dreams in *Bumming in Beijing: The Last Dreamers* (1990) and a group of traveling performers who struggle to make a living in *Jiang Hu: Life on the Road* (1999), both full-length documentaries. Other marginal subjects quickly followed, in particular prostitutes, gays, lesbians, and bisexuals, as well as the newly unemployed *(xiagang)* and migrant workers in the city.[32]

Admittedly, the lives of these marginal subjects, who have otherwise remained voiceless and powerless, constitute politically sensitive subject matter in the contemporary Chinese media. Such subject matter is sensitive not because it cannot be addressed (for the official and semiofficial media have covered some of them regularly) but because its coverage requires an unwavering alignment with the official line of interpretation. Since official interpretations of such subject matter are judged nothing but "lies," independent directors therefore present their reinterpretations as real and truthful. Interestingly, precisely because of censorship issues in China, Chinese independent productions are treated favorably at international film festivals as daring revelations of otherwise "hidden" truths and realities (see Chapter 6).

However, just as the ontology of the camera does not confirm any claim to reality, the mere treatment of sensitive subject matter and real subjects does not validate truth in a given independent work. Apart from alternative styles and sensitive subjects, what further sustains the claim "my camera doesn't lie" is the decision by most independent directors to "see" from the otherwise unfamiliar point of view of "ordinary" people (the adjective emphasized both by Jia Zhangke and Zhang Ming) and for the filmmakers to resist the feeling that they are intellectually superior to their subjects. This is why Wang Chao intended his debut feature *The Orphan of Anyang* (2001) to be a testimony to "certain modes of life" of the underprivileged (such as unemployed workers, prostitutes, gangsters). Wang's justification of his documentary-like, minimalist presentation of miserable subjects is worth quoting: "What right do you have to arrange plots for them? What right do you have to script dialogue for them? What right do you have to declare their salvation as your theme? . . . And what right do you have to assert your moralist stance?"[33]

Figure 5.2. *The Orphan of Anyang* (2001): a makeshift "happy" family sleeping together

THE DILEMMA OF SELF-POSITIONING: AUTEUR, AUTHORITY, AMATEUR

Wang Chao's emotionally charged questions bring us to the dilemma of self-positioning among independent directors. After renouncing their preassigned role as the "spokespersons" of the nation and the Party (as articulated by Zhang Ming), they inevitably confront the question of whether they, as "auteurs," are speaking for "ordinary people" *(putongren)*—a new term to be distinguished from "people" *(renmin)*, an official ideological construct as in "serve the people." Wang Chao seems to suggest that they do not have the right to speak for the underprivileged, but the way he voices their concerns about daily survival—albeit in a fictional film—squarely places him in a position to speak, if not for, at least on behalf of, them. Wang's dilemma is unavoidable; even though he tries to script his characters in many "speechless" or silent scenes, as a whole *The Orphan of Anyang* gives voice to the otherwise voiceless.

Wang Chao's case is not unique. In the second half of the 1990s, Wu Wenguang also experienced the dilemma of repositioning himself and went so far as to dismiss his earlier documentaries about marginal artists as "junk" *(feipin)* or "trash" *(laji)*.[34] While working on *Jiang Hu*, Wu lived with performers in a song-and-dance troupe traveling among rural towns and small cities, and he arrived at this vision of self-positionality: "You scrutinized yourself and discovered that you no longer belonged to any group, not to the stage nor to the audience—you belong to yourself."[35] Wu thus clarifies the positionality that authorizes his call for "returning to oneself" *(huidao zishen):* his new position is not an official position (government), not a popular or folk position *(minjian)*, not a people's position *(renmin)*, not an intellectual's position (enlightenment), not an underground position (marginality), nor even an oppositional position (rebellion), but simply an individual's position—"I would speak of *myself rather than my position.*"[36]

Here, Wu represents one extreme position for independent directors: as if fed up with all responsibilities, the auteur chooses to retreat into the safe haven of subjectivity and remove him- or herself from all social obligations. This new position of speaking simply of oneself is definitely not identical to Wang Chao's position of not speaking for the underprivileged subjects and of their salvation. Yet Wu faces a similar dilemma in that his *Jiang Hu* cannot help but speak for the migrant performers, even though his way of speaking is to provide a documentary context in which they speak to and for themselves on camera and in print.[37]

Contrary to Wu, who has settled for the individual in his new self-positioning (with which Zhang Ming would most likely concur), Jia Zhangke suspects that the concept of "personal film" is misleading in spite of its manifesto-like rebellion against the state system. After all, Jia reasons, film requires *collective* work. In order to get rid of any lingering sense of superiority that many directors have acquired through their formal training in China, Jia has chosen to advocate the notion of "amateur filmmaking" *(yeyu dianying)*.[38] In an attempt to reclaim the right of filmmaking for the majority, Jia promotes "amateurism" *(yeyuxing)* as a kind of avant-gardism supportive of the freedom of expression and democratization of filmmaking in contemporary China.[39]

What does such amateurism entail? Other than anticipating a more egalitarian field of film- and videomaking, which is now feasible in the age of personal DV (digital video), does amateurism mean an endless proliferation of the by-now formulaic "documentary methods" (such as extreme long takes and shaky handheld cameras) or of the equally formulaic construction of symbolic rebellion by way of staging subcultural rock music?[40] Or does amateurism look forward to a new stage of diverse artistic styles? With respect to the second possibility, Duan Jinchuan warns us against a facile celebration of an age of insubstantial amateurism and diagnoses a persistent problem in China—"Film lacks artistic power as it has become more and more amateur, more and more nonprofessional, and therefore less and less significant."[41]

Again, the differences between Duan Jinchuan and Jia Zhangke as well as Wu Wenguang and Wang Chao further highlight the dilemma of self-positioning among independent directors. Nonetheless, most of them would probably agree with Jia that Chinese independent film- and videomaking must move past the current "stage of slogans" and strive to produce high-quality works of art that will stand the test of time.[42]

THE QUESTION OF AUDIENCE: DISMISSED, DESIRED, AND DISPERSED

The dilemma, in which Wang Chao and Wu Wenguang found themselves, simultaneously distanced from a moralist stance and engaged in speaking for marginal people, is compounded by a number of related problems. Do their works speak to

their subjects? If so, in what condition do they reach their intended audience and what effect does their communication generate? If not, how do they convey their perceptions of reality to others? Indeed, how can they convince their audience that their works are truthful representations of the real? Like it or not, the question of audience pops up on these directors' radar screen, but its flickering image points to an uneasy relationship between artist and audience.

Understandably, independent directors each position themselves differently toward the audience. In an idealistic fashion, Cui Zi'en speculates thus on "the first audience": in a society where the audience has been worshipped as a "god," Cui's resistance to binary oppositions has motivated him to place the author in the audience's position—an author cannot help but watch his or her own work in the audience's place.[43] But if the audience is understood as a "fictive construct" of the market, Cui declares that he "despises" this audience because he does not want his creative freedom to be restricted by commercial considerations.[44] However, no matter how Cui reimagines the audience, as a concept and in reality, the audience undeniably exists vis-à-vis the author and the text.

In contrast to Cui's position, several independent directors do not hide their desire for an audience. Zhang Ming acknowledged in 1996 that subconsciously the goal most new directors desperately wanted to achieve was to get an audience—at least a "respectable audience"—to see and discuss their films; as he puts it succinctly, "You are successful as long as you find your own audience."[45] To tone down Zhang's implicit elitist stance, Lu Xuechang states in a more defensive manner that he has not forgotten the "ordinary audience" and that he felt terribly dejected when a viewer who looked like a worker expressed his confusion after watching *The Making of Steel* in a theater.[46] Among independent documentarists, Jiang Yue argues that since they are making videos now, they necessarily hope to have audiences right away rather than to have to wait for the future.[47] Surprisingly, even Zhang Yuan, a figure of absolute defiance in the early 1990s, later admitted that he had struggled for years to communicate with more audiences (in particular, domestic audiences) and that he had succeeded in this goal only after directing *Seventeen Years,* his first aboveground feature released commercially in China.[48]

Two questions remain, though: where are the audiences, and who are they? Historically, the audience for independent Chinese film and video has been dispersed all over, especially outside China in Europe and North America. Dai Jinhua, who questioned the existence of the Sixth Generation back in 1994, made a telling observation: "News about 'China's underground films' . . . was communicated to me only through overseas publications and friends. They were seen only at Western film festivals and foreign embassies in Beijing, and in the cramped, small rooms of friends."[49]

It is safe to estimate that most theater audiences for Chinese independent works are people who go to film festivals overseas, who, as Bill Nichols observes, are mostly "white, Western, and middle class" (except in Asian cities like Hong Kong, Pusan, and Yamagata) and who travel along with screen images in search of audacious political ideas, distinctive artistic visions, and "authentic" (read: exotic) national cultures.[50] The categories of new artists or debut works in many film festivals encourage the entry of independent works, and the remnants of Cold War ideology compels the Western media to play up potentially subversive elements in Chinese independent works. In many cases Chinese directors are fully complicit: they want their films publicized in just this sense.

In turn, the awards from international film festivals and the "underground" or "banned" status of most independent works in China generates a certain curiosity among Chinese urban intellectuals. To reach this audience (beyond circulating the works among their friends), independent directors often make their works available to local art galleries, film clubs, and cafés, where duplicated, low-quality video versions are screened.[51] *Along the Railroad* (Du Haibin, 2000), for instance, was shown in 2000 at now-demolished Yellow Pavilion (Huangtingzi) 50 Bar near Beijing Film Academy, a bar inside the Beijing Jade Palace Hotel (Cuigong), and 101 Workshop in Shanghai.[52] A one-day DV film program offered by Loft Bar (Zangku) in Beijing's popular Sanlitun area screened DV shorts from artists like Cui Zi'en. Other noted film-related bars in Beijing include Box Café (Hezi) and Sculpting in Time (Diaoke shiguang) near Qinghua University, as well as Swallowtail Butterfly (Yanweidie) and Trainspotting (Chaihuoche).[53]

In addition to these small audiences, independent works may reach a substantially larger number of viewers in two other ways: unofficial film festivals on college campuses or special exhibits at art galleries, and on the Internet and through unauthorized or semiauthorized home video use. During September 22–27, 2001, the First Unrestricted Image Festival took place at Beijing Film Academy. The event came complete with a select group of jurors and open competitions in several categories; *Along the Railroad* (voted the best picture) and *The Box* were outstanding titles among the more than fifty documentaries exhibited.[54] Focusing on a lesbian couple, *The Box* (2001) was also included in the Shanghai Exhibit of Unofficial Films (see Chapter 6). Similar events have taken place in bars and video rooms in large cities like Chengdu, Guangzhou, and Wuhan, and the exhibited works have included *Jiang Hu* and the feature film *Seafood* (Zhu Wen, 2001).[55] During December 26–29, 2001, an unofficial film festival in Kunming showed independent documentaries and features in two local bars, Blue Velvet (Lansirong) and Upriver Creative Workshop (Shanghe chuangku). Leading independents like Wu Wenguang, Du Haibin, and Jia Zhangke met with the audiences. Among the

lesser-known documentary titles screened there were *Out of Phoenix Bridge* (Li Hong, 1997), *Old Men* (Yang Tianyi, 1999), *There's a Strong Wind in Beijing* (Ju Anqi, 2000), and *Leave Me Alone* (Hu Shu, 2001).[56] Subsequently, Wu and Jia were featured in a series of monthly forums on independent directors sponsored by Shanghai's Dongdaming Art Center in its DDM Warehouse. Also included in the series, Cui Zi'en's thirteen works were screened to Chinese and foreign audiences on five different days during January 2–20, 2004, and a dozen media venues covered the event.[57]

Compared with the publicity and excitement of unofficial exhibitions generated by actual or potential government bans, Internet access may be less problematic or confrontational, and it has definitely reached a silent majority of the domestic audience. My discussions with Chinese undergraduate and graduate students at Beijing University and Nanjing University in 2005 confirm relatively easy access to campus broadband systems, through which they can frequently manage to upload and download available independent film works, although such titles may not stay in the systems for long. The students' familiarity with the names of leading Chinese independents such as Zhang Yuan and Jia Zhangke testifies to the largely efficient circulation of their works through unofficial channels, and knowledge of current independent titles among a core group of film fans is evident in online film forums and Internet BBS chat rooms.[58] Directors like Cui Zi'en and Wu Wenguang, as well as film critics like Zhang Xianmin and Cheng Qingsong, occasionally contribute film reviews and film columns to periodicals, a practice that further facilitates the circulation of knowledge about independent works inside China and heightens the curiosity of an even broader potential audience.[59]

A FILM WITH DIVIDED RECEPTIONS: *XIAO WU* ABROAD AND AT HOME

The dispersed-audience phenomenon complicates domestic and international reception. Using *Xiao Wu* (a 16mm feature produced on a meager budget of RMB 280,000) as example, we can discern a pattern of drastic difference in the reception of "truth" inside and outside China. After winning two prizes at the 1998 Berlin Film Festival, *Xiao Wu* picked up distributors in France, Germany, Belgium, Switzerland, Austria, Australia, Japan, South Korea, and Hong Kong. In January 1999, the film showed in four Paris theaters and reportedly topped their box office for four weeks. In addition, Arta Television paid 400,000 francs for the exhibition rights, the French press published positive reviews, and a French foundation granted Jia Zhangke 700,000 francs for the postproduction work on his next project, which was to be done in France.

In sharp contrast, his few film screenings in Beijing in 1998 generated mixed but mostly negative responses, at least to the best of Jia Zhangke's knowledge. Arranged through a French embassy staff member, the first screening took place

in a French-run elementary school in Sanlitun, where Jia's friend Lin Xudong invited his acquaintances to attend. Another screening at Beijing University was hosted by poet Xie Mian and attended by thirty or so faculty members, but one of them criticized the film for describing China as a poverty-stricken third-world country.[60] Xie Fei, a professor and film director at Beijing Film Academy (from whose Department of Literature Jia graduated in 1997), arranged a clandestine screening on the academy's campus, after which the film was ridiculed as a negative example in some classroom lectures. The largest screening in Beijing, organized by poet Ouyang Jianghe, took place in an art center owned by Zeng Laide and housed one hundred viewers, including Zhang Yimou.[61] Although Zhang did not say anything, Jia heard that one of Zhang's close associates trashed the film ruthlessly. What distressed Jia the most at these unofficial Chinese screenings were regular accusations from his classmates and fellow filmmakers that his film was shot to please foreigners and that he was an opportunist whose "crude" style was nothing but a fixed camera recording random street scenes.[62]

On the other hand, Jia may take comfort in the fact that most film critics and scholars appreciate his films, and a long list of illustrious awards from international film festivals testifies to the significance of his artistic vision.[63] Nonetheless, the sharply divided difference in reception of *Xiao Wu* in China and abroad reveals what seems to be an unbridgeable gap between the artist's vision and its acceptance by certain domestic audiences. Given such a conspicuous gap, independent directors may find their claims to truth profoundly problematic. If what they perceive as truth is routinely dismissed in China—significantly not only by the authorities—as something that merely caters to international film festivals overseas, independent directors have a long way to go before finding their domestic audiences, especially "ordinary people" like the worker Lu Xuechang encountered.

Colin MacCabe's comment on cinematic realism seems relevant here: "What is at issue is not simply the reality external to the text but the reality of the text itself. We must understand the text's effectivity within the social process, which is to say we have to consider the relation between *reader and text in its historical specificity.*"[64] The historical specificity, in our case, stretches across cultural, linguistic, and national borders, and the apparent effectivity of *Xiao Wu* in the foreign context and the lack thereof in the native one raises further questions. To what extent do overseas investment and distribution impact the production and reception of Chinese independent works as documents of truth? How does one reconcile the sheer incompatibility between the politics of circulating these truths overseas and the poetics of representing the underrepresented (or giving voice to the voiceless) in Chinese independent film and video? Obviously, more research is needed to address questions like these, especially firsthand ethnographic work on different audiences and comparative study of diverse receptions.

MY VISION, MY CAMERA, AND MY TRUTH

We should return to the context in which the statement "my camera doesn't lie" first emerged. As Lou Ye explains in an interview, *Suzhou River* was started as a documentary project because he wanted to capture the "real look" *(zhenshi mianmao)* of life along this polluted river in Shanghai.[65] We are reminded of the character Meimei's exchanges with the off-screen photographer, which echo like a haunting presence at the beginning and end of the film:

> "If I left you, would you look for me? Like Mada?"
> "Yes."
> "Forever?"
> "Yes."
> "Your whole life?"
> "Yes."
> "You're lying [*sahuang*]."

Although *Suzhou River* is as much about lies and betrayals as about unreliable memory and vanishing idealism, Lou Ye is nonetheless convinced that as a filmmaker he himself does not lie, despite all his tricks of cinematic doubling, narrative suspense, and optical illusion.[66] In his words, the film "can express my true impression [*zhenshi yinxiang*] of Suzhou River. My camera doesn't lie [*sahuang*]."[67]

Figure 5.3. *Suzhou River* (2000): my impression, my camera, and my truth

Although he immediately qualifies the statement—"my camera doesn't lie"—as a mere philosophical "thesis" *(mingti)* open to rebuttal, it is all the more noteworthy when we establish Lou's key words in the logical sequence of his two sentences— my impression (or vision), my camera (or style), and my truth (or text).

To conclude, I suggest that we take "my camera doesn't lie" as a statement not so much about a certain truth inherent in Chinese independent film and video as about the new *positions* independent directors have claimed for themselves with regard to truth, subjectivity, and audience. By declaring "my camera doesn't lie," they broke through to the Chinese media and succeeded in reclaiming the space of subjectivity, which authorizes them to proceed in a self-confident manner: my vision, my camera, and my truth. Although it may be too early to celebrate the accomplishments of these independents now, we must recognize that they have, since the early 1990s, tipped the balance of power—however symbolically—in Chinese cultural production and have remained an unrelenting challenge to the hegemony of official filmmaking and media representation in China. It is in posing their challenge that the statement "my camera doesn't lie" makes the most profound sense at home and abroad.

Styles, Subjects, and Special Points of View

ALMOST A CHINESE DOCUMENTARY MOVEMENT

We now focus on certain recurring stylistic choices, sensitive subjects, and special points of view in Chinese documentaries. Independent Chinese filmmaking is generally known to have emerged in the early 1990s with Zhang Yuan, Wang Xiaoshuai, and He Yi, who are regarded as key figures among China's Sixth Generation directors. *Beijing Bastards, The Days,* and other "underground" or "outlawed" feature films—so designated because they were produced outside the state system and exhibited overseas without official approval (or, in some cases, despite official protests and bans)—caught the attention of the Western media and have generated a sustained interest in alternative Chinese filmmaking.[68] However, if we extend the term "independent" to encompass works produced independently of direct state funding and administrative control, we come to realize that Chinese independent productions actually began with the new documentaries in the late 1980s, when China was undergoing an unprecedented intellectual transformation.[69] Wu Wenguang, for instance, started *Bumming in Beijing* as an independent artist associated with the state-owned CCTV (China Central Television) in 1988.[70] In the same year, Shi Jian obtained external funding for the series *Tiananmen* (1991) and began the project with some colleagues despite discouragement from his superiors inside CCTV.[71]

Indeed, the early activities of Wu, Shi, and their friends affiliated with CCTV now constitute the "forgotten" origins of the "Chinese new documentary" *(Zhong-guo xin jilu pian)*—forgotten because most of these works are not seen by the public and therefore seem to have been lost to history.[72] To combat such oblivion, Li Xing and his associates revisit the late 1980s and define the Chinese new documentary as a group of visual productions from 1988 to 1995, characterized by their independent, individualist *(geren)* spirit and its creative, avant-garde form.[73] Li Xing's generic designation of "new documentary" is contrasted with a more glamorous expression, "new documentary movement" *(xin jilu yundong),* which was made popular in part by Lü Xinyu's book in 2003. As we shall see, "new documentary movement" is a slogan coined by the early new documentarists in 1991, but a decade later, one of them, Duan Jinchuan, had come to think that their works of the early 1990s did not constitute a movement or a revolution.[74] I agree with Duan's modest assessment and suggest that "movement" may be too strong a word for describing the Chinese independent documentary of the 1990s, especially when we consider the small number of its participants, the unavailability of its representative works to the public, and its practically nonexistent impact on general domestic audiences. Lü herself uses the phrase "common concerns without prearrangement" *(buyue ertong)* to describe the group,[75] which reveals its initial lack of the large-scale coordination that is typical of a sustained artistic movement. Nonetheless, Lü's phrase also indicates that there are enough shared elements in this group of works to merit our study of them as a special phenomenon. I have named this phenomenon "marginality" (see Chapter 3) and treat it as alternative cultural production in contemporary China.

We should not indiscriminately accept the characteristic claims of Chinese independents to truth, reality, and objectivity; instead, we must investigate their chosen *means* of achieving their perceptions of truth and reality. To that end, I focus less on claims to the inherent truth content of particular subjects but rather on the preferred styles in the Chinese documentary and ideological implications of preferring certain styles to others. A comparative perspective is needed for stylistic and ideological considerations, and my observation about the parallels between Chinese and Euro-American documentaries is meant to foreground the historical specificities in the meandering development of the Chinese independent documentary.

ORIGINS: UNOFFICIAL VIEWS INSIDE AND OUTSIDE THE STATE SYSTEM

In June 1991 Shi Jian gathered a few close friends at CCTV and organized the first independent Chinese documentary group, "Structure-Wave-Youth-Cinema" (Jiegou-Langchao-Qingnian-Dianying) or, for short, SWYC, which takes one letter each from their names in pinyin romanization—Shi Jian, Wang Zijun, Kuang

Yang, and Chen Jie. To gather momentum, Shi Jian organized a conference on the documentary at the Beijing Broadcast Institute (now Communication University of China) near the end of 1991, which attracted considerable public interest and drew around 200 people, including Jiang Yue, who signed his registration card as an "independent," reputedly the first of similar self-declarations to come. While working on *Tiananmen* and *I Graduated* (1992) with his group,[76] Shi Jian met Wu Wenguang, Duan Jinchuan, Jiang Yue, Wen Pulin, Hao Zhiqiang, Li Xiaoshan, and other aspiring independents in Zhang Yuan's apartment in Beijing in 1991. They discussed the significance of the documentary and decided to launch a new documentary movement in China.[77]

Wu Wenguang quickly emerged as the nominal leader of the independents, who defined their oppositional stance vis-à-vis the mainstream: they sought to resist the "corrupt" filmmaking tradition and to turn the world of film and television upside down. They set two requirements for the independent documentary: independent production (that is, raising money on one's own and controlling the entire process) and independent thinking (that is, no longer serving as a mouthpiece for the official ideology). Private money, however, was difficult to obtain in the early 1990s. While on the CCTV payroll, Shi Jian did moonlighting work to earn additional money for the eight-part *Tiananmen* and even sold his refrigerator to make ends meet.[78] Outside the state system, Wu Wenguang did various odd jobs, producing television programs and designing VCDs for exhibition events.

Given the sensitive political climate right after June Fourth of 1989, the Chinese independent documentary had a bumpy start. Originally conceived to celebrate the fortieth anniversary of the People's Republic of China, the *Tiananmen* series did not pass the censors because its depiction of the daily lives of ordinary Beijing residents was judged too "gray" and too "passive," and in 1992 Shi Jian was disciplined and transferred from the special themes *(zhuanti)* department to the news reporting department.[79] By the time *Tiananmen* entered a German film festival in 1994, Shi Jian and his colleagues had already abandoned independent production and were instead working diligently for structural changes within the CCTV system. In January 1993 Shi helped launch "Eastern Horizons" (Dongfang shikong), a program focused on investigating contemporary issues; in May 1993, he inaugurated "Eastern Talents" (Dongfang zhi zi), a program of in-studio interviews; and in March 1996, he established the first full-scale Chinese talk show, "Speak in Ernest" (Shihua shishuo). All these programs became extremely popular and influential across China due in part to their fresh look and in part to their emphasis on real people, authentic lives, and truthful revelations.[80]

These new CCTV programs reflected a radical conceptual change in television programming and an increasing awareness of the documentary as a new tactical method. Corresponding to what happened in the independent documentary, the

efforts to distance these programs from propaganda and to address the audience's everyday concerns were clearly visible inside the official institution. Chen Meng, a producer of the popular CCTV program "Living Space" (Shenghuo kongjian), issued the slogan "let ordinary people tell their own stories" in 1993 and instructed his crew to readjust their attitude:[81]

> Abandon your so-called sense of responsibility, abandon your concern for the so-called deep structure of culture, and treat your interviewees as you would your friends and loved ones. As a result, you will acquire the most honest sense of responsibility and produce the deepest kind of criticism.[82]

Chen's words demonstrate that shifting the point of view to "ordinary people" (*laobaixing*, literally, "people of hundreds of surnames") was becoming a major trend in both the official and the unofficial documentary in China during the 1990s. For example, Kang Jianning advocated replacing the high-sounding rhetoric of official documentaries with the less condescending views of lower-class people. For Kang, *River Elegy* (1988), a controversial television series scripted by Su Xiaokang and others, relied too much on an authoritative voiceover commentary and sounded as if a priest were "preaching on the clouds." While working at Ningxia TV, Kang spent a great deal of time in a poverty-stricken rural village and produced *Yinyang* (1997), a documentary that exhibits a distinctive "plebeian consciousness" (*pingmin yishi*).[83]

Indeed, a similar attempt at achieving a plebeian point of view was undertaken by Beijing TV's program "Ordinary People's Lives" (Baixing jiayuan), which issued an eye-catching slogan—"this program serves the poor"—for internal use in 1996. In its first few episodes, the "poor" (*qiongren*) they covered included a schoolteacher, a handicapped person, someone raising an abandoned child, and a teenage maid—all underrepresented in the previous official programming. Significantly, rather than serve "the people" (*renmin*) or "workers, peasants, and soldiers" (*gong-nong-bing*), the urgent mission was changed to serve the *laobaixing*, which had been reconceived as more concrete or humanist than *renmin* and less political or propagandist than *gong-nong-bing*.

Obviously, the desires to distance—if not always to resist—the official rhetoric and to document the everyday lives of the *laobaixing*, especially those from the lower social strata, had united documentarists inside and outside the state system.[84] Indeed, during the 1990s the boundary between the official and the unofficial was porous and frequently crossed. Just as Shi Jian had directed independent documentaries as a CCTV employee, Jiang Yue was recruited to shoot short documentaries for CCTV's "Living Space" in between his own independent projects. In fact, *No. 16 Barkhor South Street* (Duan Jinchuan, 1997) was originally funded by

and produced for CCTV. After years of censorship problems, a thirty-minute version was broadcast in the CCTV's program "Documentary" (Jilu) in August and September 2001.[85]

Three things are worth noting. First, like Sixth Generation directors, most Chinese documentarists believed their works were more realistic, more truthful, or at least more objective than any comparable official news program. Second, with a few exceptions, full-length documentaries came from the independents, who typically worked on their projects over a long period. Third, in spite of their passion, most artists were not yet ready to define the documentary. Even years later, when confronted with the questions as to whether short documentary (or nonfiction) programs produced for CCTV programs belong to the genre of documentary in a strict sense, and whether "special-theme projects" (zhuanti pian) qualify as documentaries, producers like Chen Meng and Shi Jian remain undecided. This prompts us to examine the conceptualization of the documentary and the sources of inspiration for the Chinese documentary in the 1990s.

STYLES: PARALLELS BETWEEN EURO-AMERICAN AND CHINESE DOCUMENTARIES

Wu Wenguang admits that he did not know what a documentary was until he attended the Yamagata Documentary Film Festival in 1991. He brought home some videotapes of Ogawa Shinsuke's documentaries, which left a deep impression on his fellow independents like Jiang Yue.[86] Jiang specifically valued Ogawa's persistence in pursuing a project and his intimate acquaintance with his subjects. In 1993 Duan Jinchuan also attended the Yamagata Festival and watched works by Ogawa Shinsuke, Frederick Wiseman, and Bob Connolly.[87] Documentary concepts like "direct cinema" (zhijie dianying) and cinéma vérité (zhenshi dianying) began to circulate among the Chinese independents, and Wiseman's name was the one most frequently mentioned. In the summer of 1997, Wiseman attended an international conference on the documentary in Beijing sponsored by CCTV's "Living Space" and initiated by Chen Meng, and as a distinguished guest, he was introduced to the Chinese cultural leaders as well as to the independent documentarists.

What made Wiseman particularly appealing to Chinese documentarists both inside and outside the state system in the 1990s? To answer this question, we must contextualize what Wiseman represents in the history of the documentary.[88] According to Bill Nichols, there are four major modes of the Euro-American documentary. First, there is the *direct-address style* of the Griersonian tradition, which employs an authoritative or even presumptuous off-screen narration (so excessive it is sometimes called the "voice of God") and works toward overwhelmingly didactic ends. Then, when the direct-address style went out of fashion after World War II, cinéma vérité and its variants like direct cinema "promised an increase in the 'reality effect' with its directness, immediacy, and impression of

capturing untampered events in the everyday lives of particular people."[89] Made possible by portable cameras and sound recorders, this *observational style* refrains from authorial commentary, prefers filming ordinary people, seeks transparency with synchronous dialogue under location conditions, and trusts the viewers to reach conclusions on their own. The third mode is the *interview-oriented style,* which incorporates direct address by bringing interviewees before the camera and having them talk directly to the viewer as witness-participants of their life stories (often feminist and antiwar). This style emerged in the 1960s to provide a sense of history that was otherwise lacking in cinéma vérité. The fourth mode, which began in the late 1970s, was a new *self-reflexive style* that experimented with more complex forms, mixing "observational passages with interviews, the voiceover of the filmmaker with intertitles" and juxtaposing a range of disparate points of views to engage the viewer in an active interpretive process.[90]

In the Chinese context, the appeal of cinéma vérité, as represented by Wiseman's work, was tremendous, coming as it did when Chinese documentarists were trying desperately to resist the propagandist tradition—the "voice of the Party"—implicit in the dominant direct-address style of official documentary and news programs. That appeal was evident at both the formal and ideological levels. At the formal level, the directness of images, the immediacy of locations, and the deep impression made by the unrehearsed actions of the people in cinéma vérité and direct cinema provided much-needed "documentary methods" (*jishi shoufa*) for the Chinese independents to get closer to reality or truth. For example, Shi Jian highlights the observational quality of *Tiananmen* by means of a series of mobile long takes that lead the viewer through a Beijing *hutong,* and he enhances the realistic effect by synchronous recording and a hidden camera.[91] In contrast to the scripted voiceover commentary, on-location sound was considered experimental in the early 1990s, and it therefore exerted an extraordinary impact on the viewer. At the ideological level, the alliance of cinéma vérité with individuals rather than with institutions, as expounded below, fit the Chinese agenda perfectly:

> As in Wiseman's films, organizational strategies establish a preferred reading—
> in this case, one that favors *the personal over the political,* that seeks out and
> celebrates the irruptions of *individual* feeling and conscience in the face of
> institutional constraint, that *re-writes* historical process as the expression of an
> indomitable human essence whatever the circumstance.[92]

Without much modification, this passage can be borrowed to describe the ideological significance of many early Chinese independent documentaries, such as *Bumming in Beijing* and *The Other Shore* (Jiang Yue, 1995).

However, pure cinéma vérité is hard to achieve, and the majority of Chinese documentarists have preferred mixing observation with talking-head interviews. Interviews have been extremely popular among Chinese documentarists because they find in this method an effective way to counterbalance official views with personal opinions—with multiple voices, "interviews diffuse authority"—and to substantiate the filmmakers' truth claims with the subjects' on-camera testimonies.[93] In *Bumming in Beijing*, Wu follows five provincial artists struggling to start a career in Beijing and he captures the dramatic changes in their lives over three years. Wu demonstrates a relatively sophisticated use of interviews; they are not simply included as the evidence of personal truth (testimony) but also as a potential space of tension (when one story is modified or corrected by another) or even as a site of irony (for example, when Gao Bo's on-camera assertion of his unwillingness to go abroad is contradicted by the fact that he then leaves for Paris in 1990).

Wu's interviews are inserted between observational footage of these artists' living conditions and their activities, and the most dramatic—and emotionally charged—episode in *Bumming in Beijing* is when Zhang Xiaping literally goes crazy after her solo art exhibit. Similarly, Jiang Yue's observational camera also captures dramatic moments in the staging of an avant-garde play based on the work of Gao Xingjian, who would emigrate to France and win the Nobel Prize for Literature in 2000.[94] Private emotions irrupt in *The Other Shore* during Jiang's follow-up interviews with the disillusioned provincial amateur actors who had been recruited to Beijing by Mou Sen, the only one of the five struggling artists featured in *Bumming in Beijing* who decides to stay in China.

As a rare exception to the Chinese preference for interviews, Duan Jinchuan has consistently pursued the cinéma vérité style.[95] In his *No. 16 Barkhor South*

Figure 5.4. *The Other Shore* (1995): a rehearsal of Gao Xingjian's avant-garde play

Street, which concentrates on apparently insignificant Tibetan people caught in their equally insignificant daily routines inside the office of a Lhasa neighborhood committee, the documentarist is completely out of the picture, and the seemingly "natural" unfolding of events gives the viewer an impression of "on-the-spot" *(xianchang)* participation and observation. Perhaps due to Wiseman's influence, Duan prefers directing his attention to public spaces: "I am increasingly interested in politics and ideology more than in an individual's fate."[96] Duan's kindred spirit in this regard is Zhang Yuan, with whom he codirected *The Square* (1994), a documentary observing random activities in Tiananmen Square, the most symbolic public space in China.

Duan continued to employ his cinéma vérité style in *The End of the Earth* (1997), an examination of what modernity—represented by a rundown truck—can and cannot bring to Tibetan herdsmen living a traditional life on the Phala grassland. Set in Tibet, where he started his career with Tibet TV as early as 1984 before going independent, Duan's two films resemble the observational tradition prevalent in ethnographic cinema, which has remained largely an academic endeavor in China.[97] Indeed, Duan himself has noticed the parallel between his documentary and anthropological fieldwork, for both aim at documenting cultural behaviors and conflicts between human and nature.

The Chinese independent documentary has also found a fertile ground in Yunnan, a mountainous southwestern province with a multiethnic population and rich cultural resources. Less well known to the outside world, Yunnan's independents differ from their Beijing counterparts in that they pay more attention to nature, culture, and community than to individuals. *The Cormorant and the Lake* (Zhou Yuejun, 1998) examines how an old couple train cormorants for fishing and how their economic life is changing. *Baka Village* (Tan Leshui, 1998) observes the dilemma of Jinuo people, the most recently classified minority group in China, who were suddenly deprived of their agricultural tradition when the government forbade their burning the hillsides for farming. *Mask* (Liu Xiaojin, 2000) is an elaborate story of the rediscovery, performance, and altered meanings of a traditional village dance-play.[98] Interestingly, like their Beijing counterparts, Yunnan independents also prefer mixing passages of observation with interviews, although they still rely on voiceover narration in their exploration of ethnic cultures.

PROBLEMS: SELF-ERASURE, OBJECTIVITY, SUBJECT EXPLOITATION

The predominance of the interview-oriented style and a misguided faith in the observational camera's objectivity has generated a number of problems in the Chinese independent documentary. First, because the majority of Chinese independents are amateurs who learn their trade while shooting documentaries,[99] their works contain obvious technical insufficiencies, which range from shaky or

gyrating cameras, blurred or racked focus, and disproportionate frames, to grainy images and muddy sound. Ironically, precisely because of their marked difference from the slick state or commercial productions, critics have interpreted these insufficiencies as signs of truth, as effects of reality, and as means by which the viewer is supposedly brought back in contact with the very tissue and texture of life. A series of international film festival prizes awarded to Chinese independent documentaries seem to have authenticated a new "documentary aesthetic" derived initially from technical insufficiencies, and impressionable newcomers are then enticed to align with this perceived "tradition" of rebellious independent documentary.[100]

Second, since nearly everyone in the early 1990s subscribed to the same documentary methods, especially strings of interviews and excessive long takes, the ensuing stylistic resemblance makes these works look rather "cheap, insubstantial, and unimaginative," to quote Duan Jinchuan's subsequent judgment.[101] By moving from one extreme (an assertive spokesperson for the people) to another (a passive listener to the interviewees), Chinese documentarists have revealed a conspicuous lack of self-confidence, so much so that they eagerly erase themselves from the picture and depend completely on other people's words to express their views.

Third, Chinese documentarists are rarely interested in theoretical issues and take for granted the seemingly indisputable objectivity of documentary methods. Working like ethnographic filmmakers, they endeavor to "interpret the behavior of people . . . by using shots of people doing precisely what they would have been doing if the camera were not there."[102] This pursuit of the "invisibility" of the camera has resulted in the self-erasure of the documentarist. Similarly, in an effort to reduce or eliminate authorial interference, the Chinese documentarist trusts the interviewees to speak the truth and forgets a truism that words, like images, are not always trustworthy.

Again, a detour through critiques of the Euro-American documentary may help us better evaluate the Chinese situation. In David MacDougall's opinion, misconceived objectivity in much of ethnographic cinema results from "the fallacy of omniscient observation," which ignores the inevitability of subjective input in filmmaking: "Observation cinema is based upon a process of selection. The filmmaker limits himself to that which occurs naturally and spontaneously in front of his camera."[103] In other words, the documentarist decides what to film, whom to interview, and which segments to delete; as a consequence, the finished documentary is never a natural or spontaneous unfolding of life as is.

Thomas Waugh takes the persistent pretense of impartiality as the most serious liability of cinéma vérité and direct cinema in his critique of their naïve claim to "the new accessibility of 'truth'—truth in the surface texture of audiovisual reality, in the immediacy of present time, and in the nuance of spontaneous behavior."[104] Using Emile de Antonio as a primary example, Waugh holds that the

new American documentary of the 1970s—what Bill Nichols classifies as the self-reflexive style—bypassed the "pseudo-objective" cinéma vérité of the 1960s and recognized the camera's undeniable subjectivity.[105]

A similar concern with subjectivity compels Bill Nichols to criticize those documentarists in the cinéma vérité camp who "forfeit their own voice for that of others (usually characters recruited to the film and interviewed)" and who "disavow the complexities of voice . . . for the apparent simplicities of faithful observation."[106] The loss of voice Nichols notices in cinéma vérité parallels the abundance of monologues (that is, one-way communication) MacDougall discerns in observational cinema. MacDougall's critique of the quest of invisibility in observational cinema prompts him to envision a "participatory cinema" in which the filmmaker not only acknowledges his or her encounter with the subjects but also creates a process of collaboration in the production of knowledge.

The question of "encounter" brings us to a touchy issue in the Chinese documentary: subject exploitation. This can be divided into three types. The first type involves a complete disregard of the subject's human value and dignity in the pursuit of a sensational or objectifying investigation. Such exploitation is most evident in official television programs. For example, Beijing TV's "Documentary" (Jilu) program aired an otherwise touching story about an HIV-positive migrant worker in Tianjin who had returned home to Henan province only to find himself completely estranged from his villagers and even his wife. Yet this fifty-minute documentary was aired in a peculiar way—divided in small sections and interrupted by "expert" comments from a program host, a reporter, and a sociologist—and the story was repackaged as an "entertaining" live show, in part to offer it as a public education forum and in part to boost the program's ratings.[107] The subject's miseries were exploited on camera and sensationalized in the studio.

The second type of subject exploitation involves a largely sympathetic treatment and is therefore benign in nature and in a sense unavoidable. While shooting *Out of Phoenix Bridge,* an intimate study of female migrant workers in Beijing, Li Hong befriended her subjects by staying overnight with them in their cramped living quarters, much to her own discomfort. Although she won their trust, in the end she developed a sense of guilt and admitted that her documentary functioned very much like a city dweller's "looting" *(lüeduo)* of migrant rural workers.[108] Documentary is a "brutal" *(canren)* method, she confesses, and she is aware that she shot the documentary for herself and not for her subjects, to whom she was able to show only part of the finished work, presumably not to embarrass or provoke them.[109] Similarly, even though Du Haibin had befriended his homeless subjects in *Along the Railroad,* his acute sense of exploitation made him feel like a "looter" *(lüeduozhe)* once the documentary was completed, and he was in sole possession of his subjects as documentary images.[110]

The third type of subject exploitation, which is rather rare, involves an unequal relationship between various subjects (or characters) in the documentary, either on- or off-camera. One case in point is *The Other Shore*. During the shooting, Mou Sen completely changed his attitude toward his amateur actors after seven successful performances of the play. A high point in their life was over, and Mou was experiencing a hard time raising funds for additional performances. One rainy day Mou flew back from Guangzhou empty-handed and vented his anger on his spiritually and financially dependent group, going so far as to blame one pretty girl for not prostituting herself. Jiang Yue regretted not capturing this emotional scene on camera, but he managed to record Mou's complaints about his students' dependency. For Mou Sen and Wu Wenguang, who was closely associated with Mou's group and likewise pestered by their frequent requests for money, these naïve actors had sunk too deeply into utopianism and did not get the essence of "deconstruction" in Gao Xingjian's original play. Precisely at that moment, Jiang realized that these poor amateurs had all along been exploited in a spiritual quest that would fulfill Mou's dream of avant-garde theater but not their dreams of securing a performing career in Beijing.[111]

READJUSTMENTS: SELF-REPOSITIONING, PERSONAL STYLES, SUBJECTIVE VOICE

Jiang Yue admits that shooting *The Other Shore* was a process of purification for himself, after which he acquired an entirely new attitude, a new perspective, and a new understanding. When he heard about the off-camera incident in which Mou had disgraced his students, Jiang discovered that the real subject of his documentary was not an independent artist's staging of avant-garde theater but the experiences of these amateur actors who were forced to abandon their dreams and disappeared in anonymity after a brief moment of fulfillment. For Jiang, self-repositioning was inevitable: "When you choose a subject, you have formed your position."[112] Jiang realized that his new role was to question the entrenched elitist position of Mou and his fellow idealists in the 1980s.

Jiang's repositioning confirms Kang Jianning's displeasure with the "aristocratic" attitude implicit in Wu Wenguang's early documentaries. Indeed, when Jiang caught Wu's complaints about Mou's dependent students on camera, Wu said in embarrassment that documentary was "brutal" *(canku)*, inadvertently echoing Li Hong's comment mentioned earlier.[113] Nevertheless, if the documentary was brutal in Li's case because of subject exploitation, it was brutal in Wu's case because of self-exposure, which one hoped would lead to self-reevaluation.[114]

And after 1995, when the independent documentary faced what Wu Wenguang saw as an impasse, he did experience such a process of self-criticism and self-repositioning. By 1999, Wu had completely repositioned himself and gone so far as to dismiss his earlier works, in particular *At Home in the World* (1995),

a 170-minute sequel to *Bumming in Beijing* that follows his five marginal artists from Beijing, Kunming, and Tibet to Belgium, France, Italy, Austria, and the United States. In retrospect, these artists now appear to him like a group of "weaklings" engaged as if in "collective masturbation" *(jiti shouyin),* and his earlier life in Beijing seems to him "illusory and unreal."[115]

After working with "tent" performers in an itinerant troupe between rural towns and small cities—the subjects of his *Jiang Hu*—Wu arrives at this new vision of his position: "You scrutinized yourself and discovered that you no longer belonged to any group, not to the stage nor to the audience—you belong to yourself."[116] Wu further clarifies his call for "returning to oneself": it is to find a "personal style" *(geren fangshi)*—"a more personal point of view, a more personal type of writing, and a more unrestricted [*ziyou de*] style."[117]

Wu's call for returning to oneself and becoming more personal can be understood as a new formulation of the artist's subjectivity in the late 1990s: the subjectivity in question now consists not in an elitist sense of the intellectual mission for enlightening the masses but in a commitment to one's own personal vision and style. In this sense Wu shares Duan Jinchuan's view on the diversification *(duoyuanhua)* of documentary styles. As indicated above, Duan has established his personal style by committing to the cinéma vérité tradition and by attending to the ideological more than the individual. Nonetheless, he did not hesitate to enhance his own subjectivity by adding some voiceover narration in his next project, *Sunken National Treasure–97* (1999), thereby showing flexibility in his pursuit of a personal style.[118] Likewise attempting stylistic changes, Wu Wenguang now favors medium and close-up shots and stays away from the extreme long takes characteristic of *Jiang Hu.*

The pursuit of a personal style is carried out in a radical fashion in *There's a Strong Wind in Beijing.* Ju Anqi goes around Beijing and tirelessly poses the same, almost silly question—"Is there a strong wind in Beijing?"—to different people in different situations. The artist's unmistakable presence highlights the moments of encounter, not just the encounter between the artist and his random interviewees but also the encounter between these interviewees and the viewer, for the viewer is forced to contemplate what his or her reaction would be if he or she were one of them.[119] Indeed, the viewer is invited to think beyond immediate answers, because what is more significant here are not the answers themselves but the ways people choose to answer or not to answer. In a sense, the moments of no answers and no images—some interviewees did not permit the camera to film them—become unique moments of encounter: when the dialogue carries on in complete darkness on screen, the viewer cannot help but ponder the symbolism of such darkness.

The distinct subjective voice in Ju Anqi's radically personal style generated heated debate after the film was screened in a few bars in Beijing and Kunming.

Wu Wenguang conceded that Ju's style represents something his generation may find repulsive, but he valued the powerful audiovisual impact of Ju's documentary, even when the screen was completely dark.[120] At the very least, Ju's formal experiment has explored options which heretofore have fallen outside the usual parameters of the documentary.

Ju's work brings us to the much-discussed relationship between truth and subjectivity. According to Chen Meng, what Michelangelo Antonioni suggests in *Beyond the Clouds* (Al di là delle nuvole, 1995) is a vision of inexhaustible truths— one truth lies behind another, which lies behind yet another, and so forth—which is visually symbolized by a black hole. Chen's argument is worth quoting at length:

> What is truth? The ultimate truth is invisible. In terms of space, truth is a point of view. In terms of time, truth is getting infinitely closer to a point. As early as the 1960s, international documentary theory has made it clear that we not only need to see them [the subjects] in front of the camera but also you [the artist] behind the camera.[121]

There's a Strong Wind in Beijing is one such work that lets us see the documentarist behind the camera and hear his subjective voice.

Not surprisingly, Wu Wenguang has also moved closer to reasserting his subjective voice and reclaiming self-reflexivity in documentary-making. In his recent 172-minute work, *Fuck Cinema* (2004), Wu speaks from time to time behind the camera as he follows a migrant worker from Shandong province, an unknown but aspiring screenwriter, who tries desperately to find a producer for his film script, but who fails to find even a regular job in Beijing except occasionally earning RMB 20 per day as an extra. After bringing him to various film-related places (including a meeting with Zhang Yuan), Wu records a scene in which the migrant reads from his screenplay and then questions Wu's unfulfilled promise to find him a producer: documentary-making is fun for Wu, the migrant says frankly on camera, but it is suffering for him. By shifting attention to the documentarist behind the camera, *Fuck Cinema* has achieved a measure of self-reflexivity unseen in Wu's previous work, and this self-reflexivity is further intensified by the documentary's cross-cutting between the migrant's futile pursuit and shots of two other strands of film culture: a dozen or so auditions with young aspiring actresses for a possibly nonexistent screen role as a hostess/prostitute *(xiaojie),* and the activities of a young street vendor of pirated videos who goes around the city to deliver nonmainstream products. In an ironically self-reflexive manner, *Fuck Cinema* exposes the false promise and glamour of a film career and its shady operations in contemporary China. With *Fuck Cinema*, Wu completed a phase of readjustment by forcing himself through a "cruel" process of self-exposure, self-scrutiny, and self-enlightenment.[122]

AMATEURISM: DEMOCRATIZATION AND INDIVIDUALIZATION IN A DV AGE

Twenty years have passed since Wu Wenguang and Shi Jian first began making independent documentaries in the late 1980s. The process of repositioning or readjustment from the late 1990s onward has convinced documentarists like Wu that special points of view are as crucial as documentary styles and that these different points of view apply not just to how filmmakers look at their subjects but to the documentarists themselves as well. Ultimately, Wu admits, it is "a question of self-liberation, a question of self-reflection."[123]

As it did with Wu, Jiang Yue's self-reflection has empowered him to speak for his fellow artists: "We are rather disgusted with the term 'underground'; one can describe us as marginal, but we are not underground. We do not want to oppose something; rather, we just like the documentary and want to use it as a special way of expressing our views about society."[124]

Independent documentarists, in other words, share the same desire to document the present as a historical record for the future. However, what has changed since the late 1990s is that many documentarists have chosen to emphasize their personal styles and individual views rather than to try to organize some kind of a documentary movement. This is why Wu Wenguang asserts, "The documentary does not equal Wu Wenguang, nor does Wu Wenguang equal the documentary. . . . I don't shoulder a sense of mission for the documentary."[125] Instead, Wu sees his desire to document as a personal choice: "I just like the positivist stuff like materials, locations, documents, archives, and so on."[126] In fact, Wu has moved to the audio and print media to document the interviews with his tent subjects that he was not able to include in *Jiang Hu*.[127]

I want to caution, however, that independent documentarists may not solve the dilemma they face simply by returning to the personal (as Wu advocates). True, they may not appear as "oppositional" as they did a decade ago, but their insistence on personal views and styles (still largely experimental, as in Ju Anqi's case) cannot alone "liberate" them from interacting with all the forces Wu has excluded—the official, the intellectual, the unofficial, the oppositional, and so on. In this light, the readjustments noted earlier are essentially subjective or even wishful in nature. Worse still, this kind of deliberate falling back to the apparently safe confines of the personal may reduce the social significance of their work, making the independent documentary more susceptible to ideological criticism from all fronts.

Ironically, the personal, which for Wu meant a turn away from any movement, has propagated a new fashion, the so-called "amateur DV movement," which is in part derived from the younger generation's similar desire to document ordinary people's lives, although they are not as serious as the independents. The connection between the 1990s independent documentary and the new DV "movement"

is obvious in the way the DV movement's leading sponsor, Hong Kong-based Phoenix Satellite TV (Fenghuang weishi), envisioned their January 2002 program, "Chinese Youth Image Competition: The DV New Generation," as being open to college students in mainland China, Hong Kong, and Taiwan. First, the Phoenix editorial group anticipated that amateur DV would be more personal, more individualistic, more truthful, and more honest (all qualities of the independents), and second, because of the many different personal points of view, they thought the DV "movement" itself would achieve diversity and provide "unofficial texts" for understanding contemporary Chinese society (something the independents are reluctant to admit nowadays that they are doing, at least publicly). In a manner similar to Jiang Yue's self-reflection mentioned above, the Phoenix TV program's editorial group declared in the name of potential DV practitioners: "We have nothing to do with the so-called 'underground condition,' 'marginal discourse,' 'independent position,' or 'unofficial voice.' We are just a group of ordinary people passionate for DV, and we care for whatever we like to care for." [128]

Democratization and individualization stand out as two key words among the expert opinions that Phoenix TV gathered from its weekly interviews with writers, directors, and professors in its attempt to promote this amateur DV program. Among them, Jia Zhangke emerges as the most outspoken promoter of amateur DV-making. In two articles widely circulated on Chinese websites, Jia celebrates "the arrival of the age of amateur film" and encourages DV fans to reclaim their right to filmmaking. In the spirit of equality and justice, Jia announces that film originally belonged to the masses and filmmaking should not be the exclusive right of a minority of professionals. He claims that the DV camera has moved film closer to individuals rather than the industry, and it will democratize the spirit of Chinese film by helping more and more people try documentary and experimental film. The documentary possesses a humanist spirit while the experimental film contains a desire for the new, so Jia contends that these two qualities are exactly what are missing in contemporary Chinese cinema. [129]

I would argue that Jia Zhangke's manifesto for a new age of "amateur" filmmaking borders on idealism and that the related enthusiasm over an unofficial DV "movement" is problematic. The reasons I have placed quotation marks around "movement" and "amateur" are twofold. What appears to be a DV "movement" is not a self-generated, grassroots exploration (as the independent documentary was initially) but part of an organized, large-scale operation coordinated by universities, television stations, and sometimes government or quasi-government units, and (at least partially) aimed at discovering and training new talents. Second, because such DV "practices" (*shijian*, a word I prefer to "movement") are comparable to other college internships in journalism and mass communication,

these college students are not exactly "amateurs" but "professionals" in the making.[130] Even Jia Zhangke cannot claim "amateur" status because he received formal training from Beijing Film Academy, although not in its excellent directing department.

ACTIVISM: COLLECTIVE PROJECTS, TRANSLOCAL NETWORKING, VISUAL DIALOGUE

By 2005 amateurism had taken a new turn in the Chinese independent documentary, gradually shifting the emphasis from personal visions to collective activism, all the while maintaining a typically unofficial—or sometimes semiofficial—status. One celebrated event was Wu Wenguang's *China Village Self-Governance Film Project* (2006), sponsored by the European Union and China's Ministry of Civil Affairs (Minzhengbu). The project offered a week-long technical training to ten villagers selected from remote areas around the country on how to handle mini-DV cameras and then sent them to document rural affairs in their home villages. Except for two cases, their footage was edited by professionals, and all ten episodes were aired on CCTV Channel 12 in May 2006.[131]

Wu Wenguang's interest in villagers dates back to *Dance with Farm Workers* (2001), a transition work between his focus on the personal and his commitment to the collective. The English term "farm workers" is a misnomer because Wu's subjects are migrant laborers working in Beijing rather than in farm fields. The documentary continues Wu's fascination with avant-garde art in Beijing and records a professional dancer, Wen Hui, leading a group of workers through eight days of rehearsals and one day of amateur performance, all on an unfinished building floor.[132] In an unusually self-reflexive mode, Wu himself appears on camera practicing dance moves with the workers. The documentary succeeds in problematizing the double marginality of migrant workers in urban life and of their relationship to avant-garde art. They remain nameless until the ending credits sequence and serve as mere embodiments of the artists' ideas of expressive bodies, just as the rural workers do in Jia's *Dong* (see Chapter 4).

In sharp contrast to *Dance with Farm Workers,* the collective *China Village Self-Governance Film Project* clearly credits the individual contributions from its two female and eight male amateur documentarists, who range in age from twenty-four (Cili Zhuoma, Tibetan) to fifty-nine (Nong Ke, ethnic Zhuang).[133] Each episode starts with an introduction of the documentarist and his or her native village. Despite the title of the documentary, not all episodes deal with village elections. Nevertheless, distinct local points of view are unquestionably in place, and the villagers appear completely at ease with their fellow villagers shooting them. In one episode, incredulous villagers poke their faces one by one in front of the camera, thus creating the ambience of a lively community in the documentary.

However, these amateur documentarists are not really activists for self-governance as the project's title implies. The real activist was Wu Wenguang, but his leadership role in this semiofficial project was inevitably compromised, as his work was mediated by other project coordinators. The domestic press coverage also raises questions about the project's "independent" nature, although Wu's name recognition overseas has lent some credibility to the project. In any case, to date the turn of the Chinese independent documentary to collective activism with Wu's project in 2005 is historically inaccurate,[134] for Guo Jing and his colleagues at Yunnan Academy of Social Sciences had experimented years ago with a similar project of amateur documentary.

As early as 1996, Guo Jing organized the Azara Visual Workshop to encourage "participatory visual education" (shequ yingshi jiaoyu) in Zhongdian county (later renamed Xianggelila or Shangri-La, now a nationally famous tourist destination) in northwest Yunnan province. Guo traces his inspiration to a "photovoice" project funded by the Ford Foundation in 1991, which provided support to fifty-three rural Chinese women so they could photograph their daily lives in an effort to promote education in women's reproductive health. From September 2000 to September 2002, Guo's project "Learn Our Own Tradition" was similarly funded by the Ford Foundation, and he recruited a few villagers to document their distinctive cultural activities in three local villages: pottery in Tangdui (Black Pottery Family), the Catholic Church and red-wine production in Cizhong (Christmas Eve in Cizhong, Cizhong Red Wine), and glacier mountain tourism in Mingyong (Glacier). The footage was sent to Kunming, where it was edited in consultation with the amateurs. To make the project truly participatory on a local scale, some of these short documentaries were incorporated into the curriculum and screened in local elementary schools.[135]

In 2004, the Azara Visual Workshop was reorganized as Bama Mountain Culture Research Institute, and its action-oriented mission is "to work with the indigenous people to promote the natural and cultural preservation in the mountain-river area of southwest China."[136] Toward that goal, Guo Jing and his colleagues have pursued translocal networking and cooperated with transnational NGOs such as Conservation International (CI) and The Nature Conservancy (TNC)— both headquartered in Arlington, Virginia—as well as local Yunnan organizations. One significant development was the inauguration of the Yunnan Multicultural Visual Festival (or Yunfest) in 2003, which was organized by Yunnan Provincial Museum (with Guo Jing as its director then) and sponsored by various university units and commercial art venues in Kunming.[137] The success of the first Yunfest attracted major funding from the Ford Foundation, TNC, and CI for the second Yunfest in 2005, which offered free admission to a theater inside Yunnan Provincial

Museum and achieved an 80 percent attendance rate at some screenings.[138] By the third Yunfest in 2007, however, its semiofficial status was downgraded as it was "banned" in Kunming and had to relocate its screenings to Dali, an ethnic tourist city hours away from Kunming.[139]

In his justification of the first Yunfest, Guo Jing evokes the spatial dichotomy of the center and the margin in China's cultural production:

> Precisely because we are far from the center, far from all those strong visual languages, we are capable of *independent thinking*. "South of the clouds" [Yunnan's literal meaning in Chinese] is a region of marginality, so our documentaries belong to neither the political nor the commercial mainstream. . . . [Yunfest constitutes] a space where a multiplicity of perspectives can coexist, different voices can be heard, and real dialogue can take place. "Voices" and "dialogue" are therefore two major themes of the Yunfest.[140]

For Guo, what is crucial is to encourage not just the artists' voices but also the voices of their subjects, for he strongly believes in a saying first found in Africa: "Give people a voice rather than a message."[141] Accordingly, all three biannual Yunfest events programmed sections like "participatory visual education" and "youth forum" that promoted dialogue between voices professional and amateur, veteran and emergent, local and transnational.[142]

Compared with Wu Wenguang's project, Guo Jing's work is more genuinely place-based, longer-running, and more characteristic of collective activism. Han Hong and Tao Anping are correct in observing in current Chinese independent documentaries a turn from the thinker to the activist, from the individual to the collective, from a superficial glimpse to an in-depth study, and they persuasively identify the increasingly important role played by a growing number of NGOs and NPOs (non-profit organizations) in China, which provide both moral and financial support for the independent documentary and encourage artists to assume social responsibility and participate in social action.[143] One example cited in Han and Tao is a documentary training workshop—similar to Wu Wenguang's—that was conducted in 2005 by independent documentarists Hu Jie, Ou Ning, and Zhou Hao for volunteers from GAD (Genders and Development in China), a translocal NGO affiliated with the project "Beijing + 10," a series of transnational events launched after the United Nations-sponsored 1995 World Conference on Women in Beijing.[144]

To return to this chapter's epigraph from Massey, "For the future to be open, space must be open too," we realize that amateurism and activism through translocal networking have opened up a new space of identity and subjectivity for the Chinese independent documentary. As illustrated in Wu Wenguang's case, the

focus has shifted from giving voice to his like-minded artists in the late 1980s to training amateurs to document their own lives in the second half of the 2000s. The newly created, albeit still marginal and unstable, spaces of unofficial exhibition like Yunfest have attracted considerable transnational attention and facilitate sincere dialogue between different voices from different age groups in different localities on different geographic scales.

Space of Performance

Media and Mediation

> Just as there are no places without bodies that sustain and vivify
> them, so there are no lived bodies without the places they inhabit
> and traverse. . . . Bodies and places are connatural terms. They
> interanimate each other.
> —Edward Casey[1]

From its initial emphasis on personal visions and individual
subjectivity to its recent turn toward audience, amateurism, and activism, Chinese
independent filmmaking seems to have traveled a full cycle and now confronts the
political once again. But political engagement in contemporary China still entails
certain risks, and no matter how marginal or unofficial they intend their activities
to be, independent filmmakers and exhibitors have never escaped the surveillance
of China's dominant power. The arrest of Hu Jia, an outspoken independent docu-
mentarist and AIDS activist, and the compulsory relocation of the third Yunfest
from Kunming to Dali in 2007 are just two chilling reminders of the precarious
political situation in China.[2]

How can Chinese independent documentarists evade political surveillance?
How do they reach their target audiences? Rather than examining the pronounce-
ments of the artists themselves, as we did in Chapter 5, here we shift our attention
to questions of the media and mediation. By focusing on the spaces of texts, inter-
texts, and contexts of visual representation, I contend that for many independent
artists, the primary concern is not so much to capture the truth out there as to
transmit the information they discover in everyday life through unconventional
means. Two effective modes of production and circulation are performance and
piracy, and both intimately engage bodies and places—they interanimate each
other, as Edward Casey reminds us. As we shall see, bodily performance on and off
screen delivers information to places far and near, while piracy engenders a series

of daring embodied performances that take place in otherwise off-limit spaces, physical or virtual.

Thinking Outside the Box

IN THE REALM OF INFORMATION: AUTHOR, AUTHORITY, AUTHORIZATION

The contemporary Chinese independent documentary functions as an unusual body of information. It is unusual because it is strictly censored at home by the mainstream state and commercial media, but is often welcomed abroad and celebrated as images of "truth."[3] While the dual status of documentary film as a medium of artistic expression and a means of recording reality has authorized Chinese independent documentarists to stake claims to truth repeatedly, the medium's inherent tension between image and reality remains troubling for most Chinese documentarists and critics.

Chinese independent filmmaking's claim to truth is most famously evidenced in the statement "my camera doesn't lie." Once publicized, the statement quickly took on a new measure of authority and authenticity. While the film of that title successfully made the rounds of the international film festivals, the book reportedly became one of the year's best-selling volumes about film in China.[4] In lieu of watching many inaccessible independent films as moving images, the Chinese audience apparently has opted to satisfy its curiosity by reading about these films and accepting printed words and illustrations as an authorized source of information.

Nonetheless, in spite of its manifesto-sounding title, neither the popularity of the book nor interest in the documentary overseas has helped to ease the tension between representation and reality. Admittedly, tension of this nature has long existed in documentary theory and practice in the West. As Brian Winston concedes, John Grierson's famous definition of the documentary as "the creative treatment of actuality" has compelled generations of documentarists and theorists to grapple with the contradiction contained in this particular form of filmmaking.[5] On the one hand, tradition-minded theorists have continued to insist on the documentary's assumed ontological proximity to reality, as is evident in Michael Renov's assertion that "every documentary issues a 'truth claim' of a sort, positing a relationship to history which exceeds the analogical status of its fictional counterpart."[6] On the other hand, radical critics have highlighted the construction and artificiality of documentary filmmaking and have proposed new ways to conceptualize truth, reality, and authenticity, as illustrated in Stella Bruzzi's statement that "documentaries are performative acts whose truth comes into being only at the moment of filming."[7]

It is in this context of contending claims to truth and reality that a study of the Chinese independent documentary as a troubling case of information can redirect our attention to a series of complex issues involved in the production, circulation, exhibition, and reception of documentary images. The case is troubling not simply because certain types of intended information (such as AIDS, homosexuality, prostitution, poverty, unemployment, forced migration) may trouble and potentially subvert age-old normative concepts in Chinese culture and society.[8] The case is troubling also because the status of images and information in the Chinese independent documentary raises critical questions regarding interpretation, access, mediation, ethics, affect, and agency.

Claimed as "true" information, the Chinese independent documentary takes it as its primary responsibility to go beyond conventional media coverage to expose and explore sensitive "news" or "newsworthy" stories, thereby unequivocally defining its disruptive role as analogous to that of investigative journalism. Ironically, even when the Chinese independent documentary deliberately rejects the use of an "authorial" commentary, and the "truth" status of its images and imaging is denied by the official national media in China, in the age of transnational information flows it is validated by the global media, most often by those venues affiliated with prestigious international film festivals and proud of their authority and expertise in artistic vision and journalistic precision. On the one hand, this kind of reputedly "true" information is routinely dismissed by China's mainstream media as ill-intended, interfering "noise"—as "misinformation" or "false" information whose author lacks authority or proper authorization—and thus is relentlessly blocked from free circulation inside China. On the other hand, it is precisely such censored information that is highlighted as the evidence of "truth" overseas, where both international film festivals and globalized news media act as if they were the ultimate "jury" on the valence of truth. Under this authoritative global jurisdiction, jury instructions are unproblematically passed on to international audiences as to where, when, and how to locate images of truth about contemporary Chinese life.

A case in point is "Bright Lights," an article Richard Corliss wrote for *Time Asia* in 2001, in which this New York-based film critic enthusiastically endorses underground Chinese directors and their feature productions: "The message may be simple, even brutal, but it is *authentic.* . . . They risk their career to deliver uncomfortable *truths.* If it is hard to find heroes in these movies, it is easy to see the *heroes behind* them."[9] As is typical of Western media pundits, Corliss cannot help but enlist "the pernicious attention of government censors" operating in "one of the world's most repressive systems." With unwavering confidence, he concludes, "Desperate circumstances create principled outlaws. The censors didn't intend this, but by their intransigence they helped spawn a truly independent film culture."[10]

Figure 6.1. First Beijing gay film festival, banned midway in 2001 (courtesy of Norman Spencer)

The assumed authority of overseas jury instructions has in turn influenced media coverage inside China. One recent example is a feature article in *City Weekend,* an online entertainment journal in English subsidized by a multinational corporation and catering to an increasing number of expatriates in Beijing and Shanghai.[11] Using a clichéd pun on the "reel" with the "real," the author opens with an assertion that "China's DV handicam documentarists are producing a mosaic of images telling the story of a country in the throes of massive change" and then interprets these images as "reflecting the desire shared by many filmmakers to *capture* the raw and the real, bearing *witness* to the resilience of the human spirit as people struggle to triumph over adversity and make places for themselves in a world that dizzies with the speed of its transformation."[12] More specifically, the article cites *Beautiful Men* (Du Haibin, 2005), a documentary about the lives of a close-knit group of drag-queen performers in Chengdu in southwest China, and interprets this reputed "darling" of the Second Beijing Gay and Lesbian Film Festival, held in April 2005, as a "signal that times are changing and the people on the margins of society are making inroads into the public sphere."[13]

The choice of words such as "capture" and "witness" barely conceals an intended correspondence between a documentary's images and its claim to truth. What is problematic in such journalistic coverage is its blind faith in the transparency of the medium, as if nothing ever gets lost or added at different levels of

the information flow: for example, from the documentary work to the news story and then to a reader/viewer. Rather than taking information at its face value as something with fixed content, we must interrogate information in all its mediating processes, from its construction as words and images through its reproduction via technological means to its circulation and reception in concrete historical contexts.

INTO THE WORLD OF *THE BOX*: ACTUALITY, ACTING, AFFECT

A source of information itself by now, *The Box* was started as a documentary in search of a particular kind of information: lesbian life hidden from the pubic view. An "absolutely straight person" in her own characterization, Ying Weiwei, a state-employed television program director from Shenyang in northeast China, had conceived the project in early 2001 but had encountered difficulties finding appropriate informants until she posted an Internet message.[14] Email responses came immediately, from as far as south China, and Ying decided to go with two lesbian artists. She borrowed a Sony DS99 DV camera, bought fifteen cassettes of tape, and traveled to a faraway city. The couple met her at the gate of a university and brought her on bicycle to their apartment, where half an hour later, she began filming the closet life of two total strangers. The result of her weeklong, nerveracking work was a documentary, whose information is now searchable online at Yamagata International Documentary Film Festival's website:

> "A" is a painter and "B" is a singer. They are lesbians who live together peacefully, building up a world between them that is both pure and beautiful, and closed and vulnerable. The director touches upon their emotional experiences, reflecting many complex factors behind homosexuality relevant to sociology, psychology, ethics and more.[15]

Like many contemporary Chinese independent documentaries, *The Box* opens with an extended sequence of talking-head interviews, in which Wang (the painter) and Liu (the singer) take turns speaking directly to the camera and narrating their personal experiences, such as lack of parental affection, disgust with heterosexual love, resentment at sexual harassment, and despair during an abortion procedure. Unlike most of its counterparts, *The Box* shows this initial sequence in black and white, as if to intensify the somber tone in which Wang and Liu recall their lives before they found each other.

An intertitle in both Chinese and English announces, "On Mooncake Festival of 2000, Wang . . . and Liu . . . got to know each other through [the] Internet," and the actuality of their intimate life is now rendered in full color. In a prolonged sequence of about twelve minutes, they are seen naked from the waist up, engaged

in daily routines like brushing their teeth, combing their hair, inserting contact lenses, and watering potted plants by the window, while outside street traffic noise confirms the actuality of the scene. The sequence is captured in long takes, similar to Hou Hsiao-hsien's signature style, with a stationary camera and a few fixed frames.[16] A brief shot of Wang and Liu hugging each other after work is followed by another sequence of roughly seven minutes. Again naked except for panties, the two are seen acting childishly in the bedroom, first chasing each other around and wrestling together, and then tenderly touching each other's face against a sound track of a piano concerto and chamber music.

Another intertitle, "Once between us there was a woman called X," brings in a second round of talking heads, this time in color. Focused on a recent disruptive episode in their life, this sequence is marked by two alterations. First, Wang looks sideways while speaking, as if turning away from the unhappy memory, for she admits to having collapsed when Liu considered separating from her for the other woman. Second, it is the only time in the film the director's voice is heard off screen, asking, "Is she [Liu] your first partner? You haven't had any one before, right?" which Wang answers affirmatively. The telephone rings while Liu explains that her motivation back then was to show sympathy for a middle-aged woman, for whom Liu subsequently found a partner via the Internet.

The film returns to black and white in a seven-minute sequence in which Liu is quarreling with her former partner over the phone. Wang walks out of the bathroom and, in a couple of rare shots, pokes her finger at the camera and stares right at it, in an extreme close-up. Color returns when Liu, again in a talking-head position, rationalizes her breakup with the other partner following six months of uncertainty. After another domestic scene of Wang painting and Liu playing a guitar, the two are seen for the first time outside the apartment, near the courtyard parking lot, in a restaurant, and in an office-like setting. Significantly, even in public they are entirely absorbed in their own world—an intimate kind of absorption further demonstrated in two other scenes. In the first, Liu is admiring Wang in a beautiful red skirt, and the camera assumes a voyeuristic gaze. In the second, Liu and Wang take showers in turn, completely naked, ignoring the presence of the camera altogether.

Such is the "naked truth" about the private life of a lesbian couple that Ying Weiwei has presented in *The Box*. Yet, as Ying insists, the film's graphic nudity does not suggest anything in particular because that was the couple's most "natural" and "truthful" condition in the summer: they lived like that when it was hot in the apartment, and they trusted Ying enough to let her film them half-naked starting from the third day. Still, it is worth noticing that the information contained in the film is by no means unadulterated, for the shifts from black and white to color and vice versa already foreground mediation, as does the insertion of intertitles. Ying

admits in an interview that she deliberately avoided filming the couple's discussion of sex because she had decided by then that in their relationship "spirituality" outweighed sexuality.[17] In order to capture the "pure beauty" of the couple's world, which exhibits a kind of "poetry" that moved her to tears on the fourth day of shooting, Ying believes she invested too much of her emotion in "every single shot."[18]

The documentarist's emotional investment is most visible in the film's final sequence, in which the couple, sitting on the bed half-naked, talks about their creative writing. Wang's work moves people to tears, Liu comments, and she proceeds to read from Wang's poetry:

> Those dead and alive, are you still awake?
> If so, please listen to me . . .
> My body is wet and warm,
> Clearly keeps the temperature exact
> Neither too cold nor too hot
> [Does] not trouble me the least. . . .
> Years have passed. It still keeps its figures unchanged.
> How moving it is!
> Man's will is no stronger than [the] body
> It is easy for you to tell.
> Even one freed from worldly cares
> Just manages to live like a running flesh. . . .

Bathed in a warm light, Wang listens to Liu's recitation with a curious, sad look. Amazingly, this intimate emotional act is unfolding right in front of the camera, a scene of actuality charged with contagious affect—so contagious that Wang proceeds to read a piece of her own writing, in which she imagines her prenatal existence in her mother's womb, her yet-unknown gender, and her anticipation of maternal love: "Then I flew away; the hell looked so beautiful." Wang spreads her arms apart on the bed and looks up at the camera, her voice echoing as if from a faraway place, and her look pointing the imaginary viewer beyond the confines of their boxed-in, "womb-like" space of existence.[19]

TOWARD "DIGITAL" PERFORMATIVITY: GESTURING, POINTING, TOUCHING

It must be obvious by now that the "true" information in *The Box*, as intended in an "honest and frank" manner by the documentarist and published online in searchable format,[20] is mediated through human emotions and bodily movements. Understandably, to intensify the affective dimension, theatricality is built into the structure of visual evidence, while the performance itself sometimes takes on the

status of evidence, of something that both demonstrates through the embodiment of the otherwise unrepresentable and compels through revelatory bodily movements. Significantly, even the director characterizes her roles as "an actress," "a recorder and witness" when she sought to "experience different lives with different persons."[21] By virtue of the performativity on both sides, affect is intensified in moments of revelation—moments that make something "take place" in front of the candid camera, bring forth the unspeakable, and set it "in place" as visual evidence.

On the other hand, by virtue of the performative, affect may accomplish a concurrent act of concealment or subversion in that it literally drives the conventional out of sight, out of touch, or even out of mind. Thus, in *The Box*, the heterosexual world is deliberately bracketed off from the image track: its ghostly presence as a verbal reference is substantiated only by a brief, random appearance of a few men riding bicycles past the couple in the courtyard. In a sense, the film's heightened theatricality has created what Foucault would call a heterotopia, a place without place (that is, a place existing in the non-place of acting, in the acting that lacks a physical place),[22] a space in which truth can be hinted at by gestures, information be obtained through tropes of embodiment, and affect be appreciated in nuanced details of motions and emotions.

A "performative impulse" has been duly cited in recent Chinese documentaries to refer to works that involve performances, like *The Other Shore,* or contain explicit theatricality, like *Crazy English.*[23] Yet, performativity can exist in a more subtle way, and Bill Nichols' characterization of the Euro-American performative documentary may be borrowed to foreground the affective dimensions of *The Box*: "The shift of emphasis toward the poetic, expressive and rhetorical also reconfigures questions of validation. . . . Our assessment and engagement, then, is 'less in terms of [the message's] clarity or its truth value with respect to its referent than in terms of its performance force.' . . . We are what such films refer to."[24] The performative, in other words, demands the viewer's immediate response in the key moments of encounter, and this opens up a third realm of performance in addition to those of informants and documentarists.

"Performative documentary . . . gives priority to the affective dimensions struck up between ourselves and the text," observes Nichols, and his statement that this new documentary mode "proposes a way of being-in-the-world as this world is itself brought into being through the very act of comprehension"[25] nicely captures the directorial intention of *The Box*: "The process of recording is the one of understanding their lives."[26] In other words, Ying Weiwei shot the documentary in order to extract taboo information and help herself and her viewers to comprehend the secret lesbian world. In light of J. L. Austin's theory of the speech act, *The Box* can be said to have both "named" and "performed" that world for the viewer,

and this simultaneity of naming and performing the act is precisely the new concept of "performance" that Bruzzi seeks to introduce into the theorization of the performative documentary. "Documentaries, like Austin's performatives, perform the actions they name"[27]—that is, actions of documenting and recording, which inevitably involve subjects, filmmakers, the apparatus, and, no less important, spectators.

The presence of the filming apparatus implies that a less visible link between performativity and technology deserves further attention. For Samuel Weber, the etymological and semantic richness of the word "digit" (from the Latin *digitus* meaning "finger") points to the connection between digital information and theatricality itself as technology:

> The hand is the organ of grasping, of appropriation, of perception and conception, of seizing and of controlling. The finger, by contrast, is that of *pointing* and of *touching*. At the periphery of the body, the finger points us elsewhere. In so pointing, it gestures not simply beyond the confines of the individual body as a self-contained whole, but, more radically, beyond the confines of place as such, which is to say, of place as the unmovable container or field required for objects of perception and of consciousness to *take place*. In pointing, the finger touches the other, or at least a certain exteriority. It can also in so doing try to put the other in its place.[28]

To rephrase this differently: by means of "pointing" or "gesturing" at the fragmentary in the existential world rather than "grasping" the imagined totality, elusive truth or hidden information may "take place" as embodied images on screen and be put in place as visual evidence. In Ying Weiwei's case, digital technology has enabled her to "put the other in place" (per Weber) and to "touch upon their emotional experiences" (per website information); it has also pointed her to a new place where she has successfully discovered a "personal" mode of expression in an otherwise male-dominated profession. This is precisely the reason behind her acknowledgment that, technologically if not ideologically, DV has brought "liberation" to female media workers in China.[29]

In an interesting way, *The Box* illustrates Weber's theorization of the gesture as "a bodily movement that interrupts and suspends the intentional-teleological-narrative movement towards a meaningful goal, thus opening up a different kind of space."[30] In turn, Weber's theory of gesturing is dovetailed by what Lesley Stern hypothesizes as a type of "cinematic gesturing" that literally moves the viewer in a kinetic, sensorial, and visceral manner. "The film works (like a dream 'works') as a patterning of doubles, mimicry, repetitions, [and] returns," Stern writes of *Good Men, Good Women* (Hou Hsiao-hsien, 1995): "This is a film propelled by

movement—filmic and bodily movement, mechanical and pathetic, movement to and fro between past and present, here and there."[31]

What Stern locates in Hou's film as "a circuit of energy that passes through actants, gestures that mobilize bodies, affects that travel between bodies on the screen and bodies in the audience"[32] are similarly present in *The Box,* in part because of its "imitation" of Hou's style of long takes. In *The Box,* cinematic gesturing works in tandem with performativity the moment when Wang's face looms large in front of the camera. The monotone of Liu's telephone quarrel with the third partner is de-referenced, and the viewer is physically forced into silent, face-to-face communication with Wang. Her fingering of the camera lens indicates simultaneously her curiosity at this enabling technology and her sadness at her inability to articulate verbally. Indeed, the cinematic technology enables the viewer to see an extreme close-up of Wang's iris, which hides nothing from view but highlights something unfathomable—a touch of profound sadness behind an act of pure curiosity. Here is a compelling example of cinematic gesturing, one in which the viewer is kinetically moved closer to the screen, emotionally touched in a poetic ambience of affect, and imaginatively pointed to a space beyond the confines of a self-contained world.

OUT OF THE BOX: ACCESS, PIRACY, DEMOCRACY

As *The Box* demonstrates, DV technology constitutes another argument in favor of studying the Chinese independent documentary as a unique kind of information, one that is increasingly reliant on and benefiting from digital production and reproduction. Through technological transmutation and transmission, Chinese documentary images transcend conventional spatiotemporal limits and deliver information otherwise inaccessible in the mainstream information system. Many of these works are shot with a DV camera, which not only enhances the documentarists' freedom in mobility and reduces the costs of independent production, but also facilitates circulation within and across the national borders.

An example of these Chinese productions taking international road trips, *The Box* was exhibited in 2002 at the Berlin International Film Festival, at a "visual truth" film festival in Switzerland, as well as at festivals in Hong Kong, Japan, and South Korea.[33] Since then, it has traveled to countries like France, the Netherlands, and the United States, where it was presented on campuses like the University of California, San Diego in October 2003 and Cornell University in March 2004.[34] *The Box* likewise received critical acclaim inside China. In fact, it was originally produced as an entry in a nationwide competition at the First Unrestricted New Image Festival organized by Guangzhou-based *Southern Weekend* (Nanfang zhoumo), the Directing Department of Beijing Film Academy, and Practice Society in Beijing, and held at Beijing Film Academy on September 21–27, 2001.[35] This

unprecedented, unofficial event showcased independent productions in fictional, experimental, and documentary categories, and *The Box* proved a huge success. Cheng Qingsong, a film critic and a juror at the festival, considers *The Box* to have been the best among all forty-seven competition entries and regrets that it lost by just one vote to *Along the Railroad,* a film about homeless children that was awarded the top prize in the documentary competition.[36]

From Beijing, *The Box* went on to screen in other small-scale, unofficial film events in China, such as the Shanghai Exhibit of Unofficial Films. Apart from film festivals and exhibitions, numerous cafés, bars, and art galleries in major cities have also provided unofficial access to Chinese independent documentaries (see Chapter 5). Located on the ground floor of a residential apartment building a few blocks from the east gate of Qinghua University in Beijing, Box Café is one of them, although its main business is serving drinks and furnishing a place where customers may browse books and magazines on shelves and tables.

In October 2002, the café hosted a documentary series in its small venue with a projection screen and twenty-some table seats. While the recent works by Hong Kong's group Documentary Power left a favorable impression, several mainland Chinese documentaries, including Jia Zhangke's *In Public* (see Chapter 4), were either booed or questioned by the audience.[37] Despite its length, Wu Wenguang's *Jiang Hu* saved the day and concluded the documentary event with satisfaction. Walking out of Box Café, one commentator recalled a sentence that a previous visitor had written in the café diaries: "The box is a space for imagination, not a harbor for escaping a storm."[38]

Unfortunately, even as a space for imagination, Box Café was not safe from state surveillance; it was soon banned from having "illegal" exhibitions inside its premises, although it could still choose to carry flyers for similar events elsewhere in the city. The persistence of official censorship proves that the most urgent problem for the Chinese independent documentary is not so much its status as the evidence of "truth" as public access to that truth or information.[39] Censored as "noise" by the national information system and suppressed as troubling information by state censorship, daring images from Chinese independent documentaries can enter into "free" flows only through international venues, and the Chinese authorities frequently accuse such unofficial "overflows" beyond the confines of China as "illegal" because the majority of independent documentaries are produced underground, distributed independently, and exhibited abroad. It is true that documentarists have been doing so without required state permits, and they are therefore technically in violation of the existing domestic legal codes and regulations.

Ironically, while international audiences have "free" access to Chinese documentary images by purchasing tickets, Chinese audiences may actually have access to the same images free of charge by resorting to piracy, an unconventional

but extremely popular means of mediation in China. Interestingly, piracy in this case may not imply a premeditated violation of the author's intellectual property rights, for many independent documentarists intend to distribute their works free through unofficial channels, such as video reproduction and Internet uploading.[40] Examined this way, piracy constitutes an act of defiance or protest against the increasingly commercial nature of Chinese media operations, which dictates that sensitive political topics are avoided first and foremost for financial reasons.

Piracy is thus an instance of the "tactics" of survival, appropriation, and potential intervention by the weak vis-à-vis the "strategies" of the hegemonic, intertwined powers of the state and transnational capitalism. As "an art of the weak," piracy operates very much the same as the "tactic" in de Certeau's explication: "It must vigilantly make use of the cracks that particular conjunctions open in the surveillance of the proprietary powers. It poaches in them. It creates surprises in them. It can be where it is least expected. It is a guileful ruse."[41]

One of the "surprises" created by the weak is a hitherto unforeseeable trajectory of filmmaking in China—"from piracy to democracy"—a trajectory made possible by the newly available digital technology and enthusiastically celebrated by independent directors like Jia Zhangke. For Jia, the wide circulation of inexpensive pirated VCDs since the mid-1990s has empowered ordinary consumers, who were previously denied access to international film classics and were treated with contempt by the "professionals," to reclaim their right to watch films otherwise classified as "for internal use" by cultural leaders and film professionals.[42] To use de Certeau's metaphor, piracy has poached in the cracks of the authoritarian monopoly of film resources in China.

What is more encouraging to Jia is that the current state of "democracy" in film-watching, made possible by piracy, promises the emergent democracy of "amateur filmmaking," made possible by digital technology. Citing Jean-Luc Godard, Rainer Werner Fassbinder, Quentin Tarantino, and Ogawa Shinsuke as stellar examples from the past, Jia anticipates a democratic future—the "second coming" of amateur, independent filmmaking:

> Their modes of filmmaking are always full of surprises, but their emotional investment always falls into solid places. They do not care about so-called professional procedures, so they discover more possibilities of innovation. They reject the fixed standards of the trade and are therefore able to underscore multiple concepts and values.[43]

Undoubtedly, *The Box* is an outcome of such amateur filmmaking, which exemplifies what Jia characterizes as "the spirit of amateurism": to "embrace equality and justice, as well as a concern with human fate and compassion for ordinary

people."[44] A "surprise" to the world of the Chinese documentary from a first-time amateur filmmaker, Ying's documentary echoes the uses of the same word "surprise" in de Certeau's theorization of the weak power and Jia Zhangke's anticipation of democratic filmmaking. For Jia as for Ying, digital technology promises a "democratizing," "liberatory," or even "revolutionary, subversive" prospect in the fast-changing mediascape of postsocialist China.[45]

THINKING OUTSIDE THE BOX: MEDIATION, SUBJECTIVITY, AGENCY

Jia Zhangke's elaboration of alternative modes of filmmaking returns us to issues of mediation in documentary. Intended as information, Chinese independent documentary images strive to capture and reproduce a semblance of transparency and immediacy, both of which are achievable by means of minimal authorial manipulation, reflected for example in the recurring tropes of talking-head interviews, natural lighting, on-location sound, a shaky camera, and grainy images. Watching such a documentary work, the viewer is given the impression of entering the "here and now" and staying "on the scene" *(xianchang),* in the actuality of unfolding events, as the screen images seem communicated directly, as if unmediated, to the viewer. Upon scrutiny, of course, this semblance of transparency and immediacy barely conceals the fact of mediation.

The mediation under discussion may occur at three levels: between author and subject, subject and image, and image and technology. The first level involves the documentarist's selection of topics and subjects, a selection-cum-mediation that inescapably touches on the issue of documentary ethics on the part of the documentarist as a knowing author. The second level, which involves subjects and their images, simultaneously foregrounds the product of truth-reality and the degree of performativity necessary for such truth-reality to "take place" literally in front of the camera. The third level involves the documentary images and their transformation or transmutation through technology, a process by which images are inevitably dislocated and relocated in different registers of time and space.

Produced as uncensored information, the Chinese independent documentary challenges the mainstream media by consistently exploring sensitive topics, topics given value more often as news than as art. These topics regularly touch on certain concealed aspects of private life, so the question of ethics arises when privacy is reproduced as voluntarily disclosed images for public viewing. Indeed, it is often through the "naked truth" behind the undisguised privacy of marginal or marginalized people that independent documentarists achieve a measure of publicity for themselves. It is ironic that privacy can obtain the status of truth only when it is publicized by entering into public circulation. But what pertains to the realm of ethics here is the fact that the one who benefits from media publicity is always the author and never the subject. The documentarist extracts information from the

informant, but then it is the documentarist who secures public recognition whereas the informant will fade into a shadowy background, if not into utter oblivion.[46]

The "cruelty" resulting from the documentary's intrinsic ability to violate privacy by rendering it public has troubled at least three female Chinese independent documentarists. They are all aware that in the process of production and circulation of such information, privacy is volunteered by the informant (as a subject rarely endowed with subjectivity), while publicity is always granted to the documentarist (as a conscientious "agent" in full possession of subjectivity). Yang Tianyi, whose *Old Men* took her two-and-a-half years to shoot and another half year to edit, felt troubled by guilt after the film received awards and she herself became famous: "The old men are still sitting outside their houses, but I feel like a thief—having stolen from them just to dress myself up."[47] Similarly, as mentioned in Chapter 5, Li Hong admits that the documentary employs a "brutal" method, and her *Out of Phoenix Bridge* constitutes an act of "looting" the privacy of "migrant workers" by a city dweller; in short, she directed the film for herself, not for her informants who had traveled from Anhui province in central China to work in Beijing.[48] For documentarists like Yang and Li, the public circulation of on-camera private life continues to generate their sense of "guilt": willingly or not, they have exploited, "looted," or "stolen from" their informants by shooting the documentaries.

Although she does not share such feelings as intensely as Yang Tianyi and Li Hong do, Ying Weiwei concedes that shooting *The Box* was a "painful" process for her. She constantly felt troubled or even "tortured" by her unsettled identity on location: "Was I a director? A recorder? A listener? A witness? Or their friend?" The friendship she established with her informants has given her some comfort, but she knows all too well that she has no control over what will happen to the beautiful but fragile world she captured in *The Box*. "This is exactly what makes a documentary cruel," she admits, "it is simply too real."[49]

Whether or not they are fully aware of the documentary's "cruelty," informants may themselves be eager coproducers of their privacy as public information, and their coproduction of on-camera privacy frequently draws on elements of performance and theatricality. The dimension of affect and performativity in *The Box* is indispensable to an independent documentary's status as compelling information. To count as compelling, a documentary must present visual evidence, in the form of real-life people, moving images, touching stories, and memorable events, to the imaginary "trial court" composed of film festival jurors, media pundits, and news reporters. The prerequisite of the "compelling," the "moving," and the "memorable" thus precludes certain visual evidence as undesirable, while at the same time motivating documentarists to pursue other kinds of evidence as enticing or even indispensable. It is exactly at this point that affect as body-oriented, sensuous, emotional, and even aesthetic experience comes into play.[50]

Finally, mediation of imaging and information points to the issue of agency in the Chinese independent documentary. But whose agency is it? More often than not, it is the agency of independent documentarists as they define their position in defiance of the mainstream media with its political censorship and commercial profit-chasing. The informants' agency, insofar as they volunteer their own privacy as information, is routinely ignored or denied by the international "jury," for the access issue—the jurors' lack of linguistic knowledge and specialized, indigenous cultural information—prevents them from knowing the (under)represented in these documentary works. Similarly, it is difficulty to talk about the informants' subjectivity because documentarists, despite their efforts to make informants into "subjects" with their own voice, have always appeared as the credited producers and directors and, by assumption, as the sole "proprietor" of the information thus captured and transmitted. Furthermore, informants are routinely excluded from viewing the products of their privacy-rendered-public information, and their on-camera performance, however compassionate and compelling, pales in comparison with the triumphant documentarists, who are praised for contributing to global information flows via the transnational media.

To a troubling degree, Chinese independent documentarists have increasingly become "agents" trusted and entrusted by the transnational media to produce images perceived as true. This noticeable shift in the proprietorship of documentary images has troubled some Chinese documentarists with regard to their alleged "independence," for they now may take orders from and report directly to some overseas funding agencies, whether these are international film festivals, private foundations, or television stations, such as Arte of France, BBC of the United Kingdom, and TV2 of Denmark. A recent Chinese documentary series produced for these three European institutions included works by three well-known Chinese independents: *The Secret of My Success* (Duan Jinchuan, 2002), *This Happy Life* (Jiang Yue, 2002), and *Dancing with Myself* (Li Hong, 2002). Likewise, Jia Zhangke's *In Public* was funded by a South Korean company and slated for the Chonju International Film Festival in South Korea (see Chapter 4).

In their capacity as the newly empowered agents, as the representatives whose agency or subjectivity is invariably compromised by their actual or potential employers, Chinese independent documentarists cannot help but act as "brokers" or mediators in the arbitration as to what kind of information will be selected, produced, edited, and circulated. It is evident that, like agency, mediation of imaging and information has proven to be a crucial, complex, and consequential question in a study of the contemporary Chinese independent documentary. In this sense, the Chinese documentary cannot be conceptualized simply as "the haunting of the real,"[51] for it is primarily the haunting of mediated images, of mediating agents, and of mediation itself. The persistence of mediation—the ghosting of the

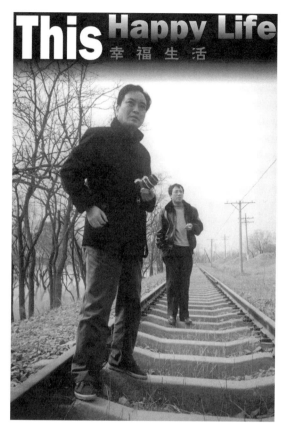

Figure 6.2. Poster for *This Happy Life* (2002): documentary agency in question

apparatus that stages and documents the interactive, performative acts of agents, informants, images, and spectators—thus foregrounds the contemporary Chinese independent documentary as a case of troubling information in need of careful scrutiny and continued tracking.

PLAYING WITH INTERTEXTUALITY

Piracy is a challenging issue that cuts across the interconnected, overlapping domains of film, law, market, morality, creativity, and democracy. Rather than endorsing the global media industry's outright condemnation of film piracy as an illegal practice in need of stringent control and eventual eradication, I am interested in both the intertextuality and the contextuality of film piracy in postsocialist China. Central to both is the concept of textuality as "an open, infinite *process* that is both meaning-generating and meaning-subverting," and as "the manifestation of an open-ended, heterogeneous, disruptive force of signification and erasure that transgresses all closure."[52] Thus conceived, textuality differs from the classic

idea of a work as a closed, finished representational object with fixed meaning. My concept of intertextuality builds on this emphasis on the process of signification and subversion that benefits from deliberate references to other texts and generates new tensions and new meanings between texts. Furthermore, contextuality is proffered to discourage an understanding of context as a closed, bounded, overdetermined concept. Rather, contextuality aims to highlight the fluid, heterogeneous nature of the contexts of film piracy in China, and these multiple contexts are brought to bear on one another by Chinese filmmakers to form a certain kind of intercontextuality in which new tactics of subversion become possible and new meanings are generated and proliferated,

The intertextuality as here conceived derives from the multiple uses of piracy on and off the Chinese screen, and my focus is the alternative production of meanings that uses "pirated" (unauthorized) images from foreign films in recent Chinese underground and independent filmmaking. By reading a few recent feature and documentary films related to piracy, I also explore the contextuality of film piracy in China and the intercontextuality constructed by the artists' deliberate juxtaposition of disparate contexts, from global to local, legal to artistic, repressive to liberatory, depressing to uplifting, and realist to parodic.

FROM PIRACY TO CONSPIRACY: THE CONTEXTUALITY OF FRAMING

In 2001, a special report of the International Intellectual Property Alliance asserted that the international community was continuing "to refer to China ignominiously—based on piracy levels of 90 percent and above—as the 'piracy capital of the world.'"[53] To be sure, piracy is not an isolated problem geographically restricted to a single nation-state, and recent studies demonstrate that piracy has been a widespread transnational phenomenon in East Asia for many years. However, because of its vast audience base, China has been subjected to escalating scrutiny through the lens of conspiracy theory, the "conspiracy" in question seeming to involve three possible scenarios. First, Chinese consumers are seen as conspiring with the Chinese state in defiance of global capitalism; this is a prevailing view in the West, which has stepped up its pressure on the Chinese state to crack down on piracy, especially since China's entrance into the WTO in 2001. Second, Chinese consumers are seen as conspiring, intentionally or not, with underground gangster tycoons in defiance of both the Chinese state and global capitalism; this view comes from some cultural critics who deplore consumers' unsavory taste in entertainment products and detect the state's growing incompetence in implementing censorship. Third, Chinese consumers are seen as conspiring with each other, albeit mainly on an individual basis, against the hegemonic powers at the global, national, and municipal levels; this is a view I will examine by reading Chinese independent works that specifically address piracy issues.

I will not here address the first conspiracy theory, which frequently surfaces in media coverage and industry reports in the West and often smacks of conspiracy on its own. The second conspiracy theory was recently articulated in Laikwan Pang's critique of film piracy as an aggressive operation that deprives global capitalism of its intellectual property rights and yet nonetheless benefits an underground, unlawful form of transregional capitalism based in Asia. Pang's study examines two large issues: the internal contradictions of globalization now manifest in contemporary Chinese culture and the impact of film piracy on a collective identity or Chineseness as constructed by Chinese cinema and the mass media. Her characterization of "Chinese cinema's metamorphosis from a collective public event to a piracy-privacy activity, from a highly controlled mode of production and distribution to a *completely underground* operation" surely borders on exaggeration.[54] On the contrary, as I have illustrated in Figure 3.1, postsocialist Chinese cinema is still an unsettled force field where four major players redefine their positions vis-à-vis the market and compete for dominance and legitimacy by adopting different strategies and modes of interaction.

There are two problematic points in Pang's critique of piracy/privacy. The first is an implied elitism in her distrust, if not dismissal, of Chinese consumers because of their supposed preference for problematic Hong Kong and Hollywood commercial products—problematic to her in terms of subject matter and ideological representation,[55] not in terms of the consumers' reception, which would certainly allow for negotiation, contestation, or even subversion. Besides, not all Chinese consumers indulge in entertainment products. Contrary to Pang's elitist distrust of consumers, Shujen Wang's sociological investigation of piracy consumption in the Chinese-language markets proves that access to nonmainstream American and European art films may be a factor as crucial as the price differences between a pirated video and a theatre ticket.[56] Although a pirated video may be ten times cheaper than a blockbuster movie ticket, with art films most consumers have no other choice than pirated versions because the films they want to see are not available in mainstream theaters or video distribution.

The second problem in Pang's critique is evident in her claim that "movie piracy can be seen as the largest crime collectively committed by the Chinese people against the authority of both the State and the global culture industry."[57] Insofar as film piracy is concerned, Chinese consumers—excluding those who also work as filmmakers—are rarely in direct opposition to the state. They are, however, delighted to seize the opportunity created by the confrontation between the state and the global media to turn the state's ineffective control into their personal consumption gain. The state's apparent ineffectiveness regarding pirated entertainment, therefore, does not indicate its fading power over matters of collectivity in China (as Pang interprets it), but rather exemplifies its strategic positioning

in negotiation with global capitalism. Piracy control, in other words, is an effective bargaining chip that the Chinese state holds in its game with the global powers, and it can choose to crack down on piracy periodically, even symbolically, in exchange for compromises and concessions in its favor. As such, piracy no longer belongs to a zero-sum game in which, according to game theory, "to the degree that one party wins, the other necessarily loses"; rather, piracy belongs to a non-zero-sum game in which both or all sides may gain at the same time.[58] Power has "to be viewed within the dynamics of those involved," Shujen Wang summarizes sociological theory, and so "power is not absolute; instead, it has to be viewed *in* relations and, indeed, *as* relations."[59]

In relational terms, film piracy may be conceptualized as a conspiracy of the weak, since piracy consumers occupy the space of marginality vis-à-vis both global capitalism and the Chinese state. Marginality, as Stuart Hall argues, "is a space of weak power, but it is a space of power, nonetheless."[60] Following Hall, we may regard the consumption—although not the production—end of film piracy as a space of weak power. This weak power operates using a tactic, defined by de Certeau as "an art of the weak": "It takes advantage of 'opportunities' and depends on them, being without any base where it could stockpile its winnings, build up its own position, and plan raids. What it wins it cannot keep. . . . [It] must accept the chance offerings of the moment."[61]

Contrary to Pang's insistence otherwise, I believe that de Certeau's concept of tactic versus strategy works adequately in the context of piracy if we approach the issue from the perspective of consumers as a "weak power," rather than from the perspective of those reputedly powerful "gangsters" who reap most profits from piracy. Shujen Wang's interviews with piracy consumers in various walks of life (university professors and students, private businessmen, and ordinary workers) remind us that, even if considered as a conspiracy, piracy does not amount to an organized crime; instead, it operates within an array of tactics of access, appropriation, proliferation, subversion, and (self-)empowerment—tactics that emerge into better view if we make a bottom-up, case-by-case study instead of a top-down, overly general critique.

But before taking such a case approach, I first want to elaborate on the metaphorical implications of Shujen Wang's book title, *Framing Piracy*. Her intention may be to provide a "framing" or methodological framework for the study of piracy rather than to "frame," implicate, or indict piracy as a "crime" to be controlled and eradicated. Her attempt at "framing piracy" is therefore one of "unframing" or exonerating piracy as a legal or moral issue and "reframing" it as a sociocultural problem. To switch the contextuality of framing, I suggest that we move from cultural consumption to cultural production and consider the ways piracy is reframed as an issue not of legal abuses but of creative use or reuse. In most cases involving

piracy, the creativity of Chinese filmmakers matters more than the authenticity of the original work, and their reuse of pirated materials is a key to producing new dimensions of intertextuality and intercontextuality. Thus working on behalf of the consumer, these filmmakers reframe piracy as a space of weak power that may generate "humanistic" or even "democratic" aspirations—two possibilities denied in Pang's critique but substantiated in the following analysis.

FROM AUTHENTICITY TO CREATIVITY: THE INTERTEXTUALITY OF REFRAMING

Concepts of intellectual property rights involve definitions of authenticity and originality as well as specifications of the parameters for fair and legal use.[62] In Chinese filmic representation, however, notions such as authenticity, originality, fairness, and legality are repeatedly subjected to scrutiny in the artist's attempts at reframing piracy, which may take the form of mere referencing, creative reconstruction, playful parody, or outright dismissal. By weaving new layers of intertextuality through reframing, Chinese filmmakers no longer treat the authenticity of the original as something to be revered or reified, but rather something to be recreated and recontextualized every time it is referenced or, simply put, pirated. Creative reframing of piracy, therefore, takes place at two levels: first, as artists use piracy off screen, in their daily life; and second, as artists reuse select pirated materials on screen, in their creative works. These two interconnected levels are combined to make sure that piracy, as a tactic, succeeds on and off screen in turning cultural consumers into cultural producers.

As suggested by its brazen English title, *Pirated Copy* builds its fictional narrative around the intertextuality of reframing film piracy. Its Chinese title plays down piracy's legal implications and foregrounds its regenerative power by evoking a metaphor of wild grass "spreading" *(manyan),* ostensibly on and of itself, across a vast land. (*Spreading* is, in fact, the English title used in a video copy of this film.) The opening scenes of *Pirated Copy* capture precisely the "wild" (untamed) power of piracy spreading among urban consumers. Avoiding conventional establishing shots, fleeting images of street vendors and buyers bargaining over prices (RMB 7–15) of pirated video compact disks (VCDs and DVDs, hereafter referred to as "pirated videos") in standard or dialect-accented Chinese heighten an overpowering sense of anarchy. The hand-held camera zooms in on the commotion of illegal transactions at crowded bus stops, street corners, and pedestrian walkways under the street, where a sudden (albeit anticipated) appearance of the police causes street chases. The title and the opening credits sequence appear right after these chases, setting the marginality of film piracy as a space of the weak ruthlessly under the state's surveillance power.

Given this tension between the weak and the powerful, *Pirated Copy* reframes piracy issues in three significant ways. First, it adopts an oppositional stance toward

hegemonic powers and subtly challenges the legitimacy of the state's crackdown on film piracy. Second, it celebrates the liberating effects of consuming pirated materials and questions conventional wisdom regarding individual identity and sexual freedom. Third, it focuses on the miserable social condition of underprivileged people and thus contributes to a reconfiguration of the global-local dynamic in postsocialist China.

Intertextuality 1: Subtle Challenges to the State

The oppositional stance in *Pirated Copy* is a distinguishing feature of its director's independent film career. He Yi studied in a special directing class at Beijing Film Academy in 1985 and worked as an assistant director on two avant-garde films, *Yellow Earth* (1986) and *King of the Children* (1987), both directed by Chen Kaige. Unlike his Fifth Generation predecessors, He Yi did not stay in the state-owned studio system but instead opted to work independently, raising private money for his feature productions and circulating them through unofficial channels, mostly abroad and intermittently at home. Together with Zhang Yuan and Wang Xiaoshuai, He Yi spearheaded a momentous trend of underground

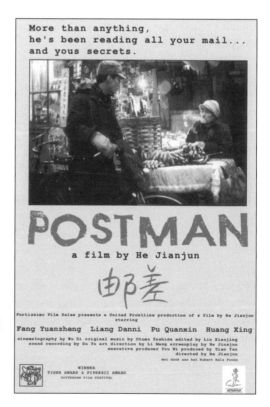

Figure 6.3. Postcard for unofficial screening of *Postman* (1995), front

filmmaking in the early 1990s by filmmakers soon recognized as the "outlawed" or "rebellious" members of the Sixth Generation, whose films consistently challenge China's cultural and political establishment in aesthetic, ideological, and institutional terms (see Chapter 3). Aesthetically, they abandon the traditions of both Chinese melodrama and Hollywood commercialism and aspire to the status of innovative European art films ridden with existentialist crises. Ideologically, they forsake grand narratives and utopian ideas (national allegory, enlightenment, and revolution) and prefer marginalized people (rock musicians, alienated artists, mental patients, migrant workers, prostitutes, gays and lesbians) and their unconventional, uneventful, and un(der)represented lifestyles (see Chapter 5).

Like He Yi's earlier works, such as *Red Beads* and *Postman*,[63] *Pirated Copy* is an "illegal" film simply because it was never submitted for official approval for production, distribution, and exhibition. The notion of illegality, nonetheless, is itself a concept this film seeks to challenge. An example is seen in the arrest of piracy vendor Wang, along with a woman who pedals a bicycle with her child on her back while selling pornography (*maopian* or "raw movies") on pirated video. "On what grounds are you arresting me? I didn't break any law!"—Wang protests

Figure 6.4. Postcard for unofficial screening of *Postman* (1995), back

in vain, as he is dragged away. In the police station, an officer looks at the cover of *In the Realm of Senses* (*Ai no corrida,* 1976) directed by Nagisa Oshima (Japan) and warns Wang that selling pornography is punishable with a jail term. Wang says that Oshima's is an "artistic film" *(yishu pian)* celebrating "humanity" (*renxing,* which can also mean "human nature" or, separately, "human sex"), but his voice subsides as the officer plays a graphic scene from the pirated video, in which a woman, out of sympathy, displays her private parts to a masturbating elderly man.

Although Wang is by no means an effective challenger of the state on the dividing line between artistic and pornographic films, He Yi's staging of this interrogation still urges the viewer to question, no matter how subtly, the state's authority in legal definitions of visual material and the legitimacy of its often-violent crackdown on film piracy. Piracy cannot be eradicated on moral grounds, He Yi seems to argue, because even pornographic films may benefit their viewers in "humanistic" terms. Evoked as self-defense by vendor Wang in the film, humanity may actually function as an excuse for certain vendors of pornographic or erotic (*qingse,* soft porn) videos, including the anonymous woman with a child in *Pirated Copy,* in the sense that film piracy provides the unemployed or the unemployable with a means of generating needed income. In reality, small-time female video vendors of various ages are a common urban sight in contemporary China, especially in residential neighborhoods away from major commercial areas.[64]

This gender aspect of film piracy sales is dramatized in another independent feature, *Cry Woman* (Liu Bingjian, 2002), which displays street scenes near Tiananmen Square, a paramount symbol of the central power in China. The female protagonist, an unemployed migrant worker, borrows a child of her neighbor's and sells pirated videos for RMB 7–8 apiece on the street. She claims to have everything, and a man stops his bicycle and looks right inside her thin jacket that the woman unzips for him. While she looks nervously around, with the child by her side, the shot of the man fumbling for pornographic titles hidden inside her jacket appears to be an act of sexual harassment. This scene is ironic because the act is displayed in broad daylight, and the location appears close to Tiananmen Square. As the film continues, the protagonist runs away from the police, only to be caught when she stops for a drink on a side street. Two passing police officers recognize her, but they let her go, as this is only her second time caught in action. Having lost her investment in pirated videos, the protagonist leaves Beijing and returns home, eventually becoming a professional "cry woman" for hire at local funerals. What is even more ironic in the arrest scene is that, after the woman is gone, the officers exchange information about confiscated videos and pocket "good" titles for their own consumption. Again, the director seems to argue in favor of piracy because it provides entertainment indispensable to consumers at large and irresistible even to agents of law enforcement.

The brief scene of chase and capture in *Cry Woman* brings us back to *Pirated Copy*, where another challenge to the state's legitimacy in cracking down on piracy occurs near the end. If its beginning scene of arrests serves as an unmistakable reminder of everyday realities in contemporary China (as further evidenced in *Cry Woman*), then the ending scene of escape represents He Yi's hope for preserving a space of tactical survival amidst the state's strategic surveillance. Unlike the beginning sequence, the final police chase does not end with the arrest of Shenming, the protagonist vendor; instead, he escapes through a pedestrian walkway and emerges to run away through the streets. As the camera follows his run for four minutes, first from behind and then from the front, the sound track punctuated with his heavy panting, the symbolism of running comes to the fore. Perhaps referencing *Run Lola Run* (*Lola rennt*, 1998), directed by Tom Tykwer (Germany), running in *Pirated Copy* takes on special significance. A few minutes into the scene, the viewer discovers that Shenming is no longer running away from legal authorities—they are already out of sight—but he is recreating meaning for his life by running, by transforming the act of running from a reactive to a creative tactic, that is, he uses running to create a space out of no space.

Pirated Copy ends with a space of hope created through an extended sequence of running. Compared with *Run Lola Run*, He Yi's characters may not run as gracefully as his German counterparts, but they seem to be facing the same existential questions as those relayed to the viewer at the start of *Run Lola Run:* "Who are we? Where do we come from? Where are we going? How do we know what we believe we know? Why do we believe anything at all?" If *Run Lola Run* turns to imaginary violence to resolve a pressing existential crisis, *Pirated Copy* repeatedly and intertextually resorts to sexuality to achieve its intended liberating effects.

Intertextuality 2: The Liberating Effects of Piracy

In *Pirated Copy*, the intertextuality created through referencing *Run Lola Run* promises liberating effects through the consumption of pirated videos. Like the three versions of Lola's running, each of which is better than the one preceding, the two versions of the vendors' running in *Pirated Copy* ends with the second one (an escape) decidedly better than the first (an arrest). However, insofar as piracy itself is concerned, its liberating effects in *Pirated Copy* are generally felt more in the sexual arena than in the legal realm.

As is illustrated by the officer's classification of material as pornography based on graphic images, the state's legal power rests on regulating the content of pirated visual material rather than the effects of its consumption. Chinese independent filmmakers, on the other hand, insist on the creative uses of piracy in order to generate liberating effects for their characters on screen, if not for consumers off screen. In *Pirated Copy*, He Yi stages at least three scenes in which pirated erotic

videos contribute to a sense of liberation. In the first, a female college lecturer visits Shenming, who has taken over Wang's piracy business after Wang's arrest. She is visibly offended by the piles of pornographic videos in Shenming's apartment, but he explains that his customers—mostly middle-aged couples—order such titles, and he watches them before delivery to make sure of the videos' quality.

Interestingly, we can trace Shenming's explanation intertextually to Jia Pingwa's observation of what had "spread" through China after the late 1980s. According to Zha Jianying, the famous novelist Jia Pingwa has admitted that those notorious erotic descriptions in his controversial novel *The Abandoned Capital* (Feidu, 1993)—so "notorious" that he, as if through self-censorship, uses empty squares to indicate deleted Chinese characters in many descriptions—are derived from his personal experience of watching pirated porn videos: a great number of porn videos were in circulation in China, and "they saved a lot of families" because they rendered an urgent service at a time when sex education was nonexistent in a nation known for repressed sexuality and conservative morality.[65] In this context, cinematic depictions of sexual repression may even function as tactical acts challenging the state, and this is exactly what Wang Xiaoshuai does with his aboveground feature, *Shanghai Dreams* (2005). Set in a remote town in southwest China during the 1970s, *Shanghai Dreams* traces the forbidden love between two young people to its tragic end: after a date rape, the female high-school student goes insane while her lover, a factory worker, is sentenced to death and executed in public.

As if to prove the immediate liberating effect of watching pornography, *Pirated Copy* shows the female lecturer, now at home, engaged in masturbation while watching a porn video. Nevertheless, He Yi's use of pirated images seeks primarily to enhance sensual pleasures rather than to "save families" or marriages, as Jia Pingwa claimed for his erotic novel. In another scene set in the same apartment that doubles as a warehouse of his material, Shenming makes love to a pretty prostitute whom he has just met in a bar while selling pirated videos. The off-screen love scene is crosscut with an on-screen exhibition of a love scene from *In the Mood for Love*, which has Wong Kar-wai's signature melancholy music filling the sound track. After sex, the prostitute demands fifty pirated videos as compensation and proudly admits that she has a collection of hundreds of videos at home, yet she refuses to tell Shenming her name: "Do you see what age we are living in now? . . . Is a name that important?" By pretending to be nameless and therefore caring little about authenticity or identity, the prostitute appears as the very embodiment of piracy itself: both are capable of evading the power of strategic surveillance, flowing freely in the urban crowd, all the while enjoying full anonymity.

The third scene of liberating effects takes place on a college campus where the lecturer teaches a summer class. She is teaching the students about *Tie Me*

Up! Tie Me Down (*Atame,* 1990), directed by Pedro Almodovar (Spain).[66] During a screening of the movie for the lecturer's class, Shenming arrives with his video delivery, and the lecturer brings him to an empty classroom where the two make love passionately. Her husband has never made her that aroused, she confesses, and she further explains that her husband, who is gay, has covered up his sexual orientation by taking a mistress. Shenming, in turn, recalls his first sexual experience with a female student while attending college, which proved disastrous because he was caught and expelled. The message *Pirated Copy* seems to convey through the intertextual reference to *Tie Me Up! Tie Me Down* is that passion-filled heterosexual love is very much an unknown pleasure in the still-repressive Chinese society. Film piracy, in this context, works to inspire people and promises liberating effects readily available for immediate and repeated experience.

Intertextuality 3: A Reconfiguration of the Global-Local Dynamic

Pirated Copy also suggests that access to and the intensity of unknown pleasures are tied to economic factors (for example, white collar versus blue collar) and that unknown pleasures may turn out not to be pleasure at all. The circulation of pirated foreign videos such as *In the Realm of Senses, Run Lola Run,* and *Tie Me Up! Tie Me Down* foregrounds the presence of the global media in everyday Chinese life. Rather than the fantasy of luxurious lifestyles projected in contemporary Chinese TV soap operas and commercial films, however, *Pirated Copy* resorts to the tactic of marginality and, in a fashion similar to Jia Zhangke's *The World* and *Still Life,* highlights the local condition of poverty and unemployment, thereby reconfiguring the global-local dynamic in favor of emphatic local grounding.

The pleasure of watching pirated foreign videos is captured in a scene in which a couple, with face masks on, play with a gun in imitation of a violent killing in *Pulp Fiction* (1994), directed by Quentin Tarantino (US). "And you will know my name is the Lord when I lay my vengeance upon you,"[67] they say, uttering Jules' line (originally from the Bible) in Chinese as Jules and Vincent empty their guns at the same time into the sitting Brett. Yet the couple's pleasure is brief because they are short of money, and the husband, who is only thirty-nine, is soon laid off by his factory. Again referencing *Pulp Fiction,* they contemplate robbing a bank, with the husband reasoning that he would at least be fed in prison if he were caught. One night, the couple go out to find an individual to rob and they settle on a prostitute, but when they pursue her to a warehouse, they find her under attack by three men and stripped almost naked. As one of the men takes off his police uniform and is about to rape the prostitute, the husband intervenes and rescues her. When the men question the authenticity of his heroic role, given the couple's suspicious outfits—they look like armed robbers—the husband shoots and kills them one by one. The scene is crosscut with the clips of Jules and Vincent gunning

Brett down and with part of Jules' Biblical line, uttered in Chinese: "Blessed is he who, in the name of charity and good will, shepherds the weak through the valley of darkness."[68]

The intertextuality formed between *Pulp Fiction* and *Pirated Copy* is ironic: violence is predicated on money in *Pulp Fiction,* but in *Pirated Copy* it is articulated with a lingering trace of heroism. After killing the three would-be rapists, the couple roam the city and eventually enter a small restaurant. Since they cannot pay for even the simple meal they have ordered, the husband decides to rob the owner. In an astonishing moment of revelation, the owner slams his two artificial legs on the counter: "If I were not crippled, I would have robbed people myself!" Completely devastated, the husband murmurs, "No one has any money," and commits suicide with his gun. The wife follows suit after saying that they will go to heaven to rob. For these two antiheroes, suicide appears to be the only heroic option left.

Juxtaposed intertextually, the attempted restaurant robbery reveals the different conditions of antiheroism in *Pulp Fiction* and *Pirated Copy.* In *Pulp Fiction,* even after Jules defeats Pumpkin's and Honey Bunny's mock-heroic robbery, they still walk away with a large sum of money, including the $1,500 Jules offered as the price for not killing Pumpkin. The couple in *Pirated Copy,* on the contrary, never get anything from their robbery plans, but instead lose everything, including their lives. The pleasure they had earlier associated with a bank robbery proves to be no pleasure at all, and the local condition of poverty seems all the more distant from the global imagery of affluence, Hollywood-style.

The ironic reconfiguration of the global-local dynamic in *Pirated Copy* is also encountered in Jia Zhangke's *Unknown Pleasures* (2002), which stages two intertextual references to *Pulp Fiction.* First, an unemployed young man from the hinterland named Xiaoji fantasizes about getting rich, American-style, in a restaurant converted from a passenger train's dining car: "If only I were born in the United States, where money is found everywhere.[69] Dining with Qiaoqiao, a local dancer/ prostitute who wears a black wig resembling Mia's retro hairstyle, Xiaoji conveys his excitement about watching an early scene of *Pulp Fiction* in pirated video in which Pumpkin and Honey Bunny hit upon the idea of robbing a restaurant after their heated discussion of how best to rob a bank. "This is a robbery!"—Xiaoji suddenly shouts, and he raises his right arm as if he carries a gun. In another reference to *Pulp Fiction,* Xiaoji and his friend Binbin plan a bank robbery with fake explosives, since they have no gun. When Binbin presents himself for Xiaoji's examination with fake explosives wrapped around his waist behind a shabby Western-style suit, Xiaoji comments, "The bomb appears faked, and you look phony, too." Nonetheless, they proceed on Xiaoji's motorcycle to a bank office. When Binbin storms up to the teller's window and shouts, "This is a robbery!" the police guard sitting

behind the entrance door is simply amused: "At least you should have brought a lighter!" he comments. *Unknown Pleasures* ends with Binbin in police custody, singing a popular song, "Unknown Pleasures" (Ren xiaoyao), about a hero from a humble family background.

Unknown Pleasures and *Pirated Copy* share more than common intertextual references to *Pulp Fiction*, for both specifically address the issue of film piracy. As an unemployed youth stranded in a hinterland city with no prospects, Binbin takes a high-interest loan from a local businessman named Xiao Wu (Wang Hongwei) and starts selling pirated videos on the street. This occurs before his failed bank robbery. One day, Xiao Wu checks out Binbin's stock and asks specifically for "art films" such as *Xiao Wu* and *Platform*, two internationally acclaimed independent features Jia Zhangke directed before *Unknown Pleasures*. Jia's insertion of this self-referential scene is ironic, not only because it verges on self-promotion but also because it alludes to a local landscape of degraded morality. In *Xiao Wu*, Xiao Wu is a tradition-minded pickpocket who refuses to accept corrupt modern business practices and who ends up handcuffed by a police officer to a roadside utility pole in public humiliation. In *Unknown Pleasures*, however, Xiao Wu (Wang Hongwei) becomes an experienced businessman dealing in illegal transactions and taking advantage of innocent newcomers like Binbin. Thus, the handcuffed Binbin in police custody reminds us of the early image of Xiao Wu as an antihero, for both belong to a disappearing local species in the age of globalization.

Figure 6.5. *Xiao Wu* (1997): an estranged pickpocket handcuffed to a utility pole

The symbolism of the handcuffs in *Unknown Pleasures* and *Xiao Wu* works beyond a mere indication of the continued surveillance by legal authorities in China; it foregrounds the landscape of the global as the space of unknown pleasure. The fulfillment of that pleasure at a local level necessarily entails a transgression of the boundaries between global and local, legal and illegal, authentic and simulated. In *Unknown Pleasures* as in *Pirated Copy,* film piracy is reframed as a way to achieve this transgression as well as a space of loaded intertextuality: through layered intertextuality, acts of transgression, despite repeated setbacks on screen, may eventually cohere into a vision of democracy off screen.

FROM PIRACY TO DEMOCRACY: THE INTERCONTEXTUALITY OF PLAYING

In his interpretation of the immense popularity of *Pulp Fiction* as an exemplary postmodern phenomenon, Dana Polan contends that what appeals to Tarantino's fans is not so much the film's meaning as its offering of "a fun-house experience of vibrant sights and sounds," which "renders cinematic experience as pure play."[70] The metaphor of play is equally present in *Pirated Copy* and *Unknown Pleasures:* these films play with the intertextuality and contextuality of pirated video images and scenarios and reframe film piracy in China as a space of tactics where subtle challenges to strategic powers are staged, liberating effects of cinematic imagination delivered, and global-local dynamics reconfigured for the local's benefit. Cinematic play in the Chinese context, however, does not aspire to be as "pure" or as "postmodern" as it is in *Pulp Fiction,* but it manages to succeed, on and off screen, in constructing a new kind of intercontextuality where "play" takes on a special significance.

This is how Jia Zhangke envisions the liberating effects of film piracy in China. After assembling a list of internationally acclaimed masters such as Luis Buñuel, R. W. Fassbinder, Jean-Luc Godard, and Roman Polanski, who engineered the New Wave of filmmaking based on their own reputedly "amateur spirit" decades before, Jia poses this intriguing question:

> What about today? You can't say for sure that a Chinese Quentin Tarantino will not emerge from crowds who hang out in VCD stores; nor can you deny that a contemporary Ogawa Shinsuke may appear from those youths who have access to digital video cameras. Film should no longer be the exclusive privilege of a minority, for it belonged to the masses originally. . . . I am always against the unjustifiable sense of professional superiority. The amateur spirit contains equality and justice, as well as a concern for human fate and empathy for ordinary people.[71]

What Jia conjures up here is undoubtedly a vision of equality and justice, not just in cultural consumption but also in cultural production. Behind this vision, I argue,

is an implied sequence "from piracy to democracy," a sequence in which "ordinary people" first resort to piracy to reclaim their rights to watch (as consumers) international film classics and then to utilize the newly available DV technology to embark on documentary and experimental filmmaking (as producers).[72] Piracy, according to Jia's view of the consumer as a potential producer, serves a liberating function in contemporary China where the previously exclusive privilege of film professionals has been stripped away and is now handed over to consumers at large, from whom future film masters may eventually emerge.

Although *Pirated Copy* and *Unknown Pleasures* recreate film piracy only in fictional contexts, two recent independent documentaries, *Hi, Guys* (Zhang Huilin, 2003) and *Pai Gu* (Liu Gaoming, 2005) capture lively scenes of piracy in south China. *Hi, Guys* follows a young piracy vendor named Gao, who operates a variety store in a shopping mall where he specializes in pirated videos. Rather than Hollywood blockbusters, the documentary focuses especially on European and American art titles, such as *Chocolat* (2000) by Lasse Hallström (Sweden), *The Decalogue* (*Dekalog*, ten TV episodes, 1989) by Krzysztof Kieslowski (Poland), *The Hairdresser's Husband* (*Le mari de la coiffeuse*, 1990) by Patrice Leconte (France), and *Identification of a Woman* (*Identificazione di una donna*, 1982) by Michelangelo Antonioni (Italy). Since many art films are hard to find on the market, Gao burns copies on his computer and sells them in brown envelopes. Of course, Gao also deals in Chinese titles, such as the banned films *Platform* and *Devils on the Doorstep* (both 2000) as well as popular Zhang Yimou dramas from the 1990s. In one ironic scene, Gao and his friends are playing games in his apartment, while the television airs official news stories, including one about the government's destruction of 16 million copies of pirated videos in Zhuhai. The film ends with Gao playing in his store with a bench as if it were a horse, and the final words heard are a television comment, "When the news of China's entrance into the WTO spreads, the entire nation rejoices."

The fact that piracy vendors and consumers are not likely to be among those rejoicing in the news of China's membership in the WTO was already anticipated in *Hi, Guys*, where an official crackdown on piracy results in the closing of many local stores. In *Pai Gu*, a piracy vendor from Jiangxi province, who uses the nickname "Pai Gu" (literally, "ribs"), is likewise reduced to street operations in Shenzhen as a result of the government's intensified campaign against piracy. The final scene, of Pai Gu standing alone on a pedestrian bridge over a bustling street, strikes a sharp contrast to the earlier scenes of his brisk business inside an apartment building. His customers know his reputation as a reliable source of films through word of mouth, and Pai Gu defends his business by asserting that piracy satisfies a particular consumer need not met by the regular releases of Hollywood and Hong Kong commercial fare, and that he feels delighted whenever he tracks

down titles his customers have been looking for but have failed to locate. Indeed, as Gao says in *Hi, Guys,* a customer would be willing to spend RMB 70 on taxi fare just to buy a rare title for RMB 10. Like Jia Zhangke, piracy vendors such as Gao and Pai Gu defend piracy not so much in terms of monetary gain as in terms of consumer need. The result they all hope for seems to be a particular kind of visual democracy—the access to international art films otherwise unavailable.

Hi, Guys and *Pai Gu* demonstrate that, as a tactic, film piracy is rapidly losing its makeshift space of operation due to the tightening grip of the hegemonic power.[73] Nonetheless, the visual democracy fostered by film piracy has discovered the Internet as another space to proliferate or spread, a space not yet represented in the films analyzed above. For years, Chinese viewers have learned to search and download pirated movies from the Internet, and the hit-and-run operations of numerous websites, which paradoxically list available films but warn against their "illegal" downloading, work like moving targets and can therefore successfully escape attempts at official crackdown or legal prosecution. Regardless of whether these movie websites are for profit or nonprofit,[74] viewers participate in the proliferation of Internet piracy as their computers, while downloading, act as relays to other computers around the globe. The virtual nature of their operation reconfigures the global-local dynamic; this time the local is no longer pitted against the global, but rather makes the global into a relay network benefiting the local. In the new global networks of play, weak power rejoices in many ways: at once poaching and proliferating, consuming and recreating/re-creating, unabashedly securing "unknown pleasures" in the sense of both finding something new and experiencing pleasures without being known or identified.

A well-known recent example of this move from piracy to democracy is a widely circulated online short video, *A Bloody Case Resulting from a Steamed Bun* (2005), created by Hu Ge, an unknown freelancer in digital audiovisual work. The video is a twenty-minute parody of Chen Kaige's estimated RMB 360-million blockbuster, *The Promise* (2005). Hu Ge playfully sent his work to a few friends on December 31, 2005, three weeks after *The Promise*'s theatrical release in China. As is typical of piracy, the parody proliferated, but in this case at an exponential rate. According to Baidu, the most popular search engine in China, 1,660 web pages relating to the pirated video were found on January 6, 2006, but by January 16, the number had already proliferated to 978,000. Chinese "netizens" shared their excitement about this blatant parody, which creatively reuses sequences from *The Promise* but reframes the narrative as a current Chinese television show on legal matters. Through ironic juxtaposition and outrageous dialogue, the "authenticity" of Chen's epic film is exposed as nothing more than pure cinematic fantasy based on irrational emotions and illogical reasoning. Love, heroism, and revenge turn out to be empty concepts, while the characters' superhuman abilities (flying high

in the sky, running at supersonic speed) are reused as two fun-filled television commercials within the parody.

Many Chinese viewers admitted watching the parody before the film (either in the theater or in video format), while perhaps many more decided not to watch the film at all after seeing the parody. The proliferation of this pirated video once again demonstrates that the authenticity of the original no longer seems to be an issue, but creativity is still what attracts viewers. Arguably, the creative reuse—or actually abuse—of the ridiculous original attracted people to the parody. Of course, Chen Kaige's threat to take legal action against Hu Ge may have also contributed to the popularity of the parody, but the anger of countless online supporters at the powerful director and sympathy for a freelance nobody forced Chen to withdraw his threat. A form of Internet democracy triumphed in this spectacular case of visual democracy, a form of democracy made possible primarily by film piracy and secondarily by digital video and Internet technologies. Once available on the Internet, a video may generate tens of thousands of hits overnight, and piracy makes sure that images are free for all to play with in a non-zero-sum game accessible around the globe.

The Internet thus provides a new context for piracy in contemporary China, one no longer spatially bound but rather composed of countless virtual intertexts (or interrelated hypertexts) instantly transmittable through networks that link multiple locals to the global. The popularity of this Internet parody video reminds us that collectivity in China is not exactly in despair, as Laikwan Pang sees it; instead, it may take on different forms now, some trivial, some vibrant, some effective, some challenging or even potentially subversive. Visual democracy as Jia Zhangke envisions it is still a largely unrealized vision at this point, but one definitely worth entertaining and fostering. While film piracy as a rampant practice may eventually disappear in China, its many creative uses have so far produced positive effects and have fundamentally reconfigured the postsocialist screen culture, as we shall see further in the two-way traffic between the underground and the aboveground in Chapter 7.

Conclusion

Progress, Problems, Prospects

> After [China joined] WTO, when global culture has arrived with a
> whirlwind of capital, neither welcome nor resistance constitutes an
> epic heroic ethos any more; what Chinese cultural workers need to
> learn is just to dance happily with capital.
> —Wang Meng[1]

This concluding chapter brings my investigation of cinema, space, and polylocality in a globalizing China up to date by offering an overview of the latest progress of Chinese cinema in the twenty-first century. Among what Massey calls "a simultaneity of stories-so-far," I pay equal attention to the spaces of production and of exhibition and their cultural logic of translocality so as to provide a context for evaluating new trends in the commercial and independent sectors, such as blockbuster coproductions and the two-way traffic between underground and aboveground production of art films. Although independent filmmaking has gradually attracted scholarly attention in recent years, the headline news has been dominated by a spectacular growth of the Chinese film market since 2004. For easy reference, I have compiled two tables of statistics, which I hope will stimulate further industry research, an area in need of development. Toward that end, I also attempt to map out problems and prospects in the dynamic, tension-ridden field of transnational Chinese cinema and conclude with a discussion of Wang Meng's call for Chinese cultural workers to dance happily with capital in the age of WTO.

PROGRESS: A SENSE OF EUPHORIA

The year 2005 was celebrated as the centennial of Chinese cinema, and no one would doubt the extraordinary growth of Chinese cinema in the new century. Production and box-office figures corroborate and continue to feed a general sense of euphoria. Annual feature productions increased from 88 in 2001 to 402 in 2007. Similarly, total box-office revenues rose from RMB 840 million in 2001 to 3,327

Figure 7.1. *Hero* (2002): doomed lovers against an exotic, gorgeous landscape

million in 2007, while the box office for domestic films jumped from RMB 294 million in 2001 to 1,801 million in 2007. In a relatively short period, overseas sales grew nearly four times from RMB 550 million in 2003 to 2.02 billion (see Table 1).[2] Moreover, new box-office records for domestic films were established one after another. By late January 2002, *Big Shot's Funeral* had raked in RMB 38 million in a mere forty days,[3] and it went on to earn RMB 42 million. A year later, *Hero* took the country by storm and set a record of RMB 250 million in domestic exhibition.[4] In the following years, *House of Flying Daggers, The Promise,* and *The Curse of the Golden Flower* reconfirmed the seemingly unstoppable expansion of Chinese cinema, respectively taking in RMB 153 million, RMB 180 million, and RMB 280 million in China alone (see Table 2).[5]

In spite of the euphoria over box-office records, fundamental problems continue to constrain Chinese cinema, which has grown into a lopsided industry strong in production but weak in exhibition. If we scrutinize annual domestic box-office hits, it is obvious that many of the top ten films are coproductions funded largely by overseas (that is, not mainland) money,[6] and some of the top ten may even be money losers when production and promotion costs are factored in. For example, *Baober in Love* (Li Shaohong, 2004) cost RMB 42 million to produce, but earned only RMB 14 million at the box office, even though it was number nine in 2004.[7] In addition, the classification of "domestic film" *(guochan pian)* becomes questionable when overseas coproduction is involved. In fact, Columbia Asia was behind several recent "domestic" successes, such as *Big Shot's Funeral, Cell Phone, Warriors of Heaven and Earth* (He Ping, 2003), and *Kung Fu Hustle* (Stephen Chiau, 2004), investing between US$1 million to US$4 million in each title except for *Kung Fu Hustle*.[8] Indeed, in 2003, apart from two Columbia Asia coproductions, Hong Kong capital was behind six of the top ten, but arguably Hong Kong productions such as *Kung Fu Hustle* cannot legitimately count as "mainland" *(neidi)* productions and are perhaps at best termed "pseudodomestic films" *(zhun guochan*

TABLE 1. Annual Feature Production and Exhibition, 2000–2007

Year	2000	2001	2002	2003	2004	2005	2006	2007
Domestic films	91	88	100	140	212	260	330	402
Growth rate of domestic films	—	(3.3%)	13.6%	40%	51.4%	22.6%	26.9%	21.8%
Coproductions with overseas	12	12	19	39	42	37	> 40	> 50
Coproductions with Hong Kong	7	6	12	35	42	32	29	> 50
Total box office (in RMB million)	960	840	900	950	1,570	2,000	2,620	3,327
Growth rate of total box office	—	(12.5%)	7.1%	5.6%	65.3%	27.4%	31%	27%
Domestic films box office (in RMB million)	280	294	—	—	900	1,100	1,440	1,801
Foreign films box office (in RMB million)	680	546	—	—	670	900	1,180	1,526
Domestic films as percentage of total box office	29.2%	35%	—	—	57.3%	55%	55%	54.1%
Overseas sales (in RMB million)	—	—	—	550	1,100	1,650	1,910	2,020
CCTV Channel 6 advertising revenue (in RMB million)	—	—	—	700	1,000	1,150	1,200	1,379
Total film-related revenue (in RMB million)	—	—	—	2,200	3,670	4,800	5,730	6,726
Growth rate of total film-related revenue	—	—	—	—	66.8%	30.8%	19.4%	17.4%

Sources: Huang Shixian, "Wenhua huimeng"; Yin Hong, *Kuayue bainian;* Yin Hong and Zhan, "2007 Zhongguo"; Zhao Weifang, *Xianggang dianying.*

pia).[9] The large-scale involvement of Hong Kong and Hollywood in mainland film production reminds us that Chinese cinema has been fully entrenched in translocal, transnational capital flows, which facilitate the by-now typical casting of multinational stars from mainland China, Hong Kong, Taiwan, Japan, South Korea, and even Hollywood.[10] On the other hand, nationalist sentiments are on the rise as Chinese officials and scholars selectively use coproductions' box office, sometimes out of context, to fortify the picture of China's spectacular economic boom.

TRANSNATIONALISM: PRODUCTION AND EXHIBITION
In an earlier mapping of Chinese cinema before 2000, I pointed out four major types of feature production: alternative film (independent), art film (auteurism),

TABLE 2. Annual Domestic Film Box Office, 2000–2007

Year/rank	Title	Director	Production Company (BJ = Beijing, HK = Hong Kong, US = United States)	Production Costs (in RMB million)	Domestic Box Office (in RMB million)	Overseas Box Office US only in square brackets (in US$ million)
2000						
1	Fatal Decision	Yu Benzheng	Shanghai Studio	—	130	—
2	Sorry Baby	Feng Xiaogang	Forbidden City (BJ), Huayi Brothers, Huayi Film (BJ)	13	30	—
3	A Sigh	Feng Xiaogang	Beijing Studio, Huayi Brothers	—	30	—
4	Shower	Zhang Yang	Xi'an Studio, Imar	3	10	[1.16 US]
2001						
1	Big Shot's Funeral	Feng Xiaogang	China Film Group, Huayi Brothers, Columbia Asia (US)	29	42	—
3	Roots and Branches	Yu Zhong	Tianshan Studio, Sihai Zongheng (BJ)	2	16	—
2002						
1	Hero	Zhang Yimou	New Picture (BJ), Elite Group (HK), Sil-Metropole (HK)	240	250	137.5 [53.71 US]
2	Together with You	Chen Kaige	China Film Group, Century Hero, CCTV Channel 6, 21st Century Kaisheng	—	140	—
3	The Missing Gun	Lu Chuan	China Film Group, Huayi Brothers	—	9	—
6	I Love You	Zhang Yuan	Xi'an Studio, Huayi Film (BJ)	4	10	—
2003						
1	Cell Phone	Feng Xiaogang	China Film Group, Huayi Brothers, Columbia Asia (US)	10	53	—

(continued)

TABLE 2. *continued*

Year/ rank	Title	Director	Production Company (BJ = Beijing, HK = Hong Kong, US = United States)	Production Costs (in RMB million)	Domestic Box Office (in RMB million)	Overseas Box Office US only in square brackets (in US$ million)
2	*Warriors of Heaven and Earth*	He Ping	Xi'an Studio, Huayi Brothers, Taihe, Columbia Asia (US)	—	38	12.05
18	*Green Tea*	Zhang Yuan	Huayi Film (BJ)	10	8	—
2004						
1	*Kung Fu Hustle*	Stephen Chiau	China Film Group, Huayi Brothers, Columbia Asia (US)	—	170	[17.11 US]
2	*House of Flying Daggers*	Zhang Yimou	New Picture (BJ), Elite Group (HK)	290	153	37.5 [11.05 US]
3	*A World Without Thieves*	Feng Xiaogang	Huayi Brothers–Taihe, Media Asia (HK), Forbidden City (BJ)	—	112	—
9	*Baober in Love*	Li Shaohong	Rosat Film (BJ)	42	16	—
19	*Kekexili*	Lu Chuan	Huayi Brothers, Columbia Asia (US), National Geographic (US)	10	5	0.8
2005						
1	*The Promise*	Chen Kaige	China Film Group, 21st Century Kaisheng, Moonstone (US)	310	180	23.3 [0.51 US first 10 days]
2006						
1	*The Curse of the Golden Flower*	Zhang Yimou	New Picture (BJ), Elite Group (HK)	360	280	—
2	*The Banquet*	Feng Xiaogang	Huayi Brothers, Media Asia (HK)	150	130	100
10	*Crazy Stone*	Ning Hao	Warner China Film HG Corp., Focus Films (HK)	4	22.5	—

2007

1	*Warlords*	Peter Chan	China Film Group, Warner China Film HG Corp., Applause Pictures (HK)	—	220
2	*Assembly*	Feng Xiaogang	Huayi Brothers, Shanghai Film Group, Media Asia (HK)	—	210
3	*Lust, Caution*	Ang Lee	Shanghai Film Group, Sil-Metropole (HK), Focus Features (US)	—	120

Note: Many top ten films were released in the New Year window (from the Christmas season in late December to the Chinese New Year in late January or early February), and their box office usually include revenues for the following year.

Sources: Dianying yishu, ed., *Zhongguo dianying*; Huang Shixian, "Wenhua huimeng"; Jia Leilei and Zhu, "Zhongguo dianying"; Rao Shuguang, "Zhongguo dianying"; Rosen, "Quanqiuhua shidai"; Yin Hong, *Kuayue bainian*; Yin Hong, "Zouxiang houhepai shidai"; Yin Hong and Zhan, "2007 Zhongguo."

commercial film (entertainment), and leitmotif film (propaganda).[11] In the new century, the government has reduced its monetary investment in film propaganda, and leitmotif films have gradually lost their market dominance, although some titles still make it to the top ten with strong government backing, such as *Fatal Decision* (Yu Benzheng, 2000) and *Deng Xiaoping* (Ding Yinnan, 2003).[12] Instead of pumping in money itself, the government has preferred to regulate the film market by encouraging private companies to enter production and compete with Hollywood, and the immediate result has been a euphoric "age of blockbusters" *(dapian shidai)*, where nongovernment investments in film productions exceeded 80 percent in 2004, and transnationalism has become the dominant industry practice.[13]

Undoubtedly, Hollywood is the primary source of inspiration for Chinese transnational practice. After China started importing Hollywood blockbusters on a revenue-sharing basis in November 1994, Chinese filmmakers were quick to respond by securing private (including Hong Kong) funding for a few high-budget commercial art films, such as *The Emperor's Shadow* (Zhou Xiaowen, 1996), which cost RMB 39 million in production.[14] Yet by 2006, *The Curse of the Golden Flower* would set a production record of RMB 360 million, and four other titles in that year also cost close to or over RMB 100 million apiece.[15] Extravagant investments like these have brought in spectacular results: in 2004, when China imported twenty-one Hollywood movies (compared with ten or fewer before 2000), domestic films outperformed foreign films in exhibition and secured a 57.3 percent market share (which would remain around 55 percent through 2007). The domestic box office of *House of Flying Daggers* (RMB 150 million) beat that of *Lord of the Rings, III* (Peter Jackson, 2003; RMB 87 million) in 2004, thereby consolidating a decisive turn in the fate of made-in-China screen products in terms of domestic market share.[16]

The rush to produce Chinese blockbusters has been motivated by the leading producers' conviction that high-budget (or Hollywood-style "high-concept") films are the only way to secure financial returns in a risky business environment. Coproduction, therefore, constitutes a risk-sharing strategy, and that is why coproductions have grown steadily from twelve in 2000 to over forty in 2006.[17] In 2007, annual coproductions with Hong Kong alone exceeded fifty titles, and altogether twenty countries and regions were involved in these coproductions.[18] Obviously, the main objectives of coproductions are twofold: attracting capital from Hong Kong and elsewhere, and penetrating overseas markets in partnership with established international distributors. After Beijing and Hong Kong signed the historic CEPA (Closer Economic Partnership Arrangement) in June 2003, which grants an advantage—a higher revenue-sharing percentage—to exhibiting coproduced Hong Kong films in mainland China, the numbers of such coproductions increased from six in 2001 and twelve in 2002 to thirty-five in 2003 and forty-three in 2004 (see Table 1).[19] Although Hong Kong had an earlier record of thirty-three

coproductions with the mainland in 1995, this time around it is the extraordinary investment and box-office figures that make headline news (see Table 2). Inspired by the unexpected success of *Crouching Tiger, Hidden Dragon* in 2000, which set a record of RMB 1.62 billion in overall revenues, Chinese filmmakers and their Hong Kong investors came to view overseas markets as a new territory to conquer in the age of globalization.[20] Riding on the bandwagon of the martial arts craze, the coproduced blockbuster *Hero* easily recouped its production costs of RMB 240 million after it earned US$53.71 million (or RMB 429.68 million) from the United States and RMB 1.1 billion from all overseas markets.[21] The lure of large profits was such that Feng Xiaogang abandoned his signature down-to-earth comic style, which had made him the most consistent top Chinese box-office grosser since the late 1990s, teamed up with Media Asia in Hong Kong, and directed a gorgeous period piece, *The Banquet,* which looks exactly like *Hero* and *The Promise* in its fantastic narrative and visual extravagance.

The problem with recent Chinese blockbusters, however, is their largely shallow content behind their alluring façade of audiovisual treats. Invariably set in ancient China, this "pseudogenre" of "magic spirits-martial arts pictures" *(shenguai wuxia pian)* tries to package too many superficial signs of Chineseness at the same time: exotic landscapes, spectacular architecture, colorful costumes and sets, sensuous music and dance, superhuman martial arts, beautiful female bodies and faces, the performances of megastars, and fantastic digital special effects such as we find in the *Lord of the Rings* series.[22] A hackneyed romantic triangle is inserted in the narrative, which features little or no developmental logic and contains abundant dim-witted, even embarrassing dialogue. Glamorous sex, titillating incest, insatiable greed, gory violence, evil scheming, and absolute power rule the screen, but ancient myths cannot disguise the ideological complicity of many recent blockbusters with the dominant power and that power's imperial ambition and moral decadence.

Ironically, what is equally spectacular about these recent blockbuster box-office records is their widespread condemnation among Chinese audiences and critics. Disappointed viewers vent their anger on the Internet, and critics express their dissatisfaction across the print and electronic media. In this new century blockbuster films have become nationwide media events, and their extravagant premieres in metropolitan cities are routinely attended by high-ranking officials, business moguls, film and music stars, and the like.[23] Such media events provide not just audiovisual entertainment but also the lure of celebrities and an open invitation to the audience to air their views in public debate. One way or another, blockbuster films generate a great deal of media attention, much to the glee of their producers, distributors, and exhibitors, who use this publicity to move on to hype their next megaprojects.

Figure 7.2. *Blind Shaft* (2001): two coal miners hunting for a new victim

VARIETY: BETWEEN UNDERGROUND AND ABOVEGROUND

Blockbusters, of course, are not the only game in town, and Chinese cinema has managed to preserve its variety in small-budget alternative films. A different kind of transnationalism is at work in the underground, independent production, with moral and financial support coming from international film festivals and NPOs overseas. Just as blockbuster films crave transnational capital, independent Chinese filmmakers seek international fame through the transnational exhibition of their challenging, sometimes subversive movies. Following the 1990s success of the early Sixth Generation directors, new Chinese talents have emerged in underground production every year and have caught the attention of viewers at international film festivals. They have enriched the Chinese screen with fiction films like *Blind Shaft* and *The Other Half* (Ying Liang, 2006), as well as documentaries like *The Box* and *Tiexi District.*

However, the most important recent change in alternative filmmaking is the two-way traffic between the underground and aboveground. After releasing two state-approved pictures in 1999, Zhang Yuan went commercial and directed *I Love You* (2002) and *Little Red Flowers* (2006), adaptations of novels by Wang Shuo, as well as *Green Tea*, which features top stars Jiang Wen and Zhao Wei and benefits from transnational cinematographer Christopher Doyle. Wang Xiaoshuai, on the other hand, prefers to move between underground and aboveground. After his triumph with a transnational coproduction, *Beijing Bicycle,* Wang directed an underground feature, *Drifters,* and then returned to a state-approved project, *Shanghai Dreams.* Jia Zhangke completed his underground Shanxi trilogy with *Platform* and *Unknown Pleasure,* and then unexpectedly launched the state-approved features *The World* and *Still Life,* both of which manage to retain his characteristic

compassion for underprivileged people. Nonetheless, as independents, the reputations of these directors carry more weight abroad than at home, although Zhang Yuan has gradually lost his vanguard position overseas.

The new century has seen a consistent output from the Sixth and Urban Generation directors who have stayed in the state system and directed low- to medium-budget art films. Their favorite multisegmented narrative structure is explored in fantastic urban milieus in *Dazzling* (Li Xin, 2002), in a picturesque rural setting in *Eyes of a Beauty* (Guan Hu, 2002), and in a magic landscape in *The Sun Also Rises* (Jiang Wen, 2007), all of them unapologetically challenging the viewer's intelligence.[24] Multiple perspectives on a single event are structured into *Curiosity Kills the Cat* (Zhang Yibai, 2006), which brought its Hong Kong star Carina Lau (Liu Jialing) the coveted title of Best Actress at China's Golden Rooster-Hundred Flowers Film Festival in 2007. On the other hand, the conventional melodrama is adopted in *Sunflower* (Zhang Yang, 2005) to delineate a strained father-son relationship from the 1970s to the 1990s, and this RMB 12 million production was picked up by the overseas distributor New Yorker Films.

Among new urban directors, Meng Jinghui integrates the theater of the absurd, black humor, and animated sequences in *Chicken Poets* (2002), while Ning Hao merges action, comedy, and detective stories in *Crazy Stone* (2006), a surprisingly popular film coproduced by Andy Lau's Focus Film (Hong Kong) and Warner China Film HG Corporation, the first joint-venture production company in China involving Hollywood (see Table 2). Attentive to genre-mixing and media cross-fertilization, Lu Chuan plays with detective and suspense stories in *The Missing Gun* (2002) and subsequently with adventure and the environment in *Kekexili* (2004), a breathtaking feature partially funded by National Geographic of the United States. In addition, Huo Jianqi has impressed critics with his quality films, *A Love of Blueness* (2000), *Life Show* (2002), and *Nuan* (2003), the first two of which capture the changing urban ethos in provincial cities, while the third enjoyed impressive box-office earnings in Japan.[25]

The example of *Nuan* indicates that young urban-educated directors are by no means averse to rural subjects. In fact, after projecting a labyrinthine city in *Lunar Eclipse* (1999), Wang Quan'an won a Golden Bear at the 2007 Berlin Film Festival with *Tuya's Marriage* (2006), an unusual love story set in rustic Inner Mongolia, which was withdrawn from domestic exhibition due to a protest from minority Mongolians but which entered art-house theaters in North America. Similarly, after his debut *When Nuoma Was Seventeen* (2002) made the rounds of the international film festivals, Zhang Jiarui directed an upbeat minority film, *Huayao Bride in Shangri-La* (2005), set in beautiful Yunnan province and rich in exotic ethnic custom.

Yunnan also provides the setting for *The Foliage* (Lü Yue, 2003), a sentimental account of fated love among the sent-down youth during the Cultural Revolution. This film points to another new trend in the new century: famous Fifth Generation cinematographers are making successful forays into directing. Like Lü Yue, Hou Yong switched to directing with *Jasmine Woman* (2004), a chronicle of cultural changes in Shanghai from the 1930s to the 1980s. It does this by following four generations of troubled mother-daughter relationships, the roles played by leading stars Joan Chen and Zhang Ziyi. Rather than a metropolis like Shanghai, Gu Changwei is fascinated with the provincial town: his directorial debut *Peacock* (2005), which takes an idiosyncratic look at a dysfunctional family, won the Silver Bear at the 2005 Berlin Film Festival; his more recent *And the Spring Comes* (2007) dramatizes the desperate attempt of a small-town schoolteacher to break away from her depressing social environment and enter the dream land of an operatic career in Beijing.

While the Fourth Generation gradually disappeared from the front lines of filmmaking in the new century, many Fifth Generation directors continued to work, but not all of them pursued the blockbuster genre. Huang Jianxin, for instance, continued his exploration of urban change in *Gimme Kudos* (2005), although he has abandoned the bitter satire characteristic of his early 1990s films and opted for mild humor and sentimentality, which probably helped his *Marriage Certificate* rank sixth in 2001. Tian Zhuangzhuang's recent career is more complicated, but like several of his Sixth Generation protégés, he has preferred to stay inside the state system since he was banned for *The Blue Kite*. He did not return to directing until *Springtime in a Small Town* (2002), a remake of Fei Mu's critically acclaimed classic, *Spring in a Small Town* (1948). After that, Tian directed a Japan-funded documentary, *Delamu* (2003), which traces a horseback trading route through the mountains in southwest China, and *The Go Master* (2006), a biography coproduced with Japan and intended as a tribute to the Japanese film style.

The new century has witnessed a small group of active woman directors. With *My Father and I* (2003) and *A Letter from an Unknown Woman* (2004), Xu Jinglei established herself as a unique director who writes her own screenplays and acts as the female lead. Notable among new woman directors is Li Yu, who follows the recent trajectory of independent filmmakers by directing *Fish and Elephant* (2001), an underground feature about a lesbian couple, and then two aboveground films dealing with sensitive issues of sex, rape, pregnancy, and child-rearing: *Dam Street* (2005) is set in a provincial town and is rich in local color, while *Lost in Beijing* (2007) unravels a *ménage-à-quatre* against a deteriorating moral landscape and ends on a triumphant note of female agency. Two veteran women directors

Figure 7.3. DVD cover, uncut version of *Lost in Beijing* (2007): sex and morality

have continued their careers: Li Shaohong moved from realism in *The Red Suit* (2000) to fantasy in *Baober in Love* (2004) and horror in *The Door* (2007), while Ning Ying alternates her focus on male and female urban experiences in *I Love Beijing* (2001) and *Perpetual Motion* (2005). Among the younger directors, many have chosen to work with the documentary, and there is by now an active group of "women with cameras," including Li Hong, Yang Tianyi, and Ying Weiwei, who confront social realities as well as individual memories.[26]

PROBLEMS: A LOPSIDED INDUSTRY

This overview of film production and exhibition in the new century indicates that there is no lack of talent in Chinese cinema. There is a fundamental problem, however; the majority of feature productions do not enter theater exhibition and therefore incur huge financial losses. In 2004, seven of top ten titles were coproductions with Hong Kong, and they represented over 70 percent of the year's box office for domestic films. Indeed, in 2004, exhibition revenues from the top three films were roughly the same as 209 other domestic films (see Table 2).[27] This means that the average box office for those 209 features was approximately RMB 2 million, and the actual revenue for the producer was much less after settling the three-way revenue-sharing with distributors and exhibitors.[28] The cost of most low-budget features ranges from RMB 1.5 to 3 million, and RMB 5 million is often considered a

safety mark beyond which it is difficult to recoup production investment.[29] Given this dire situation, up to 85 percent of low-budget feature productions in 2005 and 2006 never enter exhibition at all and therefore never recover their investment from theaters.[30] Of course, investors may defray part of the production costs from video rights, award monies, and broadcast contracts with CCTV 6 (Movie Channel). The state-owned Movie Channel has, moreover, grown into a formidable financial powerhouse, raking in RMB 1.38 billion in annual advertising revenues in 2007. In fact, its 2003 revenues of RMB 700 million exceeded the total overseas sales of Chinese films that year, although the Movie Channel lost its lead in this category starting in 2004.[31] Understandably, given its financial windfalls, the Movie Channel has ventured into film coproductions, and three of its coproduced titles even made it into the top ten as early as 2002.[32] In addition, the Movie Channel has regularly invested in digital film production, and the nationwide annual production numbers of digital films doubled from 52 in 2005 to 110 in 2006.

Nonetheless, with over two-thirds of films losing money each year, Chinese cinema is at best a lopsided industry built on a shaky foundation. Industry people and scholars have listed other problems that constrain Chinese cinema, such as rampant video piracy, exorbitant ticket prices (RMB 40–80 in major cities), underreported ticket sales, and the absence of a ratings system that continues to make censorship unpredictable. One recent example is the ban on *Summer Palace* (Lou Ye, 2006), which repeatedly displays frontal female nudity in its depiction of the 1989 Tiananmen student demonstration and the traumatic consequences. Although the theme of moral degradation is not exactly sensitive, *Lost in Beijing* (2007) went through several cuts to downplay its sexual dynamics before its domestic release. The most daring sex scenes came from *Lust, Caution* (Ang Lee, 2007), and the director agreed to cut shots of "objectionable" positions in lovemaking and make his mainland China version considerable shorter than those in Hong Kong and the United States, especially in DVD releases.

Censorship of politics and sex aside, the government has been willing to address some problems by installing computerized ticket systems and encouraging theaters to offer half-priced tickets on Tuesdays (and sometimes on Wednesdays as well), while calls for establishing art-house theaters have been issued from time to time in the press and at academic conferences. As an encouraging sign, a nationwide alliance of fifty theaters was launched in January 2008, and each multiplex theater member has agreed to devote a screening hall exclusively for exhibiting high-quality small-budget domestic films.[33] However, given the fact that the film industry remains insignificant in terms of its financial contribution to the current economic development in China, it is unrealistic to expect quick solutions to the problems that have afflicted Chinese cinema for decades. For the time being, the government is pleased to see transnational capital flowing in and out

Figure 7.4. DVD cover, uncut version of *Lust, Caution* (2007): sex versus nationalism

of the country as long as a few coproductions keep Chinese cinema on the global map each year and no major production ever challenges the Party-state's legitimacy. To varying degrees, film directors are content as long as minor investors are willing to support their projects regardless of financial returns, while minor investors—from private companies to municipal government units—are satisfied too, as long as their dreams of making films are realized. New government reform measures encourage private investment, and in 2006 alone, 277 nonstate film companies invested in productions, although close to 70 percent of them committed to one picture only.[34] With such diverse groups of players, the Chinese film industry promises neither short-term regularity of funding nor long-term stability, and all players plan their moves anxiously, with the market at stage center.

PROSPECTS: DANCING WITH CAPITAL

The centrality of the market returns us to the epigraph from Wang Meng, who dismisses both an enthusiastic "welcome" and outright "resistance"—both predicated

on an outsider position—as equally deprived of any "epic heroic" potential in the age of WTO. Instead, his advice to Chinese cultural workers is to get involved, to be a partner, to learn how to "dance happily with capital." While my overview here has demonstrated the extent to which Chinese filmmakers have learned to deal with the omnipresence of capital in the new century, the unresolved question has more to do with the degree of their agency and subjectivity than with their happy feelings or lack thereof. Most of the time, we see a situation in which Chinese filmmakers are forced—often unhappily—to dance according to the logic of transnational capital, which works relentlessly to extract maximum surplus value rather than to cultivate artistic vision. Indeed, except for a few leading directors, most Chinese filmmakers face a situation worse than what the Fifth Generation went through in the mid-1980s, when filmmakers could still count on some measure of state subsidy. Behind the shiny spots of a handful of media-hyped blockbusters is a vast space of irregularity and instability that continues to define the lopsided industry that is Chinese cinema.

In his discussion of Wang Meng's advice, Huang Shixian warns against capital's profiteering shortsightedness and endorses culture's potential to help increase the flow and appreciation of capital, thereby creating a win-win situation for both capital and culture. Nonetheless, aware of the contradiction between the logics of capital and culture, Huang asks, "If one loses the subjectivity of a national culture . . . what happiness can one speak of?"[35] Huang does not hide his indignation with recent blockbusters, which tend to trade Chinese subjectivity for Hollywood homogeneity and manufacture superficial ethnic elements to gain admission to overseas markets. Rather than turning market control over entirely to transnational capital, Huang recommends that a dialogue, conducted on an equal basis, take place between Eastern and Western culture.

Rao Shuguang envisions a state of "harmonious development" *(hexie fazhan)* in Chinese film production, where scholars are urged to "defend high-budget films, clear the way for medium-budget films, and plead on behalf of small-budget films."[36] Rao's proposal for Chinese cinema includes two systems, a mainstream state cinema and a mainstream commercial cinema, although he identifies the development of medium-budget film as the most urgent task, presumably for both the state and commercial sectors. Small-budget films are deemed inconsequential.

For many scholars, the latest encouraging sign in Chinese cinema has come not from medium- or small-budget films, but from the high-budget category, in which *Assembly* (Feng Xiaogang, 2007), a war film with a compelling narrative, emotional acting, and powerful images, succeeded in winning critical and popular acclaim and earned RMB 210 million at the domestic box office.[37] Released in the New Year window, *Assembly* differs from Feng's earlier New Year's pictures in its treatment of serious subjects such as personal sacrifice and group honor, but it

managed to evade censorship largely due to its ultimate conformity to the official ideology. Scholars are quick to celebrate significant shifts in Chinese blockbusters as embodied in *Assembly*: from grand political narrative to individual moral tale, from Western concepts to Eastern ethics, from visual bombardment to moving narration, from ancient China to modern times, and from overseas orientation to local grounding.[38] Overwhelmingly positive responses aside, it remains to be seen whether *Assembly* is an exception to the rule or a new direction in Chinese blockbuster production.

"After its first centennial celebration," writes Dai Jinhua, "Chinese cinema has found itself at a crossroads," facing suspense, a puzzle, and a series of uncertainties that also challenge China's future.[39] In any case, "danc[ing] happily with capital" is just a piece of personal advice, not a promise of financial or emotional returns.

Figure 7.5. DVD cover of *Assembly* (2007): a turning point for Chinese blockbusters?

To reiterate Massey's words, the space of capital is itself "a product of relations-between . . . it is always in the process of being made. It is never finished; never closed."[40] It is precisely this unfinished, open-ended process of space that produces, in contrast to the general sense of euphoria mentioned earlier, the sense of suspense and uncertainty that Dai alludes to, and space as process thus promises scenarios unintended by and alternative to the logic of capital. To say the least, the rapid development of Chinese independent film and video in polylocal grassroots places and translocal networks points to a vast space of alternative film where culture carries more weight than capital and where geography and humanity are of paramount importance. In the final analysis, the power of Chinese cinema resides not so much in its ability to generate profits across the board as in its production and exhibition of high-quality moving images that communicate to a wide spectrum of audiences at home and abroad; intervene in social, cultural, and political transformation; sustain a balanced film market overall on various scales; and leave an enduring mark on international film history.

Notes

Chapter 1: Introduction

1. Massey, *For Space*, p. 9.

2. Lefebvre, *The Production of Space;* Tuan, *Cosmos and Hearth.* As Edward Casey asserts, "Just as a place is animated by the lived bodies that are in it, a lived place animates these same bodies as they become emplaced there" (*The Fate of Place,* p. 242).

3. For that line of inquiry, see Deleuze, *Cinema I.*

4. Lefebvre, *The Production of Space,* pp. 36–37.

5. Ibid., pp. 38–40. Harvey complicates Lefebvre's triad by using three slightly modified terms in a vertical axis—"material spatial practices (experience), representations of space (perception), and spaces of representation (imagination)"—and supplementing them with a horizontal axis of three additional categories—"accessibility and distanciation, appropriation of space, and domination of space," thereby creating nine slots in a new grid of spatial practices; see Harvey, *The Urban Experience,* pp. 262–264. Edward Soja, who concurs with Harvey that "spaces of representation" is a better term than the "representational spaces" used in the English translation, likewise commends Lefebvre's triple dialectic, which "produces what might best be called a cumulative *trialectics* that is radically open to additional otherness, to a continuing expansion of spatial knowledge" (*Thirdspace,* p. 61).

6. Lefebvre, *The Production of Space,* p. 42.

7. See Negt and Kluge, *Public Sphere.* See also Habermas, *The Structural Transformation,* a seminal work beyond which Negt and Kluge try to move by delineating a proletarian public sphere.

8. Hansen, *Babel and Babylon,* pp. 11–12.

9. Massey, *Space, Place and Gender,* p. 3.

10. See, for instance, P. Huang, "'Public Sphere'"; Madsen, "The Public Sphere."

11. For alternative film culture, see Pickowicz and Zhang, eds., *From Underground.*

12. Hansen, *Babel and Babylon,* p. 394.

13. De Certeau, *The Practice of Everyday Life,* pp. 97–98; original emphases.

14. Ibid., p. 99.

15. Quoted in Clarke and Doel, "Zygmunt Bauman," p. 36.

16. Lefebvre, *The Production of Space,* p. 42. For a critique of de Certeau's mono-lithic concepts, see Massey, *For Space,* pp. 45–48. Other critics also argue that a partic-ular way of "walking" or operating need not always be construed as only oppositional. For example, see Kort, *Place and Space,* p. 178.

17. See Hansen, *Babel and Babylon,* p. 15.

18. Quoted in Hubbard, "Manuel Castells," pp. 74–75; original emphasis.

19. Castells, *The Information Age,* p. 200. However, this concept of place as self-contained is questioned by, among others, Massey, *Space, Place and Gender,* pp. 1–16.

20. Castells, *The Information Age,* p. 350.

21. Augé, *Non-places,* pp. 29, 78–79. Augé offers this definition: "If a place can be defined as relational, historical and concerned with identity, then a place which cannot be defined as relational, or historical, or concerned with identity will be a non-place" (ibid., pp. 77–78).

22. See Robertson, "Glocalization."

23. See Beilharz, ed., *The Bauman Reader,* p. 307.

24. Quoted in Clarke and Doel, "Zygmunt Bauman," p. 37.

25. Bauman, *Globalization,* p. 2.

26. Escobar, "Culture Sits in Places," pp. 155–156. For an eloquent expression of such an assignment of capital and power to space and, conversely, of working classes, "racial minorities, colonized peoples, women etc." to place and "placed-bound iden-tity," see Harvey, *The Postmodern Condition,* pp. 302–303.

27. See Escobar, *Encountering Development.*

28. Massey, *For Space,* p. 84.

29. Massey, "A Global Sense," p. 29.

30. Dirlik, "Placed-Based Imagination," p. 24. See also Latour, *We Have Never Been Modern.*

31. Dirlik, "Placed-Based Imagination," p. 38.

32. Ibid. p. 41; original emphasis.

33. Ibid., pp. 41–42.

34. Ibid., p. 22.

35. Tuan, *Space and Place,* p. 149.

36. N. Smith, "Contours of a Spatialized Politics."

37. Swyngedouw, "Neither Global nor Local," p. 140.

38. J. Wang, ed., *Locating China,* pp. 1–30.

39. R. Zhang, *The Cinema of Feng Xiaogang,* pp. 107–113; Yingjin Zhang, *Chinese National Cinema,* p. 293. For film policy in the new century, see G. Xu, *Sinascape,* pp. 13–14.

40. Cartier, *Globalizing South China,* p. 26.

41. For migrant workers in Chinese cities, see Logan, ed., *The New Chinese City,* pp. 183–226; L. Ma and Wu, eds., *Restructuring the Chinese City,* pp. 222–259; L. Zhang, *Strangers in the City.*

42. Oakes and Schein, eds., *Translocal China,* pp. xii, 1; original emphases.

43. Ibid., p. 9. Television is an outstanding example of a translocal force.

44. Oakes, "The Village as Theme Park"; Schein, "Negotiating Scale."

45. Oakes and Schein, eds., *Translocal China*, p. 19. Oakes and Schein are aware that translocality is not exclusively tied to globalization in China and that symbolic and material translocality existed from imperial China through Maoist China. For a study of translocality in late-imperial Beijing, see Belsky, *Localities at the Center*.

46. Y. Yan, "Managed Globalization," p. 21.

47. Hall, "New Cultures for Old," p. 207.

48. Oakes and Schein, eds., *Translocal China*, pp. 16–17.

49. J. Wang, *Locating China*, pp. 28–29.

50. The quotation is taken from the subtitle in Marchetti and Kam, eds., *Hong Kong Film*.

51. Major production companies for this film included Sony Pictures Classics, Columbia Pictures Film Production Asia, Good Machine (all three U.S. companies), Zoom Hunt (Taiwan), and China Film Coproduction Corporation (Beijing). For detailed information regarding the companies and personnel, see Sunshine, *"Crouching Tiger,"* pp. 140–144.

52. Rosen, "Chinese Cinema," p. 570.

53. Sunshine, *"Crouching Tiger,"* p. 46.

54. Ibid., p. 63.

55. Tim Yip remarks, "Jen's embroidered landscape robe, the transparent landscapes in [a character's] library, and Jen's room were all meant to express shadows of two co-existing worlds," that of rules-governed mundane life and that of free-roaming *jianghu* life; quoted in Sunshine, *"Crouching Tiger,"* p. 49.

56. Ibid., p. 116.

Chapter 2: Space of Scholarship

1. Quoted in Soja, *Post-modern Geographies*, p. 61.

2. Hayward, *French National Cinema*, pp. xi, 7.

3. Mast, *A Short History of the Movies*, p. 2.

4. Higson, *Waving the Flag*, p. 22.

5. Crofts, "Reconceptualizing National Cinema/s," p. 62.

6. Higson, *Waving the Flag*, pp. 273–274.

7. Higson, "The Concept of National Cinema," p. 42.

8. O'Regan, *Australian National Cinema*, p. 3.

9. Hayward, *French National Cinema*, p. 14; original emphasis.

10. Crofts, "Reconceptualizing National Cinema/s"; Crofts, "Concepts of National Cinema."

11. Crofts, "Concepts of National Cinema," p. 386.

12. O'Regan, *Australian National Cinema*, p. 71.

13. McIntyre, "National Film Cultures," p. 67.

14. Higson, "The Concept of National Cinema," p. 36.

15. Crofts, "Reconceptualizing National Cinema/s," p. 61.

16. Sorlin, *Italian National Cinema.*

17. Hill, "The Issue of National Cinema," p. 14.

18. The debate between Hill and Higson has more to do with British film policy regarding national cinema production than with the exhibition and consumption of Hollywood films. For problems of cultural protection, see also Higson, "The Limiting Imagination"; Jarvie, "National Cinema."

19. O'Regan, *Australian National Cinema*, p. 5.

20. Hayward, *French National Cinema*, p. x.

21. The notion that a national cinema is "historically fluctuating" comes from Hayward, *French National Cinema*, p. 16; the second quotation is from Williams, ed., *Film and Nationalism*, p. 6; original emphases.

22. The first quotation comes from O'Regan, *Australian National Cinema*, p. 2; the second from Yingjin Zhang, *Chinese National Cinema*, p. 3.

23. S. Lu and Yeh, eds., *Chinese-Language Film*, pp. 1–24.

24. Columbia Asia coproduced both *Big Shot's Funeral* (see Chapter 4) and *Double Vision*, two top-grossers in China and Taiwan in their respective release years. For cultural hybridization and global mélange, see Pieterse, *Globalization and Culture.* For global mélange in Taiwan cinema, see Yingjin Zhang, *Screening China*, pp. 299–305.

25. S. Lu, *Chinese Modernity*, pp. 162–163.

26. Shih, *Visuality and Identity*, p. 4.

27. Berry, "If China Can Say No," p. 132.

28. Ibid., p. 148.

29. The messiness of Hong Kong cinema is evident in Yinchi Chu's categories: "Hong Kong cinema as part of Chinese national cinema, 1913–56," "Hong Kong cinema as Chinese diasporic cinema, 1956 to 1979," "Hong Kong cinema as quasi-national cinema, 1979–97," and "Hong Kong cinema after 1997." See Chu, *Hong Kong Cinema.* For ruptures between the nation and the state in Taiwan, see Yip, *Envisioning Taiwan.* For further debate on a singular versus a plural designation of Chinese cinema(s), see C. Berry and Pang, "Introduction."

30. See Yingjin Zhang, *Screening China*, pp. 95–96.

31. See Chow, *Primitive Passions*; Clark, *Reinventing China*; T. Lu, *Confronting Modernity*; Tam and Dissanayake, *New Chinese Cinema*; Berry and Lu, eds., *Island on the Edge*; Yeh and Davis, *Taiwan Film Directors.* There are numerous other monographs on these individuals and their works.

32. See Pang, *Building a New China*; Shen, *The Origins of Left-wing Cinema*; Hu, *Projecting a Nation.* For a discussion of two of these books, see Yingjin Zhang, "Beyond Binary Imagination," pp. 66–69.

33. For further discussions of cinema in Taiwan, see Davis and Chen, eds., *Cinema Taiwan.*

34. Yingjin Zhang, *Chinese National Cinema*, pp. 244–249.

35. In addition to the East-West axis connecting Hong Kong to the United States, there is also a North-South axis in Hong Kong's intimate relationship with mainland China; see Law and Bren, *Hong Kong Cinema,* pp. 1–189.

36. For sample industry analyses, see Davis and Yeh, *East Asian Screen Industries;* Curtin, "The Future of Chinese Cinema"; Rosen, "The Wolf at the Door"; S. Wang, *Framing Piracy;* Y. Zhu, *Chinese Cinema.*

37. See relevant articles in Meng Jian, Li, and Friedrich, eds., *Chongtu, hexie;* Zhang Fengzhu, Huang, and Hu, eds., *Quanqiuhua yu Zhongguo yingshi.*

38. Williams, *Film and Nationalism,* p. 1.

39. Danan, "From a 'Prenational.'"

40. One example is the earliest extant Chinese film, *Laborer's Love* (Zhang Shi-chuan, 1922), which contains both Chinese and English intertitles. Quite a number of early Chinese films included English intertitles to attract foreign expatriates and overseas audiences.

41. See Qiu Shuting, *Gang Ri dianying guanxi,* pp. 4–7.

42. Higson, "The Limiting Imagination," p. 67.

43. Williams, *Film and Nationalism,* p. 19.

44. For New Year's pictures, see Kong, "Genre Film, Media Corporations."

45. See Hjort and MacKenzie, eds., *Cinema and Nation,* p. 13. See also Rentschler, "From New German Cinema."

46. For discussions, see McGrath, *Postsocialist Modernity,* pp. 165–202; R. Zhang, *The Cinema of Feng Xiaogang.*

47. Columbia Asia was behind Feng Xiaogang's *Cell Phone* (2003), and Hong Kong's Media Asia behind his *A World Without Thieves* (2004) and *The Banquet* (2006). See Davis and Yeh, *East Asian Screen Industries,* pp. 54–60.

48. Higson, "The Limiting Imagination," p. 73.

49. See Paul Willemen's statement, "The economic facts of cinematic life dictate that an industrially viable cinema shall be multinational" ("The National," p. 27). For the term "paranational," see Hayward's intriguing explication: "Hollywood's *para*-nationalism is pathologic—'*para*' in the sense of its internal nationalist discursive practices ('near')—'*para*' in the sense of its proto-colonialist practices ('beyond'). '*Para*' in the sense that, both near and beyond, its nationalism is abnormal and defective. . . . Hollywood's ability only to reflect itself to itself, to repeat its discourses inter- and extra-nationally, is both its strength and its weakness. . . . It denies and senses its own alienation—it repeats its own 'success formulas' and buys up, to remake (American-style), the successes of other national cinemas." See Hayward, "Framing National Cinema," pp. 99–100. One recent Hollywood trend is precisely to purchase the rights to Asian commercial hits (especially in the action and horror genres), delay or deny their exhibition in North America, and remake them "American-style" to flaunt Hollywood's borrowed innovation. For more discussion of Hollywood remakes of Asian hits, see G. Xu, *Sinascape,* pp. 151–158.

50. S. Lu, ed., *Transnational Chinese Cinemas,* p. 25; original emphasis.

51. Berry and Farquhar, *China on Screen*, pp. 4–13.

52. Ibid., p. 5.

53. See Yingjin Zhang, *Screening China*, pp. 39–41. This site-oriented approach derives from James Hay's proposal for "a way of discussing film as a social practice that begins by considering how social relations are spatially organized—through sites of production and consumption—and how film is practiced from and across particular sites and always in relation to other sites" ("Piecing Together," p. 216).

54. For Bruce Lee, see Berry and Farquhar, *China on Screen*, pp. 197–204.

55. Z. Zhang, *An Amorous History*, pp. 199–243; Bao, "From Pearl White." See also Hansen, "Fallen Women."

56. Berry and Farquhar, *China on Screen*, p. 14.

57. Willemen, "The National," p. 22.

58. See Saussy, ed., *Comparative Literature*; Yingjin Zhang, *Shenshi Zhongguo*, pp. 161–172.

59. Bernheimer, ed., *Comparative Literature*.

60. Willemen, "The National," pp. 26–27.

61. Ibid., pp. 28–29.

62. Ibid., p. 30.

63. See Shohat and Stam, *Unthinking Eurocentrism*; Yingjin Zhang, *Screening China*, pp. 115–147.

64. My examples are mostly from English scholarship. For Chinese scholarship, see Li Daoxin, *Zhongguo dianying*; Yan Chunjun, *Zhongguo dianying*.

65. Berry, ed., *Perspectives on Chinese Cinema*, p. i.

66. Yingjin Zhang, *Screening China*, pp. 43–113.

67. Kaplan, "Melodrama/Subjectivity/Ideology," p. 26.

68. Berry, "The Sublimative Texts," p. 79. Laikwan Pang also questions Berry's sublimation hypothesis and argues instead for the complementary coexistence of sexuality and revolution in *Big Road* (aka *The Highway*). See Pang, *Building a New China*, p. 101.

69. Ryan, "The Politics of Film," p. 480.

70. See Berry, "Independently Chinese."

71. For an exception, see Curtin, *Playing to the World's Biggest Audience*.

72. M. Yang, "Film Discussion Groups."

73. Higson, "The Concept of National Cinema," pp. 45–46; original emphasis.

74. Nakajima, "Film Clubs in Beijing."

75. Jia Zhangke, "Yeyu dianying shidai."

76. Pang, "Piracy/Privacy," p. 115.

77. S. Wang, *Framing Piracy*, p. 91.

78. For ethnographic films, see Yingjin Zhang, *Screening China*, pp. 220–239.

79. See Harris, "Adaptation and Innovation"; Z. Zhang, "Cosmopolitan Projections"; Pickowicz, 'Sinifying and Popularizing"; Hoare, "Innovation through Adaptation." There are a few film adaptations of Ba Jin's *Family*, but they are not included here or in the Filmography; for further information, see Robinson, "*Family*."

80. For a discussion of these questions, see Qin, "Trans-media Strategies."
81. See Semsel, Xia, and Hou, eds., *Chinese Film Theory.*
82. For a semiotic analysis, see Denton, "Model Drama as Myth."
83. Wu Hung, "Between Past and Future."
84. Chang, "The Good, the Bad."
85. Yingjin Zhang, *The City in Modern Chinese Literature,* pp. 185–231.
86. Z. Zhang, *An Amorous History,* p. 37.
87. Bao, "From Pearl White," pp. 215, 231.
88. See Tuohy, "Metropolitan Sounds"; Yeh, "A Life of Its Own."
89. See Ehrlich and Desser, eds., *Cinematic Landscapes,* pp. 39–80. See also Lin Niantong, "A Study of the Theories."
90. Bordwell, "Aesthetics in Action," pp. 80–82.
91. L. Liu, *Translingual Practice.*
92. Chow, "Film and Cultural Identity," p. 171; original emphasis.
93. Bordwell, "Transcultural Spaces," p. 143.
94. Ibid., pp. 143–150.

Chapter 3: Space of Production

1. Soja, *Thirdspace,* p. 2.
2. Lefebvre, *The Production of Space,* p. 42.
3. Dai, *Cinema and Desire,* p. 213.
4. Ibid., p. 233.
5. For the recent successes of Chinese cinema at international film festivals, see Yingjin Zhang, *Screening China,* pp. 16–17. In relation to Western modernity, Chinese efforts at "bringing the world home" started more than a century ago, in literary translation; see Huters, *Bringing the World Home.*
6. For a brief account of the Red classics, see K. Liu, *Globalization and Cultural Trends,* pp. 92–94.
7. For a survey of the 1990s, see Yingjin Zhang, *Chinese National Cinema,* pp. 281–296.
8. In Chinese, *qunzhong* carries the connotation of top-down political mobilization and is closely related to the socialist legacy; *dazhong,* on the other hand, is linked to the popular and is open to commercial as well as ideological manipulation.
9. Both Huang Jianzhong and Wu Ziniu were known for their experimental art films in the late 1980s, such as Huang's *Questions for the Living* (1986) and Wu's *Evening Bell* (1988), and this fact makes their willing participation in state-sanctioned leitmotif films in the late 1990s highly ironic. See Yingjin Zhang, *"Evening Bell."*
10. *Beijing Bicycle* had a relatively small overseas investment of RMB 3 million; see Yin Hong, *Kuayue bainian,* p. 185. *Hero,* on the other hand, involved RMB 240 million from Beijing, Hong Kong, and Hollywood (Columbia Asia) and set a box-office record of RMB 250 million (see Chapter 7).

11. Zhang Yimou's words illustrate this tension between art and marginality: "The same youthful defiance exists in other walks of life too. This is also true with the Sixth Generation's rebellion. It is not clear whether the rebellion is against politics, or art forms, or art content, or older generations, or traditional aesthetics." See Gateward, ed., *Zhang Yimou*, p. 153.

12. For the production of *Platform*, Jia Zhangke received funding from Hu Tong Communications of Hong Kong, Bandai Entertainment of Japan, and Artcam of France. Somewhat ironically, Zhang Yimou, who had benefited tremendously from overseas funding in the early 1990s, complained about the young directors' complicity with capital in 1999: "The Sixth Generation was subject to practical considerations. It cannot be resisted: the need for money, the dilemma caused by censorship, and the awards at international film festivals." See Gateward, *Zhang Yimou*, p. 162.

13. I put the word "private" in quotes because the company Forbidden City was founded in 1996 exclusively with state money totaling RMB 5.18 million. It came from the following government units: Beijing TV Station (25.5 percent), Beijing TV Art Center (25.5 percent), Beijing Film Company (24.5 percent), and Beijing Culture and Arts Audio-Visual Press (24.5 percent). See Zhongguo dianying nianjian she, ed., *Zhongguo dianying nianjian 1997*, 342. After launching the popular New Year's picture, a comedy genre masterminded by Feng Xiaogang, Forbidden City has prospered in the postsocialist market economy.

14. As Wang Xiaoshuai observes of his struggling young characters, "Their resistance, unorthodoxy, avant-gardism, even marginality are always ignored in mainstream cinema." See Fu Ying, "Jiqing suo guanzhu," p. 72.

15. Zhang Yuan stated a decade ago, "Being an independent director in China is an absolutely marginal activity." See Berry, "Zhang Yuan," p. 42.

16. Nakajima, "Film Clubs in Beijing," pp. 161–208.

17. See Cheng Qingsong, *Kandejian de yingxiang*, pp. 245–246.

18. Kluge, "On Film," p. 212.

19. For reform measures in the film industry, see Y. Zhu, *Chinese Cinema*.

20. De Certeau, *The Practice of Everyday Life*, p. 37.

21. Shu Kei's name appears as producer or distributor on all three Sixth Generation films screened at the 1994 Vancouver International Film Festival: *Beijing Bastards*, *The Days*, and *Red Beads* (He Yi, 1993). See Chute, "Beyond the Law." Shu Kei continued to serve as the producer on *Postman* (1995) and *Frozen* (1997).

22. Cheng Qingsong and Huang, *Wode sheyingji*, pp. 294–313.

23. *Beijing Bicycle* is distributed, among others, by Sony Pictures Classics (U.S.), Pyramide Distribution (France), Teodora Film (Italy), and Vértigo Films S. L. (Spain). For analyses of Wang's films, see Xiaoping Lin, "New Chinese Cinema"; G. Xu, *Sinascape*, p. 70–78; J. Xu, "Representing Rural Migrants."

24. Massey, *Space, Place and Gender*, p. 2.

25. Ibid., p. 3.

26. Ibid.

27. Lefebvre, *The Production of Space*, p. 366.

28. Quoted in Reynaud, "New Visions/New Chinas," p. 236.

29. See Yin Hong, *Kuayue bainian,* p. 173.

30. For these four types of space, see T. Lu, *Confronting Modernity,* pp. 76–92.

31. Tian Zhuangzhuang appears as a paternal, heroic figure in Lu Xuechang's debut film, *The Making of Steel* (1997).

32. Not surprisingly, Shu Kei was the distributor for both films overseas; see Chute, "Beyond the Law." Andrew Morris writes of *The Blue Kite* in *New York Observer:* "The most amazing act of political courage I have ever seen in the cinema" (see the Kino Video package).

33. Donald, "Symptoms of Alienation," p. 94.

34. Foucault, "Of Other Spaces," p. 24.

35. For an account of *yaogun* culture, see Efird, "Rock in a Hard Place."

36. Dai, *Cinema and Desire,* p. 93. For a reading of Zhang's protest lifestyle as a subcultural phenomenon that can be interpreted as a "cultural revolution" in disguise, see Schell, *Mandate of Heaven,* pp. 323–326.

37. For further analysis, see Reynaud, "Zhang Yuan's Imaginary Cities."

38. Foucault, "Of Other Spaces," p. 25. Another such heterotopic site of deviation, the psychiatric hospital, is briefly represented in *Sons* (Zhang Yuan, 1996), a docudrama about and acted by a real-life alcoholic family. Interestingly, among the first group of Sixth Generation films released in the West, *Red Beads* also focuses on the asylum as a heterotopia.

39. Foucault, "Of Other Spaces," p. 24.

40. For cinematic images of demolition, see Braester, "Tracing the City's Scars"; S. Lu, *Chinese Modernity,* pp. 167–190.

41. Wu Hung, "Ruins, Fragmentation," p. 60.

42. The quotation comes from a reading of the ruins of Angkor Wat in *In the Mood for Love* (Wong Kar-wai, 2000). See Khoo, "Love in Ruins," pp. 244–245.

43. See Eckholm, "Feted Abroad."

44. Born in Sydney, Australia, in 1952, Christopher Doyle (or Du Kefeng in Chinese) is best known for the showy cinematography he has done for Wong Kar-wai, but he has also worked with other leading directors, such as Chen Kaige and Zhang Yimou in mainland China, Peter Chan and Stanley Kwan in Hong Kong, as well as Stan Lai and Edward Yang in Taiwan.

45. For Duan's contribution to the genre of independent documentary, see Berry, "Independently Chinese."

46. For Duan's role in *The Square,* see Li Xing, Liu Xiaoqian, and Wang Jifang, *Bei yiwang,* pp. 210–214; Mei Bing and Zhu, *Zhongguo duli jilu,* pp. 107–108, 127–128.

47. Jaivin, "Defying a Ban."

48. As Duan Jinchuan recalls, *The Square* was shown in a China Newsreels Film Studio auditorium, but the audience was puzzled and wanted to know what the documentary meant. See Li Xing, Liu Xiaoqian, and Wang Jifang, *Bei yiwang,* pp. 213–214.

49. Lefebvre, *The Production of Space,* p. 366.

50. Berry, "Zhang Yuan," p. 42.

51. Ibid., p. 42.

52. McGrath, *Postsocialist Modernity*, p. 136. Jia's own memory may be fuzzy, for he dated this documentary ambiguously in 1995 or 1996, and he described the work as unedited; see Lin Xudong, Zhang, and Gu, eds., *Jia Zhangke dianying: "Ren xiaoyao,"* p. 6.

53. Kluge, "On Film," p. 210.

54. See Pickowicz, "Huang Jianxin"; Xudong Zhang, *Chinese Modernism*; Xudong Zhang, ed., *Whither China?*; S. Lu, *China, Transnational Visuality.*

55. Note Dai Jinhua's caution, however: "But being different does not in itself say anything about the Sixth Generation. This is precisely the cultural absurdity of the 'Sixth Generation.'" In other words, Dai suspects that the artists may have generated differences in order to meet the expectations of the West. See Dai, *Cinema and Desire,* p. 78.

56. Han Xiaolei, "Dui diwudai"; Yin Hong, "Zai jiafeng zhong."

57. For concepts of postsocialism, see Yingjin Zhang, "Rebel without a Cause?" pp. 50–52.

58. See L. Liu, *"Beijing Sojourners."*

59. For political reasons, Zhang Yuan, like many other members of his generation, prefers "independent" filmmaker to "underground" or "dissident" filmmaker. See Dai, *Cinema and Desire,* p. 90. See also S. Cui, "Working from the Margins"; Lau, "Globalization and Youthful Subculture."

60. Yu Yunke, "Toufa luanle?" Many Sixth Generation directors had experience shooting MTV pieces before their directorial debuts. Zhang Yuan, for instance, shot music videos for artists like Ai Jing and Cui Jian. See Barmé, *In the Red,* p. 195; Reynaud, "New Visions/New Chinas," p. 238. Many directors were and are still involved in shooting television commercials.

61. Railroad tracks, along with railroad crossings and signal lights, simultaneously suggest an otherwise definitively charted direction of travel and paths not taken or abandoned, and they have thus become a recurring motif among this generation. For instance, Lu Xuechang depicts two of his protagonists working near the railroad tracks in Beijing: a young apprentice in *The Making of Steel* (1997) and an ordinary pet-lover in *Cala, My Dog* (2002).

62. Stephanie Donald argues that Sixth Generation directors tend to displace male anxiety unto the female body and that abortion not only functions as a metaphor for disguising the empty anarchy of male subjectivity but also reduces the woman to her reproductive capacity alone. See Donald, *Public Secrets,* pp. 106–119. It is quite true that male anxiety over the pregnant woman—a body out of male control—runs consistently from *Beijing Bastards* (1993) and *The Days* (1993), through *No Visit after the Divorce* (1997) and *Urban Love* (1997), to *Mr. Zhao* (Lü Yue, 1998) and *Platform* (2000).

63. Drawing the sartorial lexicon from their Western counterparts, Chinese male rock musicians typically have long hair and wear torn jeans, T-shirts, studded leather jewelry, and sunglasses. See Jones, *Like a Knife.* p. 118.

64. Han Xiaolei, "Dui diwudai," p. 61.

65. Lü Xiaoming calls attention to the importance of the Tiananmen event of 1989, when many of these young directors experienced for the first time something close to a mass revolution movement. If their acute sense of alienation and disillusion originated in part from this experience, then their screen rebellion may perhaps be seen as a belated revisiting of this hidden trauma. See Lü Xiaoming, "90 niandai Zhongguo dianying."

66. Massey, *For Space,* pp. 124–125.

67. "Hey Jude," John Lennon/Paul McCartney, Apple Records, 1968. The released DVD version of *Dirt* has changed all original uses of the "Hey Jude" song to an Italian opera sound track, presumably to rid it of the potential subversion symbolized by the Beatles song. Ironically, in the final credit sequence, the Chinese subtitles of the Beatles lyrics remain, mocking the irrationality of film censorship.

68. Jones, *Like a Knife,* p. 4.

69. See Barmé, *In the Red,* pp. 360–361; Jones, *Like a Knife,* p. 127.

70. Jones, *Like a Knife,* p. 2. The song lyrics go: "This guitar in my hands is like a knife. . . . I want to cut at your hypocrisy till I see some truth." See ibid., p. 97.

71. Ibid., p. 91.

72. Wu Guanping, "Fang qingnian daoyan," p. 64.

73. Jones, *Like a Knife,* p. 102.

74. Ibid., pp. 100–101.

75. Barmé, *In the Red,* pp. 194–196.

76. Jones, *Like a Knife,* p. 117.

77. Ibid., p. 89.

78. Barmé, for example, characterizes Zhang Yuan as an example of "bankable dissent" or "packaged dissent" in postsocialist China (*In the Red,* p. 188).

79. Jones, *Like a Knife,* pp. 138–142.

80. Ibid., p. 117.

81. It took three years for *The Making of Steel* to clear censorship.

82. Barmé, *In the Red,* p. xiv.

83. Barmé himself does not seem to endorse the term "postsocialism," but he does refer to "the post-Sino-socialist cultural palette" (ibid., p. xx).

84. Ibid., p. xv.

85. For a complete list of these invited submissions, see Yingjin Zhang, *Screening China*, pp. 327–328.

86. Partly because Zhang Yuan was willing to shoot *Seventeen Years* (1999) with official endorsement, his other films like *Mama* (1991) and *Crazy English* (1999) were also approved for public release. For Western anxiety, see Eckholm, "Feted Abroad."

87. Jin Chen directed *Love in the Internet Generation* (1999).

88. Ni Zhen, "Shouwang xinsheng dai," p. 72. For more discussion of the newcomers, see Han Xiaolei, "Tuwei hou de wenhua piaoyi."

89. Wu Guanping, "Fang qingnian daoyan," p. 65.

90. Li Yan, "WTO laile," p. 53.

91. See Dazhong dianying, ed., "Xinren xinzuo *Yueshi.*"

92. See Silbergeld, *Hitchcock with a Chinese Face*, pp. 11–46; G. Xu, *Sinascape*, pp. 78–87; Z. Zhang, "Urban Dreamscape."

93. See S. Cui, "Ning Ying's Beijing Trilogy."

94. On Xia Gang, see Yingjin Zhang, *Screening China*, pp. 293–299.

95. The age range among these new directors is estimated to be as much as twenty years, with Meng Jinghui, a renowned drama director whose experimentalist debut film is *Chicken Poets* (2002), among the oldest. Like many earlier members of the urban generation, several new directors have formal ties with Beijing Film Academy and Central Drama Academy. From the former came Lu Chuan and Yu Zhong (from the graduate program in directing), Li Jixian (from art design), Chen Daming, and Xu Jinglei (both acting); from the latter came Ma Xiaoying (directing) and Zhang Yibai (literature). See Dangdai dianying, ed., "Xin shiji xin daoyan," pp. 31–33.

96. Ibid. China Film Group, which now owns Beijing Film Studio, was behind the production or coproduction of ten out of the twenty-one debut titles in 2001–2002.

97. Estimated to have brought in RMB 15 million at the box office, *Roots and Branches* could be credited as the top-grosser of 2001 because the box office for the year's first-place film, *Big Shot's Funeral,* included revenues from its 2002 showings, and the second-place film was a "science and education" *(kejiao)* documentary about the universe and humans.

98. Zhang Yibai, "Tongwang chuntian," p. 77.

Chapter 4: Space of Polylocality

1. Foucault, "Of Other Spaces," p. 22.

2. For an argument that the imagination is a constituent of social reality in general and of urban space in particular, see Çinar and Bender, eds., *Urban Imaginaries,* pp. ix–xxvi.

3. See Jameson, "Remapping Taipei"; Abbas, *Hong Kong;* Dai, *Cinema and Desire,* pp. 49–70.

4. King, ed., *Culture, Globalization,* p. 12; emphasis added.

5. Hall, "The Local and the Global," p. 28.

6. See Pieterse, *Globalization and Culture.*

7. Sassen, *The Global City,* pp. 14–15.

8. I would not go so far as to agree that the local is already "transnationalized," as Kwai-cheung Lo asserts for Hong Kong cinema. See Lo, "Transnationalization of the Local." In mainland China, the national—represented by the state and its programs of nationalism—systematically intervenes to preempt any large-scale translocal, trans-regional convergence or coalition.

9. Quoted in M. Smith, "Power in Place," p. 125.

10. Esherick, ed., *Remaking the Chinese City,* p. ix. For recent books on early Shanghai cinema, see Pang, *Building a New China;* Shen, *The Origins of Left-wing*

Cinema; Yingjin Zhang, ed., *Cinema and Urban Culture*; Z. Zhang, *An Amorous History*. For Shanghai culture, see Lee, *Shanghai Modern*.

11. For images of China in American films, see Yingjin Zhang, *Screening China*, pp. 240–244; Yingjin Zhang, *Shenshi Zhongguo*, pp. 66–78.

12. Furthman, *"Morocco" and "Shanghai Express*," p. 67.

13. IMDb, "Trivia for 55 Days at Peking."

14. Sklarew et al., eds., *Bertolucci's "The Last Emperor*," pp. 45, 50.

15. For Beijing-Shanghai cultural differences, see Yingjin Zhang, *The City in Modern Chinese Literature*. For recent takes on Beijing, see, L. Li, Dray-Novey, and Kong, *Beijing*; Dong, *Republican Beijing*; Wu Hung, *Remaking Beijing*.

16. For instance, Yuan Muzhi re-edited a montage sequence of Shanghai scenes from his *Cityscape* (1935) and included it as the initial credit sequence of his *Street Angel* (1937).

17. The upscale teahouse now comes with a chic interior design and furnishings, as in *Green Tea*. Images of *hutong* recur in many films by Sixth Generation directors (see Chapter 3).

18. My usage dovetails with Linda Lai's concept of "drifting" as a cinematic speech act, which works toward "the violation of managed space, the breakaway from structured powers of containment by reopening settled meaning." See Lai, "Whither the Walker Goes," pp. 206–207. However, I do not share her view on a neat dichotomy between two modes of walking—*flâneurie* for the transcendental, rational, and modernist subject versus *dérive* (drifting) for the decentered, deconstructive, and postmodern subject—because *flâneurie* can be just as digressive if not as subversive as drifting vis-à-vis the dominant system.

19. As Jia Zhangke comments, "Different means of transportation have already divided social realities" in the Chinese city. See Yang Yuanying and Li, eds., *Yingxiang*, p. 21.

20. For an English translation of the novel, see Lao She, *Rickshaw*; for a film adaptation, see *Camel Xiangzi* (Ling Zifeng, 1982).

21. The term comes from L. Liu, *Translingual Practice*, pp. 103–127.

22. For a different reading of the bicycle, which focuses on a transnational circuit of value and on Guei and other migrant workers in relation to the Chinese discourse of *suzhi* (quality), see G. Xu, *Sinascape*, pp. 70–78.

23. For the ethnoscape and other kinds of "scapes," see Appadurai, *Modernity at Large*.

24. Compare Bertolucci's perception in connection with *The Last Emperor*: "This bicycle is very . . . phallic, because it goes between the legs and it has two wheels." See Sklarew et al., *Bertolucci's "The Last Emperor*," p. 39.

25. Quoted in Xiaoping Lin, "New Chinese Cinema," p. 268; the original source is S. Žižek, *The Fragile Absolute*.

26. Jian Xu reads the film's ending as ambivalent: it could be either a celebration of "rural values endangered by urban expansion" or a criticism of "the mentality of the

rural and the provincial for impeding the development of cosmopolitan China" ("Representing Rural Migrants," p. 445). To me, the film endorses neither of these binary readings, for the director's intention is not to formulate a fixed position but to delineate a city of profound contradictions.

27. For a discussion of class issues in this film, see Dai Jinhua, *Dianying lilun*, pp. 357–365.

28. For the film's construction of a social map of gender and space in the geography of Beijing, see S. Cui, "Ning Ying's Beijing Trilogy," pp. 254–262.

29. For further discussion of the capitalist logic, whereby the film director acts as a cultural broker in contemporary China, see Braester, "Chinese Cinema."

30. For different emphases on Feng's metacinema, see Kong, "Big Shot from Beijing"; McGrath, *Postsocialist Modernity*, pp. 165–202.

31. The film's multinational cast is clearly aimed at maximum market appeal in various distribution territories. See S. Wang, *"Big Shot's Funeral."* Not surprisingly, the film set a box-office record in China (see Chapter 7).

32. For more discussion, see T. Lu, "Trapped Freedom."

33. The actual official website address is: www.beijingworldpark.cn. The theme park is located in Beijing's Fengtai district, off the southeast part of the Fourth Ring Road. Jia admits that the idea for the film came from Zhao Tao's experience working at World Park (Shijie zhichuan) in Shenzhen. See Yang Yuanying and Li, *Yingxiang*, p. 17.

34. Havis, "Illusory Worlds," p. 59.

35. M. Smith, "Power in Place," p. 127.

36. *Beijing Bicycle* was coproduced by Arc Light Films (Taiwan), Pyramide Productions (France), and Beijing Film Studio (China). *I Love Beijing* was coproduced by Eurasia Communications (Italy-China) and Happy Village (China). *Big Shot's Funeral* was coproduced by Columbia Asia (US) and Huayi Brothers–Taihe (China). *The World* was coproduced by Office Kitano (Japan), Shanghai Studio (China), and Lumen (France) on a budget of RMB 12 million, but its North American rights alone earned US$4 million. Interestingly, whereas *The World* had a dismal RMB 1 million at the domestic box office, its legal DVD sales sold over 300,000 copies and earned about RMB 4.5 million. See Davis and Yeh, *East Asian Screen Industries*, pp. 158; Yin Hong, *Kuayue bainian*, pp. 193, 198.

37. Lin Xudong, Zhang, and Gu, eds., *Jia Zhangke dianying: "Ren xiaoyao,"* pp. 2–4.

38. Ibid., p. 3.

39. Ibid., p. 4.

40. Ibid., p. 5.

41. Ibid., p. 8.

42. Havis, "Illusory Worlds," p. 58.

43. For Jia's early experiments, see McGrath, *Postsocialist Modernity*, pp. 131–164.

44. Koehler, "The World," p. 56.

45. Ibid., p. 57.

46. Bauman, *Liquid Modernity,* p. 101; original emphasis.

47. See Clarke and Doel, "Zygmunt Bauman," pp. 36–37.

48. Tuan, *Topophilia,* p. 93.

49. Low and Smith, eds., *The Politics of Public Space,* p. 3.

50. *Still Life* won a Golden Lion at Venice International Film Festival in 2006.

51. Baidu Baike, "Fengjie."

52. Baidu Baike, "Sanxia daba." Jia estimates that by the time shooting started in summer 1995, two-thirds of Fengjie had already been submerged. See Wu Jing and Wang, "Zai chanyehua chaoliu zhong," p. 29. Three other notable documentaries on the dam project are *A River Is Stilled* (Jiang Yue, 1998), *Before the Flood* (Li Yifan, Yan Yu, 2005; shot on location in Fengjie in 2002), and *Bing Ai* (Feng Yan, 2006).

53. After suppressing dissenting voices for years, the Chinese government has recently admitted some of the project's ecological and environmental consequences, such as erosion and landslides on steep hillsides, visible climate changes in Chongqing and Sichuan, as well as algae bloom downstream and a deterioration of aquatic life. See Macartney, "Three Gorges Dam."

54. The Three Gorges Dam is located close to the city of Yichang in Hubei province. According to legend, a riverside ridge named Huangniuyan (Yellow bull cliff) was discovered in 1993, the centennial of Mao's birth year, to resemble Mao lying down on top of the mountain. It was interpreted as an auspicious sign for the project, which would realize Mao's vision, as expressed in his verse, "a tranquil lake emerging between steep gorges" *(gaoxia chu pinghu).* The cliff has since been renamed Maogong shan (Mount Mao), and Mao is thus symbolically emplaced in the Three Gorges landscape. See Baidu Baike, "Sanxia daba."

55. Donald, "Landscapes of Class."

56. Lefebvre, *The Production of Space,* p. 70.

57. Donald, "Landscapes of Class."

58. Cui Weiping goes so far as to assert that ruins are the actual protagonist in *Still Life.* See Ouyang Jianghe, ed., *Zhongguo duli dianying,* p. 245.

59. Donald, "Landscapes of Class."

60. In the past few years, the average annual death tolls from coal-mining accidents in China stand around 5,000, compared with about 30 mining deaths a year in the United States. See Barboza, "105 Killed." Two notable independent Chinese feature films dealing with the dangers of coal mining are *Blind Shaft* (Li Yang, 2001) and *Night and Day* (Wang Chao, 2005); a historical look at coal mining in the 1950s is provided by a 172-minute independent documentary, *Sanli Dong* (Lin Xin, 2006).

61. Jia's use of popular songs is a crucial translocal device. In *Still Life,* a film theme song about the red maple leaves on a hillside evokes the widespread idealism of the 1980s, while two other popular songs conjure up linkages to Hong Kong (Little Brother Ma's cell phone ring tone, originally sung in Cantonese) and Taiwan (migrant workers' applaud a Taiwanese song in an evening entertainment show).

62. Wu Jing and Wang, "Zai chanyehua chaoliu zhong," p. 31.

63. Jia Zhangke et al., "Sanxia haoren," p. 19.

64. Harvey, "Between Space and Time." See also Hubbard, Kitchin, and Valentine, eds., *Key Thinkers,* p. 185.

65. A similar compass of polylocality is developed in Jia's latest feature-length documentary, *Useless* (2007), where he examines different forms of clothing/fashion in three geographic localities in China: industrial manufacturing garments in Zhuhai, Guangdong province; entrepreneurish high-concept fashion in a transnational Guangzhou-Paris axis; and the products of a local small-town tailor shop in Fenyang.

66. Wu Jing and Wang, "Zai chanyehua chaoliu zhong," 30. A notable figure in the Beijing avant-garde art scene, Liu Xiaodong appears as a depressed artist abandoned by his wife in *The Days* (see Chapter 3).

67. Foucault, "Of Other Spaces," p. 22.

68. Kort interprets this loosening of people's ties to places as one consequence of modern history (*Place and Space,* p. 191).

69. Deleuze and Guattari, *A Thousand Plateaus,* pp. 15, 192. Similarly, James Clifford emphasizes routes over roots, or travels over home, in our effort to reconsider human experience (*Routes,* p. 3).

70. Wu Jing and Wang, "Zai chanyehua chaoliu zhong," p. 30.

Chapter 5: Space of Subjectivity

1. Massey, *For Space,* p. 12.

2. An early example was the Chinese government's ban on Wu Wenguang, Zhang Yuan, and other independents in 1994. See Jaivin, "Defying a Ban." State censorship activities like this may be seen as an official protest against a string of top awards given to Chinese independent film and video since the early 1990s by international film festivals such as Berlin, Cannes, Chicago, Edinburgh, Hawaii, Locarno, Montreal, Nantes, Pusan, Rotterdam, Singapore, Tokyo, Vancouver, Venice, and Yamagata. For details, see the relevant pages in Cheng Qingsong and Huang, *Wode sheyingji.* A lower-level disciplinary mechanism is at work in the case of Cui Zi'en, a high-profile, openly gay videomaker in China. After teaching homosexual films years ago, Cui has been banned from classroom instruction at Beijing Film Academy. Although from time to time he offers lectures at one university campus or another in Beijing, he has been discouraged from going back a second time once the authorities find out about his "unofficial" activities.

3. Among a few early English studies are Reynaud, "New Visions/New Chinas"; Xiaoping Lin, "New Chinese Cinema." However, the scholarship situation has improved with the publication of two recent volumes: Pickowicz and Zhang, eds., *From Underground;* Z. Zhang, ed., *The Urban Generation.*

4. The book also contains brief information regarding other "equally important directors" (again, all male): Li Jixian, Hu Xueyang, Liu Bingjian, Meng Jinghui, Wang Quan'an, Yu Liwei (Yu Likwai), Wang Guangli, Zhang Yang, Guan Hu, Zhu Wen, Tang

Danian, Li Xin, and Shi Runjiu. See Cheng Qingsong and Huang, *Wode sheyingji,* pp. 398–429. For a more comprehensive discussion of films banned from theatrical release in China, see Zhang Xianmin, *Kanbujian de yingxiang.*

5. Solveig studied at Beijing Film Academy, and Schneidere-Roos taught German literature at Beijing University. Including postproduction, the two of them spent US$10,000 out of their own pockets on *My Camera Doesn't Lie.* The author's interview with Katharina Schneidere-Roos, Friendship Hotel, Beijing, Dec. 27, 2003.

6. Quoted in Reynaud, "New Visions/New Chinas," p. 236.

7. For Fifth Generation films as a mode of "ethnographic cinema," see Yingjin Zhang, *Screening China,* pp. 208–220.

8. Cheng Qingsong and Huang, *Wode sheyingji,* p. 31.

9. Ibid., pp. 362, 370.

10. Ibid., p. 370.

11. See Chute, "Beyond the Law."

12. Han Xiaolei, "Dui diwudai"; Yin Hong, "Zai jiafeng zhong."

13. See Chen Mo and Xiao, "Chinese Underground Films."

14. For their alternative modes of production and their funding sources, see Yin Hong, *Kuayue bainian,* pp. 169–228.

15. Cui Zi'en, *Diyi guanzhong,* pp. 128–131.

16. Cheng Qingsong and Huang, *Wode sheyingji,* p. 77; emphasis added. For an analysis of Jiang's subjective confrontation with official history in *In the Heat of the Sun,* see Braester, *Witness Against History,* pp. 192–205.

17. Zhang Ming, *Zhaodao yizhong,* pp. 27–28.

18. Jia Zhangke et al., "Sanxia haoren," p. 24.

19. These directors' avoidance of realism, however, does not prevent critics from using the term to describe their works, as is the case with "postsocialist realism" in McGrath, *Postsocialist Modernity,* pp. 131–136.

20. Bazin, "De Sica," p. 39.

21. Cheng Qingsong and Huang, *Wode sheyingji,* p. 362.

22. Zhang Ming, *Zhaodao yizhong,* p. 9. Jia Zhangke echoes Zhang's view by saying that no one has the right to represent the majority, and one has the right to represent only oneself; see Cheng Qingsong and Huang, *Wode sheyingji,* p. 367.

23. Cheng Qingsong and Huang, *Wode sheyingji,* pp. 25, 34.

24. Cui Zi'en, *Diyi guanzhong,* p. 22.

25. For additional English publications on recent Chinese documentaries, see Berry, "Getting Real" and "Independently Chinese"; Y. Chu, *Chinese Documentaries,* pp. 183–211; M. Johnson, "A Scene beyond Our Line"; Jaffee, "Everyman a Star"; Reynaud, "Dancing with Myself"; Voci, "From the Center."

26. For *Mr. Zhao* and gender issues, see X. Zhong, "Mr. Zhao."

27. See Cheng Qingsong and Huang, *Wode sheyingji,* pp. vi–vii.

28. Ibid., p. 126.

29. See Wu Wenguang, ed., *Xianchang (di yi juan),* p. 204. Likewise, Du Haibin, a documentarist himself, admires Hou Hsiao-hsien's films for their magical unraveling

of familiar life experience; see Zhang Xianmin and Zhang, *Yigeren de yingxiang,* p. 117.

30. Cheng Qingsong and Huang, *Wode sheyingji,* pp. 283–328.

31. Ibid., pp. 113–117.

32. In this area, Cui Zi'en's recent DV features are most representative, such as *Enter the Clowns* (2001) and *Old Testament* (2001). For further information, see Berry, "The Sacred, the Profane"; Q. Wang, "The Ruin Is Already a New Outcome."

33. Cheng Qingsong and Huang, *Wode sheyingji,* pp. 165, 173.

34. Lü Xinyu, *Jilu Zhongguo,* pp. 8–9.

35. Ibid., p. 9.

36. Ibid., pp. 11, 31; emphasis added.

37. In addition to the audiovisual "documents" in *Jiang Hu,* Wu also developed a print space for his subjects to speak. See Wu Wenguang, *Xianchang (di yi juan),* pp. 242–273; Wu Wenguang, ed., *Xianchang (di er juan),* pp. 276–293.

38. Wu Wenguang, *Xianchang (di yi juan),* pp. 190–191, 212.

39. Cheng Qingsong and Huang, *Wode sheyingji,* pp. 358–359. Jia Zhangke identifies three new forces that challenge the exclusive right of film institutions: independent productions, VCD (its affordability disrupted the monopoly of film texts and enabled ordinary people to watch film classics), and DV (which democratizes the means of filmmaking by bringing it closer to individuals rather than the industry). See Fenghuang weishi, ed., *DV xin shidai,* pp. 10–17; Wu Wenguang, *Xianchang (di yi juan),* p. 211; Zhang Xianmin and Zhang, *Yigeren de yingxiang,* pp. 306–311. See also Jaffee, "Everyman a Star."

40. This is what happened initially to Hong Kong–based Phoenix Satellite TV (Fenghuang weishi) when it sponsored "New DV Age," an exhibit of video works by Chinese young people; see Fenghuang weishi, *DV xin shidai,* pp. ii–iv. For further discussion, see Y. Wang, "The Amateur's Lightning Rod."

41. See Lü Xinyu, *Jilu Zhongguo,* p. 99.

42. Cheng Qingsong and Huang, *Wode sheyingji,* pp. 358–359.

43. Cui Zi'en, *Diyi guanzhong,* pp. ii–iii.

44. Ibid., p. 7.

45. Zhang Ming, *Zhaodao yizhong,* pp. 27, 35.

46. The confusion might have derived in part from the fact that *The Making of Steel* was forced to undergo eleven revisions between its completion in 1995 and its approval for release near the end of 1997; see Cheng Qingsong and Huang, *Wode sheyingji,* p. 209.

47. Lü Xinyu, *Jilu Zhongguo,* p. 138.

48. Still, it took seven months for *Seventeen Years* to clear censorship in China. See Cheng Qingsong and Huang, *Wode sheyingji,* pp. 110, 125. Zhang Yuan's subsequent films, such as *I Love You* and *Green Tea,* are officially approved projects, funded in part by his own Beijing-based company, Shiji xixun (Century Good-Tidings). That is perhaps why, in the documentary *My Camera Doesn't Lie,* one critic calls Zhang "corrupted," because he has joined the state system.

49. Dai, *Cinema and Desire,* pp. 77, 91.

50. Nichols, "Discovering Form."

51. In addition to cafés and other venues mentioned in the text, noted film clubs include 101 Workshop in Shanghai (founded on Oct. 1, 1996), U-Thèque or Film Connection (Yuanying hui) in Guangzhou (founded in 1998), Practice Society (Shijian she) in Beijing (founded in April 2000), Rear Window (Houchuan) in Nanjing (founded in 2000), Free Cinema (Ziyou dianying) in Shenyang (founded in 2000), Marginal Society (Bianyuan she) in Zhengzhou, M Commune (M gongshe) in Chongqing, and Approximating Line (Jianjinxian) in Taiyuan. Many of these cineclubs have since been shut down for political reasons. See Mei Bing and Zhu, *Zhongguo duli jilu,* pp. 49–54; Yin Hong, *Kuayue bainian,* p. 197; Yu Aiyu, "Guanyu Zhongguo"; Z. Zhang, "Bearing Witness," pp. 27–33.

52. See Wu Wenguang, *Xianchang (di er juan),* p. 132.

53. Significantly, several cine-bars are named after foreign films dealing with the urban subculture, such as *Blue Velvet* (David Lynch, 1986), *Swallowtail Butterfly* (Shunji Iwai, 1996), and *Trainspotting* (Danny Boyle, 1996).

54. For detailed descriptions of these exciting days of screenings, see Cheng Qingsong, *Kandejian de yingxiang,* pp. 235–246; Zhang Xianmin and Zhang, *Yigeren de yingxiang,* pp. 272–274.

55. See Zheng Wei, "Jilu yu biaoshu," 86; Zhang Xianmin and Zhang, *Yigeren de yingxiang,* pp. 265–292.

56. See Yan Jun, "Kan dianying." *Out of Phoenix Bridge* was reportedly collected by the Museum of Modern Art in New York City and was the first mainland Chinese independent documentary to air overseas (Taiwan Public TV, March 2000). See Cui Weiping, "Zhongguo dalu."

57. See Qiao, "The Metaphysics of Film."

58. For example, Wei Xidi (a pseudonym based on the homophone of VCD pronounced in Mandarin Chinese) set up an Internet forum called Rear Window (Houchuan) in Nanjing in December 1998. See Zhang Xianmin and Zhang, *Yigeren de yingxiang,* pp. 293–298. A currently active online company in Beijing is Zhu Rikun's Fanhall (Xianxiang), which runs a comprehensive website, www.fanhall.com; operates campus screenings (at places such as Beijing Film Academy, Beijing Broadcast Institute, and Beijing Normal University); and occasionally distributes printed magazines to thousands of registered members. More recently, Fanhall invested RMB 120,000 in *Pirated Copy* (He Yi, 2004), an independent film that toured international film festivals (see Chapter 6).

59. For instance, Cui Zi'en contributed articles on independent films to *Yinyue yu biaoyan* (Music and performance), a journal run by Nanjing Art Academy, in 2000 as well as the literary magazine *Furong* (Hibiscus) in 2001. For further information, see Chen Mo and Xiao, "Chinese Underground Films." For an overview of the circulation of independent works in various venues in China, see Yin Hong, *Kuayue bainian,* pp. 195–199.

60. The image of China as a third-world country is exactly what fascinates those Western critics who still operate with a Cold War mentality. For example, Robert

Koehler believes that Jia's films would ease the anxiety of those "members of the chattering class warning of the behemoth named China, and how it will soon take over the planet" by knowing that "China is actually, 'China'—a dream, a wish, a nation-to-be" (*"The World,"* p. 56).

61. Ouyang Jianghe, *Zhongguo duli dianying,* p. 243.

62. Wu Wenguang, *Xianchang (di yi juan),* pp. 202–207. Jia Zhangke brought Du Haibin's *Along the Railroad* to the Yamagata Documentary Film Festival in 2001. When he told Du that the documentary won a top prize, Du did not believe right away that his "crude" video could have won such an honor. See Wu Wenguang, *Xianchang (di er juan),* p. 212.

63. For Jia's sample awards, see Cheng Qingsong and Huang, *Wode sheyingji,* pp. 339–340. An early endorsement in Chinese is found in Jintian, ed., "Jia Zhangke." For appreciative scholarship in English, see S. Cui, "Negotiating In-between"; Xiaoping Lin, "New Chinese Cinema"; T. Lu, "Music and Noise"; McGrath, *Postsocialist Modernity,* pp. 129–164.

64. MacCabe, "Theory and Film," p. 91; emphasis added.

65. Cheng Qingsong and Huang, *Wode sheyingji,* pp. 258, 265. *Suzhou River* was originally shot in 16mm in 1997 as part of *The Super City* (Chaoji chengshi), a projected ten-title series of made-for-TV dramatic shorts from young directors. The series was aborted due to a funding shortage, but Lou Ye was able to secure overseas investment for his own title, *The Rushing City* (Benpao de chengshi), converted it from 16mm to 35mm, renamed the full-length film *Suzhou River,* and released overseas in 2000 to international acclaim. See Yingjin Zhang, *Screening China,* pp. 329–330.

66. See Silbergeld, *Hitchcock with a Chinese Face,* pp. 11–46; G. Xu, *Sinascape,* pp. 78–87; Z. Zhang, "Urban Dreamscape."

67. Cheng Qingsong and Huang, *Wode sheyingji,* p. 265.

68. Chute, "Beyond the Law"; Jaivin, "Defying a Ban."

69. For an insightful analysis of this transformation, see Wang Hui, *China's New Order.*

70. Much of *Bumming in Beijing* is based on Wu's episode, "Artists," for an aborted CCTV series, *Chinese People,* which was shot in 1988 but is now presumed lost. See Li Xing, Liu, and Wang, eds., *Bei yiwang,* pp. 27–28.

71. Also in April 1988, Jiang Yue and Wen Pulin started shooting a documentary on art scenes related to the twelfth anniversary of the Tangshan earthquake, but the project was not finished; see Zheng Wei, "Jilu yu biaoshu."

72. The word "forgotten" is prominently used in the title of a book of interviews with early new documentary artists. "By now," Chen Zhen asserts in the preface, "the new documentary movement in China has disappeared altogether, as most of people listed in the book are no longer making documentaries." See Li Xing, Liu, and Wang, eds., *Bei yiwang,* pp. i–iv.

73. Li Xing places *No. 16 Barkhor South Street,* which Duan Jinchuan started shooting in 1995, as the end point of the Chinese new documentary, because after that similar works became too numerous to claim the status of new anymore. See ibid., p. 1.

74. Lü Xinyu, *Jilu Zhongguo,* p. 97.

75. See Mei Bing and Zhu, *Zhongguo duli jilu,* p. 36.

76. Wang Guangli claimed that he was the director of *I Graduated,* while Shi Jian acted as its producer; see Q. Wang, "Writing Against Oblivion," p. 229. Another version indicates that the documentary was a SWYC team product, but Shi Jian was financially responsible for postproduction, hence his credit as director. See Li Xing, Liu, and Wang, eds., *Bei yiwang,* p. 260.

77. In fact, they even drafted a manifesto and read it at the documentary conference, and a toned-down version appeared in the *Journal of the Beijing Broadcast Institute.* See ibid., pp. 263–268, 276–279.

78. Lü Xinyu, *Jilu Zhongguo,* p. 150. Shi Jian reportedly brought a roast chicken to share with the CCTV editing-room staff every time he used the state-owned equipment for his independent work. See Li Xing, Liu, and Wang, eds., *Bei yiwang,* pp. 2–3.

79. Lü Xinyu, *Jilu Zhongguo,* p. 151; Li Xing, Liu, and Wang, eds., *Bei yiwang,* p. 249.

80. Liang Jianzeng and Sun, eds., *Dongfang shikong de rizi;* Liang Jianzeng, Sun, and Chen, eds., *Dongfang zhizi;* Liang Jianzeng, Sun, and Chen, eds., *Shihua shishuo.*

81. Wang Weici, *Jilu yu tansuo,* pp. 183–206.

82. Lü Xinyu, *Jilu Zhongguo,* p. 230.

83. Ibid., pp. 40, 57; Wang Weici, *Jilu yu tansuo,* pp. 207–270; Wu Wenguang, *Xianchang (di yi juan),* pp. 70–102.

84. For more information regarding new television programs that gave the *laobaixing* a chance to tell their own stories, see Wang Weici, *Jilu yu tansuo,* pp. 541–576; Liang Jianzeng, Sun, and Chen, eds., *Baixing gushi.*

85. Lü Xinyu, *Jilu Zhongguo,* p. xix. Some other stations, such as Beijing TV, run similar programs called "Documentary" (Jilu), and Shanghai TV operates a separate channel named "Jishi" (literally "documenting reality").

86. Ogawa was an influential documentary artist in Japan who sided with the underprivileged and insisted on independent production. See Nornes, *Forest of Pressure.*

87. Lü Xinyu, *Jilu Zhongguo,* pp. 71, 107.

88. See Benson and Anderson, *Reality Fictions.*

89. Nichols, "The Voice of Documentary," pp. 259–260.

90. Ibid., p. 260. Nichols gradually expanded his genealogy of the documentary so that it now includes the "expository" mode (1930s, the Griersonian tradition intended to "directly address the real"), the "observational" (1960s, these "eschew commentary, observe things as they happen"), the "interactive" (1960s to 1970s, these "interview, retrieve history"), the "reflexive" (1980s, these "question [the] documentary form, defamiliarize the other modes"), and the "performative" (1980s to 1990s, these "stress subjective aspects of a classically objective discourse"); see Nichols, *Blurred Boundaries,* p. 95. More recently, Nichols has renamed the "interactive"

mode "participatory" and has added the "poetic" mode (1920s, these "reassemble fragments of the world poetically"); see Nichols, *Introduction to Documentary*, pp. 99–138. For further elaborations, see Barnouw, *Documentary;* Nichols, *Representing Reality;* Renov, *Theorizing Documentary;* Rothman, *Documentary Film Classics;* Winston, *Claiming the Real.*

91. For an analysis of *Tiananmen*, see Voci, "From the Center," pp. 80–90.

92. Nichols, "The Voice of Documentary," p. 261; emphases added.

93. Ibid., p. 265.

94. For Gao Xingjian, see Yingjin Zhang, "Cultural Translation."

95. Another unusual example of cinéma vérité in China is Wang Bing's *Tiexi District: West of the Tracks* (2002), a three-part study of the bankruptcy of a factory town in northern China; it runs a total of 450 minutes and offers an immersion experience of epic proportions. For analyses, see Lü Xinyu, "Ruins of the Future"; B. Wang, "Documentary as Haunting"; Q. Wang, "Navigating on the Ruins."

96. Lü Xinyu, *Jilu Zhongguo*, pp. 85–86.

97. Ethnographic cinema emerged in China as early as 1927, and fieldwork was conducted with the assistance of European anthropologists. Between 1956 and 1965, ethnographic cinema had been institutionalized as an academic practice, which has helped the government to classify and document at least fourteen ethnic minority groups. In 1979 the Chinese Academy of Social Sciences established a film group, which subsequently changed into a research unit on visual anthropology. In 1994, supported in part by a German grant, Yunnan University set up the East Asian Institute for Visual Anthropology. See Fang Fang, *Zhongguo jilupian*, pp. 255–265, 301–305, 448–491; Shan Wanli, *Zhongguo jilu*, pp. 27–31, 225–228, 379–390; Wang Weici, *Jilu yu tansuo*, pp. 20–60. See also relevant sections in Lin Shaoxiong, ed., *Duoyuan wenhua shiyu*, and Shan Wanli, ed., *Jilu dianying wenxian.*

98. These films were collected in videotape format by the REC Foundation (Records of the Essence of Culture), a small nonprofit organization based in New York City. They constitute part of a documentary series, "Reel China," that was shown at Columbia University in April 2001.

99. Among the few professionally trained independents are Wang Bing, who graduated with a major in photography from Shenyang Lu Xun Arts Academy in 1995, and Du Haibin, who graduated with a major in still photography from Beijing Film Academy in 2000.

100. Zhang Xianmin and Zhang, *Yigeren de yingxiang*, p. 2.

101. Lü Xinyu, *Jilu Zhongguo*, pp. 88–89.

102. MacDougall, "Beyond Observational Cinema," p. 278.

103. Ibid., p. 281.

104. Waugh, *"Beyond Vérité,"* p. 234.

105. To be fair, the development of cinéma vérité was not as homogeneous as these critics describe. For visual evidence of stylistic variations within the tradition, see *Cinéma Vérité: Defining the Moment* (1999), a 102-minute documentary film directed

by Peter Wintonick and produced for the National Film Board of Canada in Montreal, Quebec.

106. Nichols, "The Voice of Documentary," p. 261.

107. Lü, *Jilu Zhongguo*, pp. 95–97.

108. Yang Lina uses a milder expression; she feels she was a "thief" *(xiaotou)* stealing from the old retirees she documented in *Old Men;* see Fenghuang weishi, *DV xin shidai*, p. 259; Wang Weici, *Jilu yu tansuo*, pp. 165–180.

109. Lü Xinyu, *Jilu Zhongguo*, pp. 209–210.

110. Wu Wenguang, *Xianchang (di er juan)*, p. 218. I suggest that the class factor may have played into the documentarists' feelings of guilt, which typically results from a situation in which the subjects are from lower social or economic strata and appear completely helpless or hopeless, as in *Out of Phoenix Bridge* and *Along the Railroad*. In contrast, when the subjects of a documentary appear to be on an equal footing with the documentarist in socioeconomic terms, feelings of guilt do not seem to occur. For instance, a mutual friendship has grown up between her two lesbian subjects and Ying Weiwei (see Chapter 6).

111. Lü Xinyu, *Jilu Zhongguo*, pp. 111–120.

112. Ibid., p. 120.

113. Ibid., pp. 54, 116.

114. Another case of self-exposure did not result exactly in self-criticism. Ning Dai cut a version of the independent filmmakers' discussion of the government's ban on Zhang Yuan's *Scattered Chicken Feathers* (Yidi jimao) in 1993, but Zhang Yuan was furious about Ning's portrayal of him in the documentary. Duan found it interesting and asked Zhang, "Isn't documentary brutal?" However, Ning Dai did not want to provoke her husband Zhang Yuan any further and cut another version, *Banned* (1994), which was screened overseas at film festivals. This episode suffices to dispel the myth of documentary objectivity. See Lü Xinyu, *Jilu Zhongguo*, p. 209.

115. Ibid., pp. 8–9, 18.

116. Ibid., p. 9.

117. Ibid., pp. 10, 30–31.

118. Ibid., p. 89.

119. Nor does Du Haibin hide the presence of his camera during his encounter with his homeless subjects in *Along the Railroad*. See Zhang Xianmin and Zhang, *Yigeren de yingxiang*, pp. 104–121; Wang Weici, *Jilu yu tansuo*, pp. 141–164; Wu Wenguang, *Xianchang (di er juan)*, pp. 132–218.

120. Lü Xinyu, *Jilu Zhongguo*, pp. 28–29; Yan Jun, "Kan dianying."

121. Lü Xinyu, *Jilu Zhongguo*, p. 241.

122. For Wu's intention to be "cruel" to himself, see Zhu Rikun and Wan, eds., *Duli jilu*, p. 5.

123. Lü Xinyu, *Jilu Zhongguo*, p. 22.

124. Ibid., p. 138.

125. Ibid., p. 32.

126. Ibid., p. 13.

127. Ibid., pp. 242–273; Wu Wenguang, *Xianchang (di er juan)*, pp. 276–293.

128. Fenghuag weishi, *DV xin shidai*, pp. iii, 1.

129. Jia Zhangke, "Yeyu dianying shidai"; Jia Zhangke, "Youle VCD."

130. On average, college students in China produce over 2,000 DV works each year. See Yin Hong, *Kuayue bainian*, p. 177.

131. Kokas, "Finding Democracy"; Han Hong and Tao, "Minjian yingxiang," p. 131.

132. Wen Hui is the chief choreographer of the Living Dance Studio; at least two Westerners, Alison Friedman (US) and Estelle Soep (France), volunteered in this experimental project, for which each worker was paid RMB 30 a day and a boxed meal—adequate but not impressive.

133. Guo Jing, ed., *Yunzhinan jilu yingxiang zhan*, pp. 128–131.

134. Han Hong and Tao, "Minjian yingxiang," p. 131.

135. Guo Jing, Zhang, and Su, "Xuexi women ziji."

136. *Bama Mountain Culture Research Institute* brochure. My thanks to Yang Kun of the Yunfest for providing the references.

137. For a listing, see Guo Jing, ed., *Yunzhinan renleixue*, pp. 159.

138. The author's interview with Yang Kun, a curator with the Yunfest, Kunming, July 2007.

139. Cui Weiping, "Zai 'Yunzhinan' kan dianying."

140. Guo Jing, *Yunzhinan renleixue*, pp. 3–4; emphasis added.

141. Guo Jing, Zhang, and Su, "Xuexi women ziji," p. 148; the quotation is originally from Jassey, ed., *Engaging Participation*, p. 25.

142. As examples of transnational networking, the 2003 Yunfest featured a report on a TNC-sponsored photovoice project on natural and cultural resources in southwest China, and a dialogue between Chinese documentarists and their American counterparts from Appalshop, a Kentucky-based documentary workshop specialized in Appalachian mountain culture. See Guo Jing, *Yunzhinan renleixue*, pp. 114–120. The 2005 Yunfest featured a section on Japanese documentary and works from the United Kingdom, the United States, Sweden, and Kazakhstan. See Guo Jing, ed., *Yunzhinan jilu yingxiang luntan*, pp. 100–138. The 2007 Yunfest, funded in part by the Jan Frijman Fund and the DOEN Foundation (both in the Netherlands), featured more works from European countries, including a section on Russia. See Guo Jing, *Yunzhinan jilu yingxiang zhan*, pp. 179–241.

143. Han Hong and Tao, "Minjian yingxiang."

144. See GAD, "Beijing + 10." The number 10 denotes the tenth year after the 1995 conference. Hu Jie's own documentaries include *Looking for Lin Zhao's Soul* (2005) and *Though I Was Dead* (2007), both sensitive works investigating two innocent victims of political violence in socialist China; Ou Ning's include *San Yuan Li* (with Cao Fei); Zhou Hao's include *Houjie Township* (2002) and *Senior Year* (2006). For further information on Hu and Zhou, see Mei Bing and Zhu, *Zhongguo duli jilu*, pp. 249–275, 404–411; Zhu Rikun and Wan, *Duli jilu*, pp. 27–31, 156–159.

Chapter 6: Space of Performance

1. Casey, "How to Get from Space," p. 24.

2. A suspected cause for this relocation was the Yunfest's original plan to screen Hu Jie's *Though I Was Dead,* which captures the widespread violence at the beginning of the Cultural Revolution; the documentary was removed from the Yunfest's Dali program. Hu Jia's video *Prisoners in Freedom City* (2008) records the time he and his pregnant wife were under virtual house arrest in Beijing from July 2006 to March 2007. On December 5, 2007, Hu was honored with a human rights award by Reporters without Borders. On December 27, 2007, he was taken away by the security police in Beijing on the charge of instigating insurrection against the state, and his wife and six-week-old daughter were left behind to fend for themselves. On September 24, 2008, Hu was reported to be a candidate to win the Nobel Peace Prize for 2008 (see Fouché, "Chinese Dissident").

3. See Berry, "Hidden Truths."

4. Cheng Qingsong, *Kandejian de yingxiang,* p. 272.

5. Winston, *Claiming the Real,* pp. 11–14.

6. Renov, "Re-thinking Documentary," pp. 3–4.

7. Bruzzi, *New Documentary,* p. 7. Bruzzi describes the tension between reality and representation as "the perennial Bazin vs Baudrillard tussle, both of whom—from polar perspectives—argue for the erosion of any differentiation between the image and reality, Bazin because he believed reality could be recorded, Baudrillard because he believes reality is just another image" (ibid., p. 4).

8. Such information pertains in a similar way to "pictures of poverty" and "zones of privacy" in the American documentary. See Rabinowitz, *They Must Be Represented.*

9. Corliss, "Bright Lights"; emphases added.

10. Ibid.

11. To quote from the journal's self-description: "*City Weekend* is published by Encyclopedia of China Publishing House with the support of its partner, Ringier Pacific Ltd. *Ringier Pacific Ltd* is the Asian holding company of Ringier AG (Switzerland), the leading provider of information and entertainment in Switzerland. With the country's largest daily newspaper, a highly successful business newspaper, and a colorful range of high circulation magazines, with television programs and Internet pages, Ringier continues to shape the future of media in Switzerland, Eastern Europe and Asia." See <http://www.cityweekend.com.cn/en/beijing/about/about_us>, accessed Aug. 16, 2005.

12. He Chang, "The Raw and the Reel"; emphases added.

13. Ibid. According to Cui Zi'en, the three-day festival was originally planned to open at Beijing University in 2005 but had to move, under official pressure and on short notice, to a club named Plebeian Film and Video Space located in Chaoyang district. This festival also screened films from Hong Kong and Taipei. In 2001 the first Beijing gay film festival was held by a Beijing University student association and was likewise ordered to stop midway by the authorities. See Yin Hong, *Kuayue bainian,*

p. 197. According to Norman Spencer, who attended the first festival, the event was organized by Cui Zi'en and attended by noted directors like Zhang Yuan, and critic Dai Jinhua conducted a special seminar. The author thanks Cui Zi'en and Norman Spencer for providing information.

14. A director's note by Ying Weiwei and an interview with Zhang Yaxuan, a female film critic in Beijing, can be found in Zhang Xianmin and Zhang, *Yigeren de yingxiang*, pp. 126–140. For the contradictory roles played by the Internet in China, see Liu Kang, *Globalization and Cultural Trends*, pp. 127–161; Tai, *The Internet in China*; Xiao Qiang, "The Internet."

15. Yamagata International Documentary Film Festival Website, "Ying Weiwei."

16. To quote one observation: since the early 1990s, "the endless and still long takes, in which 'nothing happens' . . . have become fashionable among independent filmmakers [in China], following the international acclaim of filmmakers like Taiwan's Hou Hsiao-hsien." See Berry, "The Sacred, the Profane," p. 198. For analysis of Hou's style, see Udden, "Hou Hsiao-hsien."

17. The director also admits that she cut footage of the couple's interactions with their families and friends because she also considered these scenes irrelevant. See Anonymous author, "Zigong li de feixiang."

18. See Zhang Xianmin and Zhang, *Yigeren de yingxiang*, pp. 129–139. Ying's projection of "beauty" into the "poetic" world, however, is criticized as following "the straight mind" that views lesbians as the other. See Zhao Xiyan, "*Hezi* neiwai."

19. See this comment on a Chinese website for homosexuals: "The metaphor of the 'box' refers precisely to a womb-like space. It is enclosed, warm, and protective of a fragile life flying freely therein. But at the same time this space exhibits a glass-like quality, easy to break into and break in pieces." Anonymous author, "Zigong li de feixiang."

20. Berlin International Film Festival Website, "Program for the Young Filmmakers' Forum." A Google search of "Ying Weiwei" in English on August 12, 2005, found dozens of references to *The Box*, and the languages used in these web pages include Chinese, Dutch, English, French, and German.

21. See Berlin International Film Festival Website, "Program for the Young Filmmakers' Forum."

22. Foucault, "Of Other Spaces."

23. Leary, "Performing the Documentary."

24. Nichols, *Blurred Boundaries*, pp. 99–100.

25. Ibid., p. 102.

26. Berlin International Film Festival Website, "Program for the Young Filmmakers' Forum."

27. Bruzzi, *New Documentary*, p. 155.

28. Weber, "Displacing the Body," p. 11; original emphases.

29. Zhang Xianmin and Zhang, *Yigeren de yingxiang*, p. 140. Jia Zhangke identifies the DV camera's "extremely" attractive factors, such as its low demand on lighting,

its small size, its easy handling, and its low budget—all of these promising the emergence of a new film aesthetic. See Jia Zhangke, "Yeyu dianying shidai," p. 311.

30. Weber, "Displacing the Body," p. 9.

31. Stern, "Ghosting," p. 192.

32. Ibid.

33. Zhang Xianmin and Zhangn, *Yigeren de yingxiang,* p. 124.

34. "Chinese Underground Film Festival," University of California, San Diego, Oct. 8–10, 2003: <http://cuff.ucsd.edu>, accessed Aug. 10, 2005; "Chinese Underground Film Festival at Cornell," Cornell University, March 12–16, 2004: <http://www.einaudi.cornell.edu/eastasia/calendar/chinese_film.asp>, accessed Jan. 12, 2006.

35. See Cheng Qingsong, *Kandejian de yingxiang,* pp. 243–246. Another source identifies Beijing University Online (Beida zaixian) as one other sponsor of the festival. See Zhang Xianmin and Zhang, *Yigeren de yingxiang,* pp. 272–274, 301–302. Practice Society was a film club headed by Yang Zi and composed largely of Beijing Film Academy students and recent graduates, and its operations included film screenings (initially at Yellow Pavilion 50 Bar) and documentary filmmaking (in collaboration with Wu Wenguang). See Mei Bing and Zhu, *Zhongguo duli jilu,* pp. 49–54; Wang Weici, *Jilu yu tansuo,* p. 102.

36. Cheng Qingsong's comment is worth quoting: "*The Box* is ambitious. Truth alone is not sufficient for it, nor is objectivity itself. Merely recording the flow of life is insufficient also. The film tries to use the camera to reach the spiritual world of two women falling in love and living together." In comparison, Cheng judges *Happy Together* (1997), an internationally acclaimed Hong Kong feature film on gay sexuality that landed Wong Kar-wai the best director award at the 1997 Cannes International Film Festival, to be merely "insubstantial and hypocritical." See Cheng Qingsong, *Kandejian de yingxiang,* pp. 242–245.

37. Documentary Power is a nongovernmental organization that was established in Hong Kong in 1989. It is headed by Zheng Zhixiong and is devoted to documenting images of popular social movements. See Zheng Wei, "'He' zhong de rizi," p. 106.

38. Ibid., p. 109.

39. Persistent censorship in China has inflicted an even more dismal or tragic outcome than the access problem: irrevocable destruction of information. Hundreds of pre-1949 films have been destroyed forever while thousands more are stored in a warehouse bunker deep inside the mountains of Shaanxi province. The first systematic destruction of early films took place right after the liberation of Shanghai in 1949, when the government was eager to get rid of "cultural trash" confiscated from the private sector; the second large-scale destruction occurred in the early 1960s, when reels of films were burned to extract rare elements "required" for a military buildup and national defense. As far as contemporary independent films are concerned, the destruction of information is an imminent threat because many titles exist only in a single print, and that print may not even be in the director's possession. See Zhang Xianmin, *Kanbujian de yingxiang,* pp. 155–161.

40. A DVD series of Chinese independent documentaries that recently circulated in the Chinese pirate market includes *Bumming in Beijing, Old Men,* and *Extras* (Zhu Chuanming, 2001).

41. De Certeau, *The Practice of Everyday Life,* p. 37.

42. The phrase "for internal use" was a pretext for protecting the (uneducated) public from being misled or poisoned by "problematic" films. In the mid-1990s, a pirated VCD cost about RMB 25, but prices dropped to as low as RMB 10 by the mid-2000s, when pirated DVDs cost as little as RMB 5 to RMB 10 depending on what city you were in. In comparison, ticket prices for a movie theater cost about RMB 20 in the mid-1990s and as high as RMB 80 in the mid-2000s. The exchange rate was pegged at RMB 8.3 to US$1 until August 2005, when the RMB started to float within a small margin and hit RMB 6.8 to US$1 in July 2008.

43. See Jia Zhangke, "Yeyu dianying shidai," p. 307.

44. Ibid., p. 308.

45. Lin Xudong, Zhang, and Gu, eds., *Jia Zhangke dianying: "Xiao Wu,"* p. 6.

46. One recent case is *Extras,* which deals with a group of extras waiting outside Beijing Film Studio in anticipation of getting small screen roles that may make them famous. After winning an award at the Hong Kong International Film Festival, the film triggered a debate on documentary ethics because its candid sexual talk was criticized as being "fascist," and its director was accused of "violating" his informants. Such supposed "violence" has been made into a selling point, for the Chinese VCD cover advertises the film as forbidden to viewers younger than eighteen years old. See Jaffe, "Everyman a Star," pp. 90–98.

47. Fenghuang weishi, *DV xin shidai,* pp. 258–259. *Old Men* received awards at several international documentary film festivals in Japan, France, and Germany; its French television rights were sold for 120,000 francs—a rare commercial success for a Chinese independent documentary. See Wang Weici, *Jilu yu tansuo,* p. 166.

48. Lü Xinyu, *Jilu Zhongguo,* pp. 209–210.

49. See Anonymous author, "Zigong li de feixiang." For further discussions of the "documentary of cruelty" and subject exploitation, see Y. Wang, "The Amateur's Lightning Rod," pp. 127–128.

50. For further elaboration of affect, see Massumi, *Parables for the Virtual.*

51. Ban Wang uses the term to discuss both fiction and documentary films from underground Chinese directors ("Documentary as Haunting").

52. Both quotes are from B. Johnson, "Writing," p. 40; original emphasis.

53. S. Wang, *Framing Piracy,* p. 73.

54. Pang, "Piracy/Privacy," p. 103, emphasis added.

55. Ibid., p. 115.

56. S. Wang, *Framing Piracy,* p. 91.

57. Pang, "Piracy/Privacy," p. 116.

58. The phrases are taken from Anthony Giddens' reading of Talcott Parsons' theory of power; see Cassell, ed., *The Giddens Reader,* p. 213.

59. S. Wang, *Framing Piracy,* p. 93; original emphases.

60. Hall, "The Local and the Global," p. 34.

61. De Certeau, *The Practice of Everyday Life,* p. 37.

62. Bettig, *Copyrighting Culture.*

63. *Red Beads* is set in a mental hospital and questions the slippery boundary between rationality and irrationality, while *Postman* follows a young postman who secretly opens letters in his possession and selectively intervenes in the addressees' lives. For an analysis, see Larson, "He Yi's *The Postman.*"

64. My own experience has convinced me that some vendors may not even care about the content of the pirated videos they sell. When I visited Shanghai in May 2004, I saw an old woman selling erotic videos in front of a crowded supermarket entrance. She paid no attention to the cover displays of naked female bodies in titillating postures. To accuse an underprivileged woman like her of supporting film piracy may actually redirect the troubling question of (il)legality and (im)morality back to the hegemonic power itself.

65. Zha Jianying, *China Pop,* p. 190.

66. *Tie Me Up! Tie Me Down* is an erotic film involving kidnap and sexual violence. It was issued an initial X certification in the United States, but its distributor took the MPAA (Motion Picture Association of America) to court and secured an NC-17 rating afterwards.

67. Tarantino, *Pulp Fiction,* p. 32.

68. Ibid., p. 32.

69. Lin Xudong, Zhang, and Gu, eds., *Jia Zhangke dianying: "Ren xiaoyao,"* pp. 42–43.

70. Polan, *Pulp Fiction,* p. 7.

71. Jia Zhangke, "Yeyu dianying shidai," p. 308.

72. On behalf of "ordinary people," Jia demands, "We want to watch Marlon Brando, but we also want Marilyn Monroe. We want to watch *Battleship Potemkin,* but we also want *The Godfather.* Everyone has the right to enjoy the spiritual wealth shared by humankind." See Jia, "Youle VCD," p. 309.

73. Wu Wenguang also implies that piracy is a losing battle when he ends *Fuck Cinema* with the street vendor riding his bicycle through the crowds at night and eventually disappearing from the camera's view (see Chapter 5),

74. Some websites have paid for uploading rights. *Still Life,* for instance, sold its Internet exhibition rights for RMB 300,000 to www.quacor.com (Kuakewang), which bills itself as "the world's first free online copyrighted movie portal." See Yang Yuanying and Li, *Yingxiang,* p. 36.

Chapter 7: Conclusion

1. Quoted in Huang Shixian, "Huayu dianying," pp. 82–83. Wang Meng is a famous fiction writer and a former vice minister of culture in China. His quotation originally appeared in *Southern Weekend,* Nov. 22, 2001: 9.

2. Yin Hong and Zhan, "2007 Zhongguo," p. 13. For consistency, I generally go with Yin Hong's numbers when there are conflicting statistics, but his calculation or print errors are corrected wherever spotted.

3. See Yingjin Zhang, *Chinese National Cinema,* p. 292.

4. Yin Hong, *Kuayue bainian,* p. 91.

5. Yin Hong, "Zouxiang houhepai shidai," p. 31.

6. One exception is *The Promise,* which is credited as the first recent Chinese blockbuster to reverse the trend of predominantly overseas financing by securing over 80 percent of its investment from mainland sources; nonetheless, its overseas investors do include Show East from South Korea and Moonstone Entertainment from the United States. See Yin Hong, *Kuayue bainian,* p. 130.

7. Ibid., p. 115.

8. Ibid., p. 131.

9. Ibid., p. 97. Dai Jinhua unequivocally identifies *Kung Fu Hustle* as a Hong Kong blockbuster ("Bainian zhiji," p. 3).

10. For instance, among the multinational cast and crew in *The Promise,* Hiroyuki Sanada (as General Guangming) comes from Japan, Dong-Kun Jang (as the slave Kunlun) from South Korea, Cecilia Cheung (Zhang Baizhi, as Princess Qingcheng) and Nicholas Tse (Xie Tingfeng, as Nobleman Wuhuan) from Hong Kong, and composer Klaus Badelt from Germany.

11. Yingjin Zhang, "Industry and Ideology."

12. Since 1995, *Dianying yishu* has published annually the top ten Chinese feature films, most often in its third issue each year, sometimes with approximate box-office revenues.

13. Yin Hong, *Kuayue bainian,* p. 111. The figures from 2005 to 2007 stayed around 75 percent in this category.

14. Yingjin Zhang, *Screening China,* p. 321.

15. Yin Hong, *Kuayue bainian,* p. 149.

16. Ibid., p. 119. This does not mean that the top-grossing Chinese blockbuster beats the top-grossing Hollywood import every year. In 2007, the number-one Hollywood import, *Transformers* (Michael Bay, 2007), took in RMB 270 million, whereas the number-one Chinese film, *Warlords* (Peter Chan, 2007), hit RMB 190 million by the year's end and reached RMB 220 million in 2008. See Yin Hong and Zhan, "2007 Zhongguo," p. 14; Yin Hong, "Zouxiang houhepai shidai," p. 29.

17. Huang Shixian, "Wenhua huimeng," p. 662; Yin Hong, *Kuayue bainian,* p. 152.

18. Yin Hong and Zhan, "2007 Zhongguo," p. 16.

19. As a coproduction, a Hong Kong film is given 30 percent share of the mainland box-office revenues; without coproduction status, it counts as an imported film and is limited to a 15 percent share only. See Davis and Yeh, *East Asian Screen Industries,* pp. 102–105; Zhao Weifang, *Xianggang dianying,* pp. 151–154.

20. Yin Hong, "Zouxiang houhepai shidai," p. 31.

21. Rosen, "Quanqiuhua shidai," p. 592; Yin Hong, "Zouxiang houhepai shidai," p. 31.

22. The terms "pseudogenre" and "magic spirit-martial arts pictures" come from Dai Jinhua, "Bainian zhiji," p. 3. For the origins of martial arts-magic spirit films in Shanghai of the 1920s, see Z. Zhang, *An Amorous History,* pp. 199–243.

23. Dai Jinhua, "Bainian zhiji," p. 4.

24. For a discussion of select new films, see McGrath, "The New Formalism."

25. On the adaptation and reception of *Nuan,* see H. Xiao, "Cross-Cultural Nostalgia."

26. The phrase "women with cameras" comes from Zhang Zhen; for her discussion of these women documentarists, see Z. Zhang, "Dai sheyingji."

27. Huang Shixian, "Wenhua huimeng," p. 663.

28. For annual imported blockbusters, the revenue-sharing scheme is 35 percent for the producer, 17 percent for the distributor, and 48 percent for the exhibitor. See Jia Leilei and Zhu, "Zhongguo dianying," p. 642.

29. Rao Shuguang, "Zhongguo dianying," p. 31.

30. Yin Hong, *Kuayue bainian,* p. 149.

31. Yin Hong and Zhan, "2007 Zhongguo," p. 13.

32. Dianying yishu, ed., *Zhongguo dianying.*

33. Dianying yishu, "Guochan dianying."

34. Yin Hong and Zhan, "2007 Zhongguo," p. 15.

35. Huang Shixian, "Huayu dianying," p. 83.

36. Rao Shuguang, "Huayu dapian," pp. 544–545.

37. Yin Hong, "Zouxiang houhepai shidai," p. 29.

38. Liu Haibo, "Zhongguo dapian."

39. Dai Jinhua, "Bainian zhiji," p. 10.

40. Massey, *For Space,* p. 9.

Filmography, Videography

All films and videos cited in the book are listed below in chronological order by year of release. The English title is followed by the Chinese title in pinyin, the director, the location, and the studio. Chinese characters are provided for titles and directors at first mention. All titles are feature films unless otherwise indicated. The reader is advised to check the Index where titles are listed alphabetically.

1905

Conquering Jun Mountain (Ding Junshan 定军山). Beijing: Fengtai Photography Studio.

1913

Zhuang Zi Tests His Wife (Zhuang Zi shiqi 庄子试妻). Li Beihai 黎北海. Hong Kong: Huamei.

1919

Broken Blossoms. D. W. Griffith. US: Paramount Pictures. 90 min.

1922

Laborer's Love (Laogong zhi aiqing 劳工之爱情). Zhang Shichuan 张石川. Shanghai: Mingxing. 22 min.

1929

The Female Knight-Errant White Rose (Nüxia Baimeigui 女侠白玫瑰). Zhang Huimin 张惠民. Shanghai: Huaju.

1932

Shanghai Express. Joseph von Sternberg. US: Paramount Pictures. 80 min.

1933

The Bitter Tea of General Yen. Frank Capra. US: Columbia Pictures. 88 min.

1934

Big Road, aka *The Highway* (Dalu 大路). Sun Yu 孙瑜. Shanghai: Lianhua. 105 min.

1935

Cityscape (Dushi fengguang 都市风光). Yuan Muzhi 袁牧之. Shanghai: Diantong. 89 min.

1937

Street Angel (Malu tianshi 马路天使). Yuan Muzhi. Mingxing. 110 min.

1948

Spring in a Small Town (Xiaocheng zhichun 小城之春). Fei Mu 费穆. Shanghai: Wenhua. 94 min.

1958

The Inn of the Sixth Happiness. Mark Robson. US: Twentieth Century-Fox. 158 min.

1963

55 Days at Peking. Nicholas Ray. US: Samuel Bronston Productions. 154 min.

1966

The Sand Pebbles. Robert Wise. US: Twentieth Century-Fox. 179 min.

1976

In the Realm of Senses (Ai no corrida). Oshima Nagisa. Japan: Argos Films/Oshima Productions. 105 min.

1982

Camel Xiangzi (Luotuo Xiangzi 骆驼祥子). Ling Zifeng 凌子风. Beijing: Beijing Studio. 119 min.

Identification of a Woman (Identificazione di una donna). Michelangelo Antonioni. Italy: Iter Film/Radiotelevisione Italiana. 128 min.

1984

Yellow Earth (Huang tudi 黄土地). Chen Kaige 陈凯歌. Nanning: Guangxi Studio. 89 min.

1986

A Better Tomorrow (Yingxiong bense 英雄本色). John Woo 吴宇森. Hong Kong: Cinema City. 95 min.

Blue Velvet. David Lynch. US: De Laurentiis Entertainment Group.

Questions for the Living (Yige sizhe dui shengzhe de fangwen 一个死者对生者的访问). Huang Jianzhong 黄建中. Beijing: Beijing Studio. 105 min.

1987

King of the Children (Haizi wang 孩子王). Chen Kaige. Xi'an: Xi'an Studio.

The Last Emperor. Bernardo Bertolucci. Italy: Yanco Films/TAO Film. 160 min.

Red Sorghum (Hong gaoliang 红高粱). Zhang Yimou 张艺谋. Xi'an: Xi'an Studio. 91 min.

1988

Evening Bell (Wanzhong 晚钟), Wu Ziniu 吴子牛. Beijing: August First Studio. 90 min.

1990

Bloody Morning (Xuese qingchen 血色清晨). Li Shaohong 李少红. Beijing: Beijing Studio. 94 min.

Bumming in Beijing: The Last Dreamers (Liulang Beijing: zuihou de mengxiang zhe 流浪北京: 最后的梦想者). Wu Wenguang 吴文光. Beijing. Documentary. 70 min./90 min.

The Hairdresser's Husband (Le mari de la coiffeuse). Patrice Leconte. France: Lambart Productions/TF1 Films. 82 min.

Tie Me Up! Tie Me Down (Atame). Pedro Almodovar. Spain: El Deseo S.A. 111 min.

1991

Mama (Mama 妈妈). Zhang Yuan 张元. Xi'an: Xi'an Studio. 83 min.

Raise the Red Lantern (Da hong denglong gaogao gua 大红灯笼高高挂). Zhang Yimou. Hong Kong: Era. 125 min.

Tiananmen (Tiananmen 天安门). Shi Jian 时间. Beijing. 8-part TV documentary.

1992

For Fun (Zhaole 找乐). Ning Ying 宁瀛. Beijing: Beijing/Hong Kong: Vanke. 97 min.

I Graduated! (Wo biye le 我毕业了). Shi Jian. Beijing: Structure, Wave, Youth & Cinema. Documentary.

1993

Beijing Bastards (Beijing zazhong 北京杂种). Zhang Yuan. Beijing: Beijing Bastards Group. 95 min.

The Blue Kite (Lan fengzheng 蓝风筝). Tian Zhuangzhuang 田壮壮. Hong Kong: Longwick/Beijing: Beijing Studio. 140 min.

The Days (Dong Chun de rizi 冬春的日子). Wang Xiaoshuai 王小帅. Beijing: Yingxiang/Hong Kong: Shu Kei Creative Workshop. Black/white. 90 min.

Farewell My Concubine (Bawang bieji 霸王别姬). Chen Kaige. Hong Kong: Tomson. 156 min./171 min.

M. Butterfly. David Cronenberg. US: Geffen Pictures/Miranda Productions. 101 min.

Red Beads (Xuanlian 悬念). He Yi 何一 (He Jianjun 何建军). Hong Kong: Shu Kai Creative Workshop. 92 min.

1994

Banned (Tingji 停机). Ning Dai 宁岱. Beijing. Documentary.

Dirt (Toufa luanle 头发乱了). Guan Hu 管虎. Hohhot: Inner Mongolia Studio. 97 min.

In the Heat of the Sun (Yangguang canlan de rizi 阳光灿烂的日子). Jiang Wen 姜文. Beijing: China Coproduction/Hong Kong: Ganglong/Taipei: Xiehe. 134 min.

One Day in Beijing (Nayitian, zai Beijing 那一天，在北京). Jia Zhangke 贾樟柯. Beijing: Youth Experimental Film Group. Documentary.

Pulp Fiction. Quentin Tarantino. US: Jersey Films/Miramax Films. 154 min.

The Square (Guangchang 广场). Zhang Yuan, Duan Jinchuan 段锦川. Beijing. Black/white. Documentary. 100 min.

To Live (Huozhe 活着). Zhang Yimou. Shanghai: Shanghai/Taipei: Era. 125 min.

Weekend Lovers (Zhoumo qingren 周末情人). Lou Ye 娄烨. Fuzhou: Fujian Studio/Hai'nan: Xinghai Real Estate Co. 96 min.

1995

At Home in the World (Sihai weijia 四海为家). Wu Wenguang. Beijing: Dragon Films. Documentary. 170 min.

Beyond the Clouds (Al di là delle nuvole). Michelangelo Antonioni. Italy: Canal+/France: Ciné B/France 3 Cinéma. 112 min.

Good Men, Good Women (Haonan haonü 好男好女). Hou Hsiao-hsien 侯孝贤. Tokyo: Team Okuyama/Taipei: Liandeng. 108 min.

On the Beat (Minjing gushi 民警故事). Ning Ying. Beijing: Beijing/Italy: Eurasia Communications. 102 min.

The Other Shore (Bi an 彼岸). Jiang Yue 蒋樾. Beijing. Documentary. 90 min./140 min.

Postman (Youchai 邮差). He Yi. Beijing: United Frontline/Hong Kong: Shu Kei Creative Workshop. 98 min.

Rainclouds over Wushan (Wushan yunyu 巫山云雨). Zhang Ming 章明. Beijing: Beijing Studio. 95 min.

Red Cherry (Hong yingtao 红樱桃). Ye Daying 叶大鹰. Beijing: Youth Studio/Moscow: Gorky Studio. 120 min.

Xiao Shan Going Home (Xiao Shan huijia 小山回家). Jia Zhangke. Beijing: Youth Experimental Film Group. 58 min.

Yellow Goldfish (Huang jinyu 黄金鱼). Wu Di 邬迪. Hohhot: Inner Mongolia Studio.

Yesterday's Wine (Yu wangshi ganbei 与往事干杯). Xia Gang 夏钢. Beijing: Beijing Studio. 90 min.

1996

East Palace, West Palace (Donggong xigong 东宫西宫). Zhang Yuan. Hong Kong: Ocean/France: Quelqu'un d'autre Productions. 94 min.

The Emperor's Shadow (Qin song 秦颂). Zhou Xiaowen 周晓文. Hong Kong: Ocean/Xi'an: Xi'an Studio. 116 min.

Sons (Erzi 儿子). Zhang Yuan. Beijing: Beijing Expression. 95 min.

Swallowtail Butterfly. Shunji Iwai. Japan: Rockwell Eyes. 146 min.

Trainspotting. Danny Boyle. UK: Channel Four Films. 94 min.

1997

The End of the Earth (Tianbian 天边). Duan Jinchuan. Tibet. Documentary. 141 min.

Frozen (Jidu hanleng 极度寒冷). Wang Xiaoshuai (Wu Ming 无名). Hong Kong: Shu Kei Creative Workshop. 95 min.

Happy Together (Chunguang zhaxie 春光乍泄). Wong Kar-wai 王家卫. Hong Kong: Block 2 Pictures, Jet Tone Production.

Keep Cool (Youhua haohao shuo 有话好好说). Zhang Yimou. Nanning: Guangxi Studio. 90 min.

Life on a Tune (Shengming ruge 生命如歌). Xia Gang. Beijing: Beijing Studio.

The Making of Steel (Zhangda chengren 长大成人). Lu Xuechang 路学长. Beijing: Beijing Studio/Great Wall Advertising. 90 min.

No Visit after the Divorce (Lihun le, jiu bie zailai zhaowo 离婚了，就别再来找我). Wang Rui 王瑞. Beijing: Youth Studio. 102 min.

No. 16 Barkhor South Street (Bakuo nanjie 16 hao 八廓南街16号). Duan Jinchuan. Tibet. Documentary. 80 min./100 min.

Out of Phoenix Bridge (Huidao Fenghuangqiao 回到凤凰桥). Li Hong 李红. Beijing. Documentary. 120 min.

Red Corner. Jon Avnet. US: MGM. 122 min.

Urban Love (Chengshi aiqing 城市爱情). Ah Nian 阿年. Hangzhou: Zhejiang Studio. 87 min.

Xiao Wu (Xiao Wu 小武). Jia Zhangke. Hong Kong: Hutong Communication. 107 min.

Yinyang (Yinyang 阴阳). Kang Jianning 康健宁. Yinchuan. Documentary.

1998

Baka Village (Baka laozhai 巴卡老寨). Tan Leshui 谭乐水. Kunming. Documentary short. 30 min.

The Cormorant and the Lake (Yuying 鱼鹰). Zhou Yuejun 周岳军. Kunming. Documentary short. 30 min.

Mr. Zhao (Zhao xiansheng 赵先生). Lü Yue 吕乐. Hong Kong: Nam Kwong Development. 90 min.

Postmen in the Mountains (Nashan naren nagou 那山，那人，那狗). Huo Jianqi 霍建起. Changsha: Xiaoxiang/Beijing: Beijing Studio. 93 min.

A River Is Stilled (Jingzhi de heliu 静止的河流). Jiang Yue. Beijing: CCTV. Documentary. 64 min.

Run Lola Run (Lola rennt). Tom Tykwer. Germany: Westdeutscher Rundfunk. 81 min.

So Close to Paradise (Biandan, guniang 扁担, 姑娘). Wang Xiaoshuai. Beijing: Beijing Studio/Jindie. 91 min.

Spicy Love Soup (Aiqing malatang 爱情麻辣烫). Zhang Yang 张扬. Xi'an: Xi'an Studio/Imar Film. 109 min.

A Time to Remember (Hongse lianren 红色恋人). Ye Daying. Beijing: Beijing Studio/Forbidden City. 98 min.

Tutor (Banni gaofei 伴你高飞). Li Hong 李虹. Shanghai: Shanghai Studio.

1999

Be There or Be Square (Bujian busan 不见不散). Feng Xiaogang 冯小刚. Beijing: Beijing Studio/Forbidden City. 103 min.

A Beautiful New World (Meili xin shijie 美丽新世界). Shi Runjiu 施润玖. Xi'an: Xi'an Studio/Imar Film. 100 min.

Call Me (Huwo 呼我). Ah Nian. Beijing: Beijing Studio. 87 min.

Cinéma Vérité: Defining the Moment. Peter Wintonick. Montreal, Quebec: National Film Board of Canada. 102 min.

Crazy English (Fengkuang Yingyu 疯狂英语). Zhang Yuan. Xi'an: Xi'an Studio/Beijing: Shijixixun. Documentary. 90 min.

Crouching Tiger, Hidden Dragon (Wohu canglong 卧虎藏龙). Ang Lee (Li An 李安). US: Columbia Pictures/Good Machine/Taipei: Zoom Hunt/Beijing: China Film Coproduction. 120 min.

Diary: Snow, Nov. 21, 1998 (Riji: 1998 nian 11 yue 21 ri, xue 日记：一九九八年十一月二十一日，雪). Wu Wenguang. Documentary short. 14 min.

A Dream House (Menghuan tianyuan 梦幻田园). Wang Xiaoshuai. Beijing: Beijing Studio.

Jiang Hu: Life on the Road (Jianghu 江湖). Wu Wenguang. Beijing. DV documentary. 120 min.

A Lingering Face (Feichang xiari 非常夏日). Lu Xuechang. Beijing: Beijing Studio. 103 min.

Love in the Internet Generation (Wangluo shidai de aiqing 网络时代的爱情). Jin Chen 金琛. Xi'an: Xi'an Studio. 97 min.

Lunar Eclipse (Yueshi 月蚀). Wang Quan'an 王全安. Beijing: Beijing Studio.

My 1919 (Wode 1919 我的1919). Huang Jianzhong. Beijing: Beijing Studio. 100 min.

Old Men (Laotou 老头). Yang Tianyi (杨天乙), aka Yang Lina 杨荔纳. Beijing: DV documentary. 94 min.

The National Anthem (Guoge 国歌). Wu Ziniu 吴子牛. Changsha: Xiaoxiang Studio. 100 min.

Seventeen Years (Guonian huijia 过年回家). Zhang Yuan. Xi'an: Xi'an Studio/Hong Kong: Ocean. 90 min.

Sky Leopards (Chongtian feibao 冲天飞豹). Wang Rui. Beijing: Youth Studio.

Sunken National Treasure-97 (Chenchuan-97 nian de gushi 沉船-97年的故事). Duan Jinchuan. Documentary.

2000

Along the Railroad (Tielu yanxian 铁路沿线). Du Haibin 杜海滨. Hi8 documentary. 98 min.

Chocolat. Lasse Hallström. US: Miramax. 121 min.

Devils on the Doorstep (Guizi laile 鬼子来了). Jiang Wen. Beijing: Asian Union/Huayi Brothers. 139 min./162 min.

Fatal Decision (Shengsi jueze 生死抉择). Yu Benzheng 于本正. Shanghai: Shanghai Studio. 162 min.

Go for Broke (Heng shu heng 横竖横). Wang Guangli 王光利. Shanghai: Shanghai Studio. 87 min.

In the Mood for Love (Huayang nianhua 花样年华). Wong Kar-wai. Hong Kong: Block 2 Pictures. 98 min.

A Love of Blueness (Lanse aiqing 蓝色爱情). Huo Jianqi. Beijing: Beijing Studio. 97 min.

Mask (Mianju 面具). Liu Xiaojin 刘小津. Kunming. Documentary. 120 min.

Platform (Zhantai 站台). Jia Zhangke. Hong Kong: Hutong Communication/Japan: Office Kitano. 154 min./193 min.

The Red Suit (Hong xifu 红西服). Li Shaohong. Beijing: Beijing Studio.

Shower (Xizao 洗澡). Zhang Yang. Xi'an: Xi'an Studio/Imar Film. 94 min.

A Sigh (Yisheng tanxi 一声叹息). Feng Xiaogang. Beijing: Beijing Studio/Huayi Brothers.

Sorry, Baby (Meiwan meiliao 没完没了). Feng Xiaogang. Beijing: Forbidden City/Huayi Brothers/Beijing Huayi. 95 min.

Suzhou River (Suzhou he 苏州河). Lou Ye. Shanghai: Dream Factory/Germany: Essential Filmproduktion. 90 min.

Tell Your Secret (Shuochu ni de mimi 说出你的秘密). Huang Jianxin. Hangzhou: Zhejiang Studio. 98 min.

There's a Strong Wind in Beijing (Beijing de feng henda 北京的风很大). Ju Anqi 雎安奇. Beijing: Haogou Film Group. Documentary. 49 min.

2001

Beijing Bicycle (Shiqi sui de danche 十七岁的单车). Wang Xiaoshuai. Taipei: Arc Light/France: Pyramide/Beijing: Beijing Studio. 110 min.

Big Shot's Funeral (Dawan 大腕). Feng Xiaogang. Beijing: Huayi Brothers–Taihe/China Film Group/US: Columbia Pictures. 100 min.

Blind Shaft (Mangjing 盲井). Li Yang. Beijing: Li Yang-Tang Splendor. 92 min.

The Box (Hezi 盒子). Ying Weiwei 英未未. DV documentary. 88 min.

Butterfly Smile (Hudie de meng 蝴蝶的微笑). He Yi. Beijing: Beijing/CCTV Movie Channel. 90 min.

Conjugation (Dongci bianwei 动词变位). Emmy Tang (Tang Xiaobai 唐晓白). 97 min.

Dance with Farm Workers (*Yu mingong tiaowu* 与民工跳舞). Wu Wenguang. Beijing: Wu Studio. DV documentary. 60 min.

Enter the Clowns (Choujue dengchang 丑角登场). Cui Zi'En 崔子恩. Beijing: Cui Zi Studio. 103 min.

Fish and Elephant (Jinnian xiatian 今年夏天). Li Yu 李玉. 106 min.

I Love Beijing (Xiari nuan yangyang 夏日暖洋洋). Ning Ying. Italy: Eurasia Communications/Beijing: Happy Village. 97 min.

In Public (Gonggong changsuo 公共场所). Jia Zhangke. South Korea: SIDUS. DV documentary short. 31 min.

Leave Me Alone (Wo bu yao ni gua 我不要你管). Hu Shu 胡庶. DV documentary. 70 min.

Marriage Certificate (Jiehun zheng 结婚证, aka Shuishuo wo bu zaihu 谁说我不在乎). Huang Jianxin. Beijing: Forbidden City/Xi'an: Xi'an Studio. 110 min.

Old Testament (Jiuyue 旧约). Cui Zi'En. Beijing: Cui Zi Studio. 100 min.

The Orphan of Anyang (Anyang yinger 安阳婴儿). Wang Chao 王超. Netherlands: Cineco. 81 min.

Quitting (Zuotian 昨天). Zhang Yang. Xi'an: Xi'an Studio/Imar Film. 114 min.

Roots and Branches (Wode xiongdi jiemei 我的兄弟姐妹). Yu Zhong 俞钟. Urumqi: Tianshan Studio/Beijing: Sihaizongheng. 95 min.

Seafood (Haixian 海鲜). Zhu Wen 朱文. 86 min.

2002

Black Pottery Family (黑陶人家). Sunnuo Qilin 孙诺七林, En Zhu 恩主. Kunming: Bama Mountain Culture Research Institute. DV documentary short. 29 min.

Cala, My Dog (Kala shi tiao gou 卡拉是条狗). Lu Xuechang. Beijing: Huayi Brothers-Taihe. 100 min.

Chicken Poets (Xiang jimao yiyang fei 像鸡毛一样飞). Meng Jinghui 孟京辉. Beijing: Guosong Productions/Xi'an: Xi'an Studio. 94 min.

Christmas Eve in Cizhong, Cizhong Red Wine (Cizhong shengdan ye, Cizhong hongjiu 茨中圣诞夜，茨中红酒). Liu Wenzeng 刘文增. Kunming: Bama Mountain Culture Research Institute. DV documentary short. 25 min.

Cry Woman (Kuqi de nüren 哭泣的女人). Liu Bingjian 刘冰鉴. Canada: Apsars. 90 min.

Dancing with Myself (He ziji tiaowu 和自己跳舞). Li Hong. Documentary.

Dazzling (Huayan 花眼). Li Xin. Shanghai: Shanghai Cinezoic. 84 min.

Double Vision (Shuangtong 双瞳). Chen Kuo-fu 陈国富. US: Columbia Pictures/ Nan Fang Film. 112 min.

Eyes of a Beauty (Xishi yan 西施眼). Guan Hu. Beijing: Jiatong Century. 125 min.

Glacier (Bingchuan 冰川). Zhaxi Nima 扎西尼玛. Kunming: Bama Mountain Culture Research Institute. DV documentary short. 31 min.

Hero (Yingxiong 英雄). Zhang Yimou. Beijing: New Picture/Hong Kong: Elite Group. 99 min.

Houjie Township (Houjie 厚街). Zhou Hao 周浩. Guangzhou. DV documentary. 112 min.

I Love You (Wo ai ni 我爱你). Zhang Yuan. Xi'an: Xi'an/Beijing: Beida Huayi. 97 min.

Life Show (Shenghuo xiu 生活秀). Huo Jianqi. Beijing: Beijing Studio. 106 min.

The Missing Gun (Xunqiang 寻枪). Lu Chuan 陆川. Beijing: China Film Group/ Huayi Brothers–Taihe. 120 min.

My Camera Doesn't Lie (Wode sheyingji bu sahuang 我的摄影机不撒谎). Solveig Klassen and Katharina Schneidere-Roos. Beijing. 90 min.

The Secret of My Success (Linqi da shetou 拎起大舌头). Duan Jinchuan. Beijing: China Memo. Documentary. 75 min.

Spring Subway (Kaiwang chuntian de ditie 开往春天的地铁). Zhang Yibai 张一白. Beijing: Electric Orange Entertainment. 93 min.

Springtime in a Small Town (Xiaocheng zhichun 小城之春). Tian Zhuangzhuang. Beijing: Beijing Studio/Netherlands: Fortissimo Films. 116 min.

This Happy Life (Xingfu shenghuo 幸福生活). Jiang Yue. China Memo. Documentary. 45 min.

Tiexi District: West of the Tracks (Tiexi qu 铁西区). Wang Bing 王兵. 3-part DV Documentary: "Rust" (Gongchang 工厂); "Remnants" (Yanfen jie 艳粉街); "Rails" (Tielu 铁路). 330 min./450 min.

Together with You (He ni zai yiqi 和你在一起). Chen Kaige. Beijing: China Film Group/Century Hero/CCTV Movie Channel. 116 min.

Unknown Pleasures (Ren xiaoyao 任逍遥). Jia Zhangke. Hong Kong: Hutong Communication/Japan: Office Kitano/France: Lumen. 117 min.

When Nuoma Was Seventeen (Nuoma de shiqi sui 诺玛的十七岁). Zhang Jiarui 章家瑞. Beijing: Youth Film Studio. 88 min.

2003

Cell Phone (Shouji 手机). Feng Xiaogang. Beijing: China Film Group/Huayi Brothers–Taihe/US: Columbia Pictures. 107 min.

Delamu (Delamu 德拉姆). Tian Zhuangzhuang. Japan: NHK. Documentary. 110 min.

Deng Xiaoping (Deng Xiaoping 邓小平). Ding Yinnan 丁荫楠. Guangzhou: Pearl River; Beijing: CCTV Movie Channel.

Drifters (Erdi 二弟). Wang Xiaoshuai. Taipei: Arc Light. 120 min.

The Foliage (Meirencao 美人草). Lü Yue 吕乐. Beijing: Beijing Poly-bona Film. 99 min.

Green Tea (Lücha 绿茶). Zhang Yuan. Beijing: Asian Union. 83 min.

Hi, Guys (Tiaoyou 条友). Zhang Huilin 张晖林. Documentary.

Lord of the Rings, III. Peter Jackson. US: New Line Cinema/Wingnut Films. 201 min.

My Father and I (Wo he baba 我和爸爸). Xu Jinglei 徐静蕾. Beijing: Asian Union. 98 min.

Nuan (Nuan 暖). Huo Jianqi. Beijing: Jinhai fangzhou. 109 min.

Warriors of Heaven and Earth (Tiandi yingxiong 天地英雄). He Ping 何平. Xi'an: Xi'an Studio/Beijing: Huayi Brothers–Taihe/US: Columbia Pictures. 114 min.

2004

Baober in Love (Lian ai zhong de baobei 恋爱中的宝贝). Li Shaohong. Beijing: Beijing Roseart. 95 min.

Fuck Cinema (Caotama de dianying 操他妈的电影). Wu Wenguang. Beijing: Caochangdi Workstation. DV documentary. 172 min.

Kekexili (Kelexili 可可西里). Lu Chuan. Beijing: Huayi Brothers/US: Columbia Pictures/National Geographic World Films. 90 min.

House of Flying Daggers (Shimian maifu 十面埋伏). Zhang Yimou. Beijing: New Picture/Hong Kong: Elite Group. 119 min.

Jasmine Woman (Molihua kai 茉莉花开). Hou Yong 侯咏. Beijing: Asian Union. 130 min.

A Letter from an Unknown Woman (Yige mosheng nüren de laixin 一个陌生女人的来信). Xu Jinglei. Beijing: Asian Union. 90 min.

Kung Fu Hustle (Gongfu 功夫). Stephen Chiau (Zhou Xingchi 周星驰). Beijing: China Film Group/Huayi Brothers–Taihe/US: Columbia Pictures. 95 min.

Pirated Copy (Manyan 蔓延). He Yi. Beijing: Fanhall Studio. 84 min.

San Yuan Li (Sanyuanli 三元里). Ou Ning 欧宁, Cao Fei 曹斐. Guangzhou: Alternative Archive. 45 min.

Silver Hawk (Feiying 飞鹰). Ma Chucheng 马楚成. Tianjin: Tianjin Studio/Hong Kong: Han Entertainment. 99 min.

The World (Shijie 世界). Jia Zhangke. Shanghai: Shanghai Studio/Japan: Office Kitano/France: Lumen. 143 min.

A World Without Thieves (Tianxia wuzei 天下无贼). Feng Xiaogang. Beijing: Huayi Brothers–Taihe/Forbidden City/Hong Kong: Media Asia. 100 min.

2005

Beautiful Men (Renmian taohua 人面桃花). Du Haibin. Documentary.

Before the Flood (Yanmo 淹没). Li Yifan 李一凡, Yan Yu 鄢雨. Beijing: Fan & Yu Documentary Studio. DV documentary. 150 min.

A Bloody Case Resulting from a Steamed Bun (Yige mantou yinfa de xuean 一个馒头引发的血案). Hu Ge 胡戈. Short video parody. 20 min.

Dam Street (Hongyan 红颜). Li Yu. France: Fond Sud Cinéma/Laurel Films. 93 min.

Gimme Kudos (Qiuqiu ni, biaoyang wo 求求你，表扬我). Huang Jianxin. 95 min.

Huayao Bride in Shangri-La (Huayao xinniang 花腰新娘). Zhang Jiarui. Beijing: China Film Group. 87 min.

Looking for Lin Zhao's Soul (Xunzhao Lin Zhao de linghun 寻找林昭的灵魂). Hu Jie 胡杰. Documentary. 104 min.

Night and Day (Riri yeye 日日夜夜). Wang Chao. France: Laurel Films. 85 min.

Pai Gu (Paigu 排骨). Liu Gaoming 刘高明. Shenzhou. DV documentary. 106 min.

Peacock (Kongque 孔雀). Gu Changwei 顾长卫. Beijing: Asian Union. 136 min./144 min.

Perpetual Motion (Wuqiong dong 无穷动). Ning Ying. Beijing: Happy Village. 90 min.

The Promise (Wuji 无极). Chen Kaige. Beijing: 21st Century Shengkai/China Film Group. 128 min.

Shanghai Dreams (Qinghong 青红). Wang Xiaoshuai. Beijing: Debo. 123 min.

Sunflower (Xiangrikui 向日葵). Zhang Yang. Beijing: China Film Group/Ming Productions/Netherlands: Fortissimo Films. 129 min.

2006

The Banquet (Yeyan 夜宴). Feng Xiaogang. Beijing: Huayi Brothers/Hong Kong: Media Asia. 131 min.

Bing Ai (Bing Ai 秉爱). Feng Yan 冯艳. DV documentary. 114 min.

China Village Self-Governance Film Project (Zhongguo cunmin zizhi yingxiang chuanbo jihua 中国村民自治影像传播计划). Wu Wenguang et al. 10 mini-episodes. DV documentary. 95 min.

Crazy Stone (Fengkuang shitou 疯狂的石头). Ning Hao 宁浩. Beijing: Warner China HG Corp./Focus Films. 98 min.

Curiosity Kills the Cat (Haoqi haisi mao 好奇害死猫). Zhang Yibai. Hong Kong: Eagle Spirit. 93 min.

The Curse of the Golden Flower (Mancheng jindai huangjinjia 满城尽带黄金甲). Zhang Yimou. Beijing: New Picture/Hong Kong: Elite Group. 114 min.

Dong (Dong 东). Jia Zhangke. Beijing: X Stream Pictures. DV documentary. 66 min.

The Go Master (Wu Qingyuan 吴清源). Tian Zhuangzhuang. Beijing: Century Hero/Japan: Hakuhodo. 104 min.

Little Red Flowers (Kanshangqu henmei 看上去很美). Zhang Yuan. Beijing: Century Good-Tidings. 92 min.

The Other Half (Ling yi ban 另一半). Ying Liang 应亮. Shanghai: 90 Minutes Film Studio. 111 min.

Sanli Dong (Sanli dong 三里洞). Lin Xin 林鑫. DV documentary. Black/white. 172 min.

Senior Year (Gaosan 高三). Zhou Hao. Documentary. 95 min.

Still Life (Sanxia haoren 三峡好人). Jia Zhangke. Shanghai: Shanghai Studio. 108 min.

Summer Palace (Yiheyuan 颐和园). Lou Ye. Shanghai: Dream Factory/France: Laurel Films. 140 min.

Tuya's Marriage (Tuya de hunshi 图雅的婚事). Wang Quan'an. Xi'an: Xi'an Film/Maxyee Cultural Industry. 86 min.

2007

And the Spring Comes (Lichun 立春). Gu Changwei. Beijing: Asian Union. 94 min.

Assembly (Jijie hao 集结号). Feng Xiaogang. Beijing: Huayi Brothers/Shanghai: Shanghai Film Group/Hong Kong: Media Asia. 124 min.

The Door (Men 门). Li Shaohong. Beijing: Stellar Megamedia.

Lost in Beijing (Pingguo 苹果). Li Yu. France: Laurel Films. 112 min.

Lust, Caution (Se jie 色戒). Ang Lee. Shanghai: Shanghai Film Group/Hong Kong: Sil-Metropole/US: Focus Features. 148 min./157 min.

The Sun Also Rises (Taiyang zhaochang shengqi 太阳照常升起). Jiang Wen. Beijing: Huayi Brothers/Hong Kong: Lotus Entertainment. 116 min.

Though I Was Dead (Wo sui si qu 我虽死去). Hu Jie. Documentary. 66 min.

Transformers. Michael Bay. US: DreamWorks/Paramount Pictures. 144 min.

Useless (Wuyong 无用). Jia Zhangke. Beijing: X Stream Pictures. Documentary. 80 min.

Warlords (Toumingzhuang 投名状). Peter Chan 陈可辛. Beijing: China Film Group/Warner China Film HG Corp./Hong Kong: Applause Pictures. 126 min.

2008

Prisoners in Freedom City (Ziyou cheng de qiutu 自由城的囚徒). Hu Jia 胡佳. Documentary. 32 min.

Bibliography

Abbas, Ackbar. *Hong Kong: Culture and the Politics of Disappearance.* Minneapolis: University of Minnesota Press, 1997.

Anonymous author. "Zigong li de feixiang" 子宫里的飞翔 (Flying in the womb). <http://www.bjmdc.com/xunyicao/new_page_32.htm>, accessed Aug. 16, 2005.

Appadurai, Arjun. *Modernity at Large: Cultural Dimensions of Globalization.* Minneapolis: University of Minnesota Press, 1996.

Augé, Marc. *Non-places: Introduction to an Anthropology of Supermodernity.* Trans. John Howe. London: Verso, 1996.

Baidu Baike 百度百科 (Baidu encyclopedia). "Fengjie 奉节." <http://baike.baidu.com/view/46733.htm>, accessed Dec. 8, 2007.

———. "Sanxia daba 三峡大坝." <http://baike.baidu.com/view/26251.htm>, accessed Dec. 8, 2007.

Bao, Weihong. "From Pearl White to White Rose Woo: Tracing the Vernacular Body of 'Nüxia' in Chinese Silent Cinema, 1927–1931." *Camera Obscura* 20, no. 3 (2005): 193–231.

Barboza, David. "105 Killed in China Mine Explosion." *The New York Times,* Dec. 7, 2007. <http://www.nytimes.com/2007/12/07/world/asia/07mine.html?_r=1&oref=slogin>, accessed Dec. 9, 2007.

Barmé, Geremie R. *In the Red: On Contemporary Chinese Culture.* New York: Columbia University Press, 1999.

Barnouw, Erik. *Documentary: A History of the Non-Fiction Film.* New York: Oxford University Press, 1983.

Bauman, Zygmunt. *Globalization: The Human Consequences.* Cambridge: Polity, 1998.

———. *Liquid Modernity.* Cambridge: Polity, 2000.

———. *Postmodern Ethics.* Oxford: Blackwell, 1993.

Bazin, André. "De Sica: Metteur-en-scenè." In *Film Theory and Criticism,* eds. Gerald Mast, Marshall Cohen, and Leo Braudy, pp. 38-47. New York: Oxford University Press, 1992.

Beilharz, Peter, ed. *The Bauman Reader.* Oxford: Blackwell, 2001.

Belsky, Richard. *Localities at the Center: Native Place, Space, and Power in Late Imperial Beijing.* Cambridge, MA: Harvard University Asia Center, 2005.

Benson, Thomas, and Carolyn Anderson. *Reality Fictions: The Films of Frederick Wiseman.* Carbondale: Southern Illinois University Press, 1989.

Berlin International Film Festival Website. "Program for the Young Filmmakers' Forum." <http://www.netloungedv.de/2002/e/DV-Filme/Ying_Weiwei/ying_weiwei.html>, accessed Aug. 10, 2005.

Bernheimer, Charles, ed. *Comparative Literature in the Age of Multiculturalism.* Baltimore, MD: Johns Hopkins University Press, 1994.

Berry, Chris, ed. "Getting Real: Chinese Documentary, Chinese Postsocialism." In *The Urban Generation,* ed. Z. Zhang, pp. 81–114. Durham, NC: Duke University Press, 2007.

———."Hidden Truths." *Cinemaya* 28–29 (1995): 52–55.

———. "If China Can Say No, Can China Make Movies? Or, Do Movies Make China? Rethinking National Cinema and National Agency." *Boundary 2* 25, no. 3 (1998): 129–150.

———. "Independently Chinese: Duan Jinchuan, Jiang Yue, and Chinese Documentary." In *From Underground to Independent,* ed. Paul Pickowicz and Yingjin Zhang, pp. 109–122. Lanham, MD: Rowman & Littlefield, 2006.

———. *Perspectives on Chinese Cinema.* East Asian Papers 39. Ithaca, NY: Cornell University, China-Japan Program, 1985.

———. "The Sacred, the Profane, and the Domestic in Cui Zi'en's Cinema." *Positions* 12, no. 1 (2004): 195–201.

———. "The Sublimative Texts: Sex and Revolution in *Big Road.*" *East-West Film Journal* 2, no. 2 (1988): 66–86.

———. "Zhang Yuan: Thriving in the Face of Adversity." *Cinemaya* 32 (1996): 40–43.

———, and Mary Farquhar. *China on Screen: Cinema and Nation.* New York: Columbia University Press, 2005.

———, and Feii Lu, eds. *Island on the Edge: Taiwan New Cinema and After.* Hong Kong: Hong Kong University Press, 2005.

———, and Laikwan Pang. "Introduction, or, What's in an 's'?" *Journal of Chinese Cinemas* 2, no. 1 (2008): 3–8.

Bettig, Ronald V. *Copyrighting Culture: The Political Economy of Intellectual Property.* Boulder, CO: Westview Press, 1996.

Bordwell, David. "Aesthetics in Action: *Kungfu,* Gunplay, and Cinematic Expressivity." In *At Full Speed,* ed. Esther C. M. Yau, pp. 73–93. Minneapolis: University of Minnesota Press, 2001.

———. "Transcultural Spaces: Toward a Poetics of Chinese Film." In *Chinese-Language Film,* eds. Sheldon Lu and Emilie Yeh, pp. 141–162. Honolulu: University of Hawai'i Press, 2005.

Braester, Yomi. "Chinese Cinema in the Age of Advertisement: The Filmmaker as a Cultural Broker." *China Quarterly* 183 (2005): 549–564.

———. "Tracing the City's Scars: Demolition and the Limits of the Documentary Impulse in the New Urban Cinema." In *The Urban Generation,* ed. Z. Zhang, pp. 161–180. Durham, NC: Duke University Press, 2007.

———. *Witness Against History: Literature, Film, and Public Discourse in Twentieth-century China.* Stanford, CA: Stanford University Press, 2003.

Browne, Nick, Paul G. Pickowicz, Vivian Sobchack, and Esther Yau, eds. *New Chinese Cinemas: Forms, Identities, Politics.* New York: Cambridge University Press, 1994.

Bruzzi, Stella. *New Documentary: A Critical Introduction.* London: Routledge, 2000.

Cartier, Carolyn. *Globalizing South China.* Oxford: Blackwell, 2001.

Casey, Edward S. *The Fate of Place: A Philosophical History.* Berkeley: University of California Press, 1997.

———. "How to Get from Space to Place in a Fairly Short Stretch of Time: Phenomenological Prolegomena." In *Senses of Place,* eds. Steven Feld and Keith Basso, pp. 13–52. Santa Fe, NM: School of American Research Press, 1996.

Cassell, Philip, ed. *The Giddens Reader.* Stanford, CA: Stanford University Press, 1993.

Castells, Manuel. *The Information Age: Economy, Society and Culture.* Vol. 1: *The Rise of the Network Society.* Oxford: Blackwell, 1996.

Chang, Michael G. "The Good, the Bad, and the Beautiful: Movie Actresses and Public Discourses in Shanghai, 1920s–1930s." In *Cinema and Urban Culture in Shanghai,* ed. Yingjin Zhang, pp. 128–159. Stanford, CA: Stanford University Press, 1999.

Chen Jingliang 陈景亮, Shan Wanli 单万里, and Zhang Zhenqin 张震钦, eds. *Huigu yu zhanwang: Zhongguo dianying 100 zhounian guoji luntan wenji* 回顾与展望: 中国电影100周年国际论坛文集 (Retrospective and prospective: International forum for the centennial anniversary of Chinese cinema). Beijing: Zhongguo dianying chubanshe, 2007.

Chen Mo, and Zhiwei Xiao. "Chinese Underground Films: Critical Views from China." In *From Underground to Independent,* eds. Paul Pickowicz and Yingjin Zhang, pp. 143–159. Lanham, MD: Rowman & Littlefield, 2006.

Cheng Qingsong 程青松. *Kandejian de yingxiang* 看得见的影像 (Films permitted for watching). Shanghai: Sanlian shudian, 2004.

Cheng Qingsong, and Huang Ou 黄鸥. *Wode sheyingji bu sahuang: Xianfeng dianying ren dang'an—Shengyu 1961–1970* 我的摄影机不撒谎: 先锋电影人档案—生于 1961–1970 (My camera doesn't lie: Documents on avant-garde filmmakers born between 1961 and 1970). Beijing: Zhongguo youyi chuban gongsi, 2002.

Chow, Rey. "Film and Cultural Identity." In *The Oxford Guide to Film Studies,* eds. John Hill and Pamela Gibson, pp. 169–175. New York: Oxford University Press, 1998.

———. *Primitive Passions: Visuality, Sexuality, Ethnography, and Contemporary Chinese Cinema.* New York: Columbia University Press, 1995.

Chu, Yingchi. *Chinese Documentaries: From Dogma to Polyphony.* London: Routledge, 2007.

———. *Hong Kong Cinema: Colonizer, Motherland and Self.* London: RoutledgeCurzon, 2002.

Chute, David. "Beyond the Law." *Film Comment* 30, no. 1 (1994): 60–62.

Çinar, Alev, and Thomas Bender, eds. *Urban Imaginaries: Locating the Modern City.* Minneapolis: University of Minnesota Press, 2007.

Clark, Paul. *Reinventing China: A Generation and Its Films.* Hong Kong: Chinese University Press, 2005.

Clarke, David, and Marcus Doel. "Zygmunt Bauman." In *Key Thinkers on Space and Place,* eds. Phil Hubbard, Rob Kitchin, and Gill Valentine, pp. 33–39. Thousand Oaks, CA: Sage, 2004.

Clifford, James. *Routes: Travel and Translation in the Late Twentieth Century.* Cambridge, MA: Harvard University Press, 1997.

Corliss, Richard. "Bright Lights." *Time Asia* 157, no. 12 (March 26, 2001). <http://www.time.com/time/asia/arts/magazine/0,9754,103002,00.html>, accessed Jan. 13, 2006.

Crofts, Stephen. "Concepts of National Cinema." In *The Oxford Guide to Film Studies,* eds. John Hill and Pamela Gibson, pp. 385–394. New York: Oxford University Press, 1998.

———. "Reconceptualizing National Cinema/s." *Quarterly Review of Film and Video* 14, no. 3 (1993): 49–67.

Cui, Shuqin. "Negotiating In-between: On New-Generation Filmmaking and Jia Zhang-ke's Films." *Modern Chinese Literature and Culture* 18, no. 2 (2006): 98–130.

———. "Ning Ying's Beijing Trilogy: Cinematic Configurations of Age, Class, and Sexuality." In *The Urban Generation,* ed. Z. Zhang, pp. 241–263. Durham, NC: Duke University Press, 2007.

———. "Working from the Margins: Urban Cinema and Independent Directors in Contemporary China." In *Chinese-language Film,* eds. Sheldon Lu and Emilie Yeh, pp. 96–119. Honolulu: University of Hawai'i Press, 2005.

Cui Weiping 崔卫平. "Zai 'yunzhinan' kan dianying" 在"云之南"看电影 (Watching films in "south of the clouds"). <http://blog.sina.com.cn/s/blog_473d066b0100098i.html>, accessed Dec. 29, 2007.

———. "Zhongguo dalu duli zhizuo jilupian de shengzhang kongjian" 中国大陆独立制作纪录片的生长空间 (Space for the growth of the independent documentary in mainland China). *Ershiyi shiji* 二十一世纪 (Hong Kong) 77 (June 2003): 84–94.

Cui Zi'en 崔子恩. *Diyi guanzhong* 第一观众 (The first audience). Beijing: Xiandai chubanshe, 2003.

Curtin, Michael. "The Future of Chinese Cinema: Some Lessons from Hong Kong and Taiwan." In *Chinese Media, Global Contexts,* ed. Chin-Chuan Lee, pp. 237–256. London: RoutledgeCurzon, 2003.

———. *Playing to the World's Biggest Audience: The Globalization of Chinese Film and TV.* Berkeley: University of California Press, 2007.

Dai Jinhua 戴锦华. "Bainian zhiji de Zhongguo dianying xianxiang toushi" 百年之际的中国电影现象透视 (An analysis of Chinese film scenes amidst its centennial celebration). *Yingshi yishu* 影视艺术 (Beijing) 2007, no. 2: 3–12.

———. *Cinema and Desire: Feminist Marxism and Cultural Politics in the Work of Dai Jinhua.* Eds. Jing Wang and Tani E. Barlow. London: Verso, 2002.

———. 戴锦华. *Dianying lilun yu piping* 电影理论与批评. Beijing: Beijing daxue chubanshe, 2007.

Danan, Martine. "From a 'Prenational' to a 'Postnational' French Cinema." *Film History* 8, no. 1 (1996): 72–84.

Dangdai dianying 当代电影 (Contemporary cinema), ed. "Xin shiji xin daoyan zongtan 新世纪新导演纵谈" (A forum on new directors in the new century). *Dangdai dianying* 当代电影 (Beijing) 2003, no. 5: 8–33.

Davis, Darrell William, and Ru-shou Robert Chen, eds. *Cinema Taiwan: Politics, Popularity and State of the Arts.* London: Routledge, 2007.

———, and Emilie Yueh-yu Yeh. *East Asian Screen Industries.* London: British Film Institute, 2008.

Dazhong dianying 大众电影 (Popular cinema), ed. "Xinren xinzuo *Yueshi*" 新人新作《月蚀》 (A new work from a newcomer: *Lunar Eclipse*). *Dazhong dianying* (Shanghai) 2000, no. 4: 12–13.

de Certeau, Michel. *The Practice of Everyday Life.* Trans. Steven Rendall. Berkeley: University of California Press, 1981.

Deleuze, Gilles. *Cinema I: The Movement-Image.* Trans. Hugh Tomlinson and Barbara Habberjam. Minneapolis: University of Minnesota Press, 1986.

———, and Félix Guattari. *A Thousand Plateaus*. Trans. and foreword by Brian Massumi. London: Athlone Press, 1988.

Denton, Kirk A. "Model Drama as Myth: A Semiotic Analysis of *Taking Tiger Mountain by Strategy*." In *Drama in the People's Republic of China,* eds. Constantine Tung and Colin MacKerras, pp. 119–136. Albany: State University of New York Press, 1987.

Dianying yishu 电影艺术 (Film art) "Guochan dianying zhuanyingting lianmeng chengli" 国产电影专映厅联盟成立 (Establishment of the alliance of special screening halls for domestic films). *Dianying yishu* 2008, no. 2: 157–158.

———, ed. *Zhongguo dianying niandu piaofang paihangbang* 1995–2004 中国电影年度票房排行榜 (Ten years of Chinese film billboards). Beijing: Dianying yishu 2004.

Dirlik, Arif. "Placed-Based Imagination: Globalism and the Politics of Place." In *Places and Politics in an Age of Globalization,* eds. Roxann Frazniak and Arif Dirlik, pp. 15–51. Lanham, MD: Rowman & Littlefield, 2001.

Donald, Stephanie Hemelryk. "Landscapes of Class in Contemporary Chinese Film: From *Yellow Earth* to *Still Life*." In *The Place of Landscape,* ed. Jeff Malpas. Cambridge, MA: MIT Press, forthcoming.

———. *Public Secrets, Public Spaces: Cinema and Civility in China*. Lanham, MD: Rowman & Littlefield, 2000.

———. "Symptoms of Alienation: The Female Body in Recent Chinese Film." *Continuum* 12, no. 1 (1998): 91–103.

Dong, Madeleine Yue. *Republican Beijing: The City and Its Histories*. Berkeley: University of California Press, 2003.

Eckholm, Eric. "Feted Abroad, and No Longer Banned in Beijing." *The New York Times,* Dec. 16, 1999: Arts & Leisure.

Efird, Robert. "Rock in a Hard Place: Music and the Market in Nineties Beijing." In *China Urban: Ethnographies of Contemporary Culture,* eds. Nancy N. Chen, Constance D. Clark, Suzanne Z. Gottschang, and Lyn Jeffery, pp. 67–86. Durham, NC: Duke University Press, 2001.

Ehrlich, Linda, and David Desser, eds. *Cinematic Landscapes: Observations on the Visual Arts and Cinemas of China and Japan*. Austin: University of Texas Press, 1994.

Escobar, Arturo. "Culture Sits in Places: Reflections on Globalism and Subaltern Strategies of Localization." *Political Geography* 20 (2001): 139–174.

———. *Encountering Development: The Making and Unmaking of the Third World*. Princeton, NJ: Princeton University Press, 1995.

Esherick, Joseph W., ed. *Remaking the Chinese City: Modernity and National Identity, 1900–1950*. Honolulu: University of Hawai'i Press, 2000.

Fang Fang 方方. *Zhongguo jilupian fazhan shi* 中国纪录片发展史 (History of the development of Chinese documentary cinema). Beijing: Zhongguo xiju chubanshe, 2003.

Fenghuang weishi 凤凰卫视 (Phoenix Satellite TV), ed. *DV xin shidai 1* (DV new generation 1). Beijing: Zhongguo qingnian chubanshe, 2003.

Foucault, Michel. "Of Other Spaces." *Diacritics* 16, no. 1 (1986): 20–27.

Fouché, Gwladys. "Chinese Dissident Tipped to Win Nobel Peace Prize." *Guardian* Sept. 24, 2008. <http://www.guardian.co.uk/world/2008/sep/24/nobelpeaceprize.hujia>, accessed Sept. 26, 2008.

Fu Ying 傅莹. "Jiqing suo guanzhu yu shengming suo jianchi de: Diliudai daoyan Wang Xiaoshuai fangtan lu" 激情所关注与生命所坚持的：第六代导演王小帅访谈录 (Passionate concern and lifetime pursuit: An interview with Sixth Generation director Wang Xiaoshuai). *Wenyi yanjiu* 文艺研究 (Beijing) 2007, no. 8: 69–78.

Furthman, Jules. *"Morocco" and "Shanghai Express": Two Films by Josef von Sternberg.* New York: Simon & Schuster, 1973.

GAD (Gender and Development in China). "Beijing + 10." < http://www.china-gad .org/ReadNews.asp?NewsID=1050>, accessed Dec. 14, 2007.

Gateward, Frances, ed. *Zhang Yimou: Interviews.* Jackson: University Press of Mississippi, 2001.

Guo Jing 郭净, ed. *Yunzhinan jilu yingxiang luntan* 云之南记录影像论坛 (Yunnan multicultural visual festival). Kunming: Yunfest, 2005.

———, ed. *Yunzhinan jilu yingxiang zhan* 云之南记录影像展 (Yunnan multicultural visual festival). Kunming: Yunfest, 2007.

———, ed. *Yunzhinan renleixue yingxiang zhan shouce* 云之南人类学影像展手册 (Yunnan multicultural visual festival brochure). Kunming: Yunnan renmin chubanshe, 2003.

Guo Jing, Zhang Zhongyun 章忠云, and Su Xiongjuan 苏雄卷. "Xuexi women ziji de chuantong: Shequ yingshi jiaoyu xiangmu baogao" 学习我们自己的传统：社区影视教育项目报告 (Learn our own traditions: The report on the project of participatory video education). Bilingual. In *Diqing Zangzu Zizhizhou Xianggelila xian Nixi xiang Tandui xiaoxue xiangtu zhishi jiaoyu de shijian* 迪庆藏族自治州香格里拉县尼西乡汤堆小学乡土知识教育的实践 (Local knowledge education in Tangdui elementary school, Nixi township, Xianggelila county, Diqing Tibetan autonomous district), eds. Guo Jing and He Yinhua 和银华, pp. 109–181. Kunming: Yunnan keji chubanshe, 2006.

Habermas, Jürgen. *The Structural Transformation of the Public Sphere: An Inquiry into a Category of Bourgeois Society.* Trans. Thomas Burger. Cambridge, MA: MIT Press, 1989.

Hall, Stuart. "The Local and the Global: Globalization and Ethnicity." In *Culture, Globalization and the World-System: Contemporary Conditions for the Representation of Identity,* ed. Anthony King, revised edition. pp. 19–39. Minneapolis: University of Minnesota Press, 1997.

———. "New Cultures for Old." In *A Place in the World? Places, Cultures and Globalization,* eds. Doreen Massey and Pat Jess, pp. 175–213. Oxford: Oxford University Press, 1996.

Han Hong 韩鸿, and Tao Anping 陶安萍. "Minjian yingxiang yu minjian xingdong: Lun xinjilu yundong de dangdai zhuanxiang" 民间影像与民间行动：论新纪录运动的当代转向 (Unofficial images and unofficial activities: A contemporary turn in the new documentary movement). *Dianying yishu* 2007, no. 2: 131–136.

Han Xiaolei 韩小磊. "Dui diwudai de wenhua tuwei: Houwudai de geren dianying xianxiang" 对第五代的文化突围：后五代的个人电影现象 (A cultural breakaway from the Fifth Generation: The phenomenon of individualist film in the post-Fifth Generation). *Dianying yishu* 1995, no. 2: 58–63.

———. "Tuwei hou de wenhua piaoyi" 突围后的文化漂移 (Cultural drifting after the breakaway). *Dianying yishu* 1999, no. 5: 58–65.

Hansen, Miriam Bratu. *Babel and Babylon: Spectatorship in American Silent Film.* Cambridge, MA: Harvard University Press, 2005.

———. "Fallen Women, Rising Stars, New Horizons: Shanghai Silent Film as Vernacular Modernism." *Film Quarterly* 54, no. 1 (2000): 10–22.

Harris, Christine. "Adaptation and Innovation: Costume Drama Spectacle and *Romance of the Western Chamber.*" In *Cinema and Urban Culture in Shanghai,* ed. Yingjin Zhang, pp. 51–73. Stanford, CA: Stanford University Press, 1999.

Harvey, David. "Between Space and Time: Reflections on the Geographical Imagination." *Annals of the Association of American Geographers* 80 (1990): 418–434.

———. *The Postmodern Condition.* Oxford: Blackwell, 1989.

———. *The Urban Experience.* Baltimore, MD: Johns Hopkins University Press, 1989.

Havis, Richard James. "Illusory Worlds: An Interview with Jia Zhangke." *Cineaste* 30, no. 4 (2005): 58–59.

Hay, James. "Piecing Together What Remains of the Cinematic City." In *The Cinematic City,* ed. Dave Clarke, pp. 209–229. London: Routledge, 1997.

Hayward, Susan. "Framing National Cinema." In *Cinema and Nation,* eds. Mette Hjort and Scott MacKenzie, pp. 88–102. London: Routledge, 2000.

———. *French National Cinema.* London: Routledge, 1993.

He Chang. "The Raw and the Reel." *City Weekend,* Aug. 3, 2005. <http://www.cityweekend.com.cn/en/beijing/features/2005_15/story.2005-08-01.9641876912>, accessed Aug. 5, 2005.

Higson, Andrew. "The Concept of National Cinema." *Screen* 30, no. 4 (1989): 36–46.

———. "The Limiting Imagination of National Cinema." In *Cinema and Nation,* eds. Mette Hjort and Scott MacKenzie, pp. 63–74. London: Routledge, 2000.

———. *Waving the Flag: Constructing a National Cinema in Britain.* Oxford: Oxford University Press, 1995.

Hill, John. "The Issue of National Cinema and British Film Production." In *New Questions of British Cinema,* ed. Duncan Petrie, pp. 10–21. London: British Film Institute, 1992.

———, and Pamela Church Gibson, eds. *The Oxford Guide to Film Studies.* New York: Oxford University Press, 1998.

Hjort, Mette, and Scott MacKenzie, eds. *Cinema and Nation.* London: Routledge, 2000.

Hoare, Stephanie. "Innovation through Adaptation: The Use of Literature in New Taiwan Film and Its Consequences." *Modern Chinese Literature* 7, no. 2 (1993): 33–58.

Hu, Jubin. *Projecting a Nation: Chinese National Cinema before 1949.* Hong Kong: Hong Kong University Press, 2003.

Huang, Philip. "'Public Sphere'/'Civil Society' in China? The Third Realm between State and Society." *Modern China* 19, no. 2 (1993): 216–240.

Huang Shixian 黄式宪. "Huayu dianying: Shijixing wenhua zhenghe jiqi dangxia de xiandaixing jueze" 华语电影：世纪性文化整合及其当下的现代性抉择 (Chinese-language cinema: Epochal cultural integration and present-day choices of modernity). In *Locality, Translocality, and De-Locality: Cultural, Aesthetic and Political Dynamics of Chinese-Language Cinema,* a conference proceeding, ed. Shanghai University, vol. 1, pp. 79–88. Shanghai, July 2008.

———. "Wenhua huimeng yu Zhongguo dianying chanye zhenxing." 文化会盟与中国电影产业振兴 (Cultural alliance and the rise of Chinese film industry). In *Huigu*

yu zhanwan, eds. Chen Jingliang, Shan Wanli, and Zhang Zhenqin, pp. 657–671. Beijing: Zhongguo dianying chubanshe, 2007..

Hubbard, Phil. "Manuel Castells." In *Key Thinkers on Space and Place,* eds. Phil Hubbard, Rob Kitchin, and Gill Valentine, pp. 72–77. Thousand Oaks, CA: Sage, 2005.

———, Rob Kitchin, and Gill Valentine, eds. *Key Thinkers on Space and Place.* Thousand Oaks, CA: Sage, 2004.

Huters, Theodore. *Bringing the World Home: Appropriating the West in Late Qing and Early Republican China.* Honolulu: University of Hawaiʻi Press, 2005.

IMDb (Internet Movie Database). "Trivia for 55 Days at Peking." <http://www.imdb.com/title/tt0056800/trivia>, accessed Jan. 2, 2006.

Jaffee, Valerie. "'Everyman a Star': The Ambivalent Cult of Amateur Art in New Chinese Documentary." In *From Underground to Independent,* eds. Paul Pickowicz and Yingjin Zhang, pp. 77–108. Lanham, MD: Rowman & Littlefield, 2006.

Jaivin, Linda. "Defying a Ban, Chinese Cameras Roll." *Wall Street Journal,* Jan. 18, 1995: A12.

Jameson, Fredric. "Remapping Taipei." In *New Chinese Cinemas: Forms, Identities, Politics,* eds. Nick Browne et al., pp. 117–150. New York: Cambridge University Press, 1994.

Jarvie, Ian. "National Cinema: A Theoretical Assessment." In *Cinema and Nation,* eds. Mette Hjort and Scott MacKenzie, pp. 75–87. London: Routledge, 2000.

Jassey, Katja, ed. *Engaging Participation: The Use of Video as a Tool in Rural Development.* Farmesa: FAO, 1996.

Jia Leilei 贾磊磊 and Zhu Yuqing 朱玉卿. "Zhongguo dianying de boyi shidai: 'Dapian' shinian qishilu (1994–2004)" 中国电影的博弈时代："大片"十年启示录 (1994–2004) (Contending years in Chinese cinema: revelation from a decade of "blockbuster films," 1994-2004). In *Huigu yu zhanwan,* eds. Chen Jingliang, Shan Wanli, and Zhang Zhenqin, pp. 641-656. Beijing: Zhongguo dianying chubanshe, 2007.

Jia Pingwa 贾平凹. *Feidu* 废都 (Abandoned city). Beijing: Beijing chubanshe, 1993.

Jia Zhangke 贾樟柯. "Yeyu dianying shidai jijiang zaici daolai" 业余电影时代即将再次到来 (The age of amateur cinema will return). In *Yigeren de yingxiang,* eds. Zhang Xianmin and Zhang Yaxuan, pp. 306–308. Beijing: Zhongguo qingnian chubanshe, 2003.

———. "Youle VCD he shuma shexiangji yihou" 有了VCD和数码摄像机以后 (Now that we have VCDs and digital cameras). In *Yigeren de yingxiang,* eds. Zhang Xianmin and Zhang Yaxuan, pp. 309–311. Beijing: Zhongguo qingnian chubanshe, 2003.

———, Rao Shuguang 饶曙光, Zhou Yong 周涌, and Chen Xiaoyun 陈晓云. "Sanxia haoren" 三峡好人 (Still Life). *Dangdai dianying* 2007, no. 2: 19–27.

Jintian 今天 (Today), ed. "Jia Zhangke he tade dianying *Xiao Wu*" 贾樟柯和他的电影《小武》(Jia Zhangke and his film *Xiao Wu*). *Jintian* 1999, no. 3: 1–39.

Jones, Andrew F. *Like a Knife: Ideology and Genre in Contemporary Chinese Popular Music.* Ithaca, NY: Cornell University, East Asia Program, 1992.

Johnson, Barbara. "Writing." In *Critical Terms for Literary Study,* eds. Frank Lentricchia and Thomas McLaughlin, pp. 39–49. Chicago: University of Chicago Press, 1990.

Johnson, Matthew David. "'A Scene beyond Our Line of Sight': Wu Wenguang and New Documentary Cinema's Politics of Independence." In *From Underground to Independent,* eds. Paul Pickowicz and Yingjin Zhang, pp. 47–76. Lanham, MD: Rowman & Littlefield, 2006.

Kaplan, E. Ann. "Melodrama/Subjectivity/Ideology: Western Melodrama Theories and Their Relevance to Recent Chinese Cinema." *East-West Film Journal* 5, no. 1 (1991): 6–27.

Khoo, Olivia. "Love in Ruins: Spectral Bodies in Wong Kar-wai's *In the Mood for Love.*" In *Embodied Modernities: Corporeality, Representation, and Chinese Cultures,* eds. Fran Martin and Larissa Heinrich, pp. 235–252. Honolulu: University of Hawai'i Press, 2006.

King, Anthony D., ed. *Culture, Globalization and the World-System: Contemporary Conditions for the Representation of Identity.* Revised edition. Minneapolis: University of Minnesota Press, 1997.

Kluge, Alexander. "On Film and the Public Sphere." *New German Critique* 24–25 (1981–1982): 306–320.

Koehler, Robert. "The World." *Cineaste* 30, no. 4 (2005): 56–57.

Kokas, Aynne. "Finding Democracy, and Other Village Tales: Wu Wenguang's China Village Self-Governance Film Project." <http://www.international.ucla.edu/article.asp?parentid=63699>, accessed Dec. 14, 2007.

Kong, Shuyu. "Big Shot from Beijing." *Asian Cinema* 14, no. 1 (2003): 183–186.

———. "Genre Film, Media Corporations, and the Commercialization of the Chinese Film Industry: The Case of 'New Year Comedy'." *Asian Studies Review* 31 (Sept. 2007): 227–242.

Kort, Wesley A. *Place and Space in Modern Fiction.* Gainesville: University Press of Florida, 2004.

Lai, Linda Chiu-han. "Whither the Walker Goes: Spatial Practices and Negative Poetics in 1990s Chinese Urban Cinema." In *The Urban Generation,* ed. Z. Zhang, pp. 205–237. Durham, NC: Duke University Press, 2007.

Lao She. *Rickshaw: The Novel Lo-to Hsiang Tzu.* Trans. Jean M. James. Honolulu: University of Hawai'i Press, 1979.

Larson, Wendy. "He Yi's *The Postman:* The Work Space of a New Age Maoist." In *Gender in Motion: Divisions of Labor and Cultural Change in Late Imperial and Modern China,* eds. Bryna Goodman and Wendy Larson, pp. 211–236. Lanham, MD: Rowman & Littlefield, 2005.

Latour, Bruno. *We Have Never Been Modern.* Trans. Catherine Porter. Cambridge, MA: Harvard University Press, 1993.

Lau, Jenny Kwok Wah. "Globalization and Youthful Subculture: The Chinese Sixth-Generation Films at the Dawn of the New Century." In *Multiple Modernities: Cinemas and Popular Media in Transcultural East Asia,* ed. Jenny Kwok Wah Lau, pp. 13–27. Philadelphia, PA: Temple University Press, 2003.

Law, Kar, and Frank Bren. *Hong Kong Cinema: A Cross-cultural View.* Lanham, MD: Scarecrow, 2004.

Leary, Charles. "Performing the Documentary, or Making It to the Other Bank." *Senses of Cinema* 27 (July–Aug. 2003): <http://www.sensesofcinema.com/contents/03/27/performing_documentary.html>, accessed July 23, 2005.

Lee, Leo Ou-fan. *Shanghai Modern: The Flowering of a New Urban Culture in China, 1930–1945*. Cambridge, MA: Harvard University Press, 1999.

Lefebvre, Henri. *The Production of Space*. Trans. Donald Nicholson-Smith. Oxford: Blackwell, 1991.

Li Daoxin 李道新. *Zhongguo dianying de shixue jiangou* 中国电影的史学建构 (Historical construction of Chinese cinema). Beijing: Zhongguo guangbo dianshi chubanshe, 2004.

Li, Lillian M., Alison J. Dray-Novey, and Haili Kong. *Beijing: From Imperial Capital to Olympic City*. New York: Palgrave, 2007.

Li Xing 李幸, Liu Xiaoqian 刘晓茜, and Wang Jifang 汪继芳. *Bei yiwang de yingxiang: Zhongguo xin jilupian de lanshang* 被遗忘的影像：中国新纪录片的滥觞 (The forgotten vision: The origins of new Chinese documentary). Beijing: Zhongguo shehui kexue chubanshe, 2006.

Li Yan 李彦. "WTO laile women zenme ban?" WTO 来了我们怎么办？ (What should we do when WTO comes?). *Dazhong dianying* 2000, no. 6: 50–55.

Liang Jianzeng 梁建增, and Sun Kewen 孙克文, eds. *Dongfang shikong de rizi* 东方时空的日子 (Days with the Eastern horizons). Beijing: Gaodeng jiaoyu chubanshe, 2003.

Liang Jianzeng, Sun Kewen, and Chen Meng 陈虻, eds. *Baixing gushi* 百姓故事 (Ordinary people's lives). Beijing: Gaodeng jiaoyu chubanshe, 2003.

———, eds. *Dongfang zhizi* 东方之子 (Eastern talents). Beijing: Gaodeng jiaoyu chubanshe, 2003.

———, eds. *Shihua shishuo* 实话实说 (Talks in earnest). Beijing: Gaodeng jiaoyu chubanshe, 2003.

Lin Niantong. "A Study of the Theories of Chinese Cinema in Their Relationship to Classical Aesthetics." *Modern Chinese Literature* 1, no. 2 (1985): 185–200.

Lin, Shaoxiong 林少雄, ed. *Duoyuan wenhua shiyu zhongde jishi yingpian* 多元文化视域中的纪实影片 (Nonfiction films in a multicultural perspective). Shanghai: Xuelin chubanshe, 2003.

Lin, Xiaoping. "New Chinese Cinema of the 'Sixth Generation': A Distant Cry of Forsaken Children." *Third Text* 16, no. 3 (2002): 261–284.

Lin Xudong 林旭东, Zhang Yaxuan 张亚, and Gu Zheng 顾峥, eds. *Jia Zhangke dianying: Guxiang sanbuqu zhi "Ren xiaoyao"* 贾樟柯电影: 故乡三部曲之《任逍遥》 (Jia Zhangke's films: Hometown trilogy, *Unknown pleasures*). Beijing: Mangwen chubanshe, 2003.

———, eds. *Jia Zhangke dianying: Guxiang sanbuqu zhi "Xiao Wu"* 贾樟柯电影: 故乡三部曲之《小武》 (Jia Zhangke's films: Hometown trilogy, *Xiao Wu*). Beijing: Mangwen chubanshe, 2003.

Liu Haibo 刘海波. "Zhongguo dapian de huigui" 中国大片的回归 (Return of Chinese blockbusters). In *Locality, Translocality, and De-Locality: Cultural, Aesthetic and Political Dynamics of Chinese-Language Cinema*, a conference proceeding, ed. Shanghai University, vol. 1, pp. 139–144. Shanghai, July 2008.

Liu, Kang. *Globalization and Cultural Trends in China*. Honolulu: University of Hawai'i Press, 2004.

Liu, Lydia H. "*Beijing Sojourners in New York:* Postsocialism and the Question of Ideology in Global Media Culture." *Positions* 7, no. 3 (1999): 763–797.

———. *Translingual Practice: Literature, National Culture, and Translated Modernity—China, 1900–1937.* Stanford, CA: Stanford University Press, 1995.

Lo, Kwai-cheung. "Transnationalization of the Local in Hong Kong Cinema." In *At Full Speed,* ed. Esther Yao, pp. 261–276. Minneapolis: University of Minnesota Press, 2001.

Logan, John R., ed. *The New Chinese City: Globalization and Market Reform.* Oxford: Blackwell, 2002.

Low, Setha, and Neil Smith, eds. *The Politics of Public Space.* London: Routledge, 2006.

Lu, Sheldon Hsiao-peng. *China, Transnational Visuality, Global Postmodernity.* Stanford, CA: Stanford University Press, 2001.

———. *Chinese Modernity and Global Biopolitics: Studies in Literature and Visual Culture.* Honolulu: University of Hawai'i Press, 2007.

———, ed. *Transnational Chinese Cinemas: Identity, Nationhood, Gender.* Honolulu: University of Hawai'i Press, 1997.

———, and Emilie Yueh-yu Yeh, eds. *Chinese-Language Film: Historiography, Poetics, Politics.* Honolulu: University of Hawai'i Press, 2005.

Lu, Tonglin. *Confronting Modernity in the Cinemas of Taiwan and Mainland China.* New York: Cambridge University Press, 2002.

———. "Music and Noise: Independent Film and Globalization." *China Review* (Hong Kong) 3, no. 1 (2003): 57–76.

———. "Trapped Freedom and Localized Globalism." In *From Underground to Independent,* eds. Paul Pickowicz and Yingjin Zhang, pp. 123–141. Lanham, MD: Rowman & Littlefield, 2006.

Lü Xiaoming 吕晓明. "90 niandai Zhongguo dianying jingguan zhiyi 'diliu dai' jiqi zhiyi" 90年代中国电影景观之一 "第六代" 及其质疑 (An inquiry into 'the Sixth Generation' as a Chinese film spectacle in the 1990s). *Dianying yishu* 1999, no. 3: 23–28.

Lü Xinyu 吕新雨. *Jilu Zhongguo: Dangdai Zhongguo xin jilu yundong* 纪录中国：当代中国新纪录运动 (Documenting China: The new documentary movement in contemporary China). Beijing, Sanlian shudian, 2003.

———. "Ruins of the Future: Class and History in Wang Bing's *Tiexi District.*" *New Left Review* 31 (2005): 125–136.

Ma, Laurence J. C., and Fulong Wu, eds. *Restructuring the Chinese City: Changing Society, Economy and Space.* London: Routledge, 2005.

Macartney, Jane. "Three Gorges Dam Is a Disaster in the Making, China Admits." *Times* (London), Sept. 27, 2007. <http://www.timesonline.co.uk/tol/news/world/article2537279.ece>, accessed Dec. 12, 2007.

MacCabe, Colin. "Theory and Film: Principles of Realism and Pleasure." In *Film Theory and Criticism,* eds. Gerald Mast, Marshall Cohen, and Leo Braudy, pp. 79–92. New York: Oxford University Press, 1992.

MacDougall, David. "Beyond Observational Cinema." In *Movies and Methods,* ed. Bill Nichols, vol. 2, pp. 274–287. Berkeley: University of California Press, 1985.

Madsen, Richard. "The Public Sphere, Civil Society, and Moral Community: A Research Agenda for Contemporary China Studies." *Modern China* 19, no. 2 (1993): 183–198.

Marchetti, Gina, and Tan See Kam, eds. *Hong Kong Film, Hollywood and the New Global Cinema: No Film Is an Island.* London: Routledge, 2006.

Massey, Doreen. *For Space*. Thousand Oaks, CA: Sage, 2005.

——. "A Global Sense of Place." *Marxism Today* (June 1991): 24–29.

——. *Space, Place and Gender*. Cambridge: Polity Press, 1994.

Massumi, Brian. *Parables for the Virtual: Movement, Affect, Sensation*. Durham, NC: Duke University Press, 2002.

Mast, Gerald. *A Short History of the Movies*. 2nd edition. Indianapolis, IN.: Bobbs-Merrill, 1976.

——, Marshall Cohen, and Leo Braudy, eds. *Film Theory and Criticism: Introductory Readings*. 4th edition. New York: Oxford University Press, 1992.

McGrath, Jason. "The New Formalism: Mainland Chinese Cinema at the Turn of the Century." In *China's Literary and Cultural Scenes at the Turn of the 21st Century*, ed. Jie Lu, pp. 207–221. London: Routledge, 2007.

——. *Postsocialist Modernity: Chinese Cinema, Literature, and Criticism in the Market Age*. Stanford, CA: Stanford University Press, 2008.

McIntyre, Steve. "National Film Cultures: Politics and Peripheries." *Screen* 26, no. 1 (1985): 66–76.

Mei Bing 梅冰, and Zhu Jingjiang 朱靖江. *Zhongguo duli jilu dang'an* 中国独立纪录片档案 (Records of China's independent documentary cinema). Xi'an: Shaanxi shifan daxue chubanshe, 2004.

Meng Jian 孟建, Li Yizhong 李亦中, and Stefan Friedrich, eds. *Chongtu, hexie: Quanqiuhua yu Yazhou yingshi* 冲突、和谐：全球化与亚洲影视 (Conflict vs harmony: Globalization and Asian film and television). Shanghai: Fudan daxue chubanshe, 2003.

Nakajima, Seio. "Film Clubs in Beijing: The Cultural Consumption of Chinese Independent Films." In *From Underground to Independent*, eds. Paul Pickowicz and Yingjin Zhang, pp. 161–207. Lanham, MD: Rowman & Littlefield, 2006.

Negt Oskar, and Alexander Kluge. *Public Sphere and Experience: Toward an Analysis of the Bourgeois and Proletarian Public Sphere*. Foreword by Miriam Hansen. Minneapolis: University of Minnesota Press, 1993.

Ni Zhen 倪震. "Shouwang xinsheng dai" 守望新生代 (Expectations for the newborn generation). *Dianying yishu* 1999, no. 4: 70–73.

Nichols, Bill. *Blurred Boundaries: Questions of Meaning in Contemporary Culture*. Bloomington: Indiana University Press, 1994.

——. "Discovering Form, Inferring Meaning: New Cinemas and the Film Festival Circuit." *Film Quarterly* 47, no. 3 (1994): 16–30.

——. *Introduction to Documentary*. Bloomington: Indiana University Press, 2001.

——, ed. *Movies and Methods*. 2 vols. Berkeley: University of California Press, 1985.

——. *Representing Reality: Issues and Concepts in Documentary*. Bloomington: Indiana University Press, 1991.

——. "The Voice of Documentary." In *Movies and Methods*, ed. Bill Nichols, vol. 2, pp. 258–273. Berkeley: University of California Press, 1985.

Nornes, Abé Mark. *Forest of Pressure: Ogawa Shinsuke and Postwar Japanese Documentary*. Minneapolis: University of Minnesota Press, 2007.

Oakes, Tim. "The Village as Theme Park: Mimesis and Authenticity in Chinese Tourism." In *Translocal China*, eds. Tim Oakes and Louisa Schein, pp. 166–192. London: Routledge, 2006.

——, and Louisa Schein, eds. *Translocal China: Linkages, Identities, and the Reimagining of Space.* London: Routledge, 2006.

O'Regan, Tom. *Australian National Cinema.* London: Routledge, 1996.

Ouyang Jianghe 欧阳江河, ed. *Zhongguo duli dianying fangtan lu* 中国独立电影访谈录 (On the edge: Chinese independent cinema). Hong Kong: Oxford University Press, 2007.

Pang, Laikwan. *Building a New China in Cinema: The Chinese Left-Wing Cinema Movement, 1932–1937.* Lanham, MD: Rowman & Littlefield, 2002.

——. "Piracy/Privacy: The Despair of Cinema and Collectivity in China." *Boundary 2* 31, no. 3 (2004): 101–124.

Pickowicz, Paul G. "Huang Jianxin and the Notion of Postsocialism." In *New Chinese Cinemas,* eds. Nick Browne et al., pp. 57–87. New York: Cambridge University Press, 1994.

——. "Sinifying and Popularizing Foreign Culture: From Maxim Gorky's *The Lower Depths* to Huang Zuolin's *Ye dian.*" *Modern Chinese Literature* 7, no. 2 (1993): 7–31.

——, and Yingjin Zhang, eds. *From Underground to Independent: Alternative Film Culture in Contemporary China.* Lanham, MD: Rowman & Littlefield, 2006.

Pieterse, Jan Nederveen. *Globalization and Culture: Global Mélange.* Lanham, MD: Rowman & Littlefield, 2004.

Ping Jie 平杰, ed. *Lingyan xiangkan: Haiwai xuezhe ping dangdai Zhongguo jilupian* 另眼相看: 海外学者评当代中国纪录片 (A new look at the contemporary Chinese documentary). Shanghai: Wenhui chubanshe, 2006.

Polan, Dana. *Pulp Fiction.* London: British Film Institute, 2000.

Qiao, Michelle. "The Metaphysics of Film." *China Daily* Jan. 14, 2004. <www1.chinadaily.com.cn/en/doc/2004-01/14/content_298716.htm>, accessed Feb. 25, 2004.

Qin, Liyan. "Trans-media Strategies of Appropriation, Narrativization, and Visualization: Adaptations of Literature in a Century of Chinese Cinema." Ph.D. dissertation. University of California, San Diego, 2007.

Qiu Shuting 邱淑婷. *Gang Ri dianying guanxi: xun zhao Yazhou dianying wangluo zhi yuan* 港日电影关系: 寻找亚洲电影网络之源 (Hong Kong–Japan film relations: In search of origins of Asian film networks). Hong Kong: Tiandi, 2006.

Rabinowitz, Paula. *They Must Be Represented: The Politics of Documentary.* London: Verso, 1994.

Rao Shuguang 饶曙光. "Huayu dapian yu Zhongguo dianying gongye" 华语大片与中国电影工业 (Chinese-language blockbusters and the Chinese film industry). In *Locality, Translocality, and De-Locality: Cultural, Aesthetic and Political Dynamics of Chinese-Language Cinema,* a conference proceeding, ed. Shanghai University, vol. 2, pp. 533–546. Shanghai, July 2008.

——. "Zhongguo dianying chanyehua: Lishi, xianzai jiqi weilai: 2004 nian de guancha" 中国电影产业化: 历史, 现在及其未来——2004年的观察 (Chinese film industry in 2004: History, present, and future). *Dangdai dianying* 2005, no. 2: 26–30.

Renov, Michael. "Re-thinking Documentary: Towards a Taxonomy of Mediation." *Wide Angle* 8.3–4 (1986): 71–77.

——. *Theorizing Documentary.* London: Routledge, 1993.

Rentschler, Eric. "From New German Cinema to the Post-Wall Cinema of Consensus." In *Cinema and Nation,* eds. Mette Hjort and Scott MacKenzie, pp. 260–277. New York: Oxford University Press, 1998.

Reynaud, Bérénice. "Dancing with Myself, Drifting with My Camera: The Emotional Vagabonds of China's New Documentary." *Senses of Cinema* 28 (Sept.-Oct. 2003). <http://www.senseofcinema.com/contents/03/28/chinas_new_documentary .html>, accessed July 23, 2005.

———. "New Visions/New Chinas: Video-Art, Documentation, and the Chinese Modernity in Question." In *Resolutions: Contemporary Video Practices,* eds. Michael Renov and Erika Suderburg, pp. 229–257. Minneapolis: University of Minnesota Press, 1996.

———. "Zhang Yuan's Imaginary Cities and the Theatricalization of the Chinese 'Bastards.'" In *The Urban Generation,* ed. Z. Zhang, pp. 264–294. Durham, NC: Duke University Press, 2007.

Robertson, Roland. "Glocalization: Time-Space and Homogeneity-Heterogeneity." In *Global Modernities,* eds. Mike Featherstone, Scott Lash, and Roland Robertson, pp. 25–44. London: Sage, 1995.

Robinson, Lewis. "*Family:* A Study in Genre Adaptation." *Australian Journal of Chinese Affairs* 12 (1984): 35–57.

Rosen, Stanley. "Quanqiuhua shidai de huayu dianying: canzhao Meiguo kan Zhongguo dianying guoji shichang qianjing" 全球化时代的华语电影: 参照美国看中国电影国际市场前景 (Chinese-language cinema in the era of globalization: Prospects for Chinese films on the international market, with special reference to the United States." In *Huigu yu zhanwan,* eds. Chen Jingliang, Shan Wanli, and Zhang Zhenqin, pp. 565–600. Beijing: Zhongguo dianying chubanshe, 2007.

———. "The Wolf at the Door: Hollywood and the Film Market in China, 1994–2000." In *Southern California in the World,* eds. Eric J. Heikkila and Rafael Pizarro, pp. 49–77. Westport, CT: Praeger, 2002.

Rothman, Williams. *Documentary Film Classics.* New York: Cambridge University Press, 1997.

Ryan, Michael. "The Politics of Film: Discourse, Psychoanalysis, Ideology." In *Marxism and the Interpretation of Culture,* eds. Cary Nelson and Lawrence Grossberg, pp. 477–486. Urbana: University of Illinois Press, 1988.

Sassen, Saskia. *The Global City: New York, London, Tokyo.* Princeton, NJ: Princeton University Press, 1991.

Saussy, Haun, ed. *Comparative Literature in an Age of Globalization.* Baltimore, MD: Johns Hopkins University Press, 2006.

Schein, Louisa. "Negotiating Scale: Miao Women at a Distance." In *Translocal China,* eds. Tim Oakes and Louisa Schein, pp. 213–237. London: Routledge, 2006.

Schell, Orville. *Mandate of Heaven: A New Generation of Entrepreneurs, Dissidents, Bohemians, and Technocrats Lays Claim to China's Future.* New York: Simon & Schuster, 1994.

Semsel, George S., Xia Hong, and Hou Jianping, eds. *Chinese Film Theory: A Guide to the New Era.* New York: Praeger, 1990.

Shan, Wanli 单万里, ed. *Jilu dianying wenxian* 纪录电影文献 (Compendium of documentary studies). Beijing: Zhongguo guangbo dianshi chubanshe, 2001.

———. *Zhongguo jilu dianying shi* 中国纪录电影史 (History of Chinese documentary film). Beijing: Zhongguo dianying chubanshe, 2005.

Shen, Vivian. *The Origins of Left-wing Cinema in China, 1932–37.* New York: Routledge, 2005.

Shih, Shu-mei. *Visuality and Identity: Sinophone Articulations across the Pacific.* Berkeley: University of California Press, 2007.

Shohat, Ella, and Robert Stam. *Unthinking Eurocentrism: Multiculturalism and the Media.* London: Routledge, 1995.

Silbergeld, Jerome. *Hitchcock with a Chinese Face: Cinematic Doubles, Oedipal Triangles, and China's Moral Voice.* Seattle: University of Washington Press, 2004.

Sklarew, Bruce H., Bonnie S. Kaufman, Ellen Handler Spitz, and Diane Borden, eds. *Bertolucci's "The Last Emperor": Multiple Takes.* Detroit, MI: Wayne State University Press, 1998.

Smith, Michael Peter. "Power in Place: Retheorizing the Local and the Global." In *Understanding the City,* eds. John Eade and Christopher Mele, pp. 109–130. Oxford: Blackwell, 2002.

Smith, Neil. "Contours of a Spatialized Politics: Homeless Vehicles and the Production of Geographical Scale." *Social Text* 33 (1992): 55–81.

Soja, Edward. *Post-modern Geographies: The Reassertion of Space in Critical Social Theory.* London: Verso, 1989.

———. *Thirdspace: Journeys to Los Angeles and Other Real-and-Imagined Places.* Oxford: Blackwell, 1996.

Sorlin, Pierre. *Italian National Cinema 1896–1996.* London: Routledge, 1996.

Stern, Lesley. "Ghosting: The Performance and Migration of Cinematic Gesture, Focusing on Hou Hsiao-hsien's *Good Men Good Women.*" In *Migrations of Gesture,* eds. Carrie Nolan and Sally Ann Ness, pp. 185–215. Minneapolis: University of Minnesota Press, 2008.

Sunshine, Linda, ed. *"Crouching Tiger, Hidden Dragon": Portrait of the Ang Lee Film.* New York: Newmarket Press, 2000.

Swyngedouw, Erik. "Neither Global Nor Local: 'Glocalization' and the Politics of Scale." In *Spaces of Globalization: Reasserting the Power of the Local,* ed. Kevin Cox, pp. 137–166. New York: Guilford Press, 1997.

Tai, Zixue. *The Internet in China: Cyberspace and Civil Society.* London: Routledge, 2006.

Tam, Kwok-kan, and Wimal Dissanayake. *New Chinese Cinema.* Hong Kong: Oxford University Press, 1998.

Tarantino, Quentin. *Pulp Fiction: A Quentin Tarantino Screenplay.* New York: Hyperion, 1994.

Tuan, Yi-Fu. *Cosmos and Hearth: A Cosmopolite's Viewpoint.* Minneapolis: University of Minnesota Press, 1996.

———. *Space and Place: The Perspective of Experience.* Minneapolis: University of Minnesota Press, 1977.

———. *Topophilia: A Study of Environmental Perception, Attitudes, and Values.* New York: Columbia University Press, 1990.

Tuohy, Sue. "Metropolitan Sounds: Music in Chinese Films of the 1930s." In *Cinema and Urban Culture in Shanghai,* ed. Yingjin Zhang, pp. 200–221. Stanford, CA: Stanford University Press, 1999.

Udden, James. "Hou Hsiao-hsien and the Question of a Chinese Style." *Asian Cinema* 13, no. 1 (2002): 54–75.

Voci, Paola. "From the Center to the Periphery: Chinese Documentary's Visual Conjectures." *Modern Chinese Literature and Culture* 16, no. 1 (2004): 65–113.

Wang, Ban. "Documentary as Haunting of the Real: The Logic of Capital in *Blind Shaft*." *Asian Cinema* 16, no. 1 (2005): 4–15.

Wang Hui. *China's New Order: Society, Politics, and Economy in Transition.* Cambridge, MA: Harvard University Press, 2003.

Wang, Jing, ed. *Locating China: Space, Place and Popular Culture.* London: Routledge, 2005.

Wang, Qi. "Navigating on the Ruins: Space, Power and History in Contemporary Chinese Independent Documentaries." *Asian Cinema* 17, no. 1 (2006): 246–255.

———. "The Ruin Is Already a New Outcome: An Interview with Cui Zi'en." *Positions* 12, no. 1 (2004): 181–194.

———. "Writing Against Oblivion: Personal Filmmaking from the Forsaken Generation in Post-Socialist China." Ph.D. dissertation. University of California, Los Angeles, 2008.

Wang, Shujen. "*Big Shot's Funeral:* China, Sony, and the WTO." *Asian Cinema* 14, no. 2 (2003): 145–154.

———. *Framing Piracy: Globalization and Film Distribution in Greater China.* Lanham, MD: Rowman & Littlefield, 2003.

Wang, Weici 王慰慈. *Jilu yu tansuo: 1990–2000 dalu jilupian de fazhan yu koushu jilu* 记录与探索: 1990–2000 大陆纪录片的发展与口述记录 (Document and explore: The growth of documentary in mainland China and its related oral histories, 1990–2000). Taipei: Guojian dianying ziliao guan, 2001.

Wang, Yiman. "The Amateur's Lightning Rod: DV Documentary in Postsocialist China." *Film Quarterly* 58, no. 4 (2005): 16–26.

Waugh, Thomas. "Beyond *Vérité*: Emile de Antonio and the New Documentary of the Seventies." In *Movies and Methods,* ed. Bill Nichols, vol. 2, pp. 232–258. Berkeley: University of California, 1985.

Weber, Samuel. "Displacing the Body: The Question of Digital Democracy." Published May 2, 1996: <http://www.hydra.umn.edu/weber/displace.html>, accessed Jan. 27, 2005.

Willemen, Paul. "The National." In *Fields of Vision: Essays in Film Studies, Visual Anthropology, and Photography,* eds. Leslie Devereaux and Roger Hillman, pp. 21–34. Berkeley: University of California Press, 1995.

Williams, Alan, ed. *Film and Nationalism.* Brunswick, NJ: Rutgers University Press, 2002.

Winston, Brian. *Claiming the Real: The Documentary Film Revisited.* London: British Film Institute, 1995.

Wu Guanping 吴冠平. "Fang qingnian daoyan Lu Xuechang" 访青年导演路学长 (An interview with young director Lu Xuechang). *Dianying yishu* 2000, no. 4: 61–65.

Wu Hung. "Between Past and Future: A Brief History of Contemporary Chinese Photography." In *Between Past and Future: New Photography and Video from China,* eds. Wu Hung and Christopher Phillips, pp. 11–36. Chicago: Smart Museum of Art, University of Chicago, 2004.

———. *Remaking Beijing: Tiananmen Square and the Creation of a Political Space.* Chicago: University of Chicago Press, 2005.

———. "Ruins, Fragmentation, and the Chinese Modern/Postmodern." In *Inside/Out: New Chinese Art,* ed. Minglu Gao, pp. 59–66. Berkeley: University of California Press, 1998.

Wu Jing 吴晶 and Wang Zhen 王桢. "Zai chanyehua chaoliu zhong jianchi ziwo: Jia Zhangke zai Xianggang Jinhui daxue de yanjiang" 在产业化潮流中坚持自我: 贾樟柯在香港浸会大学的演讲 (Being myself amidst commercialization: Jia Zhangke's speech at Hong Kong Baptist University). *Dianying yishu* 2007, no. 1: 27–34.

Wu, Wenguang 吴文光, ed. *Xianchang (di yi juan)* 现场 (第一卷) (Document: The present scene, vol. 1). Tianjin: Tianjin shehui kexueyuan chubanshe, 2000.

———, ed. *Xianchang (di er juan)* 现场 (第二卷) (Document: The present scene, vol. 2). Tianjin: Tianjin shehui kexueyuan chubanshe, 2001.

Xiao, Hui. "Cross-Cultural Nostalgia and Visual Consumption: On the Adaptation and Japanese Reception of Huo Jianqi's 2003 Film *Nuan.*" In *From Camera Lens to Critical Lens: A Collection of Best Essays on Film Adaptation,* ed. Rebecca Housel, pp. 142–159. Newcastle: Cambridge Scholars Press, 2006.

Xiao Qiang. "The Internet: A Force to Transform Chinese Society?" In *China's Transformations: The Stories beyond the Headlines,* eds. Lionel M. Jensen and Timothy B. Weston, pp. 129–143. Lanham, MD: Rowman & Littlefield, 2007.

Xu, Gary G. *Sinascape: Contemporary Chinese Cinema.* Lanham, MD: Rowman & Littlefield, 2007.

Xu, Jian. "Representing Rural Migrants in the City: Experimentalism in Wang Xiaoshuai's *So Close to Paradise* and *Beijing Bicycle.*" *Screen* 46, no. 4 (2005): 433–449.

Yamagata International Documentary Film Festival Website. "Ying Weiwei." <http://www.city.yamagata.yamagata.jp/cgi-bin_01/fsearch-e.cgi?title=Box&director=Ying+Weiwei&country=China&year=&synopsis=>, accessed Aug. 5, 2005.

Yan Chunjun 颜纯钧, ed. *Zhongguo dianying bijiao yanjiu* 中国电影比较研究 (Comparative studies of Chinese cinema). Beijing: Zhongguo dianying chubanshe, 2002.

Yan Jun 颜峻. "Kan dianying, ting yinyue, guang gongyuan" 看电影, 听音乐, 逛公园 (Watching films, listening to music, and visiting parks). *Xin qingnian* 新青年. Posted on April 15, 2002 at <http://xueshu.newyouth.beida-online.com/data/data.php3?db=xueshu&id=kandianying>.

Yan, Yunxiang. "Managed Globalization: State Power and Cultural Transition in China." In *Many Globalizations: Cultural Diversity in the Contemporary World,* eds. Peter L. Berger and Samuel P. Huntington, pp. 19–47. New York: Oxford University Press, 2002.

Yang, Mayfair. "Film Discussion Groups in China: State Discourse or a Plebeian Public Sphere?" *Visual Anthropology Review* 10, no. 1 (1994): 112–125.

Yang Yuanying 杨远婴, and Li Bin 李彬, eds. *Yingxian, tansuo rensheng: Duihua xinrui daoyan* 影像·探索人生: 对话新锐导演 (Images, explorations of life: Interviews with cutting-edge directors). Beijing: Zhongguo dianying chubanshe, 2008.

Yau, Esther C. M., ed. *At Full Speed: Hong Kong Cinema in a Borderless World.* Minneapolis: University of Minnesota Press, 2001.

Yeh, Emilie Yueh-yu. "A Life of Its Own: Musical Discourses in Wong Kar-Wai's Films." *Post Script* 19, no. 1 (1999): 120–136.

———, and Darrell W. Davis. *Taiwan Film Directors: A Treasure Island*. New York: Columbia University Press, 2004.

Yin Hong 尹鸿. *Kuayue bainian: Quanqiuhua beijing xiade Zhongguo dianying* 跨越百年: 全球化背景下的中国电影 (Crossing the centennial year: Chinese cinema against the background of globalization). Beijing: Qinghua daxue chubanshe, 2007.

———. "Zai jiafeng zhong zhangda: Zhongguo dalu xinsheng dai de dianying shijie" 在夹缝中长大：中国新生代的电影世界 (Growing up between the fissures: The film world of the new born generation). *Ershiyi shiji* 49 (Oct. 1998): 88–93.

———. "Zouxiang houhepai shidai de huayu dianying" 走向后合拍时代的华语电影 (Toward the post-coproduction era in Chinese-language cinema). In *Locality, Translocality, and De-Locality: Cultural, Aesthetic and Political Dynamics of Chinese-Language Cinema*, a conference proceeding, ed. Shanghai University, vol. 1, pp. 17–38. Shanghai, July 2008.

Yin Hong, and Zhan Qingsheng 詹庆生. "2007 Zhongguo dianying chanye beiwang" 2007中国电影产业备忘 (Memorandum on the Chinese film industry in 2007). *Dianying yishu* 2008, no. 2: 13–21.

Yip, June. *Envisioning Taiwan: Fiction, Cinema, and the Nation in the Cultural Imaginary*. Durham, NC: Duke University Press, 2004.

Yu Aiyu 余爱鱼. "Guanyu Zhongguo 'dixia dianying' de wenhua jiexi" 关于中国"地下电影"的文化解析 (Cultural analysis of "underground film" in China). *Shiji Zhongguo* 世纪中国 (Aug. 9, 2000). <www.cc.org.cn/zhoukan/shidaizhuanti/0208/0208091002.htm>, accessed Feb. 20, 2004.

Yu Yunke 余允科. "Toufa luanle? Mei luan!" 头发乱了？没乱 (Disheveled hair? No!). *Dazhong dianying* 1995, no. 1: 32–33.

Zha Jianying. *China Pop: How Soap Operas, Tabloids, and Bestsellers Are Transforming a Culture*. New York: New Press, 1995.

Zhang Fengzhu 张凤铸, Huang Shixian 黄式宪, and Hu Zhifeng 胡智锋, eds. *Quanqiuhua yu Zhongguo yingshi de mingyun* 全球化与中国影视的命运 (Globalization and the destiny of Chinese film and television). Beijing: Beijing guangbo xueyuan chubanshe, 2003.

Zhang, Li. *Strangers in the City: Reconfigurations of Space, Power, and Social Networks Within China's Floating Population*. Stanford, CA: Stanford University Press, 2001.

Zhang Ming 章明. *Zhaodao yizhong dianying fangfa* 找到一种电影方法 (Discovering a film method). Beijing: Zhonggguo guangbo dianshi chubanshe, 2003.

Zhang, Rui. *The Cinema of Feng Xiaogang: Commercialization and Censorship in Chinese Cinema after 1989*. Hong Kong: Hong Kong University Press, 2008.

Zhang Xianmin 张献民. *Kanbujian de yingxiang* 看不见的影像 (Films banned from watching). Shanghai: Sanlian shudian, 2004.

Zhang Xianmin, and Zhang Yaxuan 张亚璇, eds. *Yigeren de yingxiang: DV wanquan shouce* 一个人的影像: DV完全手册 *(All about DV: Works, making, creation, comments)*. Beijing: Zhongguo qingnian chubanshe, 2003.

Zhang, Xudong. *Chinese Modernism in the Era of Reforms: Cultural Fever, Avant-garde Fiction, and the New Chinese Cinema*. Durham, NC: Duke University Press, 1997.

———, ed. *Whither China? Intellectual Politics in Contemporary China.* Durham, NC: Duke University Press, 2001.

Zhang Yibai 张一白. "Tongwang chuntian de wuge zhantai" 通往春天的五个站台 (Five platforms in the subway to spring). *Dianying yishu* 2002, no. 6: 76–78.

Zhang, Yingjin. "Beyond Binary Imagination: Progress and Problems in Chinese Film Historiography," *Chinese Historical Review* 15, no. 1 (2008): 65–87.

———. *Chinese National Cinema.* London: Routledge, 2004.

———. *The City in Modern Chinese Literature and Film: Configurations of Space, Time, and Gender.* Stanford, CA: Stanford University Press, 1996.

———, ed. *Cinema and Urban Culture in Shanghai, 1922–1943.* Stanford, CA: Stanford University Press, 1999.

———. "Cultural Translation between the World and the Chinese: The Problematics in Positioning Nobel Laureate Gao Xingjian." *Concentric: Literary and Cultural Studies* (Taipei) 31, no. 2 (July 2005): 127–144.

———. *"Evening Bell:* Wu Ziniu's Visions of History, War and Humanity." In *Chinese Films in Focus: 25 New Takes,* ed. Chris Berry, pp. 81–88. London: British Film Institute, 2003.

———. "Industry and Ideology: A Centennial Review of Chinese Cinema." *World Literature Today* 77, nos. 3–4 (Oct.-Dec. 2003): 8–13.

———. "Rebel without a Cause? China's New Urban Generation and Postsocialist Filmmaking." In *The Urban Generation,* ed. Z. Zhang, pp. 49–80. Durham, NC: Duke University Press, 2007.

———. *Screening China: Critical Interventions, Cinematic Reconfigurations, and the Transnational Imaginary in Contemporary Chinese Cinema.* Ann Arbor: Center for Chinese Studies, University of Michigan, 2002.

——— 张英进. *Shenshi Zhongguo: Cong xuekeshi jiaodu guancha Zhongguo dianying yu wenxue yanjiu* 审视中国: 从学科史的角度观察中国电影与文学研究 (China in focus: Studies of Chinese cinema and literature in the perspective of academic history). Nanjing: Nanjing University Press, 2006.

Zhang, Zhen. *An Amorous History of the Silver Screen: Shanghai Cinema, 1896–1937.* Chicago: University of Chicago Press, 2005.

———. "Bearing Witness: Chinese Urban Cinema in the Era of 'Transformation' *(Zhuanxing)*." In *The Urban Generation,* ed. Z. Zhang, pp. 1–45. Durham, NC: Duke University Press, 2007.

———. "Cosmopolitan Projections: World Literature on Chinese Screens." In *A Companion to Literature and Film,* eds. Robert Stam and Alessandra Raengo, pp. 144–163. Oxford: Blackwell, 2004.

——— 张真. "Dai sheyingji de nüren: Dangdai Zhongguo nüxing jilupian paishe huodong yilan" 带摄影机的女人: 当代中国女性纪录片拍摄活动一览 (Women with cameras: A review of women documentarists in contemporary China). In *Lingyan xiangkan,* ed. Ping Jie, pp. 84–95. Shanghai: Wenhui chubanshe, 2006.

———. "Urban Dreamscape, Phantom Sisters, and the Identity of an Emergent Art." In *The Urban Generation,* ed. Z. Zhang, pp. 344–387. Durham, NC: Duke University Press, 2007.

———, ed. *The Urban Generation: Chinese Cinema and Society at the Turn of the Twenty-first Century.* Durham, NC: Duke University Press, 2007.

Zhao Weifang 赵卫防. *Xianggang dianying chanye liubian* 香港电影产业流变 (Trans-
 formation of Hong Kong film industry). Beijing: Zhongguo dianying chubanshe,
 2008.
Zhao Xiyan 赵锡彦. "*Hezi* neiwai de qingyu zhengzhi: Jianlun *Nütongzhi youxing
 ri*"《盒子》内外的情欲政治: 兼论《女同志游行日》(The politics of desire
 inside and outside *The Box:* Also on *Dyke March*). In *Lingyan xiangkan,* ed. Ping
 Jie, pp. 143–151. Shanghai: Wenhui chubanshe, 2006.
Zheng, Wei 郑伟. "'He' zhong de rizi" "盒"中的日子 (Days spent in the "Box"). *Dushu*
 读书 2003, no. 6: 105–109.
———. "Jilu yu biaoshu: Zhongguo dalu 1990 niandai yilai de duli jilupian" 记录与
 表述: 中国大陆1990年代以来的独立纪录片 (Documenting and expression:
 mainland Chinese independent documentary since 1990). *Dushu* 2003, no. 10:
 76–86.
Zhong, Xueping. "Mr. Zhao On and Off the Screen: Male Desire and Its Discontent." In
 The Urban Generation, ed. Z. Zhang, pp. 295–215. Durham, NC: Duke University
 Press, 2007.
Zhongguo dianying nianjian she 中国电影年鉴社 (China Film Yearbook Press), ed.
 1997 Zhongguo dianying nianjian 1997中国电影年鉴 (1997 China film year-
 book). Beijing: Zhongguo dianying nianjian she, 1998.
Zhu Rikun 朱日坤, and Wan Xiaogang 万小刚, eds. *Duli jilu: Duihua Zhongguo xin-
 rui daoyan* 独立记录: 对话中国新锐导演 (Independent record: Interviews with
 Chinese cutting-edge directors). Beijing: Zhongguo minzu sheying yishu chuban-
 she, 2005.
Zhu, Ying. *Chinese Cinema during the Era of Reform: The Ingenuity of the System.* West-
 port, CT: Praeger, 2003.
Žižek, Slavoj. *The Fragile Absolute, Or, Why Is the Christian Legacy Worth Fighting For?*
 London: Verso, 2000.

Index

About the Author

YINGJIN ZHANG (Ph.D., Stanford University) is director of the Chinese Studies Program and professor of Chinese literature and film, comparative literature, and cultural studies at the University of California, San Diego. He is the author of *The City in Modern Chinese Literature and Film: Configurations of Space, Time, and Gender* (Stanford, 1996), *Screening China: Critical Interventions, Cinematic Reconfigurations, and the Transnational Imaginary in Contemporary Chinese Cinema* (Center for Chinese Studies, University of Michigan, 2002), and *Chinese National Cinema* (Routledge, 2004); coauthor of *Encyclopedia of Chinese Film* (Routledge, 1998); editor of *China in a Polycentric World: Essays in Chinese Comparative Literature* (Stanford, 1998) and *Cinema and Urban Culture in Shanghai, 1922–1943* (Stanford, 1999); and coeditor of *From Underground to Independent: Alternative Film Culture in Contemporary China* (Rowman & Littlefield, 2006).

Production Notes for Zhang / CINEMA, SPACE,, AND POLYLOCALITY

Interior designed by University of Hawai'i Press production staff with text in
Minion Pro and display in Seria Sans LF.

Composition by Lucille C. Aono

Printing and binding by Edwards Brothers, Inc.